Museums, Society, Inequality

Museums, Society, Inequality explores the wide-ranging social roles and responsibilities of the museum. It brings together diverse international perspectives (including those from Australia, New Zealand, South Africa, Kenya, Greece, the US and the UK), which collectively seek to stimulate critical debate, inform the work of practitioners and policy makers and advance recognition of the agency of museums: their purposes, responsibilities and value to society.

The notion that the cultural and the social are inextricably linked and, more particularly, that museums have the potential to act as agents of social change is neither new nor radical. However, debates claiming the museum's social agency, that have for many years been marginalised, have moved centre stage and fundamental questions about the museum's social purpose and responsibility, and in particular its potential to impact on both the indicators and the causes of social inequality, are subject to increasing scrutiny and debate.

This challenging new work is divided into three parts. The first offers different understandings of the social agency of the museum. Each contributor presents recent thinking on the impact, both positive and negative, that museums have on society and the lives of specific individuals and communities. The second section examines ways in which museums have sought to engage with contemporary social concerns, to tackle specific manifestations of inequality and to act, in partnership with other agencies and with communities, in order to instigate social change. The final section begins to imagine the character of inclusive museums and the processes that might be employed to enable them to become more relevant, effective and useful to society in the future.

Though the authors hold wide-ranging perspectives on the museum's social role, they all acknowledge that museums both influence society and must also respond to its changing characteristics and concerns. This crucial new work is essential for all museum academics, practitioners and students.

Richard Sandell is Lecturer in Museum Studies at the University of Leicester and Research Associate of RCMG (Research Centre for Museums and Galleries).

Museum Meanings

Series editors

Eilean Hooper-Greenhill
Flora Kaplan

The museum has been constructed as a symbol in Western society since the Renaissance. This symbol is both complex and multi-layered, acting as a sign for domination and liberation, learning and leisure. As sites for exposition, through their collections, displays and buildings, museums mediate many of society's basic values. But these mediations are subject to contestation, and the museum can also be seen as a site for cultural politics. In post-colonial societies, museums have changed radically, reinventing themselves under pressure from many forces, which include new roles and functions for museums, economic rationalism and moves towards greater democratic access.

Museum Meanings analyses and explores the relationships between museums and their publics. 'Museums' are understood very broadly, to include art galleries, historic sites and historic houses. 'Relationships with publics' is also understood very broadly, including interactions with artefacts, exhibitions and architecture, which may be analysed from a range of theoretical perspectives. These include material culture studies, mass communication and media studies, learning theories and cultural studies. The analysis of the relationship of the museum to its publics shifts the emphasis from the museum as text, to studies grounded in the relationships of bodies and sites, identities and communities.

Also in this series:

Colonialism and the Object
Empire, Material Culture and the Museum
Edited by Tim Barringer and Tom Flynn

Learning in the Museum
George E. Hein

Museum, Media, Message
Edited by Eilean Hooper-Greenhill

Museums and the Interpretation of Visual Culture
Eilean Hooper-Greenhill

Museums, Society, Inequality

Edited by

Richard Sandell

London and New York

First published 2002
by Routledge
11 New Fetter Lane, London EC4P 4EE

Simultaneously published in the US and Canada
by Routledge
29 West 35th Street, New York, NY 10001

Routledge is an imprint of the Taylor & Francis Group

Typeset in Sabon by
Florence Production Ltd, Stoodleigh, Devon
Printed and bound in Great Britain by
TJ International Ltd, Padstow, Cornwall

British Library Cataloguing in Publication Data
A catalogue record for this book is available from the British Library

Library of Congress Cataloging in Publication Data
Museums, society, inequality / edited by Richard Sandell.
p.cm. – (Museum meanings)
Includes bibliographical references and index.
1. Museums—Philosophy. 2. Museums—Social aspects.
3. Museums—Educational aspects. 4. Political correctness.
5. Social influence. I. Sandell, Richard, 1967– II. Series.
AM7 .M8853 2002
069–dc21
2001049112

ISBN 0–415–26059-0 (hbk)
ISBN 0–415–26060–4 (pbk)

To my parents, with love

Contents

Illustrations

Figures

Tables

Notes on contributors

Ruth J. Abram is President of the Lower East Side Tenement Museum, which she founded in 1988. The Tenement Museum, whose mission is 'to promote tolerance and historical perspective through the presentation and interpretation of the variety of immigrant and migrant experiences on Manhattan's Lower East Side, a gateway to America' is undertaking the nation's first effort to preserve and interpret a nineteenth-century tenement building. Using the building and its Lower East Side neighbourhood, the museum has pioneered the interpretation of the home and community life of urban, immigrant, working-class and poor peoples, and it has set a precedent in using history as a tool for addressing contemporary social issues. Ruth has received many awards, including the Camille Mermod Award from the American Medical Women's Association; Honorary Doctor of Public Service, Russell Sage Colleges; and, most recently, the 'Women in Preservation' Award. She has served as a reviewer for the National Endowment for the Humanities and as a participant in the 2000 Museums and Community National Task Force of the American Association of Museums.

David Butts completed an MA in archaeology at Otago University. He held curatorial positions at two regional museums in the lower North Island before moving to the Department of Internal Affairs to work for the Cultural Conservation Advisory Council. In 1989 he was appointed Director of the Museum Studies programme at Massey University, Palmerston North. The Museum Studies programme amalgamated with the School of Māori Studies in 1998 and David was appointed Programme Co-ordinator, Heritage and Museum Studies. David teaches courses in collection management, government and heritage, and repatriation. His research interests are in the history of museums, collecting strategies, heritage legislation, museums and indigenous peoples and repatriation. He is currently undertaking doctoral research on Māori participation in museum governance. David has been a trustee of the Whanganui Regional Museum since 1998.

Gerard Corsane is a lecturer in the Department of Museum Studies at the University of Leicester. He completed his MA in Museum Studies at Leicester in 1989 and started work in the History Division of the Albany Museums' complex in Grahamstown, South Africa, becoming Head of the division in

1992. In 1997, he was appointed as the first Robben Island Training Programme Co-ordinator and played a key role in the establishment of the Postgraduate Diploma in Museum and Heritage Studies offered by the Robben Island Museum, the University of the Western Cape and the University of Cape Town. He served on the South African Museums Association (SAMA) Council in different positions between 1993 and 1997, and has published a number of articles on museum studies.

Annie Delin is a disability consultant working principally in the fields of arts, museums and media. After beginning her career as a local newspaper reporter and editor in Leicestershire, she founded a public relations consultancy partnership offering advice on media relations and print design. She developed a specialism in disability and communications partly due to her lifelong experience of disability, which also led to her appointment as co-presenter of a BBC television disability magazine series and a Channel 4 documentary on advertising representation. She now advises and trains clients in the regional and national arts and museums sector on issues including equality, public consultation, imagery and representation, building and gallery design and inclusive marketing.

Jocelyn Dodd is currently Research Manager at RCMG, the Research Centre for Museums and Galleries in the Department of Museum Studies at the University of Leicester, which focuses on research and evaluation around the relationship between museums, galleries and their audiences. Prior to joining RCMG she worked for over ten years for Nottingham City Museums and Galleries in various roles, including Museums Education Officer, Access Manager and Museums Services Manager. During this time she was instrumental in embedding across the museum service an ethos that centred on social inclusion. Jocelyn is the co-author of *Building Bridges: Guidance for Museums and Galleries on Developing New Audiences* (1998) and co-author/editor of *Including Museums: Perspectives on Museums, Galleries and Social Inclusion* (2001).

David Fleming is Director of National Museums and Galleries on Merseyside, having formerly worked at museums in Tyne and Wear, Hull, Leeds and York. David is currently a Trustee of the National Football Museum, a member of the North East Cultural Consortium, a Board Member of the North East Museums, Libraries and Archives Council, and President of the Museums Association. He is passionate about the need to democratise the UK's museums and to make them relevant to the whole population, rejecting the notion that museums need to go 'down market' in order to achieve these aims. He believes that museums can be powerful agents of social change.

Phil Gordon is Head of Anthropology and Manager of the Aboriginal Heritage Unit at the Australian Museum. He has been involved in the development of policy and procedures dealing with Indigenous cultural issues including repatriation and overseeing the development of Indigenous public programmes at the Museum. The main role of the Aboriginal Heritage Unit is to act as an intermediary service between the Australian Museum and the Indigenous communities of Australia on issues of Indigenous cultural heritage management. He also

provides advice for various government agencies on cultural heritage issues and policy development and has recently been appointed to the Joint Federal and State Committee dealing with the Return of Indigenous Cultural Property.

Despina Kalessopoulou holds a BA in Archaeology and History of Art (University of Athens), and an MA in Museum Studies (University of Leicester). Since 1992 she has worked in various museums and cultural institutions as an assistant officer in developing art exhibitions and as a museum educator. Since 1998 she has been Head of the Education Department of the Hellenic Children's Museum. Her major areas of interest are towards strengthening the role of the museum in the community through the implementation of outreach projects. In 1999 she started her research into the contribution of museum educational programmes to the improvement of quality of life for hospitalised children. She has also worked as a special scientific collaborator of the Museum Education Department at the University of Thessaly, Volos, Greece.

Fredrick Karanja Mirara is currently Head of the Education Department at the National Museums of Kenya. He attended Kenyatta University, Kenya and subsequently gained a Masters Degree in Museum Studies from the University of Leicester. He began his career teaching history and religious education in secondary school and joined the National Museums of Kenya as an Education Officer in 1980. His responsibilities include developing and implementing education projects with a wide range of visitor groups and organising training workshops for teachers and museum education officers.

Gaynor Kavanagh is Dean of the Faculty of Media and Culture at Falmouth College of Arts. Her published work includes *Dream Spaces: Memory and the Museum* (2000) and *Museums and the First World War* (1994), both published by Leicester University Press (LUP). She is series editor of *Making Histories in Museums*, also with LUP. She is a Fellow of the Museums Association and has served on the Museums Association's Ethics Committee.

Lynda Kelly is the Head of the Australian Museum Audience Research Centre (AMARC). She has extensive experience in planning and conducting quantitative and qualitative research for a variety of purposes, from large-scale exhibition and programme evaluations through to small targeted studies for specific projects. Lynda has written widely, presented many conference papers and facilitated workshops in evaluation and visitor research. She is particularly interested in visitor experiences and learning outcomes and how these can be measured, as well as the strategic uses of evaluation and visitor research in organisational change.

Fiona McLean is a Senior Lecturer in the Department of Marketing at the University of Stirling. She holds a Ph.D. in Museum Marketing from the University of Northumbria. Fiona has been awarded a number of grants by the Leverhulme Trust and the Economic and Social Research Council to investigate issues of identity and the social role of museums. She has published widely on heritage matters, and is the author of *Marketing the Museum*, published by Routledge.

Khwezi ka Mpumlwana was part of the first Robben Island Museum management team and is currently the Education Manager for the museum. He leads a team that facilitates lifelong learning and critical debate on the Robben Island legacy through dynamic public programming. He has also co-ordinated various other museum and inter-institutional projects. A graduate in Library and Information Science from the University of the Western Cape, he has been an information practitioner and later an archivist. He has completed internships and study tours at various museums and cultural institutions internationally, where he looked at management, fundraising and public programming in changing contexts. He is interested in questions of knowledge production, culture and development, information technology and social inclusion.

Andrew Newman is a lecturer in Museum Studies at the University of Newcastle upon Tyne. Based in the International Centre for Cultural and Heritage Studies, he contributes to the suite of Cultural MAs offered by the Centre. His main responsibility is in teaching collection management to students taking the MA in Museum Studies. His research interests include developing a better understanding of the social role of museums and galleries, the conservation of material culture, and the use of new technologies to communicate with museum and gallery audiences.

Mark O'Neill is currently Head of Museums and Galleries, Cultural and Leisure Services Department, Glasgow City Council. He began his museum career in 1986, working for a local trust to establish a community museum in Springburn, a multiply-deprived area in North Glasgow, and devising new ways of involving people in how their history and contemporary lives were represented in displays. By 1990 Springburn had won a number of Scottish and UK awards. In 1990, Mark was appointed Keeper of Social History in Glasgow City Council's museum service, worked with the Education Department to set up the Open Museum, Glasgow's innovative outreach service, and later originated the concept for, and established, the St Mungo Museum of Religious Life and Art. He represented Glasgow Museums in devising the process that responded to the request from the Wounded Knee Survivors Association for the return of a Ghost Dance Shirt said to be taken from a body at the massacre.

Juanita Pastor-Makhurane has trained and worked in various aspects of heritage-making (history, oral history, archaeology, cultural resources management) and obtained an MA in Museum Studies from the University of Leicester in 1995. She is currently working as the Heritage Resources and Environmental Manager at Robben Island Museum where she has an overview of exhibition development, collection management, research strategy and environmental management. In 1997, she initiated the *Cell Stories* exhibition and collection strategy, which has now become the basis for a broader interpretive strategy for Robben Island Museum.

Ciraj Rassool is a senior lecturer in History, and Museum and Heritage Studies at the University of the Western Cape. He has written widely on South African public history, visual history and resistance historiography. His co-authored book, *Skeletons in the Cupboard: South African Museums and the Trade in*

Human Remains 1907–1917, was published in 2000. In 2001, his co-edited book, *Recalling Community in Cape Town: Creating and Curating the District Six Museum*, was published by the District Six Museum. He is a trustee of the District Six Museum in Cape Town, and a councillor of the South African Heritage Resources Agency.

Richard Sandell is a lecturer in Museum Studies and Research Associate of RCMG (the Research Centre for Museums and Galleries) at the University of Leicester. He was formerly Marketing Manager of Nottingham City Museums and Galleries. He has published, and presented at international conferences, many papers on the changing social role of museums. Richard is the co-author of *Building Bridges: Guidance for Museums and Galleries on Developing New Audiences* (1998) and co-author/editor of *Including Museums: Perspectives on Museums, Galleries and Social Inclusion* (2001).

Carol Scott is the Manager of Evaluation and Audience Research at the Power-house Museum in Sydney, Australia, a position that she has held since 1991. She was the inaugural chairperson of the Evaluation and Visitor Research Special Interest Group, an association of museum evaluators and audience research specialists. In April 2001, she was elected President of Museums Australia, the professional organisation representing museums and galleries nationally. Her recent publications include *Leisure and Change: Implications for Museums in the 21st Century*, an exploration of the impact of postmodern leisure patterns on museum attendances. She is a consultant to museums throughout Australia and New Zealand.

Lois H. Silverman holds a Ph.D. from the Annenberg School for Communica-tion, University of Pennsylvania. A Professor at Indiana University, she has been involved with museums and visitors for over eighteen years. A former museum educator, Lois teaches, publishes, and lectures internationally on her work in the areas of meaning-making, historical and cultural interpretation, the future of museums and, most recently, the therapeutic potential of museums. A former Smithsonian Institution Fellow and three-time winner of Indiana University's Teaching Excellence Award, Lois currently serves as Associate Editor of the *Journal of Interpretation Research*. Through her work and research, Lois aims to broaden and diversify the nature and function of museums.

Viv Szekeres has been Director of the Migration Museum in Adelaide, South Australia since 1987 and began her museum career there as curator in 1984. Her role at the museum is as programme co-ordinator of a small team of talented and creative staff who produce exhibitions, school programmes, publi-cations and events. Her background is in theatre design and history and she also trained and worked as a Montessori teacher and a lecturer in Education before finding her passion was working in a museum. She has a particular and personal interest in issues that surround racism and cultural diversity and believes that the success of the Migration Museum has been the active partici-pation and involvement of community groups from many different back-grounds. She feels strongly that museums need to be as much about ideas as they are about objects.

Angela Vanegas first became involved in community history when she managed *Flashback*, the Islington Local History Project, in the 1980s. She then completed an MA in Museum Studies at the University of Leicester, writing her dissertation on the combating of racism in local history museums. After working briefly at Vestry House Museum in Walthamstow, she joined Croydon Museum Service as Community Research Manager in 1990. She now works on corporate projects for Croydon Cultural Services Department.

Lola Young is Professor of Cultural Studies at Middlesex University. Before becoming an academic, Professor Young worked in the arts, promoting black arts and culture, an interest she still pursues through active involvement with various organisations. Professor Young has advised the Arts Council on cultural diversity issues and worked with the BBC on black representation on and off screen. Public appointments and committee responsibilities include membership of the board of the Royal National Theatre, Chair of the Arts Council's Cultural Diversity Panel, membership of the Board of Resource: the Council of Museums, Archives and Libraries, and Commissioner for the Royal Commission on Historical Manuscripts. She has written and broadcast widely on television and radio, reviewing plays and films for *Kaleidoscope*, and commenting on issues relating to arts and culture. Author of numerous academic essays and articles, her book, *Fear of the Dark: 'Race', Gender and Sexuality in Cinema*, is published by Routledge. Professor Young was awarded an OBE for her contribution to black British history in the New Year's Honours List.

Preface

The notion that the cultural and the social are inextricably linked and inter-related and, more particularly, that museums have the potential to act as agents of social change, to impact positively upon the lives of individuals and com-munities, is hardly a radical one. And yet many of the practices and structures to be found in museums, many of the goals that they articulate, and the philos-ophies and beliefs that underpin them, appear to deny their social agency and responsibility. Furthermore, many museums' efforts to remain discretely cult-ural in their outlook, and to autonomously pursue agendas that are fiercely resistant to social change and concerns, are reflected in their allocation and use of resources. Even those that have gained greater confidence in articulating a social role acknowledge that there is much to do in transforming their organi-sations to reflect new priorities.

Many museums continue to view the processes of collection, preservation and display, not as functions through which the organisation creates social value, but as outcomes in their own right. Whilst there is a growing consensus of the importance of broadening access to museums and diversifying their appeal and visitor profiles, relatively few museums have purposefully explored their wider social role to engage with and impact upon social issues facing their communi-ties. Nevertheless, there is a growing body of museums and museum workers who view their social role and purpose beyond that of simply facilitating access to the museum. Museums are beginning to explore their contribution towards the combating of *social* as well as *cultural* inequality.

What role can museums realistically play in tackling the causes and ameliorating the symptoms of social inequality? It may yet be too early to answer this question comprehensively but what is already clear is that, in many of the issues with which museums seek to be involved, their role is unlikely to be central. Rather museums, alongside many other organisations and agencies, are acknow-ledging their responsibility and their potential to play a part in addressing social issues and concerns. However, recognition of museums' limitations as agents of social change is not to deny their significance, nor does it lend support to those who argue that museums must 'stick to core business' and that which they know best.

The social roles and responsibilities of museums are many and varied; they may differ radically from context to context, organisation to organisation. They are relevant to and impact upon all aspects of the museum and are not confined discretely to the direct work with communities that many initiate through their education and outreach departments. The nature of these social roles and responsibilities will be influenced by many factors, including, amongst others, the needs and concerns of communities, the museum's history and that of its collections, the way in which it is funded, the political priorities of its stake-holders and the financial and human resources it has available. The multiplicity of ways in which museums have responded to their social circumstances became very evident at *Inclusion*, an international conference exploring the social role of museums that was organised by my colleagues and I in the Department of Museum Studies at the University of Leicester in 2000. The conference provided a springboard for this book and underscored the international relevance of, and growing interest in, these issues.

The conference was organised in response to increasing calls from museum professionals for opportunities to explore the relevance of social inclusion to the sector. Concepts of social inclusion and exclusion have, over the past five years, achieved a prominence in the UK museum sector, spurred on by a government that employs them in many areas of policy making. The concept of social exclusion is complex and shifting and has been used predominantly to describe increases in social inequality in Western societies.[1] Though the social inclusion agenda provided a springboard for the conference, this book is concerned with more fundamental questions surrounding the social agency and purpose of all museums.

Contributors approach the social role of museums in vastly differing ways. Some explore, directly or indirectly, issues of social inequality and, in doing so, acknowledge the dynamic processes of power that shape individuals' lives, that serve to exclude them and to constrain the opportunities and the resources available to them. Others explore the agency of the museum as more broadly defined to consider its impact on and value to society. Some contributors consider specific manifestations of inequality and the museum's responsibilities and potential contributions towards addressing them. Though approaches differ, they are all underpinned by acknowledgment that museums are fundamentally social institutions that influence and respond to the changing characteristics and concerns of society. They reflect a belief in the social utility and responsibility of museums.

The contributors themselves – practitioners, academics and commentators – are also writing from diverse perspectives. Very often, access to debate, and specifically to publication, has been reserved for a narrow cohort of academics (a practice often based on spurious claims to authority and scholarship). The aims of this book, however, are to open up and to move forward debates about the social purpose of museums, to influence and inform practice, and it has therefore set out to provide a forum in which the theoretical and abstract, the practical and professional are brought together.

Structure of the book

Contributors have been grouped according to three main themes. However, in many cases, their placing was difficult as each has something to say in relation to all areas. Part 1, *Museums and society: issues and perspectives*, offers different ways of understanding the social agency of the museum. Whilst there is some consensus, the approaches are diverse and, indeed, some are more tentative in their conclusions and more cautious in identifying the implications for museum practice than others. Each presents ways of thinking about the impact, both positive and negative, that museums have on society and the lives of individuals and communities. Part 2, *Strategies for inclusion*, presents ways in which museums have sought to engage with social issues and to act as agents of change. Though the issues they have tackled are sometimes specific to their context, they offer valuable insights for museums of all kinds to reflect upon. The chapters that comprise Part 3, *Towards the inclusive museum*, focus on change. In what ways might museums evolve, what processes might be employed to enable them to become more relevant, effective and useful to society?

Though care has been taken to represent a diverse body of opinions throughout, it is recognised that, given the nature of the subject and the complex issues involved, a project of this kind can never be comprehensive. There are, of course, other ways of exploring and understanding the relationship between museums, society and inequality and, indeed, many more examples of good practice that, for reasons of space, could not be included. This book makes no claim to offer a definitive last word on the subject but rather seeks to stimulate debate, to inform museum practice and to catalyse further research and evaluation that, together, will advance recognition of the social roles, responsibilities and purposes of museums.

Richard Sandell
June, 2001

Note

1 See, for example, Byrne, D. (1999) *Social Exclusion*, Buckingham and Philadelphia: Open University Press. For a discussion of the relevance of this concept to museums see, for example, Sandell, R. (1998) 'Museums as agents of social inclusion', *Museum Management and Curatorship* 17(4).

Acknowledgements

There are many people and organisations I would like to thank for their support in bringing this book to fruition.

I am grateful to the Heritage Lottery Fund and the Museums and Galleries Commission (now Resource: the Council of Museums, Archives and Libraries) for their financial support of the international conference that provided a springboard for this book. In particular I thank Stuart Davies, Caroline Lang and Alison Coles who provided not only encouragement and support but also advice that informed the process of conference programming. I would like to thank all the speakers, chairs, performers, delegates and students for making the conference such a lively and stimulating forum for debate.

I am indebted to all of my colleagues within the Department of Museums Studies for many things. Everyone played a key role in the organisation, planning and running of all aspects of the conference. In particular I thank Barbara Lloyd for her patience and enthusiasm. In addition, colleagues have given generously of their time in discussing the ideas that have driven this project and provided many valuable insights along the way. I owe particular thanks to Eilean Hooper-Greenhill for her untiring encouragement, assistance and advice.

I am grateful to Jocelyn Dodd, with whom I have worked for over ten years. The many projects we have collaborated on and the ideas we have explored together have been tremendously influential in my own research.

I would also like to thank all the contributors to this book for their enthusiasm for the project; Peter Davies, Maurice Davies, Elaine Heumann Gurian and Shar Jones for their helpful comments on the original book proposal, which have informed both content and structure; Julene Barnes and Polly Osborn at Routledge for patiently guiding me through the process of bringing everything together; and the University of Leicester for granting me study leave. Thanks also to Gurpreet Ahluwalia, Jim Roberts, Samantha Hunt, Janet Owen, Clare van Loenen, Pamela Wood, Llewella Selfridge, Nottingham City Museums and Art Galleries and Colchester Museums for generously providing illustrations and assisting my own research.

Finally, I am indebted to Craig, Nicola and my friends for all their support and encouragement in so many ways, and to Lewis and Anna for giving me a sense of perspective.

Richard Sandell
June, 2001

Part 1

Museums and society: issues and perspectives

1

Museums and the combating of social inequality: roles, responsibilities, resistance

Richard Sandell

Museums and galleries of all kinds have both the potential to contribute towards the combating of social inequality and a responsibility to do so. Though by no means entirely new,[1] such claims to social influence and agency are still likely to elicit challenges from both within and outside the museum. Within the museum and wider cultural sector, there are many who remain uncomfortable with the assignment of overtly social roles; roles that are perceived as imposed, extraneous and unnecessary. For the majority of those working in social, welfare and health agencies – those whose day-to-day work is concerned with issues of inequality and disadvantage – museums' roles in terms of education and leisure are more likely to be acknowledged than their potential contributions to social equity. Museums are viewed as unlikely partners[2] whose goals are discretely cultural rather than social.

Claims to social agency – the ability to influence and affect society – may not be new, but in recent years these are taking on both a new form and a new confidence. First, claims are moving from the more abstract, theorised and equivocal to become more concretised and more closely linked to contemporary social policy and the combating of specific forms of disadvantage. For example, whilst there has been a burgeoning literature that explores the political effects of representation and the generative potentials of culture, this has focused largely on processes of *construction* within the museum, rather less on processes of *reception* and the tangible impact on audiences.[3] Here, the social impact of the museum is linked to outcomes such as the creation of cultural identity or the engendering of a sense of place and belonging (as well as negative outcomes such as the subjugation of minorities). These complex outcomes that are difficult to measure have been based, for the most part, on theoretical assumptions around the signifying power of culture. Alongside increasingly sophisticated conceptual development in the area of representation there are now increasingly bold and explicit claims that are beginning to explore the museum's impact on the lives of individuals and communities and the role that cultural organisations are playing in tackling specific manifestations of inequality – such as racism and other forms of discrimination, poor health, crime and unemployment.[4]

Second, within the cultural sector, fundamental questions about the social purpose and role of museums and galleries, that have for many decades been marginalised, have more recently been foregrounded and have achieved a currency and confidence that has proved difficult to ignore, even by the most entrenched and traditional sections of the museums and arts community.[5] Those who work within and with museums and those who fund and support them are increasingly asking: What kind of difference can museums make to people's lives and to society in general? What evidence exists to support this view?

This chapter draws on recent empirical and conceptual research to posit a framework within which the social agency of museums can be further explored. It argues that museums can contribute to the combating of the causes and the amelioration of the symptoms of social inequality and disadvantage at three levels: with individuals, specific communities and wider society. It is recognised that the arguments are presented from a British perspective, though examples of museum initiatives in Australia and the US are cited. The concepts discussed and the conclusions reached are by no means confined to the British context. It is then argued that, whilst not all organisations have the resources or the mandate to deliver benefits at all three levels, nonetheless, *all* museums and galleries have a social responsibility. The argument for acknowledgement of a social responsibility emerges from discussion around the interplay between the notions of social inequality[6] and cultural authority.[7] The chapter concludes by suggesting that all museums have an obligation to develop reflexive and self-conscious approaches to collection and exhibition and an awareness and under-standing of their potential to construct more inclusive, equitable and respectful societies.

Museums and inequality: roles and outcomes

In what ways can museums engage with and impact upon social inequality, disadvantage and discrimination? The framework posited below (see Figure 1.1) has emerged from recent conceptual and empirical research and a range of international and UK examples are presented to illustrate the roles described.[8]

The framework suggests that museums can impact positively on the lives of disadvantaged or marginalised *individuals*, act as a catalyst for social regener-ation and as a vehicle for empowerment with specific *communities* and also contribute towards the creation of more equitable *societies*. It is this latter role that will receive greatest attention here, as it is argued that it is through the thoughtful representation of difference and diversity that all museums, regard-less of the nature of their collections, the resources available to them, their mission and the context within which they operate, can contribute towards greater social equity. The framework purposefully challenges the notion that the museum's contribution to the combating of social inequality is confined to its outreach or education work with specific groups and communities. It attempts to illustrate the wide-ranging outcomes museums can deliver and the most

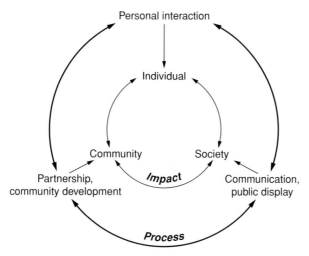

Figure 1.1 Museums and the combating of social inequality: impact and process.

commonly deployed means or processes through which these are achieved. It is, however, necessarily schematised and it is recognised that, in practice, the categories of impact and process are neither so distinct nor discrete.

Individual

This category concerns the impact that museums can have on the lives of individuals. Here the potential outcomes are wide-ranging, from the personal, psychological and emotional (such as enhanced self-esteem or sense of place) to the pragmatic (such as the acquisition of skills to enhance employment opportunities).[9] In some instances, these outcomes are unintended, peripheral or at least are not always articulated within the goals of the museum or specific programme. For example, projects that may be motivated at the outset by a desire to encourage members of a specific group, under-represented in the museum's visitor profile, to make use of its services, have later resulted in unexpected positive outcomes for individuals (Sandell 1998). In such cases, the impact on individuals' lives may only emerge informally through anecdote or remain undisclosed or unevaluated. In recent research undertaken into the contribution of large local authority museums to social inclusion, one gallery described a project with visually impaired and blind people:

> The visually impaired group – now just a group of friends – have real rapport with staff and feel at home in the building. One blind person told us how she learned to handle public places through coming to the museum, which took her out of her shell. You only get that kind of feedback from individuals themselves, as evidence from group leaders is always second hand. I hope we are doing that for others too.

> (GLLAM 2000: 25)

Another project at Nottingham Museums initially sought to enhance access to its programmes and facilities for users of mental health services in the city (Dodd and Sandell 1998). Over time, the partnership between the museum and the health service developed to include new goals, based around using the museum programmes as a vehicle to deliver skills and confidence that would enhance the quality of life for individuals.

In other instances, museums are purposefully designing programmes that position access to, or use of, the museum, not as a goal in itself but as the means of helping to bring personal and practical benefits to individuals. Though the exact nature of that benefit or outcome is not always known at the outset, crucially the programmes are developed with a focus on bringing benefit to the individual and enhancing their quality of life, rather than the museum.[10] Such programmes reflect a belief in the social utility of museums.

An example can be found in the training projects established by the Living Museum of the West, Melbourne, Australia. The museum has provided the setting for a number of projects that have sought to provide training for long-term unemployed people:

> In Australia, such job creation schemes have frequently been criticised as merely providing cheap labour pools, and for failing to deliver meaningful long-term benefit to the participants . . . However, for the Living Museum of the West, such schemes offer an opportunity to provide valuable training and skills development for local people, in particular those from disadvantaged groups with few opportunities to gain employment . . . For example, the Koorie Garden Project . . . aims to provide culturally relevant employment for indigenous people within the locality combined with horticultural training. The project enables the participants . . . to develop skills to help them gain employment after the lifetime of the project. The original members of the Koorie Garden Project have now moved on to form a separate company in which all participants are shareholders and run a gardening business within the region.
>
> (Sandell 1998: 413)

Finally, recent research into the role that small museums can play in relation to social inclusion highlights the potential significance for some individuals of voluntary work.

> The research [also] highlighted the significance of volunteering as a means by which individuals gained benefit. At the Ragged School Museum in London, volunteers come from many backgrounds and for many reasons. As well as benefiting the museum, volunteers can also gain. Through volunteering, unemployed people can learn new skills, people with mental health problems learn to develop confidence and elderly people can develop a social network and combat isolation and loneliness.
>
> (Dodd and Sandell 2001: 27)

The processes by which these individual outcomes are delivered are, for the most part, characterised by face-to-face interaction between museum staff or

representatives and members of, for example, a community group. In larger museums, they are often developed by the museum's education or outreach section. In many instances the most effective of these are developed in partnership with the agencies that have direct links with, and knowledge of, the group with which the museum is engaged (Silverman 1998).

Community

What role can museums play in delivering benefits to specific, geographically defined communities? Within this category we might consider museums' contributions to regeneration and renewal initiatives in, for example, deprived inner city or rural neighbourhoods. Specific outcomes include enhanced community self-determination, and increased participation in decision-making processes and democratic structures. Though empirical data is limited, it appears that cultural organisations, in comparison with other agencies, might be uniquely positioned to act as catalysts for community involvement and as agents for capacity building. An international conference on the role of culture in regeneration initiatives concluded that: 'Cultural initiatives are inclusive, and have an unsurpassed capacity to open dialogue between people and engage their enthusiasm and commitment to a shared redevelopment process.' Furthermore, 'culture and the development of creativity has a major part to play in helping to develop the capacity of local communities to address their own needs' (Matarasso and Landry 1996: v).

Although little formal evaluation of the museum's role in community empowerment and capacity building has been undertaken, those project experiences that have been documented point to the potential for museums to engage and enable groups that have previously been deprived of decision-making opportunities. Museums have provided an enabling, creative, perhaps less threatening forum through which community members can gain the skills and confidence required to take control and play an active, self-determining role in their community's future. Nancy Fuller, in her account of the Ak-Chin Indian community's ecomuseum project, provides further insight into the specific role that museums can play and the methods and techniques they can employ in empowering a community. She suggests that the ecomuseum model offers,

> a new role for community museums: that of instrument of self-knowledge and a place to learn and regularly practice the skills and attitudes needed for community problem solving. In this model the museum functions as a mediator in the transition from control of a community by those who are not members of the community to control by those who are.
>
> (Fuller 1992: 361)

In the categories of individual and community impact outlined briefly so far, the role of face-to-face engagement, partnerships with non-museum agencies and approaches and working practices that might be likened to those used by, for example, social, health or community development workers can be identified. This perhaps goes some way to explaining the perception that the museum's

7

role in combating social inequality is equated solely with the outreach and education function. Furthermore, this may also account, in part, for reticence and resistance on the part of some museums' staff who feel that they are ill-equipped to embark on projects of this kind, lacking the skills and resources to work directly with communities.

However, what role might museums play in tackling inequality through their ubiquitous and long-established functions of collection and display? The growing body of literature that explores the generative potential of museum representations focuses largely on its negative consequences and the museum's part in excluding, stereotyping or silencing difference through the selection, arrangement and public display of objects. In what ways then are museums reversing processes of exclusion and othering, to include and to celebrate, rather than stereotype, difference? Where this is happening, what impact does it have on the perceptions and actions of those who visit and on the creation of more equitable, tolerant societies?

Society

Claims that museums can change society can appear inappropriately immodest and naïve, a sentiment reflected in Stephen Weil's cautionary scepticism.

> Museums might [also] be more modest about the extent to which they have the capability to remedy the ills of the communities in which they are embedded. We live, all of us, in a society of startling inequalities, a society that has badly failed to achieve community, and a society that seems determined to lay waste to the planet that is its sole source of support. Museums neither caused these ills nor – except for calling attention to them – have it within their power alone to do very much to cure them.
>
> (Weil 1995: xvi)

Indeed, it is problematic to establish a direct, causal relationship between museum practices and contemporary manifestations of social inequality or their amelioration. On the other hand, museums and other cultural organisations cannot be conceived as discretely cultural, or asocial – they are undeniably implicated in the dynamics of (in)equality and the power relations between different groups through their role in constructing and disseminating dominant social narratives. What then of the political role that museums might play, alongside other organisations within civil society,[11] in promoting equality of opportunity and pluralist values?

Constructing equality

> The ways in which objects are selected, put together, and written or spoken about have political effects. These effects are not those of the objects *per se*; it is the use made of these objects and their interpretive frameworks that can open up or close down historical, social and cultural possibilities. By making marginal cultures visible, and by legitimating

difference, museum pedagogy can become a critical pedagogy.

<div align="right">(Hooper-Greenhill 2000: 148)</div>

As a medium for mass communication and with a powerful, perceived cultural authority or 'weight' (Macdonald 1998: xi) the museum's potential as an agent of change is, perhaps, underestimated. Within the framework illustrated in Figure 1.1, the role that museums can play at a societal level is based on the notion of culture as generative. As Eilean Hooper-Greenhill states:

> Culture is frequently conceived as *reflective*. However, this is less accurate than the idea of culture as *constitutive*. Cultural symbols have the power to shape cultural identities at both individual and social levels; to mobilise emotions, perceptions and values; to influence the way we feel and think. In this sense, culture is generative, constructivist.

<div align="right">(2000: 13)</div>

This understanding of culture therefore suggests a critical role for museums in picturing and presenting inclusive, equitable societies. However, despite many examples of ways in which museums have sought to implement a 'critical pedagogy', to redress previous misrepresentations or exclusions, to legitimise difference, celebrate community diversity and challenge stereotypes, there is a dearth of empirical audience studies that attest to the influence of these projects on peoples' attitudes and actions towards others.[12] The following examples pose more questions than they answer about the social agency of museums and the effects of display on people's values, perceptions and social actions. They do, however, begin to suggest a possible role that museums might play in the combating of inequality and serve to highlight issues relating to the relative efficacy of different modes of exhibition and display.

At Nottingham Castle Museum and Art Gallery, a display dating from the 1970s insensitively contrasted, on one side of a gallery, 'ethnographic' objects and on the other the military collections of the Sherwood Foresters Regiment. The display's overtly colonial interpretation angered many local communities and was eventually replaced with *The Circle of Life* exhibition in 1994. The gallery, like others of its kind, set out to replace an unequivocal 'us and them' message with one that gives equal attention to sameness as it does to difference. The gallery explores the ways in which people from different cultures mark their outward appearance through different stages in their lives and uses objects from the collections alongside material loaned by local communities, including Lithuanian, Hindu, Ghanaian and Jewish groups (Figure 1.2). As the introductory panel states:

The Circle of Life

Life is a journey, a road upon which we all must travel from the cradle to the grave. We all share the experiences of life; good fortune or bad, success or failure, youth, maturity or old age and finally death.

> We mark these changes in our lives, these steps along the road, in our outward appearance. Our clothes, jewellery, hairstyles and body decoration all proclaim to others our status, beliefs, attitudes, sex, occupation or origin.
>
> Different cultures in different times have all found ways of saying 'Look, this is me. This is who I am!'

So, British military uniforms that were once displayed symbolically and physically in stark opposition to objects from non-western cultures now share a case with them and an interpretive framework that no longer prioritises one over another. The objects displayed were selected to represent the diversity of communities that currently live within the city.

Though redisplays, such as *The Circle of Life*, represent a conscious attempt to engage with ideas of equality and to foreground the value of community diversity, there are very few examples where the impact of the exhibition on visitors' perceptions and values has been researched. What cognitive, psychological and emotional reactions can occur during or following the visitor–exhibition encounter? How might cultural representations of those perceived as 'other' be received and decoded by visitors when difference is no longer exoticised, but rather integrated within and alongside the familiar? Does the cultural authority of the museum play a part in challenging visitors' beliefs and values about, for example, a specific community or group?

It can sometimes seem as if cultural organisations are uncertain about asserting their value in constructing and imagining inclusive societies. On the other hand, where the political implications and social consequences of culture are negative, these can be more confidently expressed. The relationship between processes of cultural production and manifestations of racial prejudice is clearly pointed out in *The Parekh Report* on *The Future of Multi-Ethnic Britain*:

> Acts of racism, racial violence, racial prejudice and abuse do not exist in a vacuum. They are not isolated incidents or individual acts, removed from the cultural fabric of our lives. Notions of cultural value, belonging and worth are defined and fixed by the decisions we make about what is or is not our culture, and how we are represented (or not) by cultural institutions.
>
> (The Commission on the Future of Multi-Ethnic Britain 2000: 159)

The political consequences of representation have received most attention in relation to displays and redisplays of collections traditionally categorised as anthropological or ethnographic (Hooper-Greenhill 2000; Macdonald 1998; Karp 1992). Though these museums have been subject to most scrutiny, as Eilean Hooper-Greenhill comments,

> the points that are made perhaps most forcibly in the anthropological museums are of more general relevance. Displayed objects of all types are

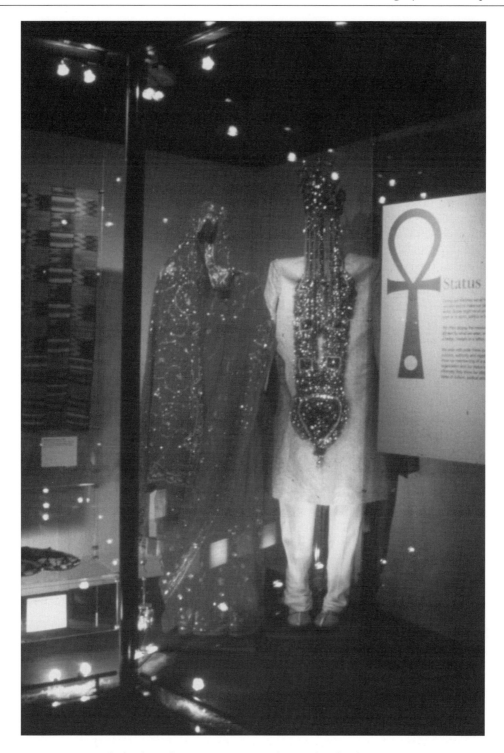

Figure 1.2 'Hindu bride and groom, 1994' in *The Circle of Life*. Photo Richard Sandell.

made meaningful according to the interpretive frameworks within which they are placed, and the historical or cultural position from which they are seen.

(2000: 8)

Similarly, Karp asserts that 'Art, history, and ethnography displays, even natural history exhibitions, are all involved in defining the identities of communities – or in denying them identity' (Karp 1992: 19).

What implications does this have for the social responsibility of *all* museums and for exhibition and collection practices in particular? Are different kinds of museum and different modes of display more authoritative, better positioned to influence and shape attitudes, more powerful agents of change than others? Though, as stated earlier, there exists little in the way of formal, in-depth research with which to test out these hypotheses, the following examples serve to highlight ways in which museum exhibitions can potentially contribute towards the combating of discrimination, intolerance and social inequities.

In 1998, during the final phase of a major refurbishment of Nottingham Castle Museum and Art Gallery, an exhibition of decorative arts, *Every Object Tells a Story* (Figure 1.3), opened on the ground floor, adjacent to the foyer and main entrance. The exhibition represents a departure from previous exhibitionary styles for the decorative arts collections within the museum. The formerly distinct and separate galleries of ceramics, silver and glass have been merged to take a thematic look at the stories attached to different objects. The gallery employs a number of interpretive devices: activities and displays aimed at very young children, reflexive texts and videos by artists that explore the colonial histories of collections[13] and the personal accounts and responses of individuals from different communities to the objects displayed. The museum is perhaps the best known and most prestigious cultural venue in the city. *Every Object Tells a Story* is the first exhibition that most of the museum's 400,000 visitors each year will encounter. The museum attracts large numbers of local families as well as tourists and is run by the local authority. One section of the exhibition, 'Stories of Love', includes just three objects displayed together in the same case. The text panel states:

Stories of Love

Objects have the power to evoke strong emotions in people.

The objects in this section are symbols of the most powerful human emotion – love.

Different objects – different kinds of love.

Do you have any object that you treasure as symbols of love?

Figure 1.3 *Every Object Tells a Story.* Photo by kind permission of Nottingham Castle Museum and Art Gallery: Nottingham City Museums and Galleries.

The three objects displayed are a pocket watch and love poem that belonged to Private John Batty, a soldier who died in the Battle of Waterloo in 1815, a child's jacket made by the Rabari people from the Kutch area of Gujerat and a large, decorative ceramic bowl, entitled 'Lovers' (Figure 1.4). The text that accompanies the bowl is the moving testimony of Andrew who explains that the bowl was created as a memorial to his partner Neil who died in 1993.

> The design of the bowl really came from myself and what I got to know of Neil over the five years that we were together – the fact that he loved ceramics and loved Karen Atherley's work . . . My definition of real love? Neil was the love of my life and we were very close and shared a hell of a lot. I used to work in my shop a lot more than I do now, but I had other things to look forward to then, so that didn't seem so bad. I used to work until 5 o'clock and Neil would come to the shop whenever he could. I just remember the happy hours at the end of the day, and Neil's little face coming past the shop window.

Though no research has been undertaken into visitor responses to the bowl, and its place within a mainstream, family-oriented exhibition, the example poses interesting questions about the political implications and consequences of display. Whilst the controversial nature of many temporary exhibitions often evokes mixed public reactions and even media controversy,[14] the placing of an object representing a gay relationship, within one of the museum's main galleries alongside those which tell the story of a historical/heterosexual

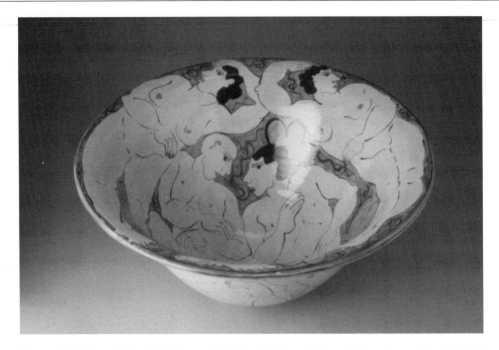

Figure 1.4 'Lovers' bowl by Karen Atherley in *Every Object Tells a Story*. Photo by kind permission of Nottingham Castle Museum and Art Gallery: Nottingham City Museums and Galleries.

relationship and that between a mother and child has, to date, produced no formal complaints or adverse comment (Wood 2001). The extent to which this is a consequence of the naturalising effects of the museum's cultural authority is uncertain.

In the 'Stories of Love' exhibit, sameness is once more conferred equal status to difference. Karp and Kratz[15] state that:

> In museum exhibits as much as in other cultural forms, the construction of cultural identity is achieved through two simultaneously occurring processes: (1) the use of exaggerated differences or oppositions that can be alternately a mode of exploration and understanding or an act of discrimination and (2) the use of varied assertions of sameness or similarity between audience and the object of contemplation.
>
> (2000: 194)

They further argue that:

> Stressing similarities produces an assimilating impression creating both familiarity and intimacy with representations and their subjects. Assertions of unbridgeable difference, on the other hand, exoticise by creating relations of great spatial or temporal distance, perhaps the thrill of the unknown.
>
> (ibid.: 198)

In this example, does the placement of objects, and the relations established between them, offer a preferred reading to visitors, one that encourages empathy, acceptance and respect? How might visitors receive such messages?

Shaping the unpredictable: visitor reception and response

It is, of course, naïve to imagine that purposefully inclusive museum displays can guide visitors, without resistance or question, towards preordained opinions and engender within them specific values. The way in which processes of communication within the museum are now understood challenges the transmission model of pedagogy in which the messages received and decoded by the audience are those intended, prescribed and predicted by the curator (Hooper-Greenhill 2000: 133). Instead, communication is now understood in a way that gives much greater emphasis to the audience or visitor.

> In this approach to communication, the focus is on how meaning is constructed through social life by active individual agents, within social networks . . . The task for communicators – or, in the museum, curators, educators and exhibition developers – is to provide experiences that invite visitors to make meaning through deploying and extending their existing interpretive strategies and repertoires, using their prior knowledge and their preferred learning styles, and testing their hypotheses against those of others, including experts.
>
> (ibid.: 139)

What are the implications of this understanding of communication for discussions about the social responsibility of museums? Since the prior knowledge, experiences and value systems of visitors are so central to the communication process, what role can the museum play in shaping their attitudes and values? The constructivist view of museum pedagogy requires us to acknowledge the complex and unpredictable nature of the visitor response (Hooper-Greenhill 2000: 124). Messages, intended by museum staff to evoke feelings of respect, empathy, understanding, and insight may instead evoke equally strong negative responses. As Eilean Hooper-Greenhill states:

> Exhibitions are produced to communicate meaningful visual and textual statements, but there is no guarantee that the intended meaning will be achieved. Visitors to museum exhibitions respond in diverse ways. They may or may not perceive the intended messages, and, perceiving them, they may or may not agree with them, find them interesting, or pay attention to them.
>
> (ibid.: 4)

This unpredictability of response is exemplified in a letter of complaint, recently sent to Nottingham Castle Museum and Art Gallery. Alongside the permanent displays of *The Circle of Life* and *Every Object Tells a Story*, previously discussed, a recent temporary exhibition of work by artist Alison Lapper, organised by the museum, clearly presented its aims in the introductory text panel. Here the artist stated:

My work reflects and responds to other people's attitude to me. I hope to question and change society's ideas about physical beauty, normality, disability and sexuality. As a disabled person, I am generally perceived as ugly, sexless, inert, helpless and miserable.

I know I am not.

My work gives me the opportunity to represent myself to the world on my own terms . . .

Visitor responses to the exhibition were largely positive and the artist herself found the experience of exhibiting in a 'mainstream' cultural organisation an empowering one.

I was in the gallery when a group of pretty robust, straight-talking children came in and we got into a conversation. They wanted to know how I got dressed, what it was like being a mum with no arms, they were inquisitive and accepting, they wanted to use their feet as I do. It was spontaneous and accidental but it seemed to me what this is all about – it was about difference, about diversity, about my disability, my life.

(quoted in Dodd and Sandell 2001)

One formal complaint however, about the visitor's experience of the whole museum, was received from a local resident and illustrates not only a general resistance to museums engaging with contemporary social issues but a reading of the exhibition that is in direct opposition with its stated aims. The visitor stated:

Only one room remained as we had remembered it and that was full of old uniforms and war memorabilia. The remaining rooms were disorganised mazes of what I can only describe as rubbish. We were particularly offended by the display of photographs of a disabled woman and her baby, which I can only compare to the old 'freak show'. I know we live in the age of 'political correctness' but I do not think that the Castle was the place to display such items of so called modern art.

Such responses may be seen to challenge the view that museums can and should exploit their cultural authority. As Hilde Hein comments:

Like a literary text, an object represents a potential effect that is realized only in an act of apprehension equivalent to the act of reading. That act may concur with, but can also resist, the author's act of writing or the judgement of a curator. Meaning is not 'put into' a text or object to be 'taken away' by someone who 'finds' it here, but comes into being through intersubjective participatory experiences.

(2000: 63)

With this understanding of communication, claims that a museum visit might transform an individual's entrenched and oppositional views and values appear both problematic and naïve.

However, Eilean Hooper-Greenhill's discussion of learning theory and the work of Gadamer on the encounter between object and viewer points to a way forward:

> Gadamer suggests that experiences, objects and other materials such as texts are approached with what he calls prejudices, or foreknowledge, given by our own historicity, and with a certain openness. This receptiveness to the objects creates a balance or dialectic between prejudice (what is already known) and openness. This dialectic permits revision of prejudices towards a greater 'truth' but this truth is still relative, historical and socially determined.
>
> (Hooper-Greenhill 2000: 117)

This might suggest that, whilst a single museum visit is unlikely to overturn the most entrenched attitudes, nonetheless, more inchoate values and perceptions may be open to challenge, question, modification. At the very least, it can be argued that, alongside other mass media, museums can play a role in the promulgation of values based on social equity.

Whilst the ways in which visitors decode purposeful attempts to promote social equality are under-researched and poorly understood, research that has been undertaken lends support to this argument. In 'Harnessing the power of history', Ruth Abram (this volume) describes a project to challenge misconceptions and stereotypical attitudes amongst schoolchildren:

> Teaming up with private and public schools, and with Lyndhurst, a National Trust Site, the Museum is developing a programme with a simple message – a person's worth cannot be measured by calculating his/her material wealth. As a first step, nine-year-olds were invited to write down words they associated with the word 'poor' both before and after a visit to the Tenement Museum. The number of negative associations with the word 'poor' (including 'mean', 'dangerous', 'dishonest') plummeted from 90 before the visit to 20 after it.

Similarly, evidence from evaluation undertaken at the Australian Museum, Sydney into the impact of the *Indigenous Australians* exhibition that opened in 1997 suggests that it has successfully achieved significant shifts in some visitors' attitudes.

> Focus group interviews were held with adults and children six months after they had visited the exhibition to investigate long-term learning, impact and change. Participants in this study gave many examples of gaining greater understanding through relating what they had seen in the exhibition to their own experiences and knowledge . . . Participants also talked about thinking differently after seeing the exhibition: '*I thought differently. I've met Aboriginal people . . . and it didn't click with the way*

17

that, as a child, when you grew up and everything you heard [was nega-tive] and then you see an exhibition like this, well then you see a lot more of the story.'

<div align="right">(Kelly and Gordon, this volume)</div>

Whilst the way in which visitors will respond to exhibitions cannot be predicted with certainty, the museum's role and efficacy could be both better understood and, as a result, enhanced through a greater understanding of the processes of audience reception. As Hilde Hein states, 'learning theorists and environmental psychologists have concluded that certain conceptual and developmental commonalities do exist and that knowledge of these would enable museums to shepherd the experience of their audience to achieve some degree of uniformity' (2000: 112).

These brief examples go some way to supporting the view that museums might purposefully employ their cultural authority to broader social ends. Despite a growing recognition that museums have often reproduced and reinforced social inequalities through their collecting and exhibitionary practices, many museum staff are uncomfortable with the notion of relinquishing their pursuit of per-ceived objectivity and neutrality in favour of adopting an active, political stance on equality issues. What obligations might be placed on museums to do so?

Museums and social responsibility

The arguments presented so far have focused on two key issues: the relation-ship between museums and social inequality and the notion of cultural authority. Where these intersect and are brought together, questions of social responsibility emerge most strongly. Within the museum context, social respon-sibility requires an acknowledgement not only of the potential to impact on social inequality, but also of the organisations' obligation to deploy their social agency and cultural authority in a way that is aligned and consistent with the values of contemporary society.

In the UK, where the concept of social inclusion has become embedded throughout central government policy, critics have argued that the assignment of social goals to cultural organisations is tying them too closely to the state and eroding their autonomy. This, it is argued, is reducing the arts to a tool for governmental social control (Thorpe 2000: 9). However, issues of social respon-sibility require museums to become responsive, not to short-term, party polit-ical objectives but rather to longer-term, paradigmatic shifts in thinking and what Hein calls the 'prevailing moral spirit' of society as a whole (2000: 92). Museums' principles and practices are no longer in step with contemporary, dominant value systems and ways of thinking. As Eilean Hooper-Greenhill states:

> The museum of the modernist period, the modernist museum, which emerged in the nineteenth century, developed characteristics which were shaped in relation to the ideas and values of the period . . . Since this time, however, these ideas and values have been challenged, modified, put away.
>
> (2000: 21)

Social responsibility requires an acknowledgement of the meaning-making potential of the museum and an imperative to utilise that to positive social ends. From her perspective as a philosopher, Hein describes this as 'institutional morality'.[16] She is critical of professional codes of ethics that have focused on the behaviour of individuals whilst neglecting the agency of the museum as an institution.

> The suggestion that institutions might originate and express moral agency appears to personify and invest them with suprahuman consciousness. We tend to believe that because morality entails intentionality, it therefore requires consciousness. I am claiming that moral character does not imply consciousness, but rather the capacity to create meaning. Institutions possess that capacity to an extent exceeding that of any individual.
>
> (2000: 103)

Alongside these moral and ethical arguments, there are also those who would argue that museums have obligations to deliver benefits to society by virtue of their status as publicly funded institutions. Edmund Barry Gaither argues that,

> Museums have obligations as both educational and social institutions to participate in and contribute towards the restoration of wholeness in the communities of our country. They ought to increase understanding within and between cultural groups in the matrix of lives in which we exist. They ought to help to give substance, correction and reality to the often incomplete and distorted stories we hear about art and social history. They should not dodge the controversy that often arises from the reappraisal of our common and overlapping pasts. If our museums cannot muster the courage to tackle these considerations in ways appropriate to their various missions and scales then concern must be raised for how they justify the receipt of support from the public.
>
> (1992: 58)

Of course, acceptance of the social and moral agency of the museum as an institution raises innumerable complex issues for those who work within them. Issues of balance, partiality and moral judgement are those that many museums are already grappling with.[17] Similarly, there are tensions between the notion of 'institutional morality' (as a force for positive change) and the potential for its misuse. Furthermore, some critics are sceptical of the museum's ability to effectively challenge the dominant narratives and power relations with which it is inextricably linked (Marcus 2000; Hallam and Street 2000: 151). These concerns again raise questions for museum practice and the need for a methodology that adequately responds to a diverse and rapidly-changing society. Increasingly museums are looking to discard exhibitions with a single,

authoritative voice in favour of multiple voices, speaking in their own words and on their own terms.[18] Stephen Levine articulates some of these concerns, and the possible way forward:

> Museum officials, accustomed to speaking authoritatively, must recognize that their choice of whom to hire and whom to listen to retains for them the cultural power to cast the terms of discourse about people and history. Even when museums consult representatives of minority cultures or bring them onto their staff, they still must consider how and on what basis their selections of such representatives have been made . . . a solution is likely to be found only in an adequate process of dialogue, one that can transform the voice of authority on which museums have traditionally relied into the voice of a pluralistic society.
>
> (1992: 145)

Social responsibility is not a new concept to the museum. It can be linked, for example, to the new approaches to social history curation that gained momentum in the early 1980s and that sought to present the histories of previously marginalised groups (Fleming 2001). Indeed, over twelve years ago, Edward Chappell wrote,

> Millions of people visit history museums each year. This vast audience is ready to be thoughtfully engaged, to be challenged to think about major issues, past and present . . . decent museums must not be passive or regressive. They should be accessible and – just as important – they should have things to say that ultimately advance the discussion about social relations and economic structure.
>
> (1989: 265)

Similarly, museums have been urged to adopt a political stance in their exhibitions that explore contemporary social problems (Ellis 1995) and to accept that they cannot be impartial observers in clashes over contested identities (Karp 1992: 15).

However, despite a growing recognition of the social agency of museums, (both positive and negative), there remains a marked reluctance to acknowledge the obligations that accompany it and to explore the possibilities and limitations in practice. Some of the most entrenched views can be found in the art museum where the belief in 'art for art's sake' remains, for some, strongly resistant to social and political influence. This resistance is exemplified by comments made by Mark Ryan:

> When the new elite says we must tackle 'social exclusion', such a statement could mean a lot of different things . . . The museum or gallery that is not prepared to turn its collection into a children's playground is being exclusive . . . Although the precise meaning is unclear, there is never a doubt as to what the new language intends. The artistic director who is concerned only with the merit of his work, when he hears that he must tackle social exclusion, knows that he is being warned. Perhaps he is thinking too much about art and not enough about The People.
>
> (2000: 17)

The concept of responsibility – individual, institutional, professional and shared – is an increasingly significant feature of contemporary society.[19] Social responsibility is receiving increasing attention in many professional arenas (ranging from business to architecture, mass media to engineering)[20] and in academic contexts exploring, for example, the social responsibility of science. Many museums, in their desire for autonomy, resistance to change, and disengagement from societal concerns run the risk of becoming increasingly irrelevant and anachronistic in their values.

Acknowledgement of a potential to contribute to social change brings many challenges as well as possibilities. However, the concept of social responsibility does not imply that the combating of inequality becomes the sole aim of all museums,[21] nor that disadvantage and discrimination are problems that museums alone must tackle. Similarly, social responsibility does not require museums to become government tools for social engineering and control. The reality, much less threatening and radical than many traditionalists assume, is based on the idea that museums, alongside many other institutional and individual agents, must consider their impact on society and seek to shape that impact through practice that is based on contemporary values and a commitment to social equality.

Notes

1 The social purpose and goals of many museums established in the nineteenth century have been widely discussed (see, for example, Davies 1994). Though these museums had a clear social purpose, the motivations behind them are generally understood as paternalistic and based on notions of civilising and facilitating the governance of the masses (Hein 2000: 44 and Hooper-Greenhill 2000: 11).

2 For example, Margaret Mackechnie (2001: 117) comments, 'In the past, with a background in residential social work, I have generally thought of museums as places to take children for a day out and that was about the extent of it. Museums did not figure in terms of thinking about childcare, I really didn't think they had much to offer. I am sure that these perceptions echo those of many who are working in the social sector.'

3 The dearth of empirical audience studies and associated delay in conceptual development is discussed by Hooper-Greenhill (1995: 9).

4 Such claims are being supported by a growing body of qualitative research into the social impact of museums. See, for example, GLLAM 2000 and Dodd and Sandell 2001.

5 In the UK, the election of New Labour in 1997 has seen the concepts and terminology of social inclusion become embedded in not only social and welfare but also cultural policies. Such policy developments have helped to highlight and bring into focus the questions of social purpose and value facing cultural organisations. A lively debate has ensued in professional journals, seminars and conferences as well as national newspapers.

6 Social inequality is understood here in terms of not only the forms of disadvantage experienced by different groups and individuals but also the dynamic social processes and power relations that operate to deny those groups opportunities, rights and access to resources.

7 Cultural authority is understood here to refer to the museum's capacity to make meaning and, in doing so, to influence and shape visitors' perceptions.

8 The framework presented here is developed from concepts originally put forward in Sandell 1998 and developed in Dodd and Sandell 2001.

9 See, for example, GLLAM 2000.

10 See for example, Silverman 1998 and this volume; 'Mandy's story' in Dodd and Sandell 2001.

11 Karp (1992: 5) states that 'Civil society includes such diverse forms of organization as families, voluntary associations, ethnic groups and associations, educational organizations and professional societies. These are the social apparatuses responsible for providing the arenas and contexts in which people define, debate and contest their identities and produce and reproduce their living circumstances, their beliefs and values and ultimately their social order.'

12 This lack of empirical research into visitors' responses to exhibitions is highlighted by Hooper-Greenhill (1995: 9) and, in relation to science exhibitions, Macdonald (1998: 2).

13 One text panel reads, 'The silver candlesticks have been displayed in the museum since 1968 as purely decorative objects. Made in 1757 at the height of the slave trade, they depict African slaves, yet this provocative subject was neither acknowledged nor interpreted. Video makers Dan Saul and Joules Ayodeji explore the wider history of the candlesticks. Take a closer look . . .'

14 It might be argued that temporary exhibitions are more likely (by virtue of their sometimes controversial content and higher profile) than their more permanent exhibitionary counterparts to provoke debate and public reaction, both positive and negative. On the other hand, they may perhaps be perceived as less authoritative, more open to scrutiny and question than more permanent displays. Sharon Macdonald, citing Roger Silverstone, suggests that the cultural authority of different media might be usefully explored in relation to the space they occupy and their degree of permanency. 'An emphasis on time and space would direct us to consideration of such matters as the authority effects of the temporal stability of most museum exhibitions, many of which are in place for years' (Macdonald 1998: 5).

15 Drawing on the ideas of Barthes 1984.

16 She also uses the term 'moral leadership' (2000: 103).

17 See, in particular, Szekeres, this volume.

18 The text that accompanies the bowl within *Every Object Tells a Story*, described earlier, is just one example of this.

19 See, for example, Strydom, P. (1999) 'The challenge of responsibility for sociology', *Current Sociology*, 47(3), London: Sage Publications.

20 See, for example, Bussel, A. (1995) 'The (social) art of architecture', *Progressive Architecture* 76, January: 43–46; Wilson, I. (2000) 'The new rules: ethics, social responsibility and strategy', *Strategy and Leadership*, 28(3): 12–16.

21 In a recent article about the under-representation of ethnic minorities on British television, Gurbux Singh, chair of the Commission for Racial Equality, considers the shared nature of responsibility. 'It helps no one that young people still grow up looking at the world and themselves through a television screen that hides much of the reality that it does not distort. It is not television's fault that the world out there is infested by racism and discrimination, but television needs to play its part in helping to deal with the problem instead of compromising with it' (2001: 17).

References

Barthes, R. (1984) 'The great family of man' in *Mythologies*, New York: Hill and Wang.

Chappell, E. A. (1989) 'Social responsibility and the American history museum', *Winterthur Portfolio* 24, Winter: 247–265.

The Commission on the Future of Multi-Ethnic Britain (2000) *The Future of Multi-Ethnic Britain: The Parekh Report*, London: The Runnymede Trust and Profile Books.

Davies, S. (1994) 'A sense of purpose: rethinking museum values and strategies' in G. Kavanagh (ed.) *Museum Provision and Professionalism*, London and New York: Routledge.

Dodd, J. and Sandell, R. (1998) *Building Bridges: Guidance for Museums and Galleries on Developing New Audiences*, London: Museums and Galleries Commission.

Dodd, J. and Sandell, R. (eds) (2001) *Including Museums: Perspectives on Museums, Galleries and Social Inclusion*, Leicester: Research Centre for Museums and Galleries, Department of Museum Studies.

Ellis, R. (1995) 'Museums as change agents', *Journal of Museum Education*, Spring/Summer: 14–17.

Fleming, D. (2001) 'The politics of social inclusion' in J. Dodd and R. Sandell (eds) *Including Museums: Perspectives on Museums, Galleries and Social Inclusion*, Leicester: Research Centre for Museums and Galleries, Department of Museum Studies.

Fuller, N. J. (1992) 'The museum as a vehicle for community empowerment: the Ak-Chin Indian Community Ecomuseum Project' in I. Karp, C. Kreamer and S. Levine (eds) *Museums and Communities: The Politics of Public Culture*, Washington and London: Smithsonian Institution Press.

Gaither, E. B. (1992) ' "Hey! That's mine": thoughts on pluralism and American museums' in I. Karp, C. Kreamer and S. Levine (eds) *Museums and Communities: The Politics of Public Culture*, Washington and London: Smithsonian Institution Press.

GLLAM (2000) *Museums and Social Inclusion – The GLLAM Report*, Leicester: Research Centre for Museums and Galleries, Department of Museum Studies.

Hallam, E. and Street, B. V. (eds) (2000) *Cultural Encounters: Representing 'Otherness'*, London and New York: Routledge.

Hein, H. (2000) *The Museum in Transition: A Philosophical Perspective*, Washington: Smithsonian Institution.

Hooper-Greenhill, E. (ed.) (1995) *Museum, Media, Message*, London and New York: Routledge.

Hooper-Greenhill, E. (2000) *Museums and the Interpretation of Visual Culture*, London and New York: Routledge.

Karp, I. (1992) 'On civil society and social identity' in I. Karp, C. Kreamer and S. Levine (eds) *Museums and Communities: The Politics of Public Culture*, Washington and London: Smithsonian Institution Press.

Karp, I. and Kratz, C. A. (2000) 'Reflections on the fate of Tippoo's Tiger: defining cultures through public display' in E. Hallam and B. V. Street (eds) *Cultural Encounters: Representing 'Otherness'*, London and New York: Routledge.

Levine, S. D. (1992) 'Audience, ownership and authority: designing relations between museums and communities' in I. Karp, C. Kreamer and S. Levine (eds) *Museums and Communities: The Politics of Public Culture*, Washington and London: Smithsonian Institution Press.

Macdonald, S. (ed.) (1998) *The Politics of Display: Museums, Science, Culture*, London and New York: Routledge.

Mackechnie, M. (2001) 'Partnerships and a shared responsibility' in J. Dodd and R. Sandell (eds) *Including Museums: Perspectives on Museums, Galleries and Social Inclusion*, Leicester: Research Centre for Museums and Galleries, Department of Museum Studies.

Marcus, K. (2000) 'Towards an erotics of the museum' in E. Hallam and B. V. Street (eds) *Cultural Encounters: Representing 'Otherness'*, London and New York: Routledge.

Matarasso, F. and Landry, C. (eds) (1996) *The Art of Regeneration*, Stroud: Comedia and Nottingham City Council.

Ryan, M. (2000) 'Manipulation without end' in M. Wallinger and M. Warnock (eds) *Art for All?: Their Policies and Our Culture*, London: Peer.

Sandell, R. (1998) 'Museums as agents of social inclusion', *Museum Management and Curatorship*, 17(4): 401–418.

Silverman, L. (1998) *The Therapeutic Potential of Museums: A Guide to Social Service/Museum Collaboration*, Indiana: Institute of Museum and Library Services.

Singh, G. (2001) 'Any colour, as long as it's white', *Guardian*, 9 April.

Thorpe, V. (2000) 'Labour using art as "tool of social control" ', *Observer*, 3 December.

Weil, S. (1995) *A Cabinet of Curiosities: Inquiries Into Museums and Their Prospects*, Washington and London: Smithsonian Institution Press.

Wood, P. (2001) Personal communication to the author.

2

The good enough visitor

Mark O'Neill

> . . . culture can be understood as the domain of all that becomes more by
> sharing it.
>
> (Gadamer 1998: 6)

The demand that publicly funded art museums contribute to the creation of a
more socially inclusive society poses a fundamental challenge to many assump-
tions about what these institutions are for and to how they function. To go
beyond providing mere physical access to the presence of works of art (even if
this is free) to providing intellectual and emotional access to the meanings of
the works of art for all potential visitors and to taking a developmental
approach to visitors' aesthetic experiences, will require changes in the conven-
tions of art museums. Such changes often evoke real and profound opposition.
Is this opposition designed to protect a valued tradition, which is coincidentally
and not intentionally exclusive? Or is it that art museums, as currently
conceived, are inherently exclusive? What is the relationship between aesthetic
standards applied to works of art and traditions of display, and the ethical stan-
dards that shape the public services provided by art museums, which receive
public subsidy either directly or through the tax system?

These questions, about how art museums achieve legitimacy in a democratic
society, are part of a debate that is not new, though the terminology has changed.
This article sets recent controversies in the context of the historical argument
about the social purpose of art museums over the past 150 years. Its purpose is
to seek a basis for going beyond the sterile conflict between 'elitism' and 'dumb-
ing down', and to contribute to the definition of what a socially inclusive
museum might be. While many art museums now have education and even out-
reach staff, this represents essentially a welfare model of provision, with a main-
stream that is well provided for alongside some cultural benefits for the less well
off. A socially inclusive art museum would transcend this model and treat all
visitors, existing and potential, with equal respect, and provide access appro-
priate to their background, level of education, ability and life experience.

What are art museums for?

According to Carol Duncan, in her book *Civilizing Rituals: Inside Public Art
Museums* (1995), there are three main views about what art museums are for.

All three theories claim that art in art museums has a power to affect or transform people, but in very different ways. The *aesthetic* view claims that the serious pleasure of aesthetic contemplation of works of art has an inspirational value, which needs no other justification. This view was expressed poetically by Kenneth Clark when he stated that,

> the only reason for bringing together works of art in a public place is that
> . . . they produce in us a kind of exalted happiness. For a moment there is
> a clearing in the jungle: we pass on refreshed, with our capacity for life
> increased and with some memory of the sky.
>
> <div align="right">(quoted in Duncan 1995: 13)</div>

The *educational* view, often seen as in opposition to the aesthetic, claims that art museums should be part of the process of educating people, aesthetically, visually, socially and historically. The third, *political*, view sees art museums as social institutions, carrying out an ideological function, reinforcing the power structure of society, transforming visitors into willing acceptors of the status quo.

Aesthetic versus utilitarian purposes

In historical terms the aesthetic is a relatively recent view, and for most of the nineteenth century there was an international consensus among cultural decision makers in the west that the first responsibility of a public art museum was to enlighten and improve its visitors morally, socially and politically. In 1835, soon after the establishment of the National Gallery in London, a Select Committee of the House of Commons was established to study the government's involvement in art education and the management of public collections. Full of Benthamite reformers and radicals, the committee's immediate purpose was to discover ways to improve the taste of English artisans and designers and thereby improve the design and competitiveness of British manufactured goods. Most of the committee members were convinced that art museums, museums and art schools, if properly organised, could be instruments of social change, capable of strengthening the social order. The committee had an 'unshakeable belief, that the very sight of art could improve the morals and deportment of even the lowest social ranks' (Duncan 1995: 42–43).

In 1902, at the opening in Glasgow of the Kelvingrove Art Gallery and Museum, perhaps the greatest achievement of the British municipal museum and art gallery movement, the city's Lord Provost was clearly in the utilitarian tradition:

> The Corporation at least were satisfied that art was in itself a refining and
> improving and ennobling thing, otherwise they would not have felt justi-
> fied in doing what they have done in order to provide for the reception of
> so many of the citizens to view the treasures that would henceforward be
> housed in the building. And there was the question of the educational
> value of the museum and the opportunities afforded the young people and
> the lads and girls who had possibly outgrown the ordinary day school and

others for still further pursuing their studies, and so broadening and enlarging their general culture.

<div align="right">(The Glasgow Herald 1902)</div>

However, Glasgow was the exception rather than the rule, for by the end of the nineteenth century the educators and improvers in general had been marginalised, and the aesthetes were winning, in both Europe and the United States. In Boston, the Museum of Fine Arts had, like the Victoria and Albert Museum that had inspired it, adopted an exclusively aesthetic position. In 1918 it published one of the most influential statements of the aesthetic philosophy, *Museum Ideals of Purpose and Method*. Its author, Benjamin Ives Gilman, had made an early statement of his views in 1904, two years after Kelvingrove opened, when he was invited to Britain to address the Museums Association. He argued: 'By no liberality in the definition of the word education can we reduce these two purposes, the artistic and the didactic, to one. They are mutually exclusive in scope, as they are distinct in value.' He did concede that art had some 'educative functions – it enables the less fortunate many to have impressed upon them the "excellencies" of the more fortunate few'. But these are secondary effects. 'To be appreciated is its whole end and aim, the fruition of all artistic effort; and neither the moulding of character, the furtherance of historical knowledge, nor the advancement of technical skill' are the main purpose. Museums should try to educate their visitors in appreciation, even though 'the capacity to comprehend works of art is in no small degree a matter of native endowment'. But even with regard to art appreciation 'it is not to be overlooked that this conclusion gives any didactic machinery but an auxiliary place in such a collection' (Gilman 1904: 220–221).

A sense of a swimming against the tide can be felt in the works of John Cotton Dana, the great innovator in American museums, and founder of the Newark Museum, writing in 1916:

> Probably no more useless public institution was ever devised than that popular ideal, the classical building of a museum of art, filled with rare and costly objects . . . All public institutions, and museums are no exceptions, should give returns for their cost, and those returns should be in good degree positive, definite, visible, measurable . . . It is easy to evade the importance of this obvious fact by airy talk of the uplift value of architectural facades in the classic manner, of priceless antiques, of paintings by masters, and of ancient porcelains, jades and lacquers, to say nothing of whales, Indians and mastodons . . . But the evasion does not serve. Common sense demands that a public supported institution do something for its supporters, and that some part at least of what it does be capable of clear description and downright valuation.

<div align="right">(Dana 1999: 63, 65, 66)</div>

His vision was of museums as 'institutes of visual instruction' (ibid.), which engaged in teaching, so as to become effective agencies in the intellectual, aesthetic, industrial and moral progress of their respective communities.

'Museums are not fundamentally educational institutions'

A very revealing encounter, and a decisive victory for the aesthetes took place in Britain in 1919. Though the 'Land Fit for Heroes' promised to the soldiers and the bereaved of the First World War never materialised, an Education Act was passed in 1918. This established medical inspection, nursery schools, special centres for 'defectives', and proposed compulsory part-time education for young people aged 14 to 18. This last provision was never implemented, for reasons of economy. Another little known, also unimplemented, proposal that followed from the Act, was set out in the Third Interim Report of the Adult Education Committee of the Ministry of Reconstruction. It recommended that 'the power and duties of the Local Government Board regarding public libraries and museums should be transferred forthwith to the Board of Education'. In other words museums should be educational institutions, run by education departments.

The *Museums Journal* records a meeting between the Board of Education and the Council of the Museums Association, with additional representatives from the Science Museum and the Victoria and Albert Museum (*Museums Journal* 1920: 123–129). The delegation was very clear that 'Museums are not fundamentally educational institutions.' They summarised the functions of museums as collecting and preserving works of nature and man, and research – 'the highest aim of a museum is the advancement of Science, Art and Industry'. The third purpose of museums, in order of importance, was education, by which 'the museum makes the results of research available for the education of the public by the suitable arrangement, exhibition and labelling of selected series of specimens' (ibid.).

The Council went on to state that:

> The educational functions of a museum can be carried out by a system of close co-operation between the Museum Committees and the Education Committees, . . . Experience gained from the working of such a co-operation between the two bodies, in towns where such experiments have been tried, has shown that the facilities offered by the museum as a factor in education can be fully utilized without interfering with the development of its more important functions.
>
> (ibid.)

One of the Museums Association representatives, E. E. Lowe, Curator of Plymouth Museum, perhaps fearing that the Board of Education did not really understand the relationship between museums, curators and objects, tried to make it clear: 'When we long for the acquisition of a rare or beautiful or typical object, we are desiring it for its own sake primarily, and not chiefly because it will educate some person or persons unknown.' Another stated: 'We acquire an object not for any educational purpose, but for its intrinsic merit.' The Museums Association concluded by saying that they would, of course, accept any funding that could be used for education.

The aesthetic approach to displaying fine art, ironically, takes over the basic framework established by the early reformers, which involved showing paintings chronologically and by national school. This was originally seen as a rational aid to public learning, and a rejection of the subjectivity of the aristocratic picture gallery, which arranged paintings according to personal preferences and extending far above eye-level (known charmingly as the 'gentlemen's hang'). The chronological/national school approach is represented by the aesthetes as part of the natural order, without a didactic purpose.[1]

Art museums as instruments of ideology

Civilizing Rituals (Duncan 1995) itself represents the third, political view of museums, as does Pierre Bourdieu et al.'s *The Love of Art* (1991). The latter argues that inequality is passed on from generation to generation because, not only do people inherit their parents' wealth, but also their 'cultural capital'. This includes the education that enables them to progress through the system, the knowledge of how the system works. One of the key forms of cultural capital that children inherit is the 'love of art', which gives them the familiarity with the icons of European culture that are signs of belonging to the social elite, within which meritocracy applies (ibid.).

Duncan similarly rejects the perception of art museums as 'neutral sheltering places for objects' that can be adequately described in terms of the collections or buildings. She tries to stand back from the aesthetic versus education arguments about what art museums should be. 'Usually (but not always) the educational museum is considered by its advocates to be more democratic and popular, while the aesthetic museum is seen (even by its advocates, but not always) as more elitist' (Duncan 1995: 4). Instead she sees art museums as ritual spaces. For her ritual implies a marked-off zone of time and space in which visitors, removed from the concerns of their daily, practical lives, open themselves to a different quality of experience, and that the organisation of the museum setting is a kind of script or scenario that visitors perform. The language of the aesthetic arguments in favour of museums (as in the quote from Kenneth Clark earlier) is very close to anthropological descriptions of the purposes of rituals – 'enlightenment, revelation, spiritual equilibrium or rejuvenation' (Duncan 1995: 20).

Rituals serve particular purposes for particular groups, and Duncan argues that, in both educational and aesthetic art museums, the ritual is a marker of identity for the middle classes who since the Revolution in France and the Reform Acts in nineteenth-century Britain have, more or less quickly, usurped aristocratic power and culture in Europe.

> [To] control a museum means precisely to control the representation of a community and its highest values and truths. It is also the power to define the relative standing of individuals within that community. Those who are best prepared to perform its ritual – those who are most able to respond to its various cues – are also those whose identities (social, sexual, racial

etc.) the museum ritual most fully confirms . . . What we see and do not
see in art museums – and on what terms and by whose authority we do
or do not see it – is closely linked to larger questions about who consti-
tutes the community and who defines its identity.

<div align="right">(Duncan 1995: 6)</div>

For Duncan, art museums are 'one of those sites in which politically organized
and socially institutionalized power most avidly seeks to realize its desire to
appear as beautiful, natural and legitimate' (ibid.) In other words, art museums
reinforce the existing power structure, not in some way peripheral to some
other more central function, but because that is what they are for. It is precisely
for this reason that museums and museum practices can become objects of
fierce struggle and impassioned debate, of the kind that took place in Glasgow
in the 1990s. The critical response to a number of exhibitions that experi-
mented, in a fairly mild way, with the display and interpretation of art was
extremely hostile. The purpose here is not to refute these criticisms but to
examine their underlying assumptions, to explore their terms of reference
through Duncan's lens.

The Glasgow culture wars

In 1993 Glasgow City Council opened the first museum of world religions in
the UK, designed explicitly to promote tolerance and to provide a multicultural
facility of international quality. This divided the subject into three main themes
– the Gallery of Religious Art, The Gallery of Religious Life and the Scottish
Gallery. The first took a very aesthetic approach, while the latter two took an
anthropological view, though all three included objects from across the whole
range of the city's collections – paintings (including Salvador Dali's *Christ of St
John of the Cross*), Nottingham alabasters and Italian majolica, as well as
African masks, Islamic prayer rugs and Buddhist Thangkas (Figure 2.1). This
was largely ignored by the critics.[2] One architectural writer however com-
plained of the 'boutique-style interior design' atmosphere of the Gallery of Reli-
gious Art, while he compared the Gallery of Religious Life to the displays in a
sex shop (Clelland 1994).

The 1994 exhibition, *Canvassing the Clyde*, was jointly curated by a social
historian and an art curator (Little and Patrizzio 1994). It installed works
painted by Stanley Spencer, when he was a war artist working in Greenock's
shipyards, in a display setting that suggested the physical context in which they
were painted. Real machine and hand tools used by the workers were displayed
alongside the paintings (Figure 2.2). Comments from shipyard workers on the
paintings were displayed, including points about how Spencer had taken artistic
licence with technicalities. This exhibition was described by *The Glasgow
Herald* as 'The most unsympathetic presentation of any artist I have ever seen
. . . Spencer is popularised and patronised in the misguided view – I assume –
that it will bring the punters in . . . Must they be spoonfed? Are they unable to
take their art neat?' (Henry 1994).

Figure 2.1 'Coming of Age' display in the St Mungo Museum of Religious Life and Art. Photo by kind permission of Glasgow Museums and Galleries.

Figure 2.2 Temporary exhibition, *Canvassing the Clyde*, Kelvingrove Art Gallery and Museum. Photo by kind permission of Glasgow Museums and Galleries.

Glasgow's Gallery of Modern Art opened in 1996 showing a selection of mostly representational work including that by naïve and self-taught artists such as Beryl Cook, alongside major Scottish figures such as Ken Currie and Alan Davie, all reflecting the personal tastes of Julian Spalding, then director of Glasgow Museums. Works deliberately chosen to appeal to novice visitors and children were placed on display with no framing that suggested they were in any way lesser works than those by John Bellany, Bridget Riley, Niki de Saint Phalle or Jean Tinguely (Spalding 1996). Even discounting the fact that this was not presented as an alternative view of modern art, but as a deliberate attack on what might be called the avant-garde establishment, the critics' responses were vitriolic. 'A travesty', said *The Guardian*, 'a mockery, quite the worst arranged collection of dire purchases I have ever seen' (Searle 1996). The fact that it was popular did not impress. When the gallery exceeded its target visitor numbers of 300,000 by 100 per cent in its first year, the *Scotsman* was not impressed. 'The Romans got lots of people into the Coliseum to see the lions munching Christians' (Macmillan 1997).

By the time *The Birth of Impressionism* was mounted in 1997 there was a sense that critics had tasted blood and were in for the kill. This was a version of an exhibition that had been toured by a French company to Japan, revised to suit Glasgow's collection and audiences. It sought to tell the fairly standard art history story of how Impressionism developed, and of how it emerged from and contrasted with the art that went before. It used videos to show the landscapes in which the Impressionists painted. A Salon hang included manikins wearing

Figure 2.3 Temporary exhibition, *The Birth of Impressionism*, McLellan Galleries.
Photo by kind permission of Glasgow Museums and Galleries.

late nineteenth-century French costume, and there was a reconstruction of the boat from which Monet painted many scenes (Hamilton 1997) (Figure 2.3). Gale in *Scotland on Sunday* wrote:

> I will be blunt . . . this is simply the worst exhibition I have ever seen . . . It is crass, unintelligible and a positive danger to the general public. What we have here is not an art exhibition at all, but a history lesson . . . in which the pictures become mere tools . . . as the father of a four year old, I would be happy to take my son here, but were he a year older, I would think twice. Art demands space, light and silence.
>
> (Gale 1997)

The good enough visitor

So what is going on here? The critics show no historical awareness, either of the fact that the kind of hang they prefer is a historical construct, or of Glasgow's inclusive tradition. They evince precisely the life and death intensity that Duncan identifies as a symptom of a group experiencing change as an attack. The way things are, however recently evolved, is a very real territory that must be defended against invaders.

Though the criticisms express considerable anger at the curators, this is not done directly, but is in fact focused on visitors. All the critics strongly imply that anyone who enjoyed these exhibitions is somehow not a 'good enough' person to be in an art gallery. If they liked the videos and the costume and the theatricality of *The Birth of Impressionism*, if they thought the shipyard sets were evocative, if they found St Mungo's inspiring, if they thought the eclectic mix in the Gallery of Modern Art exciting, then they are punters, they can't take their art neat, they are shoppers or voyeurs in a pornography shop, they have a mental age of four, and are so weak-minded that they might be damaged by the exhibition; they are the kind of ghouls who would enjoy public executions. This kind of exhibition, the critics say, is no longer for us, who belong here, but for *them*, who don't.

Aesthetic appreciation and human goodness

The logic is difficult to follow through. Do art museums have no role to play in the lives of people (including artists) who have voyeuristic tendencies, or people with a mental age of four, or even for people who are ignorant or stupid (which are often wrongly assumed to be the same thing)? Or is the assumption that the capacity for the appreciation of great art is linked to human goodness? Are people who like art never voyeuristic, immature or ghoulish? If there is such a link, the goodness does not seem to acknowledge any obligation to fellow human beings who may not have had an opportunity to develop an interest in art. By some sleight of hand, art in art museums becomes the object of an amoral hedonism, which has no social purpose other than to give a higher form

of pleasure, but is also the epitome of all that is good, 'beautiful, natural and legitimate', and so deserving of public subsidy. The extraordinary horrors that humans can visit upon each other are in the background of this assumption – the human species is flawed, and what is of value, like great art, must be protected from this destructiveness. The splitting off of aesthetic experiences, which may not in themselves have a moral value, from the moral context in which they take place, represents a narrowing of the definition of what is good about humanity to something that can be owned by the privileged. The ghost which haunts it is the image, evoked again and again by George Steiner, of the concentration camps being run by cultured and civilised people (1971: 54). The case for public funding of 'civilizing rituals' is partly undermined by the Glasgow critics' assumption that they should be reserved for the already civilised, implying that they are unable to civilise those who are barbarians. It is more fundamentally challenged however by the failure of the rituals to prevent one of the most civilised countries in the world from descending into barbarism.

Making access to difficulty, or making access difficult?

The reviews of the Glasgow exhibitions reflect more general criticisms made of art galleries and museums that attempt to be socially inclusive. The most common charge is of superficiality, of 'dumbing down'. This is levelled at exhibitions that provide basic information, especially if it is done using a format different from one of the three available for art museums – the national schools/chronology, the country house drawing room, or the modernist white box. Most art museums, like the Burrell Collection or the Prado, provide virtually no information about the exhibits for visitors. How can it be superficial to provide more information? Can all art, produced in a vast variety of contexts, really only communicate in such a limited range of display formats?

Another charge is that modern culture has turned away from anything difficult, that there is a pretence that everything can be made easy. Art history and appreciation are difficult, just as science is difficult, and people should be prepared to work at them. This is singularly unhistorical and mean-minded. There is no period in the past when anything more than a tiny minority of the population had the leisure and wealth to seek out subjects of intellectual difficulty. The challenge is a new one, and requires new thought, not a nostalgia for a non-existent golden age, however much current critics may like to identify themselves with elites in the past. It is mean-minded to the extent that it implies that people whose life opportunities have been limited by poverty, illness, poor education and discrimination, have to undergo some sort of painful initiation, to earn the right to basic information about what they as citizens own.

Displays like *Canvassing the Clyde* or *The Birth of Impressionism* are sometimes accused of showing art for people who don't like art. In a sense this is true. People who visit may not have a developed interest in and background knowledge of art. Is it too late for them to develop this? Even if 'the capacity to

comprehend works of art is in no small degree a matter of native endowment' (Gilman 1904: 220–221), is it inherited exclusively by people from the better-off classes of society? For many people, their lack of background is as likely to be the result of never having been given the opportunity as of having been introduced to art and finding that it didn't really interest them. The underlying assumption amongst many museum and art museum staff, rarely spoken, is that museums are for people who are already educated. Curators with this outlook tend to develop exhibitions in a way that mutes enthusiasm and narrows the focus to exclude human interest, as if they subject them to a boredom test. Their instinctive question is 'Is it boring enough?' Boring is the opposite of dumb. 'Boring' implies academic respectability, because it restricts access to the meaning of the works to those who are already knowledgeable.

The suggestion that curators have responsibilities other than to provide aesthetic experience to the already educated often elicits the response that they are not social workers or therapists, that it is not their job to compensate for the inadequacies of the state education system. If the display of art is in some way central to a society's self-definition, whether it is the serious pleasure of the aesthetes, or the social, moral and cognitive education of the improvers, then art museums are part of society as a whole and have to define their relationship to the excluded in ethical terms consistent with their espoused values. The implications of the fact that the twin processes of inclusion and exclusion are self-reinforcing systems are very clear: any organisation that is not working to break down barriers to access is actively maintaining them. Neutrality is not possible. Splitting art museums off from the rest of society is not about aesthetic standards but avoiding working out a relationship between aesthetic and ethical values.

Cultural rights

Article 27 of the Universal Declaration of Human Rights states that 'Everyone has the right freely to participate in the cultural life of the community, to enjoy the arts and to share in scientific advancement and its benefits.'[3] At another more local level, the legislation authorising local government in Scotland to provide art museums places an obligation on them to 'make adequate cultural provision' (Scottish Museums Council 2000: 2). What 'culture' is and what an 'adequate' amount of it might be, is not specified, but there is nonetheless a legal obligation on the Glasgow City Council to provide culture, presumably in a way that reflects the needs of citizens, systematically and equitably. Neither edict says that access should only be provided for clever and educated people.

The analysis underlying social inclusion is that exclusion from the opportunities society has to offer is a deeply sustained culture reinforced by attitudes of excluded and included alike. For the excluded, whether they be so for reasons of poverty, ethnicity, gender or sexual orientation, or most often, some combination of these, their situation in society can generate a lack of confidence, a sense of not belonging, which make supposed opportunities seem unattainable. In Bourdieu's terms they lack the cultural capital to access society's benefits

(Bourdieu et al. 1991). In Duncan's they lack knowledge of the correct behaviours to perform the rituals of the systems run by the middle-class state (1995). For the better off, social exclusion reflects itself in the usually unconscious communication that those who are not already 'in', are really not welcome. The analysis suggests that, unless attitudes on both sides change, unless confidence is built up among the excluded and the included are genuinely welcoming, no amount of equal opportunities or welfare will break down the barriers. The inclusive principle also means that bringing in the excluded should not have to be done at the expense of the already included. In museum terms, this means bringing as many as possible of existing loyal audiences along with any programme of change.

So what happens to first-time visitors to art museums, for whom none of the works makes sense. They are unlikely to say, as they would if attending a sporting event for the first time – 'well that didn't do anything for me', 'I won't bother with that again'. There will almost inevitably be a sense of having failed some sort of test, a touchstone of sensibility, because the whole message of the building, of facades in the classic manner, the aura of reverence, of the ritual, clearly says that this is important stuff, this is a high point in human achievement, and it should mean something to you. The message is clear: if you don't know what it's about, if it doesn't reach you, you shouldn't be here, you don't belong. For those confident enough to say, 'I've tried it and it's not for me', this may be an exercise of legitimate choice. For anyone who doesn't have that confidence, faced with the carefully constructed impressiveness of the art museum, they will have a negative rather than a neutral experience. Managing the context in which individuals encounter aesthetically charged objects so that individuals can have positive rather than negative experiences is the ethical responsibility of art museum curators.

The unwillingness to share

Resistance to change in how art is interpreted comes not just from critics but from some existing visitors. Many who feel comfortable in art museums know little or nothing about art, but have the crucial understanding of how art museums work, and this enables them to feel that they belong. They can take a guided tour, they can read labels if there are any, they can take the opportunities offered. In a multidisciplinary museum like the Burrell Collection, the British Museum or the Museum of Fine Arts in Boston, only a tiny percentage of visitors can have significant knowledge of more than two or three of the cultures on display. The minimal support provided for visitors lets these people down more than any others – they may already be interested, keen to learn, open to experience and there is little or nothing for them. Ironically it is often members of this group who are most opposed to change in art museums. This is, perhaps, because their comfort with museums as social places is combined with a lack of specific knowledge, so that they lack the confidence to deal with changes in presentation, even if these don't affect the works in any intrinsic way. More knowledgeable visitors also sometimes oppose interpretation, as if

35

putting on display basic information that they already know is offensive – 'patronising' is the word usually used. It threatens their privileged position, as it means that their special knowledge is available to all. What does it mean to be patronised? Perhaps it is the opposite of being flattered.

The welfare model of access

Modern art museums are experienced in dealing with the tensions arising from this diversity of response. James Wood, Director of the Art Institute of Chicago, stated the current liberal position in an interview in *The Chicago Tribune*:

> It's easy to think: 'Museums are educational institutions, and education means words.' Then we fall into what Bob Hughes calls the therapeutic trap – museums are supposed to make us 'healthier'. Museums are places to learn, but they are more places to experience. An aesthetic experience is not the same thing as learning. The most perfect wall label will not artic-ulate the most essential part of the experience. In surveys, people have commented on the calm repose, the light and the elegance of the surround-ings, which suggest an experience other than just being in an educational center. Still some viewers get offended, feeling that they are preached at. Others get angry for not knowing (what they feel the museum should tell them). Our obsession with democracy tells us everyone has the same right, but people enter museums with very different levels of experience, and there's no simple solution to giving everybody the best experience.
>
> (Artner 1999)

Wood believes art museums,

> must offer a range of solutions, using the best formats at the best times and places. The trick is to match the right means to the right pieces while remaining discreet enough so self-sufficient viewers can commune with the objects – and their own feelings – unimpeded.
>
> (ibid.)

In some ways Wood's view is admirable, offering something for everyone, and the Art Institute of Chicago has made major advances in art interpretation. But even here there is a sense of reluctance that having to accept all visitors as being inherently 'good enough' is a struggle – the assumptions that education is verbal and noisy, and is somehow not about experiences, that having to cater for all types of visitors reflects a degree of commitment to democracy that is unhealthy – as if art museums only reluctantly acknowledge responsibilities with regard to inequalities in the world outside their walls. The pragmatic approach is thus not really about developing the museums so that they work for all citizens but is about making small adjustments to avoid any fundamental change. It provides add-on services that pose no real challenge to the aesthetic traditions of the museum. These will be of most benefit to existing visitors who want to learn, in effect teaching people something of the language of art; they are unlikely to create new visitors from existing non-visitors, because people will

sense that they are only being asked in because some people, especially some funders, are obsessed with democracy. Many are invited, but how many are made really welcome? This is the welfare model of cultural provision, a mild redistribution of cultural capital, to appease political pressures and consciences, allowing in some people who are prepared to learn the ritual, even if the initiated find the cue cards a bit offensive. As a curator in the Prado put it, reflecting the traditionalism of many European art museums: 'We must not say that we are going to adapt the museum to the public. No, it is the public that must adapt to the museum' (de Horcajo et al. 1997: 166).

Acceptable levels of unequal access

If Duncan is correct, if art museums reflect the interests and identity of the dominant groups in society, not by accident, but because that is what they are for, then it is possible to argue that it is impossible for art museums to change. The question for staff and governors of publicly funded art museums (or museums funded by private donations which have received tax relief) then becomes: What is an acceptable level of inequality in access to our museum? Given the value of our tradition, should we be amongst the last to change? Given the value of what we can offer, should we be in the forefront of creating equality? What is the relationship between ethical and aesthetic standards? An honest answer to this question is crucial to maintaining the legitimacy of the museum as a social institution.

While traditionalist curators may take comfort from Duncan's thesis, and accept, with varying degrees of regret, that cultural change will have to wait until society at large becomes more egalitarian, the ethical challenge remains. Society is not monolithic and there are areas where change takes place at a faster pace than others, and underlying economic change does not automatically produce cultural development – it has to be worked through in its own arena. Campaigners against slavery may not have succeeded in having it abolished until the needs of the economy shifted, and paid workers became more effective than enslaved workers, but they prepared the ground for the new ways of thinking and provided the essential advocacy for winning the battles in the Houses of Parliament – and of the American Civil War. The realpolitik of social inclusion is a realisation that excluded people not only don't make a full contribution to the economy, but they in fact are an expensive drain on it. Traditional welfare has not succeeded in diminishing the percentage of excluded people. International economic competitiveness is undermined by having to pay welfare to large numbers of people, by having too many sick people and by the opportunity cost of failing to realise the potential of every citizen.

If social inclusion means anything, it means actively seeking out and removing barriers, of acknowledging that people who have been left out for generations need additional support in a whole variety of ways to enable them to exercise their rights to participate in many of the facilities that the better off and better educated take for granted. The change in the way people with disabilities have

been treated in the past hundred years is an instructive example. When our great Victorian museums were built, with their majestic steps, it did not trouble the authorities that they would effectively exclude them, because, well, because it was the way things were. Art museums had to have big steps, facades in the classic manner, and cripples had to accept the difficulties sent them. As awareness grew, as disability activists demanded first better access, then equal access on the same terms as others, not just through a ramp at the back, and as understanding of disability was broadened from wheelchair users to people with other disabilities, more and more groups became visible and vocal. As this happened, few actually disagreed that they should have equal access, but it was difficult emotionally for officials on the receiving ends of these pressures not to react defensively, not to feel blamed or caught out. For many years the problems were seen as insurmountable. Kelvingrove is a Category A listed building, and for years it was accepted that there was no way for wheelchair users to gain access, other than through the goods entrance – it seemed impossible to design an aesthetically acceptable ramp; it was only in 1998 that a lift was introduced at the front of the building with an architectural sensitivity appropriate to the building. Learning to see the needs of hitherto invisible people meant learning new ways of thinking, and this process still has a very long way to go. If we believe that museum objects on public display have a value, that museums are in some way central to our society, then the ethical context of the visitor experience must be addressed. Access cannot be an aspect of provision, it must be integral to the whole way a museum is organised, and at the forefront of the work of all staff, including conservators, administrators and curators, as well as educators.

This is in no way to underestimate the difficulty of breaking down the barriers involved in the arts in general, or for paintings in particular. In no other art form, with the exception of architecture, is it possible to encounter masterpieces so easily. You can walk into an art museum (often for free) and see a Rembrandt, in a way in which one is unlikely to come across a late Beethoven quartet, a Mozart opera or a Michelangelo sonnet. The facility and speed of sight is also a factor. Music, literature, drama and other arts unfold over time, whereas you can see, at least superficially, a painting as a whole in an instant. And yet most masterworks were created not with, for example, children in mind, but rather for small sophisticated aristocratic audiences at very specific times in cultures that are now distant. Even educated ethnic European people now no longer have the basic knowledge of classical mythological and Christian iconography required to read much of western art. Highly educated people from non-European cultures have a completely different frame of reference.

The task is to face these difficulties in terms of inclusive principles. This means a redefinition of many art gallery and museum functions on the basis of an explicit reconciliation of aesthetic, ethical and academic standards. In Glasgow we are trying to face up to this challenge. We are changing our museum staff structures and developing new approaches to all museum services, but the fundamental change is refusing to write off entire sections of the population as non-visitors. We refuse to accept the current level of inequality.

This means:

- accepting the level of education of potential visitors as they are, as the starting point;
- accepting that many of the conventions of museums are traditions valued by many but which may need to be modified to be welcoming to new visitors;
- that museum staff can only understand the reality of exclusion by working with representatives of excluded groups;
- that we must develop a pluralistic approach to our displays so that everyone from the novice visitor to the scholar feels welcome;
- redefining research, so that staff are as informed and as rigorous about visitors as about collections; and
- redefining display standards so that they not only look beautiful, but also provide access, in all senses, to the target audience, in ways that respect the reality of their lives.

All remaining issues are not of principle, but of aesthetically acceptable technical solutions.

George Steiner, one of the great appreciators of our time and a devotee of European high culture, is interestingly ambivalent about museums. Though they contain many of the art treasures he cherishes, he repeatedly uses the word 'museum' to refer to dead relics of a dead culture.[4] He regards the whole of American visual arts as a 'museum culture' obsessed with preservation at the expense of creativity (Steiner 1996: 281). He is equally ambivalent about the need for and dangers of popularisation. 'We are being asked to choose. Would we have something at least, of the main legacy of our civilization made accessible to the general public of a modern, mass-society?' If we do, it may mean that:

> Dumped on the mass market, the products of classic literacy will be thinned and adulterate . . . Or would we rather see the bulk of our literature, of our interior history, pass into the museum? . . . Already a dominant proportion of poetry, of religious thought, of art, has receded from personal immediacy into the keeping of the specialist . . . an archival pseudo-vitality surrounding what was once felt life.
>
> (Steiner 1971: 82–83)

A commitment to social inclusion by museums may help create museums where the encounter between the objects so lovingly preserved and the citizens who own them is not thin and adulterated but rich and full of genuine vitality. The process of acknowledging the ethical obligations involved in managing the context in which visitors experience objects may also change museums, making them part of a living culture, capable of responsiveness, growth and evolution.

Notes

1 See the critical response to the thematic hang of Tate Britain and Tate Modern, for example. 'It is all very well for curators to want to ignore chronology. But chronology

is not a tool of art-historical interpretation which can be used at one moment, discarded at another. It's an objective reality, built into the fabric of the work' (Sylvester 2000: 20).

2 Ironically the best review was from the conservative magazine, *The Spectator*: 'In terms of interpreting and inspiring society afresh the St Mungo Museum is probably the most important museum to have been opened in Britain since the V&A' (Artley 1993: 51).

3 Quoted in Scottish Museums Council (2000) *Museums and Social Justice: How Museums and Galleries can Work for their Whole Communities*, p. 1.

4 '. . . the dominant apparatus of American high culture *is that of custody*' (original italics, Steiner 1996: 281).

References

Artley, A. (1993) 'Many mansions', *The Spectator*, 15 May.

Artner, A. G. (1999) 'Just how much information should art museums provide?', *The Chicago Tribune*, 8 August.

Bourdieu, P., Darbel, A. and Schnapper, D. (1991) *The Love of Art: European Art Museums and their Public*, Cambridge: Polity Press (translation of a 1969 work).

Clelland, D. (1994) 'Idol work', *Museums Journal*, February: 30.

Dana, J. C. [1916] (1999) 'A plan for a new museum: the kind of museum it will profit a city to maintain', reprinted in *The New Museum: Selected Writings of John Cotton Dana*, The Newark Museum and The American Association of Museums.

Duncan, C. (1995) *Civilizing Rituals: Inside Public Art Museums*, London: Routledge.

Gadamer, H.-G. (1998) *Praise of Theory: Speeches and Essays* (translated by Chris Dawson), New Haven and London: Yale University Press.

Gale, I. (1997) 'A hanging offence', *Scotland on Sunday*, 15 June.

Gilman, B. I. (1904) 'On the distinctive purpose of museums of art', *Museums Journal* 3(7), January: 220–221.

The Glasgow Herald (1902) 'Lord Provost Chisholm at the opening of Kelvingrove Art Gallery and Museum', 29 October.

Hamilton, V. (1997) *The Birth of Impressionism, From Constable to Monet*, Glasgow: Glasgow Museums.

Henry, C. (1994) 'Up the Clyde in a banana boat', *The Glasgow Herald*, 6 May.

de Horcajo, J. J., Sanchez Alvarez, A. C., Abio, A., Arraztoa, J. M. and Corchado, A. L. (1997) *Sociologia del Arte, Los Museos Madrileños y su Publico*, Madrid.

Little, F. and Patrizzio, A. (1994) *Canvassing the Clyde, Stanley Spencer and the Shipyards*, Glasgow: Glasgow Museums.

Macmillan, D. (1997) 'If art is like football, let's make a better pitch for it', *Scotsman*, 22 December.

Museums Journal (1920) 'Report of a conference between representatives of the Board of Education and a committee of the Museums Association on the proposed transfer of museums to the local education authorities', February.

Scottish Museums Council (2000) *Museums and Social Justice: How Museums and Galleries can Work for their Whole Communities*, Scottish Museums Council.

Searle, A. (1996) 'One man's folly', *Guardian*, 28 March.

Spalding, J. (1996) '*Gallery of Modern Art, Glasgow*', Glasgow: Glasgow Museums and Galleries.

Steiner, G. (1971) *In Bluebeard's Castle: Some Notes Towards the Re-Definition of Culture*, London: Faber and Faber.

Steiner, G. (1996) 'The archives of Eden' in *No Passion Spent*, London: Faber and Faber.

Sylvester, D. (2000) 'Mayhem at Millbank', *London Review of Books*, 18 May.

3

Measuring social value

Carol Scott

A major outcome of the policies of microeconomic reform that have swept Western industrialised countries since the mid-1980s has been the introduction of increased accountability for the expenditure of public monies. Generally, the model that has been adopted to account for the use of resources in the public sector is one in which performance is measured against quantitative indicators. The application of this model to the museum sector has generated considerable debate and discussion regarding the limited ability of short-term, quantitative indicators to adequately reflect both the complexity of the role that museums play in society and the long-term contribution that they make to social value.

This chapter is in three parts. First, it will give a brief synopsis of the issues generated by the introduction of the performance measurement model to assess the work of museums. Second, it will describe two models that have been developed to assess the long-term social value of participation in the community arts sector with relation to the vexed question of assessing the long-term impacts of museums. Finally, it will explore some indicators on which the long-term benefits and contributions of museums might be assessed.

Introduction

Following World War II, governments of Western industrialised countries embarked upon a period of economic expansion that was to last for a quarter of a century (Redfern 1986). Large investment in public spending was one of the characteristics of this time and governments had sufficient resources to respond to the changing demands of the community. Initially concerned with basic needs, government responsibility expanded into increased welfare and social services, subsidies for all branches of the arts, consumer protection and protection for the environment. The level of expenditure could be sustained during the postwar period of rapid economic growth but, with the economic downturn of the 1970s, governments were faced with the necessity of reducing spending (Douglas 1991: 1). Significant changes introduced in the 1980s and 1990s saw governments reverse the expansionist trend through policies of economic reform that sought 'economies' in public spending. In Australia, the intent of a 'Review of

Commonwealth Development in Museums and Similar Collecting and Exhibiting Institutions' was indicative of this trend:

> To review the Commonwealth's involvement in the development of museums, collecting and exhibiting institutions and other collections owned by the Commonwealth, with a view to identifications of any duplication and scope for economies amongst museums, existing and proposed, and to examine other ways to limit the call on the Commonwealth to meet the recurrent funding needs of existing and proposed museums and institutions.
>
> (Department of Finance 1989: 1)

These changes have had a major impact on museums. Of necessity, museums have had to diversify their funding base, often through the combination of admission charges and increased external sponsorship. In addition, the introduction of fiscal accountability and performance evaluation has ensured that museums and other public agencies account for the public monies they receive (Cossons 1988).

Performance evaluation as an accountability system fits comfortably within the corporate 'management for results' approach that has enjoyed currency since the introduction of economic reform (Redfern 1986; Douglas 1991). A key ingredient of 'management for results' is ongoing evaluation to provide a mechanism for assessing the progress of programmes and determining whether intended outcomes have been achieved. In addition, *performance evaluation*, as the name implies, requires demonstrable and tangible outcomes for assessment. These tangible results are measured against numerical targets to identify increased efficiency in the use of resources. As the model has been more associated with quantitative indicators, it has also become more commonly referred to as *performance measurement*.

Not surprisingly, indicators of successful museum performance arising from this model are predominantly quantifiable and include items such as the number of visitors to the museum, the numbers of users of facilities such as websites, the number of new exhibitions presented and travelled, the number of publications produced, educational programmes offered, objects conserved and registered, etc. (Scott 1991; Office of Arts and Libraries 1991; Ames 1991; COCOG 1997). Moreover, these indicators are most often compared with either a previous year's performance or with the performance of other museums in order to ascertain trends and patterns of resource usage.

A new vocabulary has accompanied the introduction of performance evaluation/measurement and 'management for results'. It is argued that sound management is based on an efficient use of resources (*inputs*) as well as concern for the results *(outputs)*. Therefore, governments provide funds to museums (*inputs*) and museums use these funds for programmes, facilities and services *(outputs)*. The *efficient* use of resources is the main criterion on which performance is based. Efficiency is determined by whether the result of a programme justifies the amount of effort invested and whether the same result could have been achieved by another programme undertaken for less cost.

It can be argued that the introduction of performance measurement has had some positive effects:

- the information about resource usage within a given period can be used to effect economies or apply for increased resources on the basis of programme needs;
- the quantitative data produced can be used to identify emergent trends across museums;
- the process of developing indicators to assess performance can achieve clarity of mission and purpose through collective objectives setting (Ames 1992);
- the necessity of providing data for accountability and reporting can result in improved management information systems;
- performance measurement is a management tool that provides information for decision makers; and
- goal setting for performance targets can give museums a clear and corporate direction at which to aim.

Nevertheless, the introduction of performance measurement has generated considerable discussion and debate. In general terms, critics have questioned the appropriateness of applying a system to the public sector that was originally based in the commercial sector where a profit-making bottom line lends itself more comfortably to quantitative measurement. Specifically, they argue that the multidimensional briefs and wide range of stakeholders characteristic of public sector institutions make meaningful performance assessment a much more complex issue. Specifically, the difficulties of quantifying the long-term, intangible outcomes of museum performance have been highlighted (Ames 1992; Bud et al., 1991; Walden 1991).

However, the adaptation of performance measurement to the public sector has not been a static process. The model has evolved over the last decade and it is now recognised that inputs and outputs should result in *outcomes*. The *impact* and *effectiveness* of performance are, therefore, important additional criteria for assessment (Weil 1994).

At first glance, the inclusion of *outcomes* as a key component of the performance evaluation model would seem to set the stage for a more reliable and comprehensive assessment of public sector institutions. However, the prevalent performance evaluation model has been constructed to *measure* rather than to *assess* performance, continuing to limit it to quantifiable, tangible and numerical data. Moreover, it stops short of assessing long-term benefits because it is generally tied to the short-term inputs of the government of the day and, as such, is as much about government performance as institutional performance.

A decade after the introduction of performance measurement, the debate continues. Moreover, it does so within a climate of accelerated social change in which the relationship between the museum and its public is being renegotiated (Ellis 1995; Weil 1997). 'Accountability' has moved from fiscal accountability to encompass accountability to the public. Increasingly, the tax-paying public

are exerting their right to ask whether the considerable expenditure allocated to museums is justified.

> As crunch time approaches, however, and as the demands that are made on the public and private resources available to the non-profit sector continue to grow at a faster rate than those resources themselves, virtually every museum may find itself faced with several much tougher questions – not creampuffs this time but hardball.
>
> Without disputing the museum's claim to worthiness, what these questions will address instead is its <u>relative</u> worthiness. Is what the museum contributes to society commensurate with the annual cost of its operation? Could some other organization (not necessarily a museum) make a similar or greater contribution at lesser cost?
>
> (Weil 1994: 42)

The pressure on museums to demonstrate public accountability has forced important questions to the fore. Specifically it has focused attention on perceived value for money in terms of whether museums actually provide benefits to the public and what kind of changes museums effect in the world beyond their doors. The notion, prevalent during the post-war years, that museums provide a 'public good' and are, therefore, deserving of funding is now under question. Museums find themselves in the situation of having to *prove* that they are providing outcomes that have long-term social benefit.

In this situation, museums face a clear challenge to 'work together to clarify and better articulate the long term impact and importance of the different outcomes museums produce' (Weil 1996: 65).

Assessing long-term social value

If museums are increasingly required to demonstrate that they provide long-term benefits to the community, how are they going to do this? The limitations of evaluation methods based on the numerical measurement of short-term, demonstrable outcomes have been discussed. What then are the alternatives? If we move into assessing long-term social value, we are in the realm of the qualitative. What models exist that assess qualitative outcomes?

Recent studies from the community arts field indicate that viable models to assess long-term, qualitative outcomes exist. Both Williams (1997) and Matarasso (1997) developed studies that set out to assess whether participation in arts programmes resulted in long-term social value for both individual participants and communities.

Williams' study, *Creating Social Capital*, was commissioned by the Community Cultural Development Board of the Australia Council. The study sought to assess whether or not there were long-term social, educational, artistic and economic outcomes as the result of participation in community arts projects. Draft indicators for each of these four generic outcomes were abstracted from grant application acquittals. These indicators were then tested by survey on a

Table 3.1 Long-term value of participation in community arts projects
(Williams 1997)

Social benefits	Educational benefits	Artistic benefits	Economic benefits
Established networks of ongoing value	Communicating ideas and information	Further work of artistic merit	Developed local enterprise
Developed community identity	Planning and organising activities	Further training or education in the arts	Led to employment
Raised public awareness of an issue	Collecting, analysing and organising information	Developed groups or arts activities	Improved productivity in business/public/ community
Lessened social isolation	Solving problems	Developed creative talents	Enhanced or developed tourism
Improved understanding of different cultures and lifestyles	Using technology	Improved access to arts education or training	Attracted new resources to the community
Improved recreational options	Using mathematical ideas and techniques	Increased sales for artworks or developed audiences	Improved or developed public facilities
Inspired action on a social justice issue			Improved planning and design of public spaces
Increased appreciation of the value of community arts projects			Improved consultation between government and community
			Created cost savings in public expenditure
			Improved crime prevention

select sample of 232 people who represented a range of paid organisers, community volunteers and observers associated with community arts projects throughout the country. The respondents were asked to rate the degree to which any of the outcomes, outlined in Table 3.1, had occurred as the result of participation in a community arts project occurring two years previously. An analysis of nine case studies provided additional context for the findings.

A similar study, undertaken in the United Kingdom between 1995 and 1997, was reported by Matarasso (1997). This project sought to identify the social impact of participation in arts projects through selecting eight case studies and conducting depth interviews and discussion groups with participants. A questionnaire was also completed by over 500 people involved in the projects. Six broad categories of outcomes were identified to provide a framework within which to categorise the data from the case studies. These six categories were: personal development, social cohesion, community empowerment and self-determination, local image and identity, imagination and vision, and health and well-being. While the Australian study was constructed to *test* a list of potential long-term outcomes arising from community arts participation, the British study sought to *elicit* these indicators in the process of the research. In both studies, a combination of qualitative methods (depth interviews, focus groups and/or case study analyses) and quantitative methods (surveys) were used. In addition, both studies shared the common aim of seeking to determine whether participation in the arts resulted in long-term social value to individuals and communities and to further clarify what the range of those outcomes might be. As Table 3.2 demonstrates, the studies shared similar outcomes and both concluded that participation has multiple, long-term benefits for both individuals and communities.

These studies have important relevance for similar issues facing the museum field. First, in both studies the overwhelming response was that long-term social value occurred as the result of cultural participation:

> over 90% of respondents reported that projects delivered ongoing community development outcomes. These included the establishment of valuable networks, the development of community pride and the raising of public awareness of a community issue. Over 80% of respondents also reported a decrease in social isolation in the community as a resulting benefit. Improved understanding of different cultures or lifestyle was reported by more than two thirds of respondents.
>
> (Williams 1997: 2)

As importantly, these studies demonstrate that models exist to validly assess qualitative outcomes.

Museums and long-term social value

So, what unique, long-term benefits do museums contribute to society? In differentiating museums from other organisations, emphasis must be given to

the experience that museums provide for people to engage with *objects* (Weil 1994: 43).

The role that objects can play in personal and collective memory, identity and meaning has been discussed by Silverman (1995, 1997), Kirschenblatt-Gimblett (1999) and Burnett (1999):

> [memory] links us to a past, a generational history and a wider, shared cultural memory. The point at which one's personal memories intersect with and are shared with others – family, friends, grandparents, a community, a nation – is a critical factor in the formation of both personal identity and a sense of cultural belonging. On the one hand, memory binds and connects us to a sense of place and historical lineage. At the same time it threatens to disintegrate under the weight of time and somehow 'fail' us. This is where – at a personal level – stories, photographs, lockets, trinkets, films and videos are used and collected by many to recall people, events and places. Somehow, we believe that our pasts are contained or made more permanent by these mementos.
>
> (Burnett 1999: 45)

Through objects, museums can provide unique experiences associated with the collective meaning, sharing, discussion and debate that are the foundation of good citizenry. Through objects, museums can reinforce personal identity and belonging. Objects convey a sense of place and can, therefore, introduce outsiders to the significance of a culture through its material heritage. Research on objects can reveal new knowledge. The stories told through objects in a museum setting have educative value. All of these outcomes are features of social value, that 'attachment of meaning to the things which are fundamental to personal and collective identity' (Johnston 1992: 10).

There is evidence in the literature that museums contribute in all these ways. Perhaps three categories will help to simplify the impact that museums have on long-term social value. Museums can be shown to contribute to collective and personal development, economic value and educational value.

Collective and personal development

How do museums facilitate collective and personal development? From even a cursory glance at the literature, there is evidence to support five areas:

- providing a forum for the discussion and debate of emergent social issues;
- affirming personal identity;
- fostering tolerance and understanding;
- providing reverential and commemorative experiences; and
- creating a collective identity through a shared history and a sense of place.

Table 3.2 Long-term social value of participation in arts projects (Matarasso 1997)

Personal development	Social cohesion	Community empowerment	Local image and identity	Imagination and vision	Health and well-being
Increased personal confidence and self-worth	Reduced social isolation	Built community organisational capacity	Developed pride in local traditions and cultures	Helped people develop creativity	Had a positive impact on how people feel
Extended involvement in social activity	Developed community networks	Encouraged local self-reliance	Contributed to a sense of belonging and involvement	Eroded the distinction between creator and consumer	Provided an effective means of health education
Gave people an active voice to express themselves	Promoted tolerance and conflict resolution	Helped people extend control over their lives	Created community traditions	Allowed exploration of values, meanings and dreams	Contributed to a more relaxed atmosphere in health centres
Stimulated interest and confidence in the arts	Provided a forum for multi-cultural understanding	Provided insight into political and social ideas	Involved residents in environmental improvement	Enriched the practice of professionals	Provided enjoyment
Provided forums to explore personal rights	Helped validate the contribution of a whole community	Facilitated effective public consultation	Provided a basis for developing community activities	Encouraged risk taking	Improved quality of life of people with poor health

Table 3.2 continued

Personal development	Social cohesion	Community empowerment	Local image and identity	Imagination and vision	Health and well-being
Contributed to educational development of children	Promoted cross-cultural contact and co-operation	Involved local people in community regeneration	Improved perceptions of marginalised groups	Helped communities raise vision beyond the immediate	
Encouraged adults to take up education and training opportunities	Promoted contact across generations	Facilitated the development of partnerships	Helped transform the image of public bodies	Challenged conventional service delivery	
	Helped address issues of crime	Built support for community projects	Made people feel better about where they live	Raised expectations about what is possible	
Helped build new skills and provided work experience	Provided offender rehabilitation routes	Strengthened community co-operation			
Contributed to people's employability					

Discussion and debate

Heumann Gurian refers to museums as sites for 'peaceful congregant behaviour' (1996) in which issues of community concern can be discussed in one of the few safe forums left available for public debate. This theme is echoed eloquently by both Weil (1997) and Maggi (2000), who envision a museum of the future that will be a centre for community confrontation, exchange and debate; what Maggi describes as a 'forum museum',

> where not only the objects of the past are shown, but the culture for the future is built, a forum that must help the community to grow . . . it is a dynamic museum, serving above all as a cultural animator in trying to interpret community changes.
>
> (2000: 51–52)

Personal identity

If social inclusion is to be realised, then the ability of the museum to allow a variety of stories to be told is critical. Weil suggests that this is exactly what a museum in a postmodern world can do, when every text is allowed to:

> have as many versions – all equally correct – as it has readers. Translated into museum terms, that would suggest that the objects displayed in the museum do not have any fixed or inherent meaning but that 'meaning making' or the process by which these objects acquire meaning for individual members of the public, will in each case involve specific memories, expertise, viewpoint, assumptions and connections that the particular individual brings.
>
> (1997: 269)

Lois Silverman has identified the special contribution that museums make to confirming this sense of special personal identity. Through remembering and connecting, visitors can affirm an individual sense of self.

> For one visitor, an important component of self-identity could be that of the knowledgeable expert, influencing her to draw upon and share her special knowledge and competencies. For another, a sense of himself as 'family historian' might activate 'relevant family stories', leading to a more subjective experience of an exhibit.
>
> (1995: 162)

Self-identity is not confined to personal selection, engagement and perspective. It can also be reflected in a sense of belonging, affiliation and identity as part of a collective whole; what Silverman describes as 'who am I as a group member?' (1995: 163).

Increased understanding and tolerance

A further dimension of social inclusion is the need for a corporate citizenry that fosters tolerance for difference and cross-cultural understanding. Museums have great potential to transcend differences as well as to communicate about them (Silverman 1993: 10).

Fred Wilson's moving description of 'mining the museum' (1996) to reveal hitherto invisible experiences of African-Americans is an example. In the course of his exploration of the African-American cultural reality, he invites us to ask questions of the objects in ways that touch our collective humanity and compassion. Highlighting black children relegated to the shadows of a painting, he poses questions for these children that reveal their loneliness and marginal place in the society of pre-Civil War America: 'Who calms me when I am afraid?', 'Am I your friend? Am I your brother? Am I your pet?'

Half a world away, at the Powerhouse Museum in Sydney, an exhibition titled *Precious Legacy: treasures from the Jewish Museum in Prague* was presented in 1999. The objects were part of a collection that had been rescued from the Holocaust by the Jewish community. The comment forms completed by visitors reveal the power of an exhibition to develop cross-cultural understanding (Scott 1999: 10):

> For me an excellent insight into Jewish life and religion. I now better understand a Jewish friend of mine who said that 'Judaism is not a religion, it is a way of life'.
>
> A very touching and informative exhibition. Gave me an insight into Jewish life and suffering.

Reverential and commemorative experiences

War museums and memorials all over the world provide a focus to remember and honour the war dead and the sacrifices made in the names of freedom, cultural preservation and democracy. In many instances, these museums have moved beyond the celebratory focus of the past to embrace and recognise the victims of war as well as its heroes. They are 'places for inward and sober reflection' (Weil 1997: 261). The commemoration of critical events enables a culture to develop a shared history, which is 'the crucial element in the construction of an "imagined community" through which disparate individuals and groups envision themselves as members of a collective with a common present and future' (Anderson 1991 in Glassberg 1996: 11–12).

Collective identity through a shared history and sense of place

This 'imagined community' is composed of the myths and symbols that hold together diverse groups in a society. Through objects, the symbolic construction of a common history around which a national or local sense of identity can be forged is played out in museums. Linked to this is a sense of place formed

through the layering of social, cultural, historical, economic, natural and personal associations that together give a locale its special character and meaning (Johnston 1992; Glassberg 1996). Many local museums and historical societies reflect a powerful sense of place through the collection of artefacts that represent the social, cultural, historical, economic, natural and personal associations that people have forged within a locale.

Economic value

The 'sense of place' that museums confirm has implications for economic value. As economic rationalism continues to dominate public sector institutions, museums are finding that they are required to 'perform a broader range of economic functions, often as part of complex urban re-development strategies' (Tufts and Milne 1999: 614). This 'economisation of culture' (Sayer 1997 in Tufts and Milne 1999) is evident in the role that museums are increasingly playing in popular leisure and urban tourism. Related to the 'sense of place' discussed above, museums are used as key attractors to define the overall tourism experience through their ability to 'reflect an essential sense of a particular time and place unavailable elsewhere' (Tufts and Milne 1999: 616). Museums enable cities to market themselves as cultural centres that appeal to residents, tourists, professionals and investors.

In addition, the synergy between cultural and consumption experiences has resulted in a trend to capitalise on the combination. A visit to a museum can involve an economic spend including admission fees, the purchase of food and drink and buying souvenir products imbued with the meaning of the exhibitions seen. Increasingly, heritage precincts are being constructed that offer both cultural attractions and the opportunity to purchase high-quality consumer goods. As urban redevelopment initiatives and tourist attractions, these precincts are part of carefully constructed urban revitalisation schemes.

Educational value

A recent study undertaken at the Powerhouse Museum in Sydney revealed that museums continue to be associated with learning and education. Museums were defined as places where one could have an *educational*, *intellectual* and *absorbing* experience (Boomerang! 1998).

The fact that the learning acquired in museums can be recalled long after the museum visit has been documented by Falk and Dierking (1995) and McManus (1993). Analysing these studies and a study undertaken by Bitgood and Cleghorn (1994), Ferguson (1997) suggests that the unique type of learning experience offered by museums, one which is mediated through objects, is particularly effective in stimulating visual memory. The visual memory of the object serves as a trigger to stimulate associated learning to a degree that purely semantic memory (knowledge-based concepts and facts) cannot. Interestingly,

across the three studies that Ferguson analysed, visual memory accounted for approximately 55 per cent of responses while semantic memory was less than half of that. In addition, museums are predominantly a social experience and there is abundant evidence that learning mediated through social interaction has longer-term 'holding power' (Falk and Dierking 1992).

Conclusion

Ensuring that the long-term contribution of museums to social value is assessed may be a matter for survival. Though the 1970s and 1980s saw an unprecedented boom in the establishment of museums throughout the industrialised world with attendance numbers attaining new highs, the 1990s began to witness evidence of declining attendances (Kirchberg 1998; Australian Bureau of Statistics 1999).

More leisure options, less time (Australian Bureau of Statistics 1998), more individualised and home-based leisure (Pronovost 1998), the ageing of the 'baby boomers' and the impact of technology (Maggi 1998) are all cited as contributors to dwindling attendances. However, recent leisure theory also suggests that the pace of leisure is speeding up and, as an antidote to increasing pressure in the workplace, people are seeking depthless, less committed forms of leisure that promise fun, entertainment and time out at the expense of education, learning and intellectual experiences (Rojek 1995; Jonson 1998).

If this is the case, then museums need to promote themselves as being agents capable of offering a value experience that has a social impact beyond the ephemeral and the transitory. They are perfectly positioned to be able to do so, thus demonstrating, to themselves and to the public to whom they are accountable, that the museum experience is unique, authentic and long term.

References

Ames, P. (1991) 'Measures of merit?', *Museum News*, Sept./Oct.: 55–56.

Ames, P. (1992) 'Breaking new ground: measuring museums' merits', *MUSE*, Spring: 15–16.

Australian Bureau of Statistics (1998) *How Australians Spend Their Time: 1997*, (Cat. of Statistics No. 4153.0), Canberra: ABS.

Australian Bureau of Statistics (1999) *Attendance at Selected Cultural Venues: 1999*, (Cat. of Statistics No. 4114.0), Canberra: ABS.

Bitgood, S and Cleghorn, A. (1994) 'Memory of objects, labels and other sensory impressions from a museum visit', *Visitor Behaviour* ix(2): 11–12.

Boomerang! Marketing and Advertising Pty Ltd (1998) *Powerhouse Museum Brand Audit and Positioning Options: In-house Report Prepared for the Powerhouse Museum*, Sydney.

Bud, R., Cave, M. and Haney, S. (1991) 'Measuring a museum's output', *Museums Journal*, January: 29–31

Burnett, D. (1999) 'Whenever I hear the word memory, I reach for my laptop', *Exploring Culture and Community for the 21st Century: A New Model for Public Arts Museums*, Ipswich, Qld: Global Arts Link.

Cossons, N. (1988) 'Performance indicators in museums', paper delivered at The Development of Performance Indicators seminar, organised by the Museums Association of Australia, Canberra, November 1988.

Council on the Cost of Government (1997) *Arts and Culture: Service Effort and Accomplishments*, Sydney: NSW Council on the Cost of Government.

Dept of Finance (1989) *What Price Heritage? The Museums Review and the Measurement of Museum Performance: Issues for Discussion*, Canberra: Dept of Finance.

Douglas, L. (1991) 'The politics of performance: measuring the value of museums', unpublished paper submitted for the Graduate Diploma in Arts Management, University of Technology, Sydney.

Ellis, R. (1995) 'Museums as change agents', *Journal of Museum Education*, Spring/Summer: 14–17.

Falk, J. and Dierking, L. (1992) *The Museum Experience*, Washington, DC: Whalesback.

Falk, J. and Dierking, L. (1995) 'Recalling the museum experience', *Journal of Museum Education* 20(2): 10–13.

Ferguson, L. (1997) 'Evaluating learning', *Museums National* 5(4), May: 15–16.

Glassberg, D. (1996) 'Public history and the study of memory', *Public Historian* 18(2) Spring: 7–23.

Heumann Gurian, E. (1996) 'A savings bank for the soul', paper presented at the Museums Australia Conference 1996, Sydney.

Johnston, C. (1992) *What Is Social Value? A Discussion Paper*, Canberra: Australian Government Publishing Service.

Jonson, P. (1998) 'Leisure in the 21st century', paper presented to the Evaluation and Visitor Research in Museums Conference: Visitor Centre Stage – Action for the Future, Canberra, 4–6 August.

Kirchberg, V. (1998) 'The changing face of arts audiences. The Kenneth Myer Lecture', Deakin University: Arts and Entertainment Management Program.

Kirschenblatt-Gimblett, B. (1999) 'Objects of memory' in *Exploring Culture and Community for the 21st Century: A New Model for Public Arts Museums*, Ipswich, Qld: Global Arts Link.

Maggi, M. (1998) *a.muse: Advanced Museums*, Italy: Fondazione Rosselli.

Maggi, M. (2000) 'Innovation in Italy: the a.muse project', *Museum International* 52(2): 50–53.

Matarasso, F. (1997) *Use or Ornament? The Social Impact of Participation in the Arts*, Stroud, Glos.: Comedia.

McManus, P. (1993) 'Memories as indicators of the impact of museum visits', *Museum Management and Curatorship* 12: 367–380.

Office of Arts and Libraries (1991) *Report on the Development of Performance Indicators for the National Museums and Galleries*, London: Office of Arts and Libraries.

Pronovost, G. (1998) *Trend Report: The Sociology of Leisure*, Thousand Oaks: Sage.

Redfern, M. (1986) *Performance Measures in the Public Sector: A Digest*, London: British Library (British Library R & D Report 5905).

Rojek, C. (1995) *Decentring Leisure*, London: Sage.

Scott, C. (1991) 'Report on the outcomes of a consultancy to develop performance indicators for national collecting institutions', prepared for the Cultural Heritage Branch of the Department of the Arts, Sports, the Environment, Tourism and Territories, April.

Scott, C. (1999) *Precious Legacy: Report on Visitor Feedback for the Powerhouse Museum*, Sydney: Evaluation and Audience Research Department, Powerhouse Museum.

Silverman, L. (1993) 'Making meaning together', *Journal of Museum Education* 18(3) Fall: 7–11.

Silverman, L. (1995) 'Visitor meaning-making in museums for a new age', *Curator* 38(3): 161–170.

Silverman, L. (1997) 'Personalising the past: a review of literature with implications for historical interpretation', *Journal of Interpretation Research* 2(1), Winter: 2–3.

Tufts, S. and Milne, S. (1999) 'Museums: a supply side perspective', *Annals of Tourism Research* 26(3): 613–631.

Walden, I. (1991) 'Qualities and quantities', *Museums Journal*, January: 27–28.

Weil, S. E. (1994) 'Creampuffs and hardball: are you really worth what you cost?', *Museum News* (US), 73(5), Sept./Oct.: 42–43, 60, 62–63.

Weil, S. (1996) 'The distinctive numerator', *Museum News*, Mar./Apr.: 64–65.

Weil, S. (1997) 'The museum and the public', *Museum Management and Curatorship* 16(3): 257–271.

Williams, D. (1997) *Creating Social Capital*, Adelaide: Community Arts Network of South Australia.

Wilson, F. (1996) 'The silent message of the museum', paper presented at the Museums Australia Conference: Power and Empowerment, Sydney.

4

Architectures of inclusion: museums, galleries and inclusive communities

Andrew Newman and Fiona McLean

Introduction

The aim of this chapter is to contribute to the debate about the social value of museums[1] and their potential contribution to inclusion within society. This will be achieved by using the concepts of cultural identity and citizenship as modes of analysis. The result of such an approach is the construction of a taxonomy of the social role of museums, which aims to identify all the major elements involved and the relationships between them. It is hoped that such a theoretical framework will aid museums wishing to develop strategies aimed at increasing their value to society.

The chapter is organised in the following way. First, we investigate the concept of cultural identity and the museum's role in identity negotiation. As repositories of cultural property museums have always played an important part in constructing identity. An understanding of this process is essential if a museum's social value is to be clarified. Once this has been achieved the chapter progresses to consider the contested concept of citizenship. The contribution museums could make to the inclusion process within a citizenship framework is then explored through illustrations of past initiatives. It is only once the contribution of museums to the construction of identity is understood that their role in fostering citizenship can be fully explained. Finally the relationships between the various elements are analysed by viewing museums as processes.

Background

The potential social value of museums within society is an area that remains underresearched and thus contested. It follows that the contribution that museums can make to resolving the problems of exclusion is not fully understood. Without this understanding it is difficult for museums to effectively address social problems, since basic questions about their potential remain unanswered. In the academic discourses of sociology and social studies, the process of social exclusion is debated within a citizenship structure, whilst one of the most important

outcomes of exclusion is considered to be related to an individual's sense of identity. This has already been recognised by the Canadian Museums Association, which has stated that citizenship, identity and social justice are all interrelated (1994).

For the purposes of this chapter the definition of social exclusion used is that produced by the UK government's Social Exclusion Unit, that is:

> A shorthand term for what can happen when people or areas suffer from a combination of linked problems such as unemployment, poor skills, low incomes, poor housing, high crime environments, bad health, poverty and family breakdown.
>
> <div align="right">(DCMS 2000: 7)</div>

However it is accepted that the concept is contested in academic discourse, as illustrated by Silver (1995) and Gore (1995).

Cultural identity, museums, galleries and inclusion

A sense of identity in an individual is considered the main precursor to inclusion. A lack of sense of self, or a loss of identity, is concomitant with exclusion from society (Woodward 1997). At the same time it is argued that museums have a significant role to play in developing people's identities. Thus, Chris Smith, the former Secretary of State for Culture, Media and Sport in the UK has stated in the forward to *Centres for Social Change: Museums, Galleries and Archives for All* that, '[Museums] are often the focal point for cultural activity in the community, interpreting its history and heritage. This gives people a sense of their own identity, and that of their community' (DCMS 2000: 3). If we are to begin to understand the role that museums can play in giving people a sense of identity, it is essential that we not only understand what is meant by identity, but also appreciate the potential of museums in fostering identity and thereby contributing to inclusion.

The concept of identity has increasingly become the subject of academic discourse as a conceptual tool that helps us to make sense of change in our social, cultural, economic and political circumstances. There are two understandings of identity. The first is an essentialist view, which posits that identity is fixed and does not change over time and space. In this understanding, those sharing an identity have a shared set of characteristics, which are claimed through innate natural or biological qualities. By contrast, contemporary commentators believe that understandings of identity must include notions of contingency and fluidity (Hall 1990). Thus, identities can change over time, can be privileged over other identities in particular contexts, and are presaged through contingency. This non-essentialist view regards identity as a social concept, where it 'gives us a location in the world and presents the link between us and the society in which we live' (Woodward 1997: 1). Identities, then, can be grouped into factors such as ethnicity, race, gender, nationality, social class, and so on.

Identities are constructed through the marking of difference. Thus, 'Identity marks the ways in which we are the same as others who share that position, and the ways in which we are different from those who do not. Often, identity is most clearly defined by difference, that is by what it is not' (Woodward 1997: 2). Difference can be construed negatively as the exclusion or marginalisation of those who are defined as 'other' or as outsiders. In other words, identity is defined as those who are either included or excluded from society. Further, Saussure (1960) maintained that meaning is relational, and so binary oppositions, such as black/white, are implicit in the meaning of difference. Between this binary opposition there is a relation of power, the power being imbalanced (Derrida 1972). Power, then, resides with the included, with the excluded being marginalised (Woodward 1997) or even considered as 'abnormal' (Douglas 1966). Being excluded, though, does not necessarily mean loss of identity. Individuals in the gay community may feel excluded but it does not follow from this that they lack a sense of self. Loss of identity is seen rather as 'accompanying changes in employment and job losses' (Woodward 1997: 1). The problem then is whom we define as excluded. What is 'social inclusion' inclusion into, and what are 'the socially excluded' excluded from (Duff 2000). We need to be clear about this when designing any inclusion programmes; that we are dealing with a loss of identity and we are not attempting to impose the dominant order on those who are excluded for reasons other than deprivation.

The quote from Chris Smith given earlier clearly makes the link between identity and museums. As Silverstone has argued, museum visiting is a social activity. The visitor to the museum connects the personal to the museum's account through spun narratives (Silverstone 1988). The museum offers the visitor 'a heritage with which we continually interact, one which fuses past with present' (Lowenthal 1985: 410). Visitors give complex, often contradictory, meanings to museum objects, meanings that are representative of their identities. The museum, then, can be seen as a place where people go to actively make and remake their identities, to selectively select and reject and to manipulate the images and identities found within (McLean and Cooke 1999). Thus, according to Woodward (1997), recovery of the past is part of the process of constructing identity. In the spirit of contemporary understandings of identity, we must also concede a multiplicity of points of view within difference and recognise the contrasting and conflicting identity constructions. Thus, for example, the Museum of Scotland has confronted the predominant representation of Scotland, that of tartan and bagpipes, in one display cabinet, but has made no specific allusion to it throughout the rest of the museum.

This process of constructing identities is probably most apparent in national museums where a national identity is being appropriated. Since their inception museums have been used politically to imbue the nation with value. Thus, the Great Exhibition of 1851 in London, collections from which formed the basis of the Victoria and Albert Museum, explicitly paraded the wares of the British Empire with pride. The creation of national museums tends to coincide with surges of nationalism (Kaplan 1994), witnessed both in the nineteenth century

and the latter half of the twentieth century, with the construction of national museums in a number of countries, including Wales, Scotland and Australia. Although the impetus to create the Museum of Scotland, for example, had a long and contentious history, stretching back to the beginning of the twentieth century, the decision to build was made in 1992, at a time when political demands for self-determination were growing. The opening of the museum on St Andrew's Day 1998 coincided with the symbolic period of the re-creation of a Scottish Parliament.

Recent research at the Museum of Scotland in Edinburgh confirms that national museums can have an implicit role in forging identities and impressions of identities. For example, findings from this research suggest that Scottish visitors to the museum felt that the museum articulated a positive history of Scotland. A new-found confidence in the Scottish nation was believed to be represented in the museum, a confidence that was equally manifest in the Scottish visitors' sense of their Scottishness. For the non-Scottish visitors to the museum, though, the museum was read as disrupting the 'taken for granted' British identity by calling attention to a perceived Scottish 'nationalism' (Cooke and McLean 1999). Such findings are interesting given the contemporary political context where the saliency of 'British', 'Scottish', and 'English' identities is shifting (McCrone 1998). This process is also taking place at a regional level where regional identities in England are assuming increased significance. Again, this has been manifested through heritage where it is argued that cultural objects can give communities or regions a focus. Hence the moves made by politicians to return the Lindisfarne Gospels to north-east England, an initiative closely related to a political campaign for regional government.[2]

This political use of heritage in constructing identities suggests that museums not only have a cultural and social role to play in inclusion policies, but because they are inherently political can also have a political role. This takes us to our next point of departure for discussion, where we intend to locate social inclusion within the concept of citizenship.

Citizenship and inclusion

This section explores the nature of exclusion within the concept of citizenship and illustrates how it provides a useful model to guide museums aiming to address social problems. It is clear that exclusion can be located within the concept of citizenship since, 'Poverty is not only a lack of an adequate income to live on, it is being classed as little or no value to society, and as such, having one's capacity for self-fulfilment crippled from birth' (Crummy 1992, cited in Matarasso 1997: 82).

First, it is important to emphasise that citizenship is a contested concept. Atkinson (1997) pointed out that, within Europe, there are major differences in the development and meaning of citizenship. Brubaker (1992) explained it in terms of rights and obligations or ethnicity. Germany was described as having

an ethnic-based citizenship and France one that was based on rights and obligations. However, there are clear overlaps between the two elements and Soysal (1996) has pointed out the shortcomings of such an approach.

The following addresses that part of citizenship that relates to rights and obligations, which is the predominant mode of analysis. However, most academic discourse has focused more on rights than obligations. A rights-based individualistic approach has been criticised by authors such as Byrne (1999) because it ignores the collective action of communities. The position of the UK government was articulated in a speech given by the Prime Minister on 2 June 1997,[3] where emphasis was placed on the importance of individual as well as collective responsibility.

An overview of a rights-based approach to citizenship is given by Atkinson (1997) who described it as originating in the work of Marshall (1950). A model was constructed as a way of analysing citizenship and social class. This described citizenship as consisting of three main components. First, a civil element, which consists of rights of individual freedom, liberty of the person, freedom of speech and justice. Second, a political element, where a citizen has the right to be involved in the political process, either as a representative on an elected body with political authority or as an elector to that body. Third, a social element was described, which relates to rights associated with economic welfare and the ability to share to the full in the social heritage of society. This component also includes the right to live as a 'civilized being according to the standards prevailing in the society' (Atkinson 1997: 11). Marshall (1950) viewed the concept of citizenship as a way of ameliorating inequalities within society, providing the basis for the demand for rights for groups that have traditionally been disadvantaged. Exclusion, then, might be seen as the denial of citizenship rights. For example, the family of Stephen Lawrence,[4] was excluded from access to justice and so denied citizenship rights (Macpherson of Cluny 1999). Inclusion as a term, then, might be used as encompassing all three of the elements of Marshall's (1950) citizenship, while social citizenship might be seen as synonymous with social exclusion as defined by the UK government, which is the area that has received most attention.[5]

The growing importance of citizenship in the UK is shown by its introduction into the national curriculum (Advisory Group on Citizenship 1998), but the UK government has yet to adopt it as a unifying political policy. However, its support for the concept was described in a speech given by Lord Irvine to the Citizenship Foundation on the 27 January 1998.

To be an active citizen, though, means that an individual is able to take part in the social, political and economic as well as the cultural life of the society (Makela 1998). Makela's argument resonates with recent commentators who have recognised the link between citizenship and identity. Thus:

> Citizenship is an individual identity. But very often group identities (race, caste, religion, language, region) are invoked as the basis for acquiring citizenship identity. Reconciling these competitive perspectives – the

individual and group bases of citizenship – poses a durable challenge in the contemporary world.

<div align="right">(Oommen 1997: 35)</div>

As Hall and Held (cited in Grossberg 1996) have suggested, the problem of citizenship is manifest in the diversity of the communities to which we belong with the complex interplay of identity and identification. As citizenship is located in the social, political, economic and cultural spheres, so conflicting identities contribute to change in these spheres (Woodward 1997). The potential role for museums, then, is to enable the individual to negotiate a sense of identity that is located within a collective identity of citizens.

Despite reservations caused by the uncertain nature of citizenship, it is a useful model within which to conceptualise exclusion. It could also help us develop our understanding of the possible contribution that museums might make in resolving the consequent problems of exclusion, as well as explore the potential social value of museums. To adopt a citizenship approach would provide a unifying structure to work within and could help initiatives to develop clearer aims. In the past many museums' social initiatives have appeared unfocused and have lacked clear objectives. This citizenship framework would provide a justification for the use of museums to help resolve social problems, and also helps to answer the question, 'why get involved in this sort of work?' In many cases the use of museums in such a way in the past has been based upon a belief that was unsubstantiated.

Such an approach also helps the development of arguments that may result in greater political recognition for what museums can do. In *Policy Action Team 10: A Report to the Social Exclusion Unit* (DCMS 1999), the Department for Culture, Media and Sport's response to the Social Exclusion Unit's report *Bringing Britain Together: A National Strategy for Neighbourhood Renewal* (1998), little mention is made of museums. The Policy Action Team set up by the Department for Culture, Media and Sport contained no representative from the museum community. The publication of a policy document by DCMS, *Centres for Social Change: Museums, Galleries and Archives for All* (2000), indicates that government has begun to recognise the potential of museums. However, no extra funding has been made available to enable museums to put new policy into practice and the most recent Social Exclusion Unit report, *A National Strategy for Neighbourhood Renewal* (2000), which was the culmination of the work of the policy review, offers museums little encouragement. The consequences of not being able to make clear cohesive arguments are that museums will remain underfunded and their potential unrecognised.

Having placed exclusion within a citizenship framework and recognised its relationship with a loss of identity, it is now possible to be clearer about the potential contribution that museums can make to inclusive communities. The next section will briefly explore the possible contributions that they might make to citizenship.

The contribution of museums to citizenship

The challenge to the museum community, if it is serious about being a force for inclusion with society, is to determine how to respond to a citizenship agenda comprising of Marshall's *civil*, *political* and *social* elements. It is also clear that any initiatives need to have multiple partners, as museums by themselves are not able to have a significant impact upon society. This is demonstrated by the most recently available data (1999) published by the Museums and Galleries Commission and MORI, where on average 35 per cent of the population had visited a museum or gallery in the 12 months prior to the survey. This suggests that the scope for museums to become agents of social change by themselves is limited.

The elements of citizenship

Civil

Examples of museums effectively tackling the civil element of citizenship, consisting of individual freedom, freedom of speech and social justice, are difficult to find. Dominy (1994) described a project run by the Natal Museum to collect the culture of apartheid and the struggle against it in South Africa. The aim of the exhibition was partly to encourage greater acceptance of the museum in the townships rather than to encourage change within society. However, as Dominy later claimed, the project 'has made a small contribution to the transformation of South Africa' (2000: 17). It is perhaps an area that museums could attempt to address, in association with other agencies, if they are to contribute to positive social change. An example taken from the arts, which is also closely related to the political dimension of Marshall's model, is the management of the tercentenary of the Siege of Derry in Northern Ireland. As Matarasso suggests:

> In Northern Ireland, tension between cultural traditions has long been a source of political instability and violence. Here, art and culture are often seen to be inseparable from identity, making them at once difficult to handle, and powerful tools for understanding.
>
> (1997: 33)

In this case, the event was symbolic for Protestant identity, and yet the events to mark the anniversary were being organised by Catholic councillors. Through the use of exhibitions, concerts and other cultural events, its celebration passed peacefully.

Political

The second of Marshall's elements of citizenship involves encouraging people to become involved in the political process. For the majority of the population this means voting in elections. If people do vote or not is a clear indicator of whether they feel empowered by the political process. By examining the percentage of

people voting in recent elections a clear distinction needs to be made between those taking place locally or nationally. In Newcastle upon Tyne the May 2000 local elections had a turnout of between 18 and 40 per cent, while the 1997 General Election turnouts ranged between 50 and 75 per cent.[6] This might indicate that local people feel more disenchanted with local politics than that taking place on a national level. Whatever the reasons for this situation it is clear that a significant proportion of the people of Newcastle upon Tyne have excluded themselves from the political process and so may be considered deficient in elements of citizenship. It is reasonable to suggest that this situation may be extrapolated throughout the UK. This is a serious problem that is not being addressed at present. As Matarasso discovered in his research into social inclusion and the arts:

> What matters so much about participation in the arts is not just that it gives people the personal and practical skills to help themselves and become involved in society – though it does – but that it opens routes into the wider democratic process and encourages people to *want* to take part. Participation is habit-forming.

> (1997: 82)

Museums could, together with local authorities and government agencies, seize the initiative to empower people to participate in the democratic process.

Social

The final element, described as social citizenship, is broadly similar to the UK government's definition of social exclusion, that is the linked problems of unemployment, poor skills, low incomes, poor housing, high crime environments, bad health and family breakdown. Much of the work that has been carried out by museums to address social problems falls into this category. An example of an interesting strategy to use culture to encourage inclusion is that used by Helsinki, Finland and described by Makela (1998). Three main types of intervention are described: primary, secondary and tertiary. Primary intervention is an attempt to interfere with the marginalisation process as early as possible. For example, Helsinki suffered from a recession in the 1990s that resulted in unemployment levels of 20 per cent, with youth unemployment reaching levels as high as 30 per cent. However, there were few examples of the sort of social problems often associated with such a situation. Research indicated that unemployed people retained hope for a better future. During the recession the number of books borrowed from public libraries increased and the libraries became small-scale cultural centres. As Makela (1998) concluded, a comprehensive cultural infrastructure may act as a buffer against exclusion by enabling unemployed people to remain within their normal social networks. Moreover, if this is to be an effective mechanism, low-price culture and leisure is essential if inclusion is to be encouraged.

Secondary intervention, according to Makela (1998), requires the targeting of groups that might already show signs of exclusion, such as young people at risk

63

and unemployed people. Such initiatives have the aim of increasing social skills and levels of confidence. For example, an arts project in Helsinki that attempted to tackle the issue of alcohol abuse in the city helped a number of heavy drinkers to reduce their alcohol consumption and to develop a healthier life-style, which was subsequently sustained by most of the men (Matarasso 1997). Finally, tertiary intervention involves initiatives with groups who suffer from serious social problems or mental illness and who are excluded from society. Nottingham Museums, for example, developed outreach work with mental health service users that addressed their personal concerns, encouraging them to visit the museum independently (Matarasso 1997; Dodd, this volume).

It is possible, however, to envisage a situation where an individual has access to a full set of citizenship rights but still feels a loss of identity and is conse-quently excluded from the community. It is the cultural element that makes an individual part of a community and it is in this area that museums have a poten-tially important contribution to make.

In order to be effective, though, museum initiatives need to reflect the interrela-tional nature of the problems they aim to solve. Interesting models for such initiatives are those associated with the Single Regeneration Budget (SRB) since they are designed to act upon a series of problems and so reflect the fact that they are interconnected. Great emphasis is also placed upon partnerships that could potentially include museums. The government guidelines for Round 6 of the Single Regeneration Bidding process[7] state that bidders should 'consider the role of culture and leisure (including, for example, libraries, museums, the arts and sport) and tourism as an integral part of their regeneration programmes', as these elements are often overlooked. This recognition of the role of museums as part of regeneration programmes is an important step forward.

Cultural identity and citizenship as a function of museums and galleries

From the above analysis it is possible to conclude that the social value of mu-seums and galleries relates to their contribution to the cultural identity of indi-viduals and groups and to citizenship. The following attempts to analyse the ways that this occurs by defining relationships between the various factors involved. To achieve this museums are seen as a process rather than something that is closely defined in terms of mechanistic functions such as conservation, display or education.[8] By concentrating on the inputs and outputs of this process the focus moves on to what the museum aims to achieve and the process or activ-ity can be tailored appropriately. Traditionally museums have concentrated on the process, the display or educational activity, without having a clear vision about what the outcome is. The greatest problem with such an approach is that it is very difficult to determine whether a particular activity has succeeded or failed.

For this analysis people are seen as the most important input into the museum process. The relationship museums have with users defines their reason for

existing. This relationship enables museums to contribute to their users' sense of identity and encourage them to be better citizens. It allows them to make and reconstruct their identities and possibly encourages them into a particular course of action. It is this effect upon people that is the outcome of the museum process. In the context of the process model, collections, buildings and staff are the resources used by the museum process and have no independent meaning. The objectives of museums must be couched in terms of the influences that they have upon people. It is through this approach that museums may contribute to inclusive communities.

From the above it is evident that seeing success in audience development initiatives as synonymous with success in dealing with social exclusion is logically a difficult position to sustain. The importance of an audience development strategy is that it results in increasing visitor numbers and broadening the range of people that museums have contact with in terms of, for example, socioeconomic or ethnic groups. This is an important approach but tells museums very little about the impact they are having on those individuals and groups, and so must be seen as a way of achieving something rather than being an end in itself. Audience development may, however, be seen as an important first step towards dealing with these issues. There are clear links between this approach and that given in the UK government's policy document, *Centres for Social Change: Museums, Galleries and Archives for All* (DCMS 2000) where access and audience development are seen as the first stages towards playing an active social role within society. The approach, described above, is summarised and presented diagrammatically as Figure 4.1.

Conclusion

The above demonstrates the main ways in which museums have a social value and provides a theoretical structure that can help to explain how that value is expressed. The two main elements, cultural identity and citizenship, are not exclusive in nature and have many common factors. However, they make useful analytical tools to consider the issues in question. Museums and galleries have

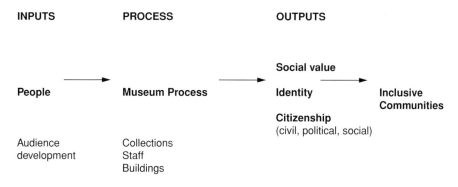

Figure 4.1 The contribution of museums to inclusive communities.

always played a part in defining the cultural identity of individuals and groups although the mechanisms through which this can be achieved are only recently beginning to be understood. The use of museums and galleries to encourage citizenship again is not a new idea; it can be seen in the motivation behind the Museums Act of 1845 that allowed museums to be established by municipal authorities. However, their use in a conscious, proactive way to achieve defined social objectives is new. The focus on social inclusion as a structure through which to achieve social goals has been shown to be limiting and may result in insufficient attention being given to other parts of citizenship and to cultural identity. The challenge to museum practitioners is to develop clear cohesive policies, based on solid theoretical foundations that achieve the required objectives. Through this approach, museums and galleries clearly do have a part to play in the socio-political agendas of the twenty-first century.

Notes

1 The term is used throughout to refer to museums and galleries.
2 An overview of the growth and importance of English regionalism has been given by Tomany and Mitchell (2000). The results of a large-scale study researching the nature of regional and national identity that will be useful in clarifying the role of museums is currently being funded by the Leverhulme Trust <http://www.ucl.ac.uk/constitution-unit/leverh/index.htm> (accessed 26 May 2000).
3 The speech given by the Prime Minister on 2 June 1997 was at Southwark, London.
4 Stephen Lawrence was murdered in a racist attack on the 22 April 1993. The subsequent police enquiry failed to identify and prosecute his attackers and has been widely criticised.
5 An interesting discussion about the relationship between social citizenship and the concept of the underclass has been given by Morris (1994) and a contemporary analysis of the work of T. H. Marshall has been given by Bulmer and Rees (1996).
6 Figures provided by Newcastle City Council (June 2000).
7 Department of the Environment, Transport and the Regions <http://www.regeneration. detr.gov.uk/srb/srb6guide/1.htm> (accessed 26 May 2000).
8 Such an approach has been explored by Newman and McLean (2000).

References

Advisory Group on Citizenship (ed.) (1998) *Education for Citizenship and the Teaching of Democracy in Schools*, London: Qualifications and Curriculum Authority.
Atkinson, R. (1997) 'Citizenship and the struggle against social exclusion in the context of the welfare state transition', paper presented at the ECPR workshop 18: Citizenship and Transition in European (Welfare) States, Bern, 27 February–4 March 1997.
Brubaker, R. (1992) *Citizenship and Nationhood in France and Germany*, Cambridge, Mass.: Cambridge University Press.
Bulmer, M. and Rees, A. M. (eds) (1996) *Citizenship Today, The Contemporary Relevance of T. H. Marshall*, London: University College London Press.
Byrne, B. (1999) *Social Exclusion*, Buckingham: Open University Press.
Canadian Museums Association (1994) *Cultural Diversity and Museums: Exploring Our Identities*, Ottawa: Canadian Museums Association.
Cooke, S. and McLean, F. (2001) ' "Our common inheritance"?: narratives of self and other in the Museum of Scotland', in D. Harvey, R. Jones, N. McInroy and C. Milligan (eds) *Celtic Geographies: Landscape, Culture and Identity*, London: Routledge.

Department for Culture, Media and Sport (1999) *Policy Action Team 10: A Report to the Social Exclusion Unit: Arts and Sport*, London: Department for Culture, Media and Sport.

Department for Culture, Media and Sport (2000) *Centres for Social Change: Museums, Galleries and Archives for All*, London: Department for Culture, Media and Sport.

Derrida, J. (1972) *Positions*, Chicago, Ill.: University of Chicago Press.

Dominy, G. (1994) 'Amandla!', *Museums Journal* 94(4): 26.

Dominy, G. (2000) 'Collecting the material culture of apartheid and resistance: the Natal Museum's Amandla Project', in C. D. Ardouin and E. Arinze (eds) *Museums and History in West Africa*, Washington: Smithsonian Institution Press, pp. 5–17.

Douglas, M. (1966) *Purity and Danger: An Analysis of Pollution and Taboo*, London: Routledge.

Duff, R. A. (2000) 'Whose law is it anyway? Inclusion, exclusion and the criminal law', *Scottish Affairs* 30, Winter: 2–15.

Gore, C. (1995) 'Introduction: markets, citizenship and social exclusion', in G. Rodgers, C. Gore and J. B. Figueiredo (eds) *Social Exclusion: Rhetoric, Reality, Responses*, International Institute for Labour Studies, Geneva: United Nations Programme, pp.1–40.

Grossberg, L. (1996) 'Identity and cultural studies – is that all there is?', in S. Hall and P. du Gay (eds) *Questions of Cultural Identity*, London: Sage: 87–107.

Hall, S. (1990) 'Cultural identity and diaspora', in J. Rutherford (ed.) *Identity: Community, Culture, Difference*, London: Lawrence and Wishart, pp. 222–237.

Kaplan, F. (ed.) (1994) *Museums and the Making of 'Ourselves': The Role of Objects in National Identity*, Leicester: Leicester University Press.

Lowenthal, D. (1985) *The Past is a Foreign Country*, Cambridge: Cambridge University Press.

Macpherson of Cluny (1999) *The Stephen Lawrence Inquiry: Report of an Inquiry*, London: Stationery Office.

Makela, L. (1998) 'Social exclusion and culture – the role of culture in preventing social exclusion', Working Paper for the Eurocities Cultural Committee.

Marshall, T. H. (1950) *Citizenship and Social Class and Other Essays*, Cambridge: Cambridge University Press.

Matarasso, F. (1997) *Use or Ornament? The Social Impact of Participation in the Arts*, Stroud: Comedia.

McCrone, D. (1998) *The Sociology of Nationalism*, London: Routledge.

McLean, F. and Cooke, S. (1999) 'Heritage and museums: shaping national identity', in M. Fladmark (ed.) *Museums and Cultural Identity: Shaping the Image of Nations*, Shaftesbury, Donhead.

Morris, L. (1994) *Dangerous Classes: The Underclass and Social Citizenship*, London: Routledge.

Museums and Galleries Commission/MORI (1999) *Visitors to Museums and Galleries in the UK, Research Findings*, London: Museums and Galleries Commission/MORI.

Newman, A. and McLean, F. (2000) 'Museums as agents of social inclusion', *Transactions of the Museum Professionals Group* 32: 3–8.

Oommen, T. K. (1997) 'Introduction: conceptualizing the linkage between citizenship and national identity', in T. K. Oommen (ed.) *Citizenship and National Identity: From Colonialism to Globalism*, London: Sage, pp. 13–52.

Saussure, F. de (1960) *Course in General Linguistics*, London: Peter Owen.

Silver, H. (1995) 'Reconceptualizing social disadvantage: three paradigms of social exclusion', in G. Rodgers, C. Gore and J. B. Figueiredo (eds) *Social Exclusion: Rhetoric, Reality, Responses*, International Institute for Labour Studies, Geneva: United Nations programme, pp. 57–80.

Silverstone, R. (1988) 'Museums and the media: a theoretical and methodological exploration', *International Journal of Museum Management and Curatorship* 7: 231–241.

Social Exclusion Unit (1998) *Bringing Britain Together: A National Strategy for Neighbourhood Renewal*, London: Social Exclusion Unit.

Social Exclusion Unit (2000) *A National Strategy for Neighbourhood Renewal: A Framework for Consultation*, London: Social Exclusion Unit.

Soysal, Y. N. (1996) 'Changing citizenship in Europe: remarks on post national membership and the national state', in D. Cesarani and M. Fulbrook (eds) *Citizenship, Nationality and Migration in Europe*, New York: Routledge, pp. 17–30.

Tomany, J. and Mitchell, M. (2000) 'Reinventing democracy, empowering the English regions'. Available at <http://www.charter88.org.uk/pubs/reinven/9911empower.html> (accessed 26 May 2000).

Woodward, K. (1997) 'Concepts of identity and difference', in K. Woodward (ed.) *Identity and Difference*, London: Sage, pp. 7–50.

5

The therapeutic potential of museums as pathways to inclusion

Lois H. Silverman

New roles for museums

Slowly but surely, an ever-broadening vision is emerging of the nature and potential of museums in society. Fuelled by both financial and ethical necessity, museum workers internationally are boldly proclaiming a critical role for museums in facilitating social inclusion, and their power as agents of change. On what basis? Even an hour of casual observation reveals the many ends to which visitors use museums: for social bonding, reminiscence, relaxation, and more. A burgeoning body of visitor research confirms the depth of feeling and range of needs that visitors bring to the museum experience (e.g. Annis 1974; Silverman 1990). Utilising this knowledge, museums are learning to work with, and not against, that which people need, want, and do. Having noticed what can happen in and because of museums, more and more writers in the field are positioning museums as facilitators of experience and/or beneficial outcome for as many different people as possible (Prentice 1996; Doering 1999; Kotler 1999; Wells and Loomis 1998).

One promising pathway to an expanded social role for museums lies in recognising their therapeutic potential. Visitors to museums can experience a wide range of benefits, including learning, reflecting on the humanities, restoring oneself, affirming one's sense of self, and feeling connected to community and culture (Graburn 1977; Kaplan et al. 1993; Silverman 1995). Yet museums assume a healthy visitor population. Seldom reached by museums is the significant number of people whose struggles impair daily functioning; for example, those wrestling with depression, or coping with the onset of old age and related losses of function, or adjusting to life with a terminal illness, or dealing with substance abuse. Such populations are rarely talked about by museums, let alone considered as potential visitors. Yet among their needs, these individuals also crave opportunities to learn, to reflect, to restore, and perhaps, most importantly, to affirm a sense of self and continued connections to others in the face of difficulty.

While many different approaches and philosophies exist (Austin 1997), therapy is generally viewed as activities and processes that seek to improve and/or maintain healthy human functioning and well-being. Due to its uniqueness as an environment for communication, the museum has been described as a promising tool for therapy (Silverman 1986, 1989). A growing number of museums throughout the world are exploring the therapeutic use of museums and museum programmes with, among others, older adults (Beevers et al. 1988; Mastoris and Shaw 1996; Chapman 1998, 1999), children in hospitals (Kalessopoulou, this volume), teenagers (Dodd, this volume), and families (Silverman 1989). While few concrete theories or formal guidelines for practice have yet emerged, the number and reported success of these projects testifies to this evolving role of museums. Through their therapeutic potential, museums have a means to social inclusion of individuals who are often overlooked by cultural institutions.

Developing knowledge and competencies: partnerships for learning

Despite successful programmes in which museums are playing key roles in their communities, institution-wide commitment to museums as agents of social change is not yet the norm. Indeed, enthusiasm and impassioned calls for change outweigh the concrete examples and the availability of skills needed to actually fulfil these expanded roles. This is neither surprising nor necessarily discouraging. Practice often lags behind theory or vision, for good reason: to operate a certain way requires possession of the requisite knowledge and abilities to do so. What is clearly needed now is a critical grasp of the knowledge and competencies required to 'walk the talk' of the changing vision.

To its credit, the museum field has long valued, advocated, and undertaken strategic partnerships with other institutions, such as schools and community organisations. As Anderson notes, 'partnerships allow museums to . . . share risks, acquire resources, reach new audiences, obtain complementary skills, improve the quality of service, achieve projects that would have otherwise been impossible, acquire validation from an external source, and win community and political support (1997: 69). Yet, typically, museum partnerships with other institutions focus more on a task at hand, such as the design of an exhibit, than on mutual mentorship and the concentrated exchange of professional expertise. The time is precisely right for ongoing partnerships across professional disciplines that allow a continuing education experience in support of the changing roles of museums. Thus, to develop their potential as effective agents of social inclusion and social change, what better partners for museums than social service professionals and their clients?

In particular, mental health professionals, such as social workers, psychiatrists, recreation therapists, and clinicians seem logical partners and teachers, for it is their *raison d'être* to help facilitate healthy individuals and healthy communities. Day in and day out they speak the language of benefits and human growth.

They work toward such goals as self-esteem and community integration. For those who seek their services, mental health agency workers can often help to alter negative behaviours and contribute to positive mental health through a range of therapeutic interventions. Among the tools of the mental health professional are numerous adjunct therapies that make use of the very resources that museums collect and preserve. For example, art therapy utilises artwork, the primary feature of an art museum; horticulture therapy utilises plants, readily found in a nature centre; reminiscence techniques utilise photos and everyday artefacts of times past, abundant in a historic house museum (Silverman 1986). Indeed, in the world of mental health professions, the sort of emotional and personal responses that people have to artefacts in museums are often explicit goals and valuable tools in therapeutic treatment. Yet, while day care and longer-term therapeutic facilities occasionally take client groups to visit museums as structured outings, or host museum outreach programmes at their facilities, few make regular use of the resources of the museum as a therapeutic tool.

In 1997, a collaborative was formed in Bloomington, Indiana, US to develop and study the therapeutic potential of museums. The Museums as Therapeutic Agents (MATA) Collaborative brought together workers from three museums at Indiana University, three leading social service/mental health programmes in the city of Bloomington, client representatives of these programmes, students, two faculty members of the Department of Recreation and Park Administration at Indiana University and, in 1999, representatives from an additional eight social service programmes. The purpose of the MATA project is to systematically and collaboratively develop, document, and study a set of pilot museum programmes with explicitly therapeutic goals, and to build a body of knowledge on the therapeutic potential of museums to share with others. The project has been made possible for the past three years by the generous financial support of the Institute of Museum and Library Services, a United States federal agency, for a total of $80,000 (USD). The project has been created and directed by the author.

The purpose of this chapter is to present and discuss eight concepts that have emerged from the MATA project and existing literature as fundamental to the theory and practice of museums as therapeutic agents. Four concepts come directly from the specific perspectives and practices of the mental health care world, while four relate to the unique environment of the museum. Together, these concepts begin to form a framework for understanding and implementing the therapeutic potential of museums. After a brief summary of MATA's work, each concept will be considered in turn.

The work of the MATA Collaborative

The MATA Collaborative includes a range of institutions. The three museums are diverse: Wylie House, a historic house, is the residence of Andrew Wylie, the first

president of Indiana University; William Hammond Mathers Museum is a small anthropological museum of world cultures; and Hilltop Garden and Nature Center is a nature and gardening facility. All three are museums of Indiana University. The social service programmes include Positive Link, a programme of services for people with AIDS; Elderhouse, a day treatment programme for older adults with mental health issues; and Horizons, a programme for adults with chronic mental illness. Other agencies include a nursing home, a hospice, a shelter, and an addictions day treatment programme. All are located in the city of Bloomington, Indiana.

The Collaborative has focused on exploring the therapeutic use of museums with three broad groups: adults with life-threatening illness and their caregivers; senior adults; and adults with behavioural health issues. In the first year of the project, three teams were formed – each partnering representatives from one museum, one social service agency, and the particular client group. These teams were formed on the basis of compatibility of resources, logistics, and mutual interests (Silverman 1998).

Each team was charged with the task of developing one pilot programme that somehow used the resources of the museum to address social and self-esteem needs of clients in their group. The only requirement was that clients come in contact with museum resources on at least one occasion, and that the team develop a strategy to the programme – a focus or way in which they believed the programme could have some therapeutic impact. Each team took a different direction with their pilot programme, and were helped in doing so by the project coordinators in order to maximise the group's learning. Programmes were designed on the basis of the client population, the museums' collections and strengths, the clients' responses and their logistical needs, the museums, and the agencies. Three different but complementary pilot programmes were developed.

Adults with life-threatening illness cannot always predict their condition or mood on any given day. Furthermore, many wish to preserve their anonymity. Hence, these clients needed a programme that they could participate in individually, or as a pair with a caregiver, scheduled at their own convenience. For many such clients, motivation is extremely low, and even getting out of the house for a leisure activity is a worthwhile therapeutic goal. Many have lost perspective on their situation and illness, and are challenged in their ability to cope. The typical tour at the Wylie House Museum talks a great deal about how the large Wylie family coped with illness and death, as tuberculosis and other stigmatised diseases were rampant at the time. The house tour even includes a stop in the 'sick room', a special room in the house where an ill person was sent to rest and/or sometimes die. This subject matter seemed a powerful reminder that people throughout history have been faced with the challenges of dire illness. As a result, this team created a very modest pilot programme, aimed at offering clients a simple opportunity for a leisure outing, and promoting a space in which to reflect on their illness with regard to history. The programme offers a person with life-threatening illness and his/her caregiver a specialised

40-minute tour of the Wylie House, followed by the viewing of a short dramatic video about the Wylie family, and some discussion questions for them to consider at the end of the tour.

Senior adults with behavioural health issues are a group often limited in their mobility. As a result, many of the agencies in the MATA Collaborative who serve seniors have developed regular programming and group meetings at their agencies. These clients are often seeking cognitive stimulation, as well as opportunities to socialise, and to reflect on their lives. The Mathers Museum of World Cultures has done a lot of work in the area of outreach kits to schools. Therefore, this team created a two-part programme, in which museum workers with a specially designed outreach kit visited a group of seniors at their facility on two different occasions within a week. The emphasis of the programme was on collecting clients' reminiscences for use in a developing exhibit on community history. On the first occasion, museum workers brought photographs of old household artefacts and a butter churn, and led the group in making butter and sharing their memories about cooking and household chores. On the second occasion, a group of museum volunteers returned to hold one-on-one interviews with clients, asking them to reminisce about their lives. The goal of the programme was to provide cognitive stimulation to the clients, and to increase their sense of self-esteem through the gathering of, listening to, and valuing of their stories.

The social service agencies for people with behavioural health issues shared a common goal: to help their clients develop their sense of self-worth and their abilities to function independently. Therapists and clients alike seek opportunities for clients to work in the community and become more socially integrated. The Hilltop Garden and Nature Center regularly offers garden plots to various community groups, and teaches gardening and other skills to people of all ages. Together, this team created a four-session programme in which clients came to Hilltop, learned how to work with certain plant materials, and then acted as volunteer interpreters demonstrating crafts to children in a holiday programme. The goal of this programme was to promote clients' sense of self-worth, community integration, and confidence.

At the end of the first year, each pilot programme was qualitatively evaluated, and the results used to guide further efforts. In the second year, additional social service agencies and client groups were recruited to help refine the pilot programmes, so that they might be effective with a broader range of like clients. An exploratory empirical study was also conducted to measure the impact of programme participation on clients' self-esteem and community integration (Silverman and McCormick 2001). Currently, the Collaborative is working on the refinement of various evaluation techniques.

Analysis of MATA's work, together with existing literature, suggests eight concepts that are central to viewing and using museums as therapeutic agents. The first four, which come directly from the perspectives and practices of mental health care, demonstrate the critical importance of partnerships for learning.

Learning from the world of mental health

In the United States, the compatibility and similarities of the mental health field and the museum field appear to outweigh the differences. Both agencies exist to serve the public good; both are usually not for profit; both tend to carry on business underfunded and understaffed; and both attract employees who tend to believe in the philosophy of the institution for which they work (Silverman 1998). This complementarity bodes well for the prospect of learning useful lessons from each other. Indeed, museums have much to learn from the world of mental health professions about acting as agents of social change. Four key concepts in the world of mental health offer valuable lessons for museums: (1) A focus on outcomes; (2) What kind? Therapeutic outcomes; (3) With whom? Mental health as common denominator; and (4) How? Working with responses.

A focus on outcomes

From cognitive therapy to behavioural health, from play therapy to family systems, 'therapy' in the world of mental health is actually a plethora of approaches with varying beliefs and hypotheses about treatment processes. Yet, in common, therapeutic approaches seek to improve and maintain healthy human functioning. In particular, they tend to focus on facilitating beneficial change in a client or patient, or maintaining a desired state, as a measure of success (Allen 1996).

For example, a recreation therapist might determine that the goal of treatment with an older adult client is to increase the number of times per week she socialises with other people, and the number of different activities she participates in. A social worker might work with a chronic schizophrenic on maintaining his self-esteem and improving his ability to make decisions for himself. With specific outcomes in mind as objectives, the basis for evaluating progress and success is clear.

Increasing scrutiny of programmes and services supported by public funding has created an environment in which therapeutic service providers are now held accountable for outcomes of service provision (Schalock 1995). This movement was greatly facilitated in the United States by the 'full-scale embrace' of the concept of outcomes by the United Way of America in 1995, one of the largest and most important social service organisations in the country (Weil 2000). According to the United Way as quoted by Weil,

> outcomes are benefits or changes for individuals or populations during or after participating in programme activities. They are influenced by a program's outputs. Outcomes may relate to knowledge, attitudes, values, skills, behavior, condition, or other attributes. They are what participants know, think, or can do; or how they behave; or what their condition is, that is different following the program.

(2000: 9)

A focus on outcomes helps promote both efficiency and effectiveness of programmes and institutions (Weil 2000). As a result of this focus, a plethora of resources on the importance of outcome and on outcome-based evaluation has emerged for the mental health care and social service worker.

Museums are just beginning to recognise the value of a focus on outcomes, embracing it in theory without quite knowing how to do it. While committed to the conduct of evaluation, and often interested in the outcome of visitors' 'getting the message' of a particular exhibit, museum workers do not routinely design programmes and evaluate them on the basis of specific outcomes for visitors. Yet the concept is critical if museums wish to operate as effective institutions for social good and document their impact on individuals and communities. In addition, the concept of outcomes provides a framework to acknowledge and support the many and varied aspects of experience that can result for visitors. Learning the value of and approaches for focusing on outcomes is a critical perspective from the world of mental health that is of great value for museums.

What kind? Therapeutic outcomes

Time spent in a museum can yield a variety of outcomes for visitors (Wells and Loomis 1998). While studies show that some visitors may seek and experience relaxation, social bonding, self-identity, self-esteem, and other outcomes from their museum experience (Graburn 1977; Worts 1992; Kaplan et al. 1993; Silverman 1995), it is still relatively rare that museums choose to focus explicitly on facilitating outcomes other than cognitive gain. Yet therapeutic outcomes can and often do occur in museums. The world of mental health can remind museums of the range of goals that are essential for a healthy society.

Like any functional system, communities need members who are independent, as well as interdependent. These two goals – individuation and integration – are fundamentals of mental health (Galvin and Brommel 1982). Often, mental health workers are involved in assessing and addressing barriers to individuation and integration. For a person with a terminal illness, this might involve reminiscing in order to make peace with one's life. For a family in crisis, this might mean learning new patterns of relating to each other. Such outcomes can and do take place in response to museum exhibits and programmes (e.g. Silverman 1989; Chapman 1998). As museums seek to serve their communities more broadly and inclusively, the perspectives of mental health offer language, approaches, and context for a range of worthwhile outcomes related to health and well-being.

With whom? Mental health as common denominator

With whom might museums consider facilitating outcomes that may be viewed as 'therapeutic'? At first glance, therapeutic approaches appear to be for people who are temporarily or permanently socially excluded. Yet the mental health professions illustrate clearly that mental health and community health issues affect

everyone (Yzaguirre 1997). The need for individuation and integration is essential for all people (Giele 1980). At any given point in time, certain community members may experience struggles with mental health that can impair daily functioning, or lead them, voluntarily or not, to the services of mental health agencies. Whether temporary or chronic, mental health issues transcend typical boundaries. Recovering from loss, increasing self-esteem, dealing with the onset of old age and related loss of functions, adjusting to life with a terminal illness, dealing with addictions or substance abuse: such challenges can and do occur in anyone's life. Mental health is a common denominator, something all people need, and addressing it is a path to broader social inclusion by museums.

Theories from mental health and human behaviour can also provide more specific frameworks and guidance to museums as they seek to fulfil their potential with all citizens. Abraham Maslow's theory of motivation is an excellent example. According to Maslow (1943), humans share the desire to satisfy five different but sequential basic needs: physiological, safety, social, ego/esteem, and self-actualisation. Meeting these needs is fundamental to human health. With the recognition that such needs can be met in a museum, and can be used as target outcomes for exhibits and programming, Maslow's hierarchy provides a useful way to approach universals among and across visitors (Silverman 1999).

How? Working with responses

The ways in which therapists and social workers work with clients toward beneficial change is extraordinarily relevant for museums. Many therapeutic approaches involve working with client or patient *responses* – memories, stories, knowledge, attitudes, emotions – the same sort of responses that are called forth when people encounter artefacts in museums. In a variety of ways, therapeutic approaches welcome and utilise such human responses as self-expression, emotion, reminiscence, opinion, interaction – as well as cognition – to explore, address, and practice new possibilities, patterns of thought, and behaviour.

In the context of a museum, certain visitor responses are expected and encouraged, while others are restricted or invalidated (O'Neill 1995; Silverman 1995). Locked within the framework of institutional history, museum workers tend to privilege a narrow range of visitor responses – typically, cognitive ones – and ignore the very personal and emotional responses that therapists value. For example, if the museum's objective for a particular exhibit is to display the finest examples of aesthetic achievement, some museum workers might be dissatisfied, even horrified, at the visitor whose response is, 'the house in that picture looks just like the one we stayed at on holiday when I was a child!' Such a response might seem naïve, uneducated, and perhaps annoying. Yet in the framework of the mental health world, not only is such a response valid, it is valuable – as opportunity, pathway for communication, entry-point for self-awareness. The approaches of therapy and mental health care can help museums to see new and different ways to appreciate, facilitate, and work with the rich diversity of human responses.

Utilising the uniqueness of the museum environment

Unquestionably, the mental health world contributes unique perspectives to the growing understanding of how museums can function as therapeutic agents. Yet collaboration with workers from the mental health professions has also illuminated the unique contributions of museums themselves and their particular environment. Four key concepts emerge as fundamental to the therapeutic role of museums: (1) People's responses to artefacts in museums; (2) The variety of interpretive media; (3) The social roles possible in museums; and (4) The need for ongoing evaluation.

People's responses to artefacts in museums

Artefacts possess an undeniable power to elicit responses from people. Objects serve as symbols of ourselves, our relationships, and our lives (Csikszentmihalyi and Rochberg-Halton 1981; Kirschenblatt-Gimblett 1989). Given the importance of artefacts to social life, it is easy to see why visitors in museums respond to them in a wide range of ways, from sharing their knowledge about them (Silverman 1990), to telling personal stories and reminiscences (Sharpe 1982; Chapman 1999), to experiencing wonder (Raphling and Serrell 1993), to feeling sadness and sorrow (Uzzell and Ballantyne 1998). Despite the tendency of museum workers to privilege visitors' cognitive responses, a growing number of writers are acknowledging the range of emotions evoked by artefacts in the museum context (Raphling and Serrell 1993; O'Neill 1995; Uzzell and Ballantyne 1998). As the mental health field demonstrates, such responses can be used as therapeutic tools, and pathways to self-exploration and growth. What museums can uniquely offer is an opportunity for individuals to encounter collections of evocative artefacts, and a laboratory for understanding the powerful connections between people and things.

In the MATA project, each team examined the nature of visitor responses to artefacts in their particular museum, and sought a way to utilise some aspect of those responses as a therapeutic strategy. As a result, each of the three programmes emphasised a different kind of personal response by clients to the museum artefacts.

In creating the Wylie House programme for people with life-threatening illness and their significant others, the team recognised that visitors often respond to artefacts in the house by comparing them and their use to similar artefacts of today. Such comparison is a common response of visitors in historic house museums (Carson and Carson 1983). Some of the artefacts, rooms, and content of Wylie House deal directly with the subject of life-threatening illness in the 1800s. Therefore, the team utilised the responses engendered by the similarity of the subject matter to the clients' own situations to promote self-reflection, historical comparison, and a recognition of the universality of human challenges.

To create an intervention involving older adults with the Mathers Museum of World Cultures, the team emphasised the power of everyday artefacts to stimulate reminiscence (Csikszentmihalyi and Rochberg-Halton 1981; Kirschenblatt-Gimblett 1989). Reminiscence and life review are necessary and helpful activities for older adults, which can lead to an increase in self-esteem and communication (Butler 1963; Edinberg 1985), and the use of museum programming for reminiscence has become increasingly popular (Chapman 1998). Therefore, the Mathers programme featured household artefacts and the interviewing of participants for their memories and stories about those artefacts.

In developing a therapeutic strategy for adults with behavioural health issues at Hilltop Garden and Nature Center, the team drew upon theories from horticulture therapy in which plants and plant activities serve to integrate people and promote social interaction (Rothert and Daubert 1981). Recognising clients' curiosity and desire to learn, this programme taught them how to teach others about the plants. As these examples illustrate, peoples' rich and varied responses to artefacts in museums offer clear suggestions about ways to use museums as therapeutic tools.

The variety of interpretive media

From role-playing to labels, museums aim to engage visitors with artefacts through an array of interpretive media. Along with artefacts, the presence of interpretive media is perhaps the most distinguishing characteristic of the museum environment. Museum media constitute two major categories: personal services, such as a gallery tour or conducted programme, in which visitors interact with a museum worker; and non-personal services, such as an exhibit or audio-visual presentation, in which visitors do not interact with a museum worker (Sharpe 1976). Just as museum media help facilitate visitor outcomes such as orientation, education, and entertainment (Bitgood 1988), so too can the rich variety of interpretive media commonly used in museums be harnessed toward therapeutic outcomes.

While personal services are time and resource intensive, they are an ideal interpretive media as they offer the immediacy, flexibility, and warmth of two-way live communication (Sharpe 1976). Furthermore, the qualities of personal interpretation – pleasurableness, relevance, organisation, and themes – distinguish it favourably from formal instruction (Ham 1993). Many approaches to therapy emphasise the facilitation of interaction and communication. Therefore, personal interpretive media appear to lend themselves well as vehicles for museum programming that is therapeutic in nature.

The three pilot programmes developed by the MATA project illustrate the therapeutic potential of a variety of standard interpretive formats or museum offerings. The Wylie House programme for people with life-threatening illness and their significant others utilised a guided tour as the central medium for teaching about the house, showing client-visitors the artefacts, and encouraging their

self-reflection and historical comparison. The team decided that their most frequently offered interpretive format was efficient and effective for all their visitors, and could best be tailored in-the-moment to the needs of the client-visitors. The tour guide could also help create a sense of specialness and appreciation for the client and his/her visit.

To best facilitate reminiscence and communication with older adults in the Mathers programme, the team utilised the standard format of an outreach programme. Since many of these clients could not easily travel, and the museum was already quite experienced in the development and use of outreach programmes and kits for schools, they readily adapted the outreach model for use at older adult care social service facilities. In both sessions, museum workers showed artefacts, and actively engaged with and interviewed participants to elicit and record their reminiscences.

In order to help promote a sense of mastery and accomplishment among adults with behavioural health issues at Hilltop Garden and Nature Center, the team developed their programme within the common interpretive format of the demonstration programme. First, client-visitors themselves were taught about the plants, and how to use them to make particular crafts. After additional training about how to be interpreters, the client-visitors then served as interpreters themselves, showing children in a holiday programme how to make the crafts, and assisting them when needed.

In these cases, personal interpretive services clearly lent themselves well to therapeutic programming. As such media are time and labour-intensive, the MATA Collaborative is also developing ways in which therapists and social workers can use museums with their clients that do not require the ongoing participation of museum personnel. The success of such projects as the AIDS Quilt and displays created by cancer patients (Keough 1994) suggest there is great potential in utilising a range of museum media, personal and non-personal alike, in the creation and delivery of therapeutic programmes.

The social roles possible in museums

A host of challenges can ensue when one is faced with a mental or physical illness, or the illness of a loved one. As enlightened by the field of social psychology, the impact of such an experience may lead to role engulfment (Skaff and Pearlin 1992). When this occurs, the role of 'sick person' or of 'caregiver' may come to engulf a person's life, overshadowing former, defining roles such as 'devoted mother' or 'athlete'. Role engulfment can have negative impacts on a person's sense of self, perceptions of competence, and social opportunities (Skaff and Pearlin 1992). The role of 'sick' or 'disabled' might increasingly constrict one's sense of personal identity, competence, and even opportunities for social participation. For example, a consistent outcome of the acquisition of a disability is the loss of close relationships and resulting social isolation (Lyons et al. 1995). Hence, for those experiencing role engulfment, any opportunity to reinforce previous valued roles or offer new, valued roles,

even temporarily, might provide individuals with a therapeutic means to impact on their sense of self and connection to others.

The pilot stages of the MATA project revealed that the environment of the museum affords a number of social roles that can be utilised in therapeutic programming. Each team's programme afforded their client-visitors a social role relevant to their needs that was possible vis-à-vis the museum. In the Wylie Team programme, each adult with a life-threatening illness became a museum *visitor* for the day, a valued and increasingly uncommon role for those who were becoming physically challenged and/or housebound. In the Mathers Team programme, each older adult took on the role of *contributor* to the museum, offering their personal stories for the benefit of the museum. In the Hilltop Team programme, each adult with behavioural health issues became a *volunteer interpreter* for the museum, possessing and teaching the expertise that others desired. In each case, the museum environment afforded a social role that was valued by others and valuable to the client-visitor. Designing therapeutic programmes around such social roles appears to be a promising strategy.

Evaluation of the MATA project suggests that affording client-visitors a relevant social role in which they engage with artefacts they find personally compelling creates a most effective therapeutic mechanism. The two components, personal connection to artefacts and a valued social role, appear to work best together. For example, engaging older adults as contributors to the museum by soliciting their stories may boost their self-esteem, but if they do not connect with the particular artefacts they are shown, they may not experience reminiscence, and the role alone may not provide the impact. Learning to work with plants and create crafts may be therapeutic in its own right, but learning them well enough to serve as a teacher or interpreter to others adds another dimension to the experience. The impact of these and other components is a promising area for further research and refinement.

The need for ongoing evaluation

The promise of and need for further research in the use of museums as therapeutic agents are clear. One way to expand both theory and practice is through the conduct of ongoing evaluation. Over the last fifteen years, the museum field has increasingly recognised and embraced the necessity of exhibit and programme evaluation (Borun and Korn 1995). As a result, a variety of models for and approaches to evaluation within museums are available, both qualitative and quantitative. The growing commitment of the museum field to evaluation and the importance of building a body of knowledge (Hirsch and Silverman 2000) bode well for the continued exploration and advancement of the therapeutic potential of museums.

The MATA Collaborative has utilised both qualitative and quantitative approaches to evaluation. Qualitative approaches, such as observation and in-depth interviewing, have enlightened the richness of the potential of museums

as therapeutic agents as perceived by client-visitors and museums and social service workers alike (Silverman 1998). Recently, the MATA project has utilised pre- and post-tests measures of such concepts as self-esteem, mastery, and alienation in quantitative evaluation (Silverman and McCormick 2001). The results suggest the challenging and critical task of accurately identifying realistic and measurable outcomes. Since changes in attitudes and behaviour often occur within the context of a process of small interrelated steps, it is critical to refine the precise therapeutic outcomes that might be facilitated with a museum programme intervention. Efforts suggest that both qualitative and quantitative approaches are necessary to understand how museums function therapeutically.

Indeed, ongoing evaluation is critically needed of any and all efforts that posit museums as therapeutic agents and facilitators of social inclusion and social change. While evaluation may be challenging, the commitment of the museum field to its value is encouraging. It is only through the systematic examination of each effort and its impact that museums will change in positive ways, and convince others to do so as well.

Conclusion

Stephen Weil has described the recent shift in museums as a movement from being inward to being outward, 'from being *about* something to being *for* somebody' (1999: 229). Yet the ultimate power of museums lies in recognising their true essence and unique capacity to be *about* something and *for* somebody *at once*; to foster, support, and utilise in new ways the fluid and vital interaction between people and artefacts. This unique capacity opens both imagination and reality to greatly expanded roles for museums as agents of change and social inclusion, and to the undeniable potential of museums as therapeutic agents.

Through learning partnerships with social service and mental health agencies, museums are embracing and extending their capabilities to foster interaction between people and artefacts toward varied beneficial outcomes. This chapter offers a beginning framework for understanding and implementing the therapeutic potential of museums, including new ways for museums to serve people who are dealing with mental health issues, and the communities to which they belong. Since ultimately that means everyone, the therapeutic potential of museums is a promising pathway toward a beckoning vision of museums that routinely address basic human needs for all.

References

Allen, L. (1996) 'Benefits-based management of recreation services', *Parks and Recreation* 32(3): 65–76.
Anderson, D. (1997) *A Common Wealth: Museums and Learning in the United Kingdom*, UK: Department of National Heritage.

Annis, S. (1974) 'The museum as a staging ground for symbolic action', *Curator* 38(3): 168–171.

Austin, D. (1997) *Therapeutic Recreation: Processes and Techniques*, Illinois: Sagamore Publishing.

Beevers, L., Moffat, S., Clark, H. and Griffiths, S. (1998) *Memories and Things: Linking Museums and Libraries with Older People*, Edinburgh: WEA South East Scotland District.

Bitgood, S. (1988) 'Problems in visitor orientation and circulation', in S. Bitgood, J. Roper and A. Benefield (eds) *Visitor Studies 1988: Theory, Research, and Practice*, Jacksonville: Center for Social Design.

Borun, M. and Korn, R. (1995) 'The quandaries of audience research', *Journal of Museum Education* 20(1): 3–4.

Butler, R. (1963) 'The life review: an interpretation of reminiscence in the aged', *Psychiatry*, 26: 65–76.

Carson, B. and Carson, C. (1983) 'Things unspoken: learning social history from artefacts', in J. Gardner and G. Adams (eds) *Ordinary People and Everyday Life*, Nashville: American Association for State and Local History.

Chapman, S. (1998) 'The power of reminiscence', *Alberta Museums Review* 24(2): 40–43.

Chapman, S. (1999) 'Membership in a society for all: programming for older adults at Glenbow', *Alberta Museums Review* 25(1): 32–35.

Csikszentmihalyi, M. and Rochberg-Halton, E. (1981) *The Meaning of Things: Domestic Symbols and the Self*, Cambridge: Cambridge University Press.

Doering, Z. (1999) 'Strangers, guests, or clients? Visitor experiences in museums', *Curator* 42(2): 74–87.

Edinberg, M. (1985) *Mental Health Practice with the Elderly*, New Jersey: Prentice-Hall, Inc.

Galvin, G. and Brommel, B. (1982) *Family Communication: Cohesion and Change*, Illinois: Scott Foresman and Company.

Giele, J. (1980) 'Adulthood as transcendence of age and sex', in T. Smelser and E. Erikson (eds) *Themes of Work and Love in Adulthood*, Massachusetts: Harvard University Press.

Graburn, N. (1977) 'The museum and the visitor experience', in S. Nichols, M. Alexander and K. Yellis (eds) *Museum Education Anthology*, Washington, DC: Museum Education Roundtable.

Ham, S. (1993) *Environmental Interpretation*, New York: North American Press.

Hirsch, J. and Silverman, L. (2000) (eds) *Transforming Practice: Selections from the Journal of Museum Education 1992–1999*, Washington, DC: Museum Education Roundtable.

Kaplan, S., Bardwell, L. and Slakter, D. (1993) 'The restorative experience as a museum benefit', *Journal of Museum Education* 18(3): 15–17.

Keough, T. (1994) 'Pictures of health', *New Age Journal*, May/June: 18–19.

Kirschenblatt-Gimblett, B. (1989) 'Objects of memory: material culture as life review', in E. Oring (ed.) *Folk Groups and Folklore Genres: A Reader*, Utah: Utah State University Press.

Kotler, N. (1999) 'Delivering experience: marketing the museum's full range of assets', *Museum News* 78(3): 30–39, 58–61.

Lyons, R., Sullivan, M. and Ritvo, P. (1995) *Relationships in Chronic Illness and Disability*, California: Sage.

Maslow, A. (1943) 'A theory of human motivation', *Psychological Review* 50(4) : 370–396.

Mastoris, S. and Shaw, L. (1996) 'Museums and reminiscence work', *Museum Practice* 1(3): 58–59, 76–79.

O'Neill, M. (1995) 'Curating feelings: issues of identity in museums', *Canadian Art Gallery/Art Museum Educators*, January: 18–30.

Prentice, R. (1996) 'Managing implosion: the facilitation of insight through the provision of context', *Museum Management and Curatorship* 15(2): 169–185.

Raphling B. and Serrell, B. (1993) 'Capturing affective learning', *Current Trends in Audience Research and Evaluation* 7.

Rothert, E. and Daubert, J. (1981) *Horticulture Therapy at a Physical Rehabilitation Facility*, Illinois: Chicago Horticulture Society.

Schalock, R. (1995) *Outcome Based Evaluation*, New York: Plenum Press.

Sharpe, E. (1982) *The Senior Series Program: A Case Study with Implications for Adoption*, Washington, DC: Smithsonian Institution.

Sharpe, G. (1976) *Interpreting the Environment*, New York: John Wiley and Sons.

Silverman, L. (1986) 'Hands across the object: humanities programming and therapy', in D. Daucus and P. Knowlen (eds) *The Future of Arts and Humanities: How, Where, and With Whom*, Washington, DC: NUCEA.

Silverman, L. (1989) 'Johnny showed us the butterflies: the museum as a family therapy tool', *Marriage and Family Review* 13(3/4): 131–150.

Silverman, L. (1990) 'Of us and other things: the content and functions of talk by adult visitor pairs in an art and a history museum', unpublished Ph.D. dissertation, University of Pennsylvania.

Silverman, L. (1995) 'Visitor meaning-making in museums for a new age', *Curator* 38(3): 161–170.

Silverman, L. (1998) *The Therapeutic Potential of Museums: A Guide to Social Service/Museum Collaboration*, Indiana: Institute of Museum and Library Services.

Silverman, L. (1999) 'Meeting human needs: the potential of museums, *Museum National* 8(1): 17–19.

Silverman, L. and McCormick, B. (2001) *Museums as Therapeutic Agents: An Integrated Approach to Theory-Based Program Design and Evaluation*, Bloomington, Indiana: Indiana University.

Skaff, M. and Pearlin, L. (1992) 'Caregiving: role engulfment and the loss of self', *Gerontologist* 32: 656–664.

Uzzell, D. and Ballantyne, R. (1998) 'Heritage that hurts: interpretation in a postmodern world', in D. Uzzell, and R. Ballantyne (eds) *Contemporary Issues in Heritage and Environmental Interpretation*, London: The Stationery Office.

Weil, S. (1999) 'From being about something to being for somebody: the ongoing transformation of the American museum', *Daedalus* 128(3): 229–258.

Weil, S. (2000) 'Transformed from a cemetery of bric-a-brac', in B. Sheppard (ed.) *Perspectives on Outcome Based Evaluation for Libraries and Museums*, Washington, DC: IMLS.

Wells, M. and Loomis, R. (1998) 'A taxonomy of museum program opportunities – adapting a model from natural resource management', *Curator* 41(4): 254–264.

Worts, D. (1992) 'Visitor-centered experiences', in A. Benefield, S. Bitgood and H. Shettel (eds) *Visitor Studies: Theory, Research and Practice Volume 4*, Jacksonville: Center for Social Design.

Yzaguirre, R. (1997) 'Keynote address', in *Museums in the Social and Economic Life of a City: Summary of a Conference*, Washington, DC: American Association of Museums.

Buried in the footnotes: the absence of disabled people in the collective imagery of our past

Annie Delin

Any casual visitor to museums in Britain would assume that disabled people occupied a specific range of roles in the nation's history. The absence of disabled people as creators of arts, in images and in artefacts, and their presence in selected works reinforcing cultural stereotypes, conspire to present a narrow perspective of the existence of disability in history. What impact might this narrow and distorted view be having on the society we live in today?

Bombarded by the requirements of legislation, by forcefully presented campaigns for change and by direct contact with disabled people with a new sense of self, non-disabled individuals could feel that history has not prepared them for the existence of disabled individuals. Non-disabled people will continue to be shocked by meeting disabled people with disfigurements that were depicted centuries ago, but are now never shown. They may expect that certain individuals will be dangerous, weak, evil or cherubic by association with artistic metaphor and biblical imagery. They may be surprised at achievement among disabled artists because they have never known it to exist among the artists of the past.

Disabled people may feel dissociated from the culture of their country because of the absence of their historical peers in what is shown. They may feel that their existence today is new and unexplained by comparison with the sanitised population of the past. They may have low expectations of their possible status and achievements, through absence of clear role models in history showing what is possible. They may be passive in a dominated role in modern society, unaware that there was ever a different perspective or more accepting view of disabled people in society.

None of the above may be true, because the thesis cannot be tested in the existing museum context. It is impossible to provide comparators where representation is detailed, balanced and well signified, in order to study different views of museum visitors before and after exposure to the historical existence of disabled people. This paper sets out to take an overview of the way in which disabled people are present or absent in museum displays, and to question what the implications of that presence/absence might be – both in terms of where it stems from, and where it leads to.

The proposition that museums have a role to play in reconstructing disabled people's identity, and allowing them to celebrate their distinctive history and culture while finding social inclusion in the twenty-first century, is set against a background of enquiry by disabled people into all aspects of historical stereotyping and cultural identity. Whilst some notable research has been undertaken into the place of film, television, advertising, literature and photography in creating notions of who disabled people are, there is little published material on the role of material evidence in museums and galleries – what of the social history, costume, fine and decorative art and many other specialist collections? Some work by Deaf historians has exposed the contribution of individual Deaf artists and craftsmen to history. Further than this there is an imperative for research, as part of which this paper makes only the first tentative steps.

> In every society human beings come together in groups and subgroups so that their society and physical environment can be modified to improve the quality of life (in food, shelter and leisure). How these different groups actively engage in shaping the world they live in, the artefacts they produce and the mannerisms observed in their use, the different interpretations they make of their lives and the way they present and convey these views to each other, all form the sum total of a society's culture. In all, then, we can locate evidence of the real experiences and aspirations of different social subgroups by the level and way their culture is expressed, especially in its concrete form in the arts.
>
> (Morrison and Finkelstein 1997: 160)

In this articulation of cultural identity, by artist Elspeth Morrison and theorist Vic Finkelstein, we can identify a number of areas where disabled people may be excluded from participation in the cultural standard of our age (based on the precedent of previous ages as we now perceive it to exist). In the artefacts they produced, the interpretations they made of their lives and the way those views are conveyed and presented, we see that disabled people have become absent or misrepresented.

Within museums, disabled people might find not a single image of a person like themselves – no affirmation that in the past people like themselves lived, worked, created great art, wore clothes, were loved or esteemed. If they do see an image of someone exactly like themselves and seek to know more about them, there is a chance that their name is missing from the catalogue or label – that they are known as 'the dwarf', 'the giant', 'a marvel of nature'.

Similarly, works of art *by* disabled people are characterised by absence of information which would allow onlookers to learn that the work was created by a disabled person. The heroic stories about admirals and poets, artists and craftspeople often neglect to point out when the illustrious were also unusual in the way they walked or spoke. Disabled history can in this sense be regarded as part of a phenomenon known as 'hidden history'. This definition comes from Anne Laurence:

> The term Hidden History is used when the history of a hitherto neglected group begins to appear: as, for example, in the case of black history, women's history, lesbian and gay history . . . The phrase is not simply used to describe the group's emergence into mainstream history: it also has an explicit message that these groups have lacked a history because society has been unwilling to see them as a separate group with particular rights. Groups hidden from history are hidden for three reasons. They are hidden because of prejudices against the group in the past, because of modern prejudices; and because of the absence of records.
>
> (1996: 3)

Therefore, to identify disabled history as hidden requires a belief in prejudice against disabled people's appearance in historical collections and records. There is evidence to support a view that such prejudice, inadvertent or deliberate, in fact exists.

The prejudices of the past

In this context, the prejudices of the past would be the way in which disabled people appear in collections in limited roles, as freaks or as beggars. It might also be manifest in the way that curatorial practice of just a few decades ago stripped identity from people who, in their own time, had names and reputations which afforded them respect.

Modern prejudices

Inadvertently prejudicial is a museum's caution about displaying evidence of disability, perhaps through an unwillingness to engage in this debate in case mistakes are made in doing so. Some may brand calls to address these issues as politically correct, others may comment that that they find the enquiry segregating and offensive. Curators refuse to search under the words 'deformity' or 'cripple' – which is where disabled history is.

Conversely, disability can be 'interpreted' to load it with contemporary meaning, losing a sense of its significance in its natural context and time period. (For example, presuming certain works to be responses to affliction or illness, or assuming that a craftsman or artist worked to 'overcome' or compensate for their disability.)

The absence of records

As time passes, there is increasing risk that recorded evidence of disabled lives is missing. In some cases, biographical evidence that points to disability in the lives of known individuals becomes lost when it is re-presented for modern audiences. In other cases, only the disability has been remembered, while the

name, occupation, relationships and other essential defining identity of an individual have been lost.

Disabled history therefore qualifies as hidden history, and there is room for an interrogation of the presence, or absence, of disabled people in museum and gallery collections in Britain, and an evaluation of the impact, on contemporary society, of the way disabled people are portrayed.

The ideas presented in this chapter are based on correspondence with museums around the British Isles. From this initial research, the historical representation of disabled people in museum collections can be explored through a number of definable categories. Against a background of contemporary studies of media representation, these categories are clearly recognisable. Colin Barnes, in his significant works *Disabling Imagery and the Media*, identified twelve commonly recurring stereotypes including disabled person as atmosphere or curio, disabled person as super cripple and disabled person as pitiable and pathetic. I found that many of these stereotypes had recognisable parallels when classifying museum examples for this research, which in itself presents an argument that some historical precedents may have been absorbed and perpetuated by modern popular culture.

In classifying the preliminary results of this research, the four categories that emerged were: disabled people as freaks; heroes who cease to be disabled; invisible disabled creators/artists; and ordinary people. Additionally, there is a significant body of evidence showing that disabled people have a special place in biblical allegory and as a metaphor for evil, in works that show, for example, the healing of the sick, metaphorical images of depravity or vice and warnings against the wages of sin. Michael Oliver has identified a historical theory of disability that states that, in societies dominated by religion, impairment can be understood as a divine punishment – and art that embraces this understanding is easy to nominate as an 'image of disability' without absorbing the historical stereotyping that is being perpetuated (cited in Hevey 1992: 13). The impact that this has on popular culture is introduced by Ann Pointon:

> Although cinema has developed conventions of its own, much of its treatment of disability is rooted in a culture that has for centuries used the impaired body to signify sins past, sins present and the threat of future evil. The simplistic equation of beauty with goodness and ugliness with badness is intrinsic to our fairy-tales and is recycled with each telling.
>
> (Pointon and Davies 1997: 7)

Finally, there are numerous and widespread examples of disabled history among collections that show medical phenomena, the history of surgery or cure and prostheses or aids. During my research, the enthusiasm with which curators proposed such items and collections as representative of disabled life evidences one of the principal controversies of modern debate – the medical model of disability. To assume that there is a 'natural link' between these collections and disability, that they are, in the words of one curator, 'ideal for your purposes', devalues the equally 'natural' (if less frequently recorded) link between disability and, say, creativity, practical endeavour or family contribution.

The choice in this chapter to focus on four categories – disabled people as freaks, heroes who cease to be disabled, invisible disabled creators/artists and ordinary people – was made for reasons of economy of time, and not because the remaining areas are less significant in examining disabled history. Indeed, these areas are, in themselves, so substantial that they require further investigation by specialists who can properly set the context of art history, or of scientific advances, against the evidence of changing attitudes to, and treatment of, disabled people.

Disabled people as freaks

Almost every region in the UK has its examples of these: The Child of Hale, Tom Thumb, Daniel Lambert, Hopcyn Bach, the Elephant Man, Owen Farrel and Black Moll. In local folklore small people, large people, people with diseases and deformities are celebrated for their oddity, but often with affection and wonder. They are recorded in local museums and history collections, mostly with images alone, less frequently with accounts of their lives and their impact on those around them.

Cheltenham's John the Muffin Man appears in many contemporary illustrations and street scenes. His real name was John Millbank, and he is described in a label in Cheltenham Art Gallery and Museum as a character of the mid-nineteenth century, when he sold muffins on the streets of Cheltenham. The label also says 'regrettably no-one has recorded where he came from or his dates' but points out that it is unusual to find a portrait of someone who is not middle-class or aristocratic. A contemporary poem goes part way to explaining why he was recorded, at the same time touching on contemporary issues of disability:

> The dwarf was not a churlish elf
> Who thought folk stared to scoff;
> He used deformity itself
> to set his muffins off.
>
> He stood at doors and talked with cooks
> While strangers took his span;
> And grimly smiled on childhood looks
> On him, the muffin man.

The children might have stared, but it seems they came to treasure his appearance. This poet records his feelings when John died:

> My path with things familiar spread
> Death's foot had seldom crossed;
> And when they said that John was dead
> I stood in wonder lost.
>
> New muffin-men, from lamp to lamp
> With careless glance I scan;
> For none can ever raze thy stamp,
> Oh John, thou muffin man.[1]

The actual personality of this individual, recognisable to someone who shares his disability, echoes down the years because of this one, accidentally preserved, account. In Portsmouth, John Pounds earned similar affection from local children for his philanthropy. He was born in 1766, and was 'rendered a cripple in early life'. From his cobbler's workshop he founded a ragged school to which street urchins were lured with boiled potatoes in his pocket. Once in his workshop, he exercised, 'a passion for teaching which nothing but the limit of his hovel could contain.' When he died in 1839 while on an errand, he was 'conveyed back to his home, where the unexpected calamity overwhelmed with sorrow about thirty of his little band, who were there waiting for their daily lessons' (Gates 1900: 686–689).

There is something to say about each of these characters, but unfortunately this is not typical. More commonly, what happens over time is that the 'freakishness' of the body transcends any personality that may have been remembered or recorded. People who were whole people with names, lives and personalities are reduced, sometimes to single images, or to stock phrases about their marvellous strength, gentleness or fearsome appearance. In modern society, we no longer actively condone the showing of 'different' people as freaks. Many of the people named here lived in a culture where it was accepted that it would be their living. Owen Farrel sold his skeleton to a local surgeon while he was still alive,[2] and even some of the artists mentioned below generated interest and income because of their oddity. Yet we do perpetuate the acceptability of staring and pointing whenever we allow a picture of a small person or someone with a disfiguring condition to be displayed without identity and context – biography, commentary on changing social views, notes on contemporary perspectives.

What is the impact of this on the museum visitor? It makes it acceptable to stare, to laugh and to forget that the real person also had feelings. In considering this issue in a modern context, Colin Barnes commented 'Being mocked publicly is only acceptable if the negative images which ensue can be offset against positive ones, or if those being ridiculed are able to defend themselves if they choose to' (1992: 27). In the absence of positive representation of disabled people in museum collections, or of supporting biographical knowledge about individuals, museums may therefore be perpetuating the unacceptable – and yet by failing to show such images they contribute further to the invisibility of disabled characters in history.

Heroes who cease to be disabled

Not all images of disabled people are negative – some defy that interpretation. Far from hidden in our collections are images of and works by Admiral Lord Nelson – the naval hero who defended his nation one-armed and one-eyed; Byron, the celebrated swashbuckler, poet and lover; John Milton, the visionary of his age; and Josiah Wedgwood, craftsman and manufacturer – part of the great industrial revolution that transformed the nation.

Disabled museum visitors might choose to identify with such strong role models, though knowing that these national icons were disabled may be problematic. When people become heroic enough, they transcend disability, their disability is forgotten and emphasis thrown on what they achieved. This is a very modern debate – the one that gives rise to the 'see the ability, not the disability' type of campaigns. We should consider whether, in forgetting the disability of some of our heroes, we are slowing the process of inclusion for today's disabled people. Instead it should be possible to remember that Nelson was disabled and (not but) brave; Byron disabled and (not but) gorgeous; Josiah Wedgwood disabled and (not but) technically able, creative, businesslike.

Sometimes images of heroes don't show their disability. Some portraits of Nelson forget his disabilities even after they happened – eliminating anything that seems to detract from his idolic status. In other cases, the sitter wanted their disability concealed – a celebrated case would be Alexander Pope of whom only one image purports to show his disability. On the reverse of Ulster Museum's copy of the work is inscribed:

> This is the only portrait that was ever drawn of Mr Pope at full length. It was done without his knowledge as he was deeply engaged in conversation in the gallery at Prior Park, by Mr Hoare, who sat at the other end of the gallery. Pope would never have forgiven the painter had he known it – he was too sensible of the deformity of his person to allow the whole of it to be represented. This drawing is therefore exceedingly valuable, as it is an unique of this celebrated Poet.[3]

Mr Hoare's behaviour, as the paparazzo of his day, gives rise to another modern debate – what if the person concerned didn't want their disability to be known? Of course, their wishes should be respected – but their wishes were shaped by the society they lived in, and, in other contexts, museums feel free to change perspective to meet the needs or desires of the modern audience. How would Queen Victoria feel if she knew her underwear is preserved at the Museum of London? We do things by today's standards, and perhaps this includes deciding that it is acceptable now to discuss disability, because it is no longer a shameful, taboo subject.

Invisible disabled artists

Effectively 'behind the camera' in our museum collections are the disabled artists and makers, of whom there must be thousands. Here are only a handful.

Sarah Biffin, a celebrated miniaturist who painted with her shoulder assisted by her mouth, was exhibited at fairs by her tutor, later married a Mr Wright, but continued to use her own name and worked for her living. She was patronised by George III, William IV and Queen Victoria. Interestingly, labels in the Walker Art Gallery's examples of her work describe her as 'artist without hands' and assistant curator, Joseph Sharples, comments that these reproduce

what she herself wrote – 'it seems she wanted people to be aware of her disability when they looked at her pictures'. That could be borne out by a self-portrait within the collections of Nottingham Castle Museum (Figure 6.1).

The eighteenth-century Irish artist Sampson Towgood Roch, also a miniaturist, was described as a 'deaf-mute'. He was a successful portraitist, married into money and lived until he was ninety, defying modern stereotypes by leading a rounded, satisfactory life.

Hedgerow scenes by artist William Henry Hunt are also held in the collections at Nottingham Castle Museum. Hunt's uncle is quoted in *The Victorian Picturesque* as saying 'He was always a poor cripple, and as he was fit for nothing, they made an artist of him' (Snelgrove et al. 1968: 104). His studies were prized, he exhibited widely, John Ruskin became his pupil, yet we find him writing to a friend in 1863, 'If you are in town . . . perhaps you would help my nephew get me up the steps and stairs of the Royal Academy. I should much like to go there' (Roget 1891: 190) – a plaintive and dignified signal of frustration that the disabled person of today might easily recognise.

Colchester artist John Vine (Figure 6.2) was exhibited as a curiosity in a caravan when a child, during which 'performance, he executed small drawings before his rustic audiences' (Gurney Benham 1931: 2). In later life he married well and became known locally as Gentleman Vine, producing portraits and studies of favourite livestock and racing hounds for local customers.

The portraits of John Vine and Sarah Biffin radiate a striking self-confidence that is at variance with the common perspective of disability being treated, in the past, in a more primitive way. The powerful impression of strong personalities that they create may be explained by two views propounded by distinguished disabled theorists.

In his work *The Creatures That Time Forgot*, David Hevey cites the work of Vic Finkelstein:

> In the feudal, pre-Industrial Revolution period . . . 'cripples', as Finkelstein calls disabled people of this phase, were not separate from society. They were not segregated from society or their social class in any way that we would recognise today. They . . . formed a broad oppressed layer along with low-paid workers, the out-of-work, the mentally ill and so on, and there were broad overlaps within this group.
>
> (1992: 14–15)

John Vine and Sarah Biffin, with their direct, unoppressed stare towards us, may be responding to this acceptance and lack of separation. They may also be demonstrating a latter day discovery of David Hevey's own, described in his introduction, that 'I have yet to meet the disabled person who was not aware, more or less, of his or her oppression, and it was often the working through of the sitter's desire to fight back which gave many of the images their energy' (ibid.: 2).

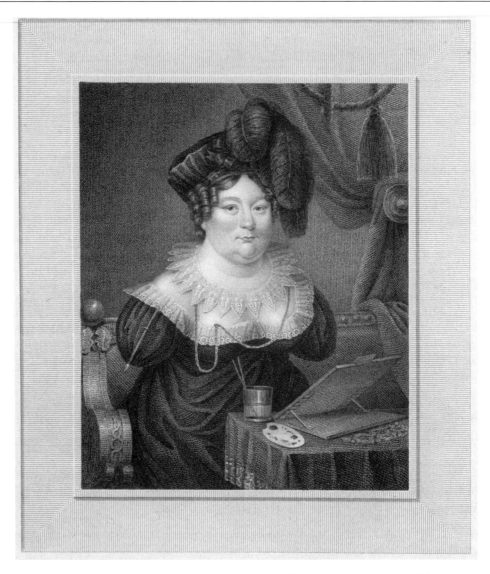

Figure 6.1 Sarah Biffin ('engraved by R. W. Sievier from a miniature painted by Miss Biffin'). By kind permission of Nottingham Castle Museum and Art Gallery: Nottingham City Museums and Galleries.

The undoubted energy of these self-portraits makes it possible for us to understand that these artists were disabled people, who absorbed their disability into their identity, whether or not it manifests directly in their work. Finding out that some artists are disabled is easy – they made a feature of it in their labelling, their way of marketing themselves. In other cases it is an accidental discovery triggered by research specifically on the subject. Catalogue entries of 100 years ago may mention a disability that is more recently forgotten. In some

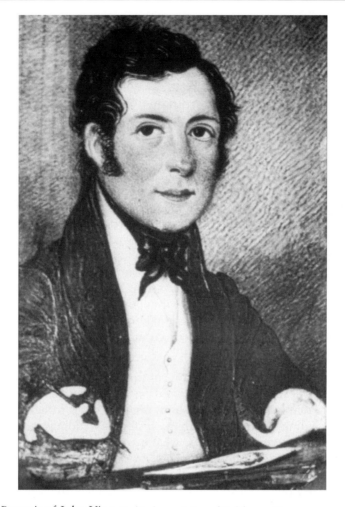

Figure 6.2 Portrait of John Vine. By kind permission of Colchester Museums.

cases curators find out 'by accident' that an artist was a wheelchair user, a deaf person or an amputee. The difficulty of finding out this information closes off a route by which disabled people could identify with artists who share some of their life experience, yet still curators hesitate to confirm, or tell, what they have learnt.

The debate needs to be progressed. How do you discuss the disability of artists without detracting from the work? Perhaps it should be a feature of labelling, perhaps self-portraits should be employed where they exist. Somehow it must be possible to identify where artists are people whose work is influenced by their disability. It is truly inspiring to any disabled person, becoming aware of their cultural and social identity, to find that all around them are examples of creative, successful people who also had disabilities.

Ordinary people

The story so far has concentrated on the extraordinary. What is most lacking is the story of the ordinary disabled person – neither talented, nor remarkable, but in everyday existence. Where are they? Where are the clothes they wore? The artefacts they used? How do we know they were there at all? There are a few clues – some decorative objects – many ceramic ornaments – show that the disabled beggars, musicians and street vendors were a common sight in the streets of Britain past.

In costume collections, there may be slight mention of why certain costumes are exceptionally small, or strangely tailored. A waistcoat at Platt Hall in Manchester appeared in *Costume* magazine because its unusual padding seemed to indicate a spinal deformity in the wearer and, during the course of this research, a curator at Carrow House in Norwich also found an example of a Spitalfields silk dress with a pleated arrangement that may have concealed spinal curvature. Otherwise there are very few recognisable examples of clothing worn by disabled people. There may be many reasons for that: self-selection by relatives unwilling to bequeath 'odd' clothing that exposes the family shame of disability; cautious curators of the past, who didn't accept gifts because they were difficult to catalogue and explain; cautious curators of the present, who may not display garments for the same reasons.

Another reason is hinted at by a London curator, who commented that it is only when costumes are measured or mounted on a mannequin that the fact that they have been adapted to individual body shapes comes to light. Undisplayed items could be hiding all sorts of disability history – weddings, parties, working lives and wealth. As with the heroes, wealth transcends disability. Fine examples of wheelchairs, canes and garments do survive. If you were rich and disabled, you could have craftsman-made aids and disguise your disability with tailoring. To bring these out of the archives and display them would celebrate the fact that there were disabled merchants and aristocrats in the corridors of power, as well as beggars and match or flower sellers in the streets.

The implications for museum practice

The novelty of this research means that there is no body of opinion on whether it is right or important to discuss disability in museum collections, no published works that provide the commentary upon which change could be founded. To move museum practice forward, it is not only further research into the impact of display on audiences, disabled and non-disabled, that is needed but also, within museums, changed priorities on exhibition programming and a greater willingness to take risks.

The evidence so far can only be anecdotal. However, these remarks taken from correspondence during the process of this initial research – all from Deaf commentators, who have progressed further in examining their cultural history

than the disability movement in general – suggest an important social role for museums.

> When you go to a museum you feel left out that this was all so long ago and not about you. When you see something made by a deaf person you feel connected.

> For a long time we had no history and now we're realising that we've got a history. It makes hearing people see us differently because we've got role models in the past.

> There should be more about Deaf in museums. Deaf people have an illustrious, albeit ignored history in all levels of society, art and science. Did you know the deaf man, Joseph Gawen, did the donkey work on the statue of Nelson in Trafalgar Square, whilst the man Bailey got all the credit?

> It is important to see deaf history and deaf people's story in museums so that deaf and hearing people can reflect on their roles within the community.[4]

Even in the absence of the body of evidence, however, there are curators who are meeting the challenge – taking the risk of representing disabled history in its own time, and with relevance to ours. Colchester Museums take the story of Anne Taylor as their starting point. Her son Isaac observed the process that made his sisters into two of the most popular children's authors of the nineteenth century.

> [My mother's] hearing being so far defective as to destroy her comfort in taking part in conversation, she had recourse to a book in order to prevent the social hours from becoming hours of silence. This practice . . . has in some degree enabled her to forget her misfortune in being shut out from free intercourse with her family; (and) to them has been directly and indirectly highly beneficial . . . in cherishing a literary taste, and in imparting . . . a great mass of information.[5]

To celebrate the effect Anne Taylor's reading aloud had on her children, Colchester Museums have taken Jane Taylor's nursery rhyme *Twinkle Twinkle Little Star* and are working with deaf people including a video-maker and an actress to create a sign language version of the poem for permanent display in their new gallery of childhood. Workshops, a video arts project and temporary exhibition have all resulted from this initiative. Deaf people are now coming to Colchester museums for the first time.

At the National Maritime Museum in Greenwich the true stories of astronomers John Goodricke and Konstantin Tsiolkowski have also been incorporated into a programme that has included costumed sign language interpretation of their work. The Deaf Astronomers club – which already existed – was the starting point for the project, which now extends into interpreted events throughout Science Week. London Deaf people place the Maritime Museum at the top of their list of successful museums.

95

What is the responsibility of museums in helping to create cultural inclusion for disabled people? In my opinion, it is time that museums were more proactive in looking for what their collections hold, digging out the information buried in the footnotes and reinstating the identity of the celebrated and ordinary disabled people in their purview. Disabled people should be brought into the museum and supported in understanding where they existed in the past, to reinforce their right to belong in the present. Non-disabled people should be informed, through clear, factual labelling and positive images, to see disabled people as having always been there – and often to society's benefit.

And does it matter, in a wider social sense? The children affected by thalidomide, for example, or other 'birth defects' seen to be created by human intervention, did not have the opportunity to learn, as I did during this research, that people with similar disabilities existed in the seventeenth, eighteenth and nineteenth centuries. Instead of being a medical blip of the 1960s, they could be seen as part of a historic and 'normal' range of variation. Their historic forebears achieved, created and were significant to other members of society. That kind of knowledge is essential in combatting a medicalising, dehumanising mindset and in letting everyone else know that disabled people are as much part of British culture as they are.

Notes

1 This poem from Cheltenham Art Gallery and Museums, entitled 'The Muffin Man' is attributed to Meyer 1866–70.
2 'Some time before his death he sold his body to Mr Omrod, a surgeon, for a weekly allowance who, after his death, made a skeleton of his bones, which . . . at present is preserved in [the museum] of the late Dr William Hunter at the University of Glasgow.' (Extracts from Cauldfield, J. (1797) *Memoirs of Remarkable Persons*, pp. 231–232, provided in personal correspondence by Hunterian Museum and Art Gallery, University of Glasgow, March 2000.)
3 The inscription, dated 1865, features in a catalogue entry supplied in correspondence from the National Museums and Galleries of Northern Ireland.
4 Private correspondence, March 2000.
5 Information supplied in private correspondence from Colchester Borough Council Museum Services.

References

Barnes, C. (1992) *Disabling Imagery and the Media: An Exploration of the Principles for Media Representations of Disabled People*, Halifax, England: British Council of Organisations of Disabled People (BCODP)/Ryburn Publishing.

Gates, W. G. (1900) *History of Portsmouth*, Portsmouth: Charpentier.

Gurney Benham, W. (1931) *John Vine of Colchester, 1808–1867*, Colchester Borough Council Museum Services.

Hevey, D. (1992) *The Creatures That Time Forgot: Photography and Disability Imagery*, London: Routledge.

Laurence, A. (1996) *Women in England in 1500–1760: A Social History*, London: Phoenix.

Morrison, E. and Finkelstein, V. (1997) 'Broken arts and cultural repair: the role of culture in the empowerment of disabled people', in A. Pointon and C. Davies (eds), *Framed: Interrogating Disability in the Media*, London: BFI Publishing.

Pointon, A. and Davies, C. (eds) (1997) *Framed: Interrogating Disability in the Media*, London: BFI Publishing.

Roget, J. L. (1891) *A History of the 'Old Water-Colour' Society, Now the Royal Society of Painters in Water Colours*, Vol. II, London: Longmans, Green, and Co.

Snelgrove, Mayne and Taylor (eds) (1968) *Watercolour Painting in Britain: Vol. 3 The Victorian Period*, London: B. T. Batsford.

Representing lesbians and gay men in British social history museums

Angela Vanegas

Few, if any, museums adequately represent the lesbians and gay men they serve and most fail to identify their contributions to society. One of the reasons for this exclusion is institutional homophobia. This chapter will look at some examples of positive representation within exhibitions, the difficulties faced by curators in achieving this and public reaction to displays. It will focus on a method of collecting material from lesbians and gay men that gives them control over their representation.

Lesbian and gay material in collections

In 1994 Gabrielle Bourn contacted twenty British social history museum departments and asked what lesbian and gay material they had in their collections (Bourn 1994). She found that Leicester Museums had Joe Orton's life mask and several had some ephemera and badges. In addition, the Victoria and Albert Museum had clothes collected for their *Street Style* exhibition. Only five museum services were actively collecting such material: Glasgow, Stoke-on-Trent, Hackney, Islington and Enfield (ibid.: 8).

Six years later, I contacted the same departments to find that little had changed, except that the Museum of London had taken in about fifty items from their *Pride and Prejudice* exhibition. Only Tyne and Wear Museums appeared to be actively collecting lesbian and gay material, as part of a larger contemporary collecting project called *Making History*. This year-long project will involve about 200 people, each of whom will be asked to donate five things that they feel represent their lives. Twenty of them will be gay, lesbian, bisexual, transvestite or transsexual.

And so, at the start of the twenty-first century, most British social history collections contain little or nothing to represent lesbians or gay men and few curators are doing anything to rectify the situation. The reasons they gave for this lack of action were diverse.

Some curators were content to borrow material from their local lesbian and gay archives. However, most of these are staffed by volunteers and are poorly funded. Even the largest may have a precarious future. Borrowing material in this way acknowledges the expertise of lesbians and gay men in collecting what is important to them, but many other minority groups are not left with the sole responsibility for collecting their own heritage. This begs the question, who do we think it is legitimate to include in our own collections?

Other museum staff said that they know that they have lesbian- and gay-related items in their collections, but they are not catalogued as such. Unfortunately, this knowledge is likely to disappear with the current curator. Enfield is one of the museum services listed as actively collecting in 1994 (Bourn 1994: 8), however, the current curator knows only of a lavender jumper and jeans worn by a gay man. In collections where contextual information is missing the lesbian and gay contributions remain invisible and might just as well not be there.

Several respondents said that many things in their collections could just as easily have been used in the everyday lives of gays and lesbians as anyone else and this may be true. Certainly, objects are not alive – they have no intrinsic sexuality – however, it is probably fair to say that their users will generally be assumed to have been heterosexual, unless the objects are explicitly connected with lesbian and gay life, such as Gay Pride badges. The history of objects has to be recorded or their real meaning is lost.

A few curators replied that they had material that could possibly be interpreted as lesbian and gay, and then mentioned items such as body-piercing jewellery or AIDS ephemera. The underlying message seemed to be that, because lesbians and gay men are defined by their sexuality, they can only be represented by objects relating to sex, an approach that denies other aspects of gay and lesbian culture. Whilst lesbians and gay men have much in common with everyone else – most gay men are more likely to use a steam iron than a cock ring – there are, nevertheless, often distinct dress codes and meeting places, tastes in music and literature and so on. In summary, many museum staff appear confused about who should collect gay and lesbian material, how to record it and, indeed, what it might be (Figure 7.1).

Collecting lesbian and gay material in Croydon

In 1995, Croydon Museum and Heritage Service, part of the local authority, opened *Lifetimes*, an exhibition about the lives of local people from 1830 to the present day. In *Lifetimes*, we aim to represent all types of Croydon people to create a more complete impression of the past. In addition, all types of people pay for the museum service through local taxation and thus deserve a service that represents them, whether they choose to use it or not. Most of our exhibits were collected from local people. We recorded interviews with them about what these belongings represented in their lives. These interviews formed the bases of short stories interpreting the exhibits on touch screens in front of the displays.

However, few interviewees identified themselves as lesbian or gay and those that did were not visible as such in the exhibition.

At the time we were collecting this material, Croydon Council's Equal Opportunities policy excluded lesbians and gay men. Indeed anecdotal evidence suggested active institutional homophobia. However, by the time *Lifetimes* opened, Labour controlled Croydon Council and one of the first things they did was to widen the policy to include sexuality. So, when we began collecting to update *Lifetimes*, we chose to conduct special projects with lesbian and gay men. This was partly because lesbians and gay men made up an estimated 12 per cent of the population (Wellings et al. 1994: 193); about 40,000 men and women, more than any local minority ethnic group. However, we were also spurred on by a comment from an early visitor:

> I very much enjoyed the exhibition and its presentation. However, there is no mention of the gay community in the exhibition – the CHE [Campaign for Homosexual Equality] group in the 1970s was the strongest in London and the focus of much activity – as ever we remain invisible.

Jon Brown, a member of the museum staff, chose to interview gay men. Rachel Hasted, then a freelance consultant, now the head of our service, was recruited to research lesbians. As with previous collecting projects with Irish, African Caribbean and South Asian people, we felt that it was important to use researchers who belonged to the groups they were investigating; people who talked about 'us' rather than 'them' when referring to their interviewees. Jon Brown said that, without the common bond, his interviewees would not have opened up. He was in tune with what subject areas to cover and could share experiences where relevant. He felt he could also operate at the appropriate level of questioning, for example when asking about sex. Rachel Hasted felt that there were some important advantages in stressing this shared identity. Respondents felt she would be sensitive to their needs for confidentiality since some of them were not 'out' in all areas of their lives. She also thought that few heterosexual researchers would have been able to contextualise what they were told and formulate follow-up questions (Hasted 1996: 10).

However, Rachel Hasted pointed out that she did not necessarily share the same identity or values as lesbians from other ethnic groups, cultural and class backgrounds. For example, some of the older women she interviewed had a fondness for the place of butch/femme role-play in lesbian culture. They identified her correctly as active in the 1970s feminist groups, which were strongly critical of role-playing, and were, as a result, somewhat defensive. She also felt the practice of hiring specialist staff also protects museum staff from directly confronting differences between themselves and parts of the community they serve (Hasted 1996: 6).

Between them, our researchers interviewed eighteen people. They found their interviewees through Croydon lesbian and gay groups, other interviewees and their own contacts. Both were asked to try to get a diverse sample. The interviewees' ages ranged from 18 to 85, four of them had disabilities and they

included Irish, Jamaican and Anglo-Indian people. Half of the women had children. The interviewees were pleased to have a voice in the exhibition, but worried about how they would be represented. They were concerned that they might be stereotyped. Some of the gay men were at pains to point out that they were not child molesters. A few preferred to remain anonymous. They included a lesbian social worker, who felt that clients might use her sexuality against her because she deals with child abuse cases. A young gay man chose to remain unidentified because his parents had not yet come to terms with his sexuality.

Jon was very positive when he started the project, but as the project progressed he became depressed about the persecution the men had suffered and how badly it had affected their lives. One man in his eighties had never recovered from the homophobic bullying he received as a child. Jon felt that he had not suffered so much from homophobia himself, but the interviews still brought back a lot of painful memories. Rachel felt that, on the whole, the women's stories were very positive, though some had experienced terrible discrimination. One of them had even been put into mental hospitals several times in the 1970s because of her sexuality. However, the women also told stories about resistance and lesbian support networks that had helped them survive.

Both Rachel and Jon used life story interviewing to uncover the memories and belongings important to the interviewees themselves. The interviewees were asked about their lives in chronological order and at each stage they were asked if they had any belongings left that they would be willing to lend for display. They were not interviewed exclusively about themes related specifically to their sexuality. This practice allowed respondents to emphasise those areas of their lives that they felt most interesting or important (Figure 7.1). One woman chose to lend us objects representing her childhood in Jamaica, her teenage attempt to become a nun and her later battle with Crohn's disease.

Most of the objects located in this manner belonged to the post-war period. However, there were, of course, lesbians and gay men in Croydon from much earlier times. We needed to represent them, both to show lesbians and gay men that they have a long history in the area and to demonstrate to the majority population that homosexuality is not just a modern phenomenon. A solution was found by including a copy of Havelock Ellis' 1896 book *Sexual Inversion*. This was the first book in English to argue that homosexual behaviour was not a crime or a disease. Ellis believed that people were born homosexual. He had lived in Croydon as a young man and the book included information on Edith Lees, who had lived in nearby Sydenham, and who was a model for his construction of the lesbian.

The connection between the objects collected later and the lives of their owners will be made in stories on touch screens in front of the displays. All the stories will be based on their recorded memories. Although the researchers selected excerpts from the interviews in writing these stories, the interviewees had to approve them and often made changes. It was critical that they had control over their representation.

Figure 7.1 A selection of objects collected to represent the lives of lesbians and gay men in Croydon. By kind permission of Croydon Cultural Services.

In the stories, it was important to show that gay men and lesbians have had varied experiences. Lesbians talk about being a nurse as well as having babies by artificial insemination, gay men about acupuncture as well as gay activism. Since sexuality is only one aspect of a person's life, the stories only mention it where it is appropriate. For example, one story describes one woman's experience of work and the workplace:

> Meg Williams of Thornton Heath grew up in Wales. 'My father built his own house, which I helped him to do and that's where I got my interest in construction.' When Meg left school in 1969, she worked in a shop. 'Had it been easier for women to get into construction, I would have gone straight into training, but the only options were to be a hairdresser, a factory worker or a shop assistant.' Soon after Meg moved to London in 1981, 'Lambeth Council introduced a new scheme taking on adult trainees, some of whom were to be women. I applied and got a traineeship. It wasn't easy, because I was the only woman electrician, although they did have women carpenters and painters. Some of the men were OK, some were absolutely hideous. There was a man who refused to refer to us as "she" and said, "If you're doing a job in construction, then you must want to be a man. I will call you "he" at all times." Three of us brought a Sexual Harassment case against him. He was dismissed and that led to us being sent to Coventry. The final two years of my apprenticeship were hell. Out of the six women who started with me – only two of us finished our apprenticeships. I had quite a lot of time off towards the end due to stress. But nevertheless I became a qualified electrician.'

Likewise, only some of the exhibits, such as the Campaign for Homosexual Equality newsletter, are visually indicative of sexuality. Most, like a lesbian electrician's drill, are not. Consequently, there is a danger that the lesbians and gay men will become invisible within the exhibition. We hope to avoid this by enabling people to search our database under the terms 'lesbian' and 'gay'. We may also use free pamphlets identifying the lesbian and gay contributions to *Lifetimes*.

It is hoped that these stories will prove to be effective tools for addressing the discrimination and inequality that lesbian and gay people may experience. In her account of the project, Rachel Hasted wrote that, in these stories,

> exhibition visitors can be challenged in their assumptions and prejudices . . . they are confronted with human beings, not with stereotypes, people speaking with strength, humour and pathos, anger about recognisable human situations . . . Over 300 voices in the gallery offer their accounts of the past with the authority of personal experience . . . within this context, lesbian and gay experience can be presented not as an anomaly, but as one aspect of complex lives.
>
> (1996: 5)

By including lesbian and gay stories within a broader historical exhibition, sexuality can be seen within its wider social context.

Lesbian and gay material in temporary and permanent exhibitions

In 1994 Gabrielle Bourn also asked whether the museums had held any temporary exhibitions of lesbian and gay interest in the last ten years. She recorded eight in total, including *Vera the Visible Lesbian* and *The Hall Carpenter Archives* at Bruce Castle Museum, an exhibition about Joe Orton in Leicester, *Street Style* at the Victoria and Albert Museum, *Love Stories* and *Fighters and Thinkers* in Islington, *Glasgay* in Glasgow and *Positive Lives* in Bradford (Bourn 1994: 10–11).

Since then, I have recorded thirteen others. Most were exhibitions on broader topics that included some gay material. These included *Dressing the Male* at the Victoria and Albert Museum, *Surrealism* (the collection of the gay connoisseur Edward James) and *Fetishism* in Brighton, some ephemera in *North East Communities*, a Tyne and Wear touring exhibition, Joe Orton's life mask in a display of museum treasures in Leicester and a very poignant account of gay love accompanying a memorial bow in *Every Object Tells a Story* at Nottingham Castle Museum.

In several temporary exhibitions, gay men appeared in the context of AIDS. They included an exhibition on health at the Science Museum, an AIDS memorial quilt in Leicester, *Brenda and Other Stories* at Walsall and Nottingham Castle Museum and *Graphic Responses to AIDS* at the Victoria and Albert Museum. It might be argued that museums prefer to relate to gay men as victims, a stance they can justify as part of their community role in promoting health education. However, the real danger occurs if this is the *only* place in such institutions that gay men are represented, when the implied message is that gay men are sick and they are sick because of their sexuality.

Only three temporary exhibitions were about gay and lesbian topics per se: *Pride Scotland* in Glasgow and photographs of London Pride at the Museum of London were relatively small scale. However, *Pride and Prejudice* in 1999 was the first comprehensive exhibition about lesbian and gay history in Britain. Part of the *Capital Concerns* series at the Museum of London, the displays were close to the museum's entrance, located where every visitor had to pass them by. The exhibits dated from Roman times to the present day. There were telephones with oral history extracts and folders with information about contact groups and campaigning organisations. Visitors were directly engaged by a computer questionnaire asking 'What's Your View?' on questions like 'Do you think that lesbians, gays and heterosexuals should be equal under the law?' (Burdon 2000: 13).

Lesbians or gay men curated at least a third of the temporary exhibitions, to my knowledge. However, it is unfair for a sole lesbian or gay curator to be 'the keeper of the conscience' (Bourn 1994: 4). If gay and lesbian staff are the driving force behind such exhibitions, they are often under a great deal of pressure. One gay curator wrote to me about mounting an exhibition about the local connections of a gay author. The only reference to the author's sexuality

was a single label saying that one of his novels was about gay love. The curator felt that he worked in 'a very conservative town and did not want his first exhibition to be seen as a militantly gay one'. He had clearly thought about the issues in depth, but felt vulnerable. Such concerns serve to remind us that there is currently very limited legal protection against homophobia in the workplace.

Bourn also asked museums whether their permanent galleries included lesbian and gay history. At the time none of the museums did, but Glasgow and the Museum of London planned to do so (Bourn 1994: 11).[1] Today, there are more examples but these are few in number and relatively small scale.

Barriers to inclusion

Overall, more lesbian and gay material has been displayed in the last six years than the preceding ten, but the vast majority of social history museums have still done little or nothing to include lesbians and gay men in their exhibitions. Some museums have excluded gay and lesbian material in response to real or imaginary local authority pressure. About two-thirds of museums in England and Wales operate with local authority funding (Hasted 1996: 1). Section 28 of the Local Government Act 1988 specifically forbids such authorities to 'promote homosexuality' or 'promote the teaching . . . of homosexuality as a pretended family relationship'. Although no one has been prosecuted under this clause, it is a convenient tool that can be used by homophobic councillors (Bourn 1994: 16).

However, most museum staff have not even attempted to portray lesbian and gay history; Section 28 has protected curators from having to deal with the issue. Some curators spoke of possibly losing jobs or funding, but many had not even identified it as an issue. Others said that they could not represent lesbians and gay men because they have nothing in their collections. Needless to say, these were not the ones who were actively collecting. Several were afraid of complaints from their existing audiences and felt that sexuality was not a suitable topic for a family audience. And yet, social history museums have long been comfortable representing sexuality through objects such as valentines and wedding dresses. It has even recently become acceptable for museums to display objects relating directly to sex itself. However, this is generally only tackled where the exhibit reflects the sexuality of the majority.

Some museums prefer to ignore, or even lie about, the sexuality of the people they represent. At Shibden Hall in Halifax, the sexuality of its celebrated Georgian owner, Anne Lister, was ignored until the appointment of a new curator in 1990. A few years later, I attended a dramatisation of the life of Lord Leighton at his Kensington home, which stated that he never wed because he was married to his art! Even people who are aware of the issues may practice self-censorship, assuming opposition where there is none. In Croydon, we initially wrote a convoluted script about the lapse in faith of a lesbian nun, before telling the true tale of how she left the convent after she found her lover in bed with a priest

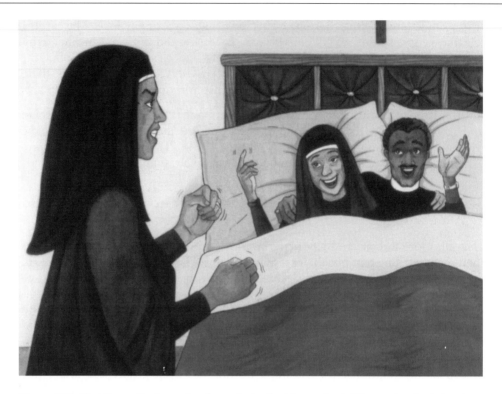

Figure 7.2 'Dahlia walks in on her lover in bed with a priest' (illustration by Maggie Raynor). By kind permission of Croydon Cultural Services.

(Figure 7.2). However, when we passed the story to the head of department for approval he made no comment. It is a form of institutional homophobia for curators to use their power to exclude, or make invisible, lesbians or gay men, whether or not it is done purposefully.

And yet, what are we afraid of? Those museums that have mounted exhibitions including lesbian and gay history have not been prosecuted and hopefully Section 28 will shortly be repealed. Also exhibitions of lesbian and gay interest have mostly been well received by visitors. At the Museum of London, 95 per cent of all visitors answering the *Pride and Prejudice* questionnaire thought the museum was right to stage the exhibition and 87 per cent agreed that lesbian and gay history should be integrated into the museum's permanent displays (Burdon 2000: 14).

Museums, because they are perceived as delivering an authoritative account of history, can play a unique role in promoting inclusion. To the heterosexual majority, they can say 'here it is, the material evidence before your very eyes'. To gay men and lesbians, they can say 'your lives count'. As one of the visitors to the *Pride and Prejudice* exhibition commented:

> It's nice to be recognised as being part of society – as real human beings.

Initiating lesbian and gay exhibitions: the experience at Croydon

Logistical difficulties in updating the touch screen interactive displays within *Lifetimes* resulted in delays to our plans to fully integrate the stories we had collected within the exhibition. To avoid disappointing our lesbian and gay contributors, we decided to mount three temporary art exhibitions: *Communion*, photographs by Rotimi Fani Kayode 'bridging the worlds of Nigerian spirituality, Western materialism and homoerotic desire'; *Ain't Ya Hungry?*, work by lesbian photographers that played with fantasy images of lesbians from cowgirls to Hollywood starlets; and *Dyke's Delight*, paintings from our own collection, chosen and captioned by local lesbians. The head of our department was very supportive, but we had to obtain the approval of the elected councillors – as we did for all our exhibitions. This was usually a formality.

In the event, though most councillors were in favour, several were strongly opposed to the proposed exhibitions. We were asked to submit, for approval, all the text for the exhibition and its publicity several months in advance – something we had never before been asked to do. After some months, the council's legal advisers decided that the exhibition contravened Section 28 of the Local Government Act 1988 and could not, therefore, take place. However, one of the representatives for the local Lesbian and Gay section of UNISON, the public services trade union, was outraged by this decision and asked for a meeting with senior officers. She pointed out that Section 28 had never been enforced and that the official view of the current central government was that it was a discriminatory piece of legislation that needed to be repealed. The officers wondered if the exhibitions could go ahead with the words lesbian and gay removed. The union representative countered that the very purpose of these exhibitions was to celebrate the achievement of the gay and lesbian contributors and to make them visible. She argued that, instead of focusing on the concerns of a bigoted few, they should acknowledge the rights of an oppressed group and have the courage to be their champions. As a result, the exhibitions went ahead – uncensored.

Even if we had not been successful, the process of fighting to mount these exhibitions had, in itself, been worthwhile. Many of our staff had not witnessed homophobia in action before. It raised their consciousness and we now consider lesbians and gay men as people to be represented in, and customers of, everything we do. Hopefully, the exhibitions have also raised the expectations of local lesbians and gay men.

We also demonstrated that terrible things will not happen if lesbians and gay men are represented in exhibitions. We weren't prosecuted under Section 28 and most comments were complimentary. The total public backlash consisted of eight homophobic or racist comments, plus a few suggestions that children should not have been allowed in because of some nude photographs. What our opponents had been scared of can be summed up in a single visitor comment:

> I took my children into this exhibition and was very surprised to be confronted by a penis. My children thought it was a giggle. I didn't.

Surely such objections do not constitute sufficient grounds on which to continue to exclude lesbians and gay men from museums?

Postscript (by Rachel Hasted and Jon Brown)

Delays in updating *Lifetimes* still persist but we are working with a company to finalise our plans for sustainable multimedia that we can edit and update ourselves. Recognising that the delay in integrating the results of our research project into our exhibitions was stretching out far too long, the museum service decided to create a temporary exhibition based on the life stories we had collected.

Celebrate opened in *Lifetimes* on 8 June 2001. The exhibition can travel and we hope that it will later be displayed in other local venues. It includes panels linking the material we collected with the themes and periods of the main *Lifetimes* displays. There are illustrations of the respondents or their stories and quotations from the oral history material, which is available on listening posts. Objects lent by the respondents are displayed beneath each panel with labels putting them into context. The exhibition is being publicised through our Local History Weekend, a promotional flyer and targeted press release to gay and lesbian media. There will be a late-night opening to coincide with a performance by lesbian duo Martha and Eve and the exhibition will remain on display throughout Croydon's *Croydi-gras* season of lesbian and gay film and live events.

In relation to policy developments, Section 28 is still with us but we welcome the recent publication of *Supporting Inclusive Communities – lesbians, gay men and local democracy* by the Local Government Association. This sets out the current position on the Human Rights Act and Section 28 of the Local Government Act 1988 and recommends that, 'in framing their policy on Section 28, authorities should explicitly consider the human rights implications of their decisions' (2001: 26).

The guidance of this document is that councils may support cultural activities such as exhibitions with a lesbian or gay theme, 'unless it can be shown that they are primarily designed to encourage their audience to become homosexual or have homosexual relationships' (ibid.: 26). This document should relieve all elected councillors of any concerns they may previously have felt over their responsibilities under the Local Government Act 1988.

Croydon will be evaluating *Celebrate* and learning from that in developing further interpretation of the social and cultural history of sexuality in the museum.

Note

1 Since Bourn's research, these museums' plans have come to fruition. The People's Palace have an interactive tenement block where different occupants, including a gay man, talk about themselves. The Museum of London has included a number of gay badges on a denim jacket in its post-war gallery. The other contributions are similarly small scale such as the lesbian tour on the *My Brighton* interactive, some flyers in Stoke-on-Trent and two items in the 1980s and 1990s section of the *Great City* in Tyne and Wear.

References

Bourn, G. (1994) 'Invisibility: a study of the representation of lesbian and gay history and culture in social history museums', unpublished MA dissertation, Department of Museum Studies, University of Leicester.

Burdon, N. (2000) 'Exhibiting homosexuality', *Social History Curators' Group News* 46: 13–15.

Hasted, R. (1996) 'Lesbian lifetimes: an oral history project for Croydon Museum Service', unpublished MA essay, University of Essex.

Local Government Association (2001) *Supporting Inclusive Communities: Lesbians, Gay Men and Local Democracy. Guidelines for Local Authorities*, London: Local Government Association.

Wellings, K. et al. (1994) *Sexual Behaviour in Britain: The National Survey of Sexual Attitudes and Lifestyles*, London: Penguin.

8

Remembering ourselves in the work of museums: trauma and the place of the personal in the public

Gaynor Kavanagh

Calls for museums to become inclusive, to contribute to the enhancement of the quality of life of individuals and to broader social change are growing stronger. Whilst there is a growing body of literature to attest to the positive impact that museums can have on individuals' lives, there is also need to consider the responsibilities and ethical issues that accompany the museum's social role. This chapter explores these issues through focusing on the museum's relationship with personal memory.

Most museums aim to be tidy, highly organised places. They operate through systems and structures designed to maximise their ability to reach set goals. The study of museums seeks to buttress this, being substantially devoted to the examination and, wherever possible, increase of their effectiveness. Neat theories, succinct strategies and diagrammatic logic offer forms of salvation. Enlightenment is held out in whatever new idea is current. In this, museums are not dissimilar from many other forms of public institution. But there is a major problem here. In all that they do, museums are people dependent; yet they have difficulty predicting with a high degree of accuracy how people really respond. It renders them vulnerable in their relationships with staff, visitors, donors and the people with whom they work in a research or outreach capacity.

Much of the available thinking rests on broad notions of people in social groups, cultural categories or definable communities (compare for example, Davies 1994, Hooper-Greenhill 1997, and Merriman 1989 with Rosenzweig and Thelen 1998). But such broad ideas are constantly disrupted in day-to-day practice by the anomaly, the variant, the essential unwillingness of people to conform to stereotypes established by others. As individuals, we have the ability to be everything we are expected not to be, leading to actions and reactions that confound the best-laid assumptions. This is not to argue against the substantial influence of cultural structures and socio-political conditions on fundamental ways of being and believing. It is however to make the case for the recognition of highly complex personal worlds and their engagement with museums. When museums, even quite sophisticated ones, are unwilling or unable to provide

such recognition, they may disappoint, at best. For them, the stereotypical visitor somehow fails to turn up; the stereotypical farmer, miner or housewife in the displays never existed, so nobody 'knows' them; and the objects on display, meant to be so provocative to reminiscence, become as cold as the response they receive.

Understanding something of the personal within the public can be achieved, but it requires very different ways of thinking and feeling. Intellectualising and problematising, however important, are simply not sufficient in themselves. They need to be accompanied by a kind of emotional literacy, an ability to work sensitively and astutely with the thoughts and feelings of others. Memory is the pivot of the personal. Self-definition, identity and a sense of well-being hinge directly on it. Museums touch memories in all that they do: history museums could not build collections, conduct outreach and present galleries without them. For this type of museum, to some degree, the shift has been from object-centred to people-centred ways of working. But the shift has been pragmatic and little prepared for; at times it is highly precarious, at others it results in major breakthroughs and radical shifts in museum practice (Ames et al. 1992; Dubin 1999; Fleming et al. 1993; Leon and Rosenzweig 1989; Kavanagh 1990, 1996).

When museums actively engage with the personal, what is discovered is that the work is neither straightforward nor anticipated – just like memory itself. Working with memories implicitly means working with emotions, with the past, present and the future. It is not easy. Anything is possible, from the unforgettably funny, to the totally heart-breaking, and much in between. Ethical responsibilities are not lightly avoided here. Such work tests the limitations as well as the potential of museum professionals and museum practice. It forces difficult questions. It exposes the dangers of 'do-gooding', surface-level only, generality-driven notions of museum practice. This is never more true when memories of trauma are stimulated; when this occurs nothing less than a serious reassessment and, if need be, realignment of museum work is required.

Memories stimulated by museums: three case studies

The following three situations have touched on memories of trauma, and the feelings of loss and sorrow that come in its wake. They are introduced here to illustrate something of the very personal aspects of remembering that can take place in the work of the public museum. They are drawn from the recording of oral testimony, reminiscence activities and the experience of the visit.

Oral testimony

This is an extract from an interview conducted in 2000 between George Scott and Monsignor James Kelly. It is a record of Monsignor Kelly's memories of the night in April 1942 when the presbytery of St John's Roman Catholic church took a direct hit during the bombing of the city of Bath. Four people

died in the presbytery; over 400 were killed in the city as a whole during the April raids. Monsignor Kelly was on fire-watching duties on the night the presbytery was hit. The interview was undertaken as part of a larger project on the civilian and municipal responses to the Baedeker raids of 1942.

George Scott: What happened the second night [of the bombing], Monsignor?

Monsignor Kelly: I think it would have been about midnight when they arrived. There were three of us in the presbytery. There was a window that looked out on to the roof of the church and we were actually trying to keep an eye out, though what we would have done if the incendiary bombs would have come down, I don't know. But we were watching for incendiaries on the roof of the church. Canon Hackett was the parish priest at the time. He was round on the north door, keeping an eye on that side. There were a lot of bombs dropping and a lot of damage done before we were hit. And we could hear the planes going out up towards Sham Castle and coming in for their run. We were very badly shaken, a lot of damage done, in and around our area.

There was another priest [Father Timothy Sheridan] with me and he said 'you had better give me absolution' and I gave him absolution, and then I said 'you can do the same for me'. He pronounced absolution and those were the last words he ever spoke. The next thing we heard was this bomb. They say you don't hear the one that hits you – but I can assure you we did, and it came down. The feeling I had distinctly at the time, and I have thought of it since, was like being on a railway line with a train coming at you, and this came! Father Sheridan was standing by the window, looking out on to the roof of the church, that whole area – there was a corridor between that, running into the church – it simply disappeared and he went. I was standing clear of it with another fire-watcher, an Irishman, and when we heard it coming we went down, facing towards it. I was wearing a tin hat and the top of it – it would have been a glass splinter, but a small piece, went through and cut me on the knee. I didn't notice at the time.

Canon Hackett came running from where he was at the north door, saw the whole place completely demolished and he never thought anyone could have survived . . . he shouted out 'are you all right?', and he said . . . the relief when he heard a voice coming back! The awful thing was that there were people in the basement, our housekeeper Catherine Keegan and a woman who had come in and the daughter's infant. We thought that was the safest place. It was a basement kitchen, but I suppose the blast of the bomb simply pulled the joists out of the wall and they simply came down in three storeys and simply buried them.

Reminiscence work

A museum worker sets up a reminiscence session for women living at a local residential centre. This week the theme will be children and motherhood. The museum store is raided for whatever objects of relevance it may hold. Care is taken to include only that material likely to be in period with the women's experiences. A structure for the session is worked out in advance involving handling and responses to the material. For the women in the group, this is the second session. Themes have not been discussed in advance; each one is a kind of surprise. The museum worker has no experience or training in this area, and has not discussed the work with anyone in the centre.

The introduction for the session involves each woman in turn being asked to say how many children they had and what were their names. Each woman is addressed by her first name. As this naming proceeds, one woman in the group tenses and begins to look really uncomfortable. When her name is called and she is asked to say how many children she had and give their names, her response is simple – 'I had one, a daughter, and she was still-born'.

The visit

The third situation relates to memory within the visit and was described to me by the then curator of the Kohima Museum, Robin McDermott. The town of Kohima sits just outside the boundary of Northeast India and was of major strategic importance during the Second World War, as it was seen as the gateway to the Indian subcontinent and therefore the heart of the British Empire. The action that took place there in April and May 1944 involved the British 2nd Division in a pitched battle with the Japanese Army's 31st Division. The fighting was hand-to-hand. Many of the wounded, dead and dying lay intermingled on the battlefield, their evacuation hampered by both the terrain and the nature of the fighting.

The museum came into being through the donations of the men who served in Kohima. It is a small regimental museum, open principally to Kohima veterans. On the fiftieth anniversary of the battle, a larger number attended the reunion at the museum than usual. Among them were a veteran and his wife attending the weekend's activities for the first time. As they were leaving and her husband was in conversation with someone at the entrance, the wife had an opportunity to slip back to speak with the curator and thank him. She explained that in the whole of the fifty years since the battle her husband had not spoken anywhere near as much about his experiences as he had done during their visit to the museum. She had learned more about what he had gone through than she had ever been privy to before. The visit, coupled with the opportunity to talk with other veterans, appeared to have lifted a burden from him. He seemed to be quite relaxed when recalling his experiences, whereas hitherto he had been ill at ease when the war in the Far East had been raised in routine conversation. For the veteran's wife, the visit to the museum had been a catalyst, acting on her husband and other veterans in a way that no other environment or setting could have done.

For the people involved in each of these three situations – experiencing oral testimony, reminiscence work, and a visit – the personal in the public was very real. They found themselves in circumstances unlike any other, ones in which memories were stimulated and brought to the surface in very specific ways. There they had to be managed, dealt with and explored in the best way deemed fit. It was not my intent to delve further into each, but instead to allow them to stimulate us into thinking about the impact such remembering might have had upon the people concerned, not just at the moment of recall or in its immediate aftermath, but later, maybe much later.

The scar tissue of trauma

Memories are like scar tissue: they stay with us through life. We can hide them, cover them up, deny their existence or disguise them as something else – but they are there nevertheless. Layer by layer they are laid down as the wealth of experience increases through a lifetime. They are settled and encoded in our minds, capable of return when cued or prompted. Things seemingly forgotten can rise to the surface, unbidden, if the context of recall is stimulating and appropriate. We use them to communicate with others and to define who we are. Their recall needs to be carefully mediated, as our self-esteem rests upon their backs. Memories are disclosed in many ways; taking the form of words, sounds, body language or silent recognition. They can survive the most severe of circumstances including the physical, and sometimes emotional, dispossession that accompanies some forms of institutional care. Memory loss, severe impairment or denial – leading to refusal, inability, or the lack of occasion to respond to stimuli – are devastating, creating a vacuum, that can result in the collapse of identity or the onset of depression, delusion and illness (Conway 1997; Groeger 1997; Kavanagh 2000; Rose 1992).

The study of trauma in recent years has been concerned with understanding something of memory impairment; that is broken memories, recovered memories and false memories. Controversies surrounding memories of sexual abuse in childhood revealed in certain types of psychotherapeutic situations have added impetus to the research. It is a highly-charged area of debate. Nevertheless, it has raised questions about how memories are laid down, the effects of trauma, the accuracy of memory of traumatic events, the circumstances that prompt recall, and the degree to which people with traumatic memories are vulnerable to suggestion (British Psychological Society 1995; Campbell and Conway 1995; Conway 1997).

The benefits of talk about trauma, especially within the immediate aftermath of the event, are now open to question. A transition in thinking is taking place. Post-traumatic stress counselling, where it exists at all, has tended to be applied as early as possible following the trauma. It is now questioned whether immediate talk about the past can do more harm than good. A trauma can provide just too much to process within a short period of time. Physically and mentally, people may not be equipped to recount something that their brain has not fully

assimilated as a memory. This, however, may vary; that which may be urgent and necessary for some, may be better left to another day for others. More sophisticated and discerning practices are being developed as a result, both in the early stages of trauma and over the longer term as its consequences are played out.

Museums are more likely to be involved with people who have already created some form of coping strategy with whatever has gone before in their lives, than with those who are in the early stages of dealing with a traumatic memory. The ways in which memories of the trauma were processed and laid down at the time will influence later recall, in such circumstances as a museum may provide. Where the person was unsupported in their experience of the trauma, as is the case with some war veterans, or unable to cope over the long term with its effects, then the recall of events in much later life can be especially difficult. In the work that museums do, contact with such memories hinges substantially on their articulation, on people being prepared to say things out loud – in the interview, reminiscence activity or within the visit. Part of the management of traumatic memories can be the active avoidance of those situations likely to promote recall or distress. The woman who has miscarried may choose never to visit Mothercare, the person who has lost a relative in a train crash may choose not to travel by rail, the war veteran may choose not to visit his regiment's museum. It follows therefore that people prepared to articulate their memories in the museum context are, to a degree, self-selecting. At some point, they have questioned, however momentarily, whether they want to do this, whether they can face the past, whether they are prepared to share something. This does not mean that they are totally prepared for what may transpire or the feelings that may result. But it does mean that museums are more, rather than less, likely to be operating with people who have come to terms with aspects of their past, sufficient to render themselves vulnerable within a context of recall.

In general terms, talk about the past seems to suit some people better than others. For many people it is welcome and comforting. It provides a currency for communication. This may be especially so for people living in isolation, experiencing the sense of loss that accompanies life in institutions, for example within long-stay wards, hospices or residential homes. Yet for others, reminiscence may be painful and unnecessary. In the worst of situations, when difficult memories are forced out or unwittingly disturbed, recall can be highly disruptive to carefully constructed means of coping that have hitherto stood the test of time. Social gerontology has sought to emphasise that people build and use their memories in their own individual ways. Talk about the past has functions and purposes that are linked to individual life experience and current situations. People choose to remember because of who, what and when they are (Bond et al. 1993; Bornat 1994; Coleman 1986).

Tom Kitwood (1990, 1992 (with Benson), 1995, 1997) crafted the notion of personhood to remind care workers of the rights of any individual *to be who they are*, not patients but people with thoughts, feelings, abilities and life

115

histories. It follows that working with memories in museums must have the same notion of personhood embedded at its core. It is a means of ensuring that only appropriate, special and permitted approaches are undertaken.

Traumatic memories and the museum

In general, museums are no more likely than any other environment to prompt recall. A visit to the supermarket, the discovery of an old sock at the bottom of a drawer, a walk in the park, the sound of distant thunder or a car backfiring are as likely to precipitate memories in some as would a visit to an art or natural history collection. These things are impossible to second guess. For example, memories of people for whom we grieve may be found in the most ordinary of things, but they may also lie in the paintings, fossils, silverware – just about any-thing – a museum may (or may not) display. These are individual matters that are difficult, but not impossible (as in reminiscence work) to predict.

Some things however can be reasonably well assumed. History museums have a responsibility to bear witness to the past, however difficult that past may be. Exhibitions on wars, civil conflict, apartheid, political suppression (in whatever form it has taken or now takes), discrimination and social injustice remain legit-imate to the history museum's agenda; indeed, the integrity of the institution rests on its ability to be honest, dignified and courageous. Both the content of exhibitions on topics within these areas and their reception are bound to involve difficult feelings for many, directly or indirectly. This can be thought about and prepared for, without undermining the exhibition or diminishing those who contributed to it, as was the case with the Holocaust Museum in Washington DC (Linenthal 1995). Acceptance has to be given to the sorrow and pain that accompany them. Indeed, greater difficulties occur when appre-ciation of the wealth of feelings and identity claims associated with a subject are misunderstood, or even worse, simply missed, as arguably was the case with the redisplay of the Enola Gay at the Smithsonian Institution in 1995 (Dubin 1999; Harwit 1996; Wallace 1995; Zolberg 1996). In such situations, the results for the museum can be disastrous, but equally they can be incalculable for those affected by them.

We live in a society damaged by wars and their after-effects, one in which hate continues to fuel discrimination and fear limits the ability to change or accom-modate other ways of thinking. However prosperous and forward moving it may be, the abilities to put the past into perspective, or leave it behind, and live tolerant lives are not universally shared. It is gratuitous and patronising to argue that museums have a major mission here, but it is possible to suggest that there are definite contributions that can be made. Museums and their collec-tions could well be of value to those dealing with difficult memories and to those who seek to help them.

Work with war veterans is a case in point. The official approach to traumatic stress within the forces appears to have been fairly light on acceptance. The expectation that salvation resides in the stiffness of the upper lip and the

manliness with which difficulties are faced is deeply encultured. Counselling is often scorned. The necessity of support is ridiculed, even though research on the psychiatric care of war veterans and on the case histories available has a lengthy pedigree. Work on the effects of the Vietnam War on American veterans, in particular, is considerable. However, slowly, appreciation of the psychiatric well-being of the combatant and the veteran is gaining ground.

Veterans from conflicts have long learned the need to depend on each other for explorative, affirming talk of that which people who have not lived their experiences could barely imagine. Veterans from conflicts in the Falklands and the Gulf, and those who have served in Northern Ireland, Bosnia and Kosovo are no less vulnerable to trauma than those of previous wars. Familiar patterns of ill health, both mental and physical, are evident, especially over the medium to long term. Such war experiences can be put to one side, for a time. Some people are perfectly capable of putting their service years behind them and living life to the full, never looking back. It is not uncommon however, as was the case with the Kohima veteran in the case studies, for detailed, hitherto unarticulated, memories to surface in later life. I experienced this in my own work. I interviewed a veteran of the First World War about his war service, first in the Royal Engineers, and then in the Royal Flying Corps. At the time, he was my neighbour, aged 82. We had talked at length about the war informally, usually over the garden wall. He then agreed to be recorded. All I needed to do in the 'interview' was keep the tape recorder going, as he methodically talked his way from August 1914 to his demob in 1919, taking care to both describe and reflect on each episode of his war years. Following the recording, I gave him a copy of the tape. He died a year or so later. After the funeral, I mentioned the tape to his son-in-law. His response was that in the forty years he had known him, his father-in-law had never talked about his experiences of the First World War. Yet in the brief time I had known him, he hardly ever talked to me about anything else. The story needed to be told.

The bringing to mind and articulation of such memories in late life is known as a process called life review. It is argued that this is a natural and necessary part of ageing, allowing a review of life's experiences, difficulties and achievements in order to achieve 'resolution', that is a certain and positive perspective on the life lived (Butler 1963). The ability to do this and the circumstances in which it is achieved is seen as a contributing factor in emotional well-being amongst older adults. It can be in thought alone, acted out, or shared through the voicing of memories. Many receive great pleasure from life review – others may not (Coleman 1986, 1993). The reviewed memories may lapse into escapism, or alternatively into a proud act of transmission, passing knowledge and understanding into the safe care of the following generations (Wong and Watt 1991). Indeed the relationship of life review in older adults and the emotional well-being of the next generations should not be underestimated. In Israel, the study of Holocaust survivors discloses the importance of articulating memories that have long been set aside, not just for the person themselves, but also for their families whose own sense of identity is bound up with the Holocaust and their forebears' histories (Schindler et al. 1992).

In the United Kingdom, most of the people in their seventies, eighties and nineties experienced the Second World War first hand. They lost friends and family; saw action directly or indirectly; experienced the privation, exhilaration and even liberation the war brought to many. Younger older adults have memories of evacuation and wartime conditions, the transformation of their lives for good or ill, and witnessed the toll paid, not least by their elders. The war and its aftermath, including National Service, was a defining period, one that stole the youth of those who have now survived to old age. Cues that could prompt recall and aid the processes of life review lie in museum collections. They often reside in those museums least likely to have outreach or education facilities – regimental museums. But before it might be inferred from this that regimental museums should be rethought or reprogrammed in some way, it is important to consider them in another light. They are museums unlike any other in that they were established to be a constructive part of a structure of remembrance. The initial underlying intention in the founding of these museums had much to do with *esprit de corps* and the recognition of valour on the field of conflict. They established spaces in which war memories could be exchanged between their primary users – members and former members of the services. Visits to service collections, the activities of veterans' associations, not least reunions (often on museum premises), provide an environment safe enough for memories. They are places of permission, where histories are told and memories exchanged in ways that can only make real sense to the people who share them. What may appear triumphalist to outsiders has a constructive memory function to those immediately connected with it. There is nothing new in this.

In the late nineteenth century, a group of 'benevolent gentlemen' in Bristol made provision for veterans of the Crimean War and the Indian Mutiny. They were provided with a little extra pension, and a room in which to meet, to enjoy free tobacco and a fire. They brought to the room their own mementoes of their war experiences. The room was still in use in 1917, presumably by this time serving the needs of veterans of later conflicts. The continuity of use suggests that the facility met a genuine need (Kavanagh 1994). The success of this provision can be explained through research conducted many years later. In the 1960s, a study of veterans of the Spanish–American war who met together on a regular basis noted how healthy and well-adjusted the group tended to be and how much many of them reminisced (McMahon and Rhudrick 1964). This is one of the early studies that supported the idea of life review being both natural and beneficial. Both instances confirm that a space for permitted and supported remembrance, within mutually shared and enabling codes, would assist veterans in finding their own way to deal with their past.

From this, it needs to be argued that the basis of museum work with memories, if it is to be ethical and responsible, has to be an understanding of what is required in the creation of a space for permitted and supported remembering. There is no formula here, no simple diagram or procedure to follow. Instead, there has to be an awareness of the dynamics of memory in different life stages and a willingness to learn from the life stories of others. There needs to be a preparedness to 'walk in someone else's shoes', in order to understand what the

bringing of memories to the surface might mean for them in the context of their lives right now. There needs also to be an awareness of the museum's agenda and an honesty about why such work is being undertaken. Who is meant to benefit most?

Ways of working with memories

Any commitment to working with the memories of other people demands a sensitive approach, one that is aware of both the potential for harm and the potential for good. This is especially critical where memories of trauma are, or are likely to be, involved. It is therefore important to be aware of the different facets of memory within the work museums undertake.

Memory is product. Memory is process. It is also the interplay of product and process. Museum work involves both. Oral history is conducted for the product, for the creation of a formal oral record. Reminiscence work is all about process – the promotion of a state of well-being through supported and positive acts of remembering. The agendas are diametrically opposed: one to produce, the other to enable. Yet in each, both product and process are inevitable; oral history must involve the processes of recall, reminiscence must involve narratives of past experiences. Then again, in the exchanges that take place within the context of the visit, whether intergenerational, group-set or solo, product and process interact. Things are brought to mind, shared, exchanged, developed – silently or collectively.

The memory encounters within oral testimony, reminiscence and the visit are profoundly different in their configuration. The conscious laying down of a memory with the aid of a near total stranger and unfamiliar technology cannot be the same as revealing something quietly and privately to a skilled reminiscence worker, or sharing an observation or comment with a life partner, colleague or grandchild during a visit. It is feasible that the same person might be involved in each of these scenarios. They may even be making reference to the same range of events or life experiences. But the agenda, setting, relationship, prompts and cues are very different. As a result in each of these situations, the remembrancer is reconstructing themselves and their memories within the singular context of recall.

The characteristic oppositions within these three memory territories are expressed in Table 8.1. The table is by definition a simplification and a reduction; it should not be read to exclude other possibilities. These are dominant trends, yet ones that are not necessarily guaranteed. Nevertheless, through their identification, working methods can be refined, assumptions and confusions reduced and the margin for error reconsidered.

Table 8.1 Characteristics of oral history, reminiscence work and the museum visit in relation to memory

Oral history	Reminiscence work	The visit
Product	Process	Product and process
Museum-centred	Person-centred	Communication-centred
Private becoming public	Private	Public becoming private
Record	Experience	Record and experience
Taking and receiving	Giving and enabling	Sharing and exchanging
Interviewer-led	Remembrancer-led	Fluid and open
Verbal	Sensual (but mainly verbal)	Verbal and sensual
Technology	No technology	Exhibition structures
Permanent	Transient	Permanent and transient
Personal	Personal	Personal
Appropriation	*Facilitation*	*Examination and illumination*

Conclusions

There are hugely important questions that museums and museum workers need to ask themselves about any form of activity where they seek to work on that which is *private* primarily for a *public* agenda. If a museum is unreflective, unmoved or not humbled by this type of contact with people's lives then these are sure signs this is work with which it should not be engaged. As is seen in Table 8.1, the underpinning motive, on the part of the museum, for the recording of oral history is *appropriation*, for reminiscence it is *facilitation* and for the visit it is *examination and illumination*. Those motives have to be explored and recognised, and – in the light of practice – carefully examined. If they are not, then there can be no discernment in approaches to working with memories, and therefore only limited caution and inadequate safeguards applied.

On the one hand, working with memories can be damaging, artificial and manipulative to those involved. A museum with an unexamined understanding of memory can be working in ways that are patronising and disruptive. It may be exploiting others in order to enrich its own agenda, so that claims of social inclusion, community outreach, and modern scholarship can be made in the right places. It may be superficially skimming the past and by so doing trivial-ising it and its meanings.

On the other hand, there are ways of working with the memories of others that can be empowering, liberating and life changing (and not just for the people immediately involved). Through working with both the memories *and* the people to whom they truly belong, museums can bear witness to the best and worst, the extraordinary and mundane, the innovative and the traditional. They

can enable others in their own explorations of life's experiences. They can create environments that may precipitate the sharing of talk and reflection on the past hitherto not expressed. Where this is handled with tact, knowledge, emotional honesty, and a genuine quality of understanding, the ability of museums to be socially relevant is increased beyond measure. Indeed, their ability to be socially inclusive cannot proceed without it.

Acknowledgements

I am grateful to Robin McDermott and George Scott for giving me access to the two accounts that appear here as case studies.

References

Ames, K. L., Franco, B. and Frye, L. T. (eds) (1992) *Ideas and Images: Developing Interpretive History Exhibits*, Nashville: American Association for State and Local History.

Bond, J., Coleman, P. and Peace, S. (eds) (1993) *Ageing in Society: An Introduction to Social Gerontology*, London: Sage.

Bornat, J. (ed.) (1994) *Reminiscence Reviewed: Perspectives, Evaluations, Achievements*, Buckingham: Open University Press.

British Psychological Society (1995) *Recovered Memories: The Report of the Working Party of the British Psychological Society*, Leicester: British Psychological Society.

Butler, R. N. (1963) 'The life review: an interpretation of reminiscence in the aged', *Psychiatry* 26: 65–76.

Campbell, R. and Conway, M. (1995) *Broken Memories: Case Studies in Memory Impairment*, Oxford: Blackwell.

Coleman, P. (1986) *Ageing and Reminiscence Processes: Social and Clinical Implications*, Chichester: John Wiley.

Coleman, P. (1993) 'Psychological ageing' in J. Bond, P. Coleman and S. Peace (eds) *Ageing in Society: An Introduction to Social Gerontology*, London: Sage, pp. 68–96.

Conway, M. (ed.) (1992) *Theoretical Perspectives on Autobiographical Memory*, Dordrecht: Kluwer Academic Publishers.

Conway, M. (ed.) (1997) *Recovered Memories and False Memories*, Oxford: Oxford University Press.

Davies, S. (1994) *By Popular Demand: A Strategic Analysis of the Market Potential for Museums and Art Galleries in the UK*, London: Museums and Galleries Commission.

Dubin, S. C. (1999) *Displays of Power: Memory and Amnesia in the American Museum*, New York: New York University Press.

Fleming, D., Paine, C. and Rhodes, J. G. (eds) (1993) *Social History in Museums: A Handbook for Professionals*, London: HMSO/Board of Trustees of the National Museums and Galleries on Merseyside and the Museums Association.

Groeger, J. A. (1997) *Memory and Remembering: Everyday Memory in Context*, London: Longman.

Harwit, M. (1996) *An Exhibit Denied: Lobbying the History of the Enola Gay*, New York: Copernicus.

Hooper-Greenhill, E. (1997) *Cultural Diversity: Developing Museum Audiences in Britain*, London: Routledge.

Kavanagh, G. (1990) *History Curatorship*, Leicester: Leicester University Press.

Kavanagh, G. (1994) *Museums and the First World War*, Leicester: Leicester University Press.

Kavanagh, G. (ed.) (1996) *Making Histories in Museums*, Leicester: Leicester University Press.

Kavanagh, G. (2000) *Dream Spaces: Memory and the Museum*, Leicester: Leicester University Press.

Kitwood, T. (1990) *Concern for Others: A Psychology of Conscience and Morality*, London: Routledge.

Kitwood, T. (1995) 'The uniqueness of persons in dementia in Europe' in *Widening Horizons in Dementia Care, A Conference of the European Reminiscence Network: Conference Papers*, London: Age Exchange, pp. 96–98.

Kitwood, T. (1997) *Dementia Reconsidered: The Person Comes First*, Buckingham: Open University Press.

Kitwood, T. and Benson, S. (1992) *Person to Person: A Guide to the Care of Those with Failing Mental Powers*, Loughton, Essex: Gale Publishers.

Leon, W. and Rosenzweig, R. (eds) (1989) *History Museums in the United States*, Urbana and Chicago: University of Illinois Press.

Linenthal, E. T. (1995) *Preserving Memory: The Struggle to Create America's Holocaust Museum*, New York: Viking.

McMahon, A. W. and Rhudrick, P. J. (1964) 'Reminiscing: adaptational significance in the aged', *Archives of General Psychiatry* 10: 292–298.

Merriman, N. (1989) *Beyond the Glass Case: The Past, the Heritage and the Public in Britain*, Leicester: Leicester University Press.

Rose, S. (1992) *The Making of Memory: From Molecules to Mind*, London: Bantam.

Rosenzweig, R. and Thelen, D. (1998) *The Presence of the Past: Popular Uses of History in American Life*, New York: Columbia University Press.

Schindler, R., Spiegel, C. and Malachi, E. (1992) 'Silences: helping elderly Holocaust victims deal with the past', *International Journal of Aging and Human Development* 35(4): 243–252.

Wallace, M. (1995) 'The battle of the Enola Gay', *Museum News*, July/Aug.: 40–62.

Wong, P. T. P. and Watt, L. M. (1991) 'What types of reminiscence are associated with successful aging?', *Psychology and Aging* 6: 272–279.

Zolberg, V. (1996) 'Museums as contested sites of remembrance: the Enola Gay affair', in S. Macdonald and G. Fyfe (eds) *Theorizing Museums*, Oxford: Blackwells, pp. 69–82.

Part 2

Strategies for inclusion

9

Harnessing the power of history
Ruth J. Abram

Introduction

In December 1999, after a week of intense discussion at Bellagio, the Rocke-feller Foundation's conference centre in Italy, leaders of ten historic sites: the Workhouse (England); the Gulag Museum (Russia); the Slave House (Senegal); District Six Museum (South Africa); the Project To Remember (Argentina); the Liberation War Museum (Bangladesh); Terezin (Czech Republic); National Park Service – sites include the Women's Rights National Historical Park (US); Manzanar (the Japanese internment camp); and the Lower East Side Tenement Museum (US), signed and issued the following statement:

> We are historic site museums in many different parts of the World, at many stages of development, presenting and interpreting a wide variety of historic issues, events and people.

> We hold in common the belief that it is the obligation of historic sites to assist the public in drawing connections between the history of our sites and its contemporary implications.

> We view stimulating dialogue on pressing social issues and promoting humanitarian and democratic values as a primary function.

> To advance this concept, we have formed an International Coalition of Historic Site Museums of Conscience to work with one another.

The idea for the Coalition grew from my frustration. For the past decade, as the founder and President of the Lower East Side Tenement Museum, I had been working to make the history of the Museum's site – a nineteenth-century tenement building, the first homestead of urban, working-class and poor immi-grant people to be preserved and interpreted in the United States – available as a tool for contemplating and addressing contemporary issues related to those broached by the Museum's historic interpretations.

I was having a hard time. Fundraising was proving unusually difficult as was finding like-minded historic sites. While anyone who must raise funds to sustain

a museum will tell you that it is difficult, I, who came to the task with over twenty years of fundraising experience, realised that this was more daunting than other projects. The reason soon became clear. Foundations accustomed to funding traditional museums could not categorise the Tenement Museum. 'Are you a settlement house?' asked one potential donor. While I was actually delighted that the Tenement Museum might be confused with a social service for the immigrant poor, I knew that the question meant the foundation would not fund the Tenement Museum. Foundations that funded social service and/or advocacy routinely rejected our proposals saying, 'We don't fund museums.'

In the Museum community, I was distressed by the number of directors and staff who described their institutions in terms of square footage rather than mission. Often, after listening to my description of the Tenement Museum's programmes and its plans to actively use history, these professionals pointed to their lack of space or funds or imagined board resistance as the reasons they would continue 'business as usual'. I was feeling isolated and in need of other museum professionals who shared my views, when a conversation with the President of the Ford Foundation decided me to focus on finding them. After listening to my concept for the Museum and the difficulties I was experiencing in fundraising, President Beresford said that it might be useful to demonstrate that this was the new direction for museums by finding even a handful of directors who saw it the same way. 'Perhaps,' she said, 'you should look outside America.' And so I did.

Memory activists

In Bellagio, as the directors of the ten historic sites introduced ourselves for the first time, we were amazed to learn that, with few exceptions, we had not come from the museum profession to our task. Rather, we shared histories of social activism – against dictatorships and terrorism, against war and poverty, for women's rights and civil rights, and more. We viscerally understood Archbishop Olivier de Berranger's ringing declaration of the necessity of history: 'Conscience is formed by memory; and no society can live in peace with itself on the basis of a false or repressed past, any more than an individual can' (1997). We were activists who had come to believe that our best contribution to the ideas we held dear could be made through history, and specifically, through historic sites. We accepted our roles as formers of public conscience. It was for this reason, I am certain, that, rather than resistance, there was general acceptance of the ideas I set forth in my opening remarks.

'The historian, Arthur Bestor,' I told my new colleagues, 'said, "Deprive me of my [historical] consciousness, and in the most literal sense, I do not know who I am"' (Bestor 1966: 8). 'We are gathered here to deepen and expand our efforts so that citizens the world over may know *who* they are, *where* they are going and *what steps* they must take to get there. This is, after all, the implicit power of history. We are here to make it explicit.' Looking forward to the coming week together, I promised we would have opportunities to suggest ways in

which each of our sites could make more *explicit* what has always been *implicit* in our work; namely, that historic sites are valuable, not because they tell a particular story (though, of course, the stories we tell are, in themselves, important). Rather, our historic sites are valuable because embedded in the stories we tell are lessons so powerful that, if taken to heart, could inform, guide and, indeed, improve our future.

If, through the work of the Gulag Museum and Project To Remember, we clearly perceive the pattern of authoritarianism, totalitarianism and political repression, we can measure that pattern against the shape of contemporary developments. And, if we perceive a match, we can demand an alteration. If the Women's Rights National Historical Park assists us in identifying the tracks of gender discrimination, we will be able to monitor its movement in our countries, our communities, and in our homes – and finally banish it. If, through the Workhouse, we understand how a society has confronted the challenges posed by the poorest of its population, we can better judge whether our current programmes are only a repetition of already failed policies or whether they represent new insight and understanding. Through these efforts, we may build a more equitable society. If, through the Liberation War Museum, we comprehend exactly what ignited the fire, which first fuelled Bangladesh citizens' demand for a democratic form of government, we can rekindle this insistence on freedom in each generation – not only in Bangladesh, but also in all countries. If, through District Six, we learn how to overcome official resistance to restoring people to a memory that they may be made whole, we can do that in every community that has been physically or emotionally obliterated. If, through the Slave House, we understand the circumstances and the thought process that can lead one human being to regard another human being as property, we can fight against the factors that encourage this insidious view. And if, through the Terezin Memorial, we uncover the details concerning how a government, threatened by the very idea of a museum on the topic of this holocaust, tried to block its birth and stunt its growth, we can assist one another should the story we tell result in government sanctions against us.

History as central to civic society: needing the past to shape the future

I plan to ask my colleagues in the Coalition if they always regarded the past as important or whether, like me, they once saw it as interesting, but peripheral to the main issues of our day and to the task at hand. Always preferring histories and biographies as reading material, I nevertheless viewed them as entertainment. Certainly I could not imagine I would ever need them to achieve my ends. And then, one day, I changed my mind.

In the 1970s, I was organising a National Women's Agenda, a political platform designed to answer the age-old question: 'What do women want?' Things had gone well. Leaders of wildly diverse American national women's organisations had actively participated in the formation of the Agenda's platform. But

suddenly it was stuck. Casting about for a solution, I telephoned Gerda Lerner, then Chair of the Women's Studies Department at Sarah Lawrence College and founder of the modern women's history movement. Introducing myself, I explained my dilemma and asked if I could have an historical consultation. After what felt to me to be an achingly long pause, Dr Lerner said, 'No one has ever asked me, an historian, to help develop strategy for the present.' A few days later, Lerner treated me to a personal lecture on the history of women's organising efforts. Learning that every successful national effort by women had been organised from the grass roots up, I realised I had been organising from the top down. I restructured the campaign. In 1975 on the steps of the US Capitol, women from over one hundred national women's organisations announced the formation of a National Women's Agenda. History had supplied a strategy. Many times since, history has afforded me comfort, inspiration, perspective and role models where none seemed to be. I have come to view history as a powerful tool for the living.

At home with the past

As it turns out, many Americans agree with me. In the first survey of Americans' relationship to history, conducted in 1999 and described in their book, *The Presence of the Past: Popular Uses of History in American Life*, Roy Rosenzweig and David Thelen found that

> Americans feel at home with the past; day to day, hour to hour, the past is present in their lives. Encountering the past, examining it, living and reliving it, they root themselves in families – biological or constructed – and root their families in the world.
>
> (1998: 36)

> Americans said they want to make a difference, to take responsibility for themselves and others. And so, they assemble their experiences into patterns, narratives that allow them to make sense of the past, set priorities, project what might happen next and try to shape the future. By using these narratives to mark change and continuity, they chart the course of their lives.
>
> (ibid.: 12)

In other words, Americans regard the past as a usable tool.

During the Coalition's first meeting, I learned that this belief in the power of history extended far beyond the boundaries of my country. Members of the Coalition are using history in unique ways. The Workhouse is planning a presentation of a contemporary 'bedsit' or shelter beside its nineteenth-century re-creation. The Gulag Museum works with Memorial, Russia's leading human rights group, to host conferences on human rights violations and to document past abuses. The District Six Museum served as the site for South Africa's Land Reclamation Court and now runs a shelter for street children. In a country where many perpetrators of 'crimes against humanity' remain free and even in

power, Project To Remember is archiving documentation of the atrocities involving thousands of 'disappeared ones'. The Liberation War Museum is conducting forensic investigation of the Killing Fields to bring the responsible parties before an international tribunal. The Women's Rights Historic District hosts international conferences on contemporary women's rights.

History as peripheral

Various historians have written movingly and convincingly about the necessity of history. In his extraordinary book, *The Historian's Craft*, published after he was murdered by Nazis, French historian Mark Bloch wrote: 'Misunderstanding of the present is the inevitable consequence of ignorance of the past' (1953: 43).

At the same time, there persists among many activists and opinion leaders the feeling I once had – that history is of little practical value to their work. Explaining why a certain cultural institution managed to flourish, a New York City leader once said, 'It has not allowed itself to become a museum', meaning, it has not allowed itself to be sterile. In America, to dismiss an idea as unimportant or irrelevant, one says simply, 'It's history'. Trying to explain why the United States Government was cutting funding for the arts and humanities, a foundation executive said, 'I don't think the arts are seen as integral to human existence' (Dobrzynski 1999: E-1).[1] Recently, as part of the Tenement Museum's ongoing effort to get to know and reach out to leaders in all aspects of our local community, we invited a housing activist to address the staff. After describing her organisation's effort to obtain decent housing for economically disadvantaged people, she announced that she could not imagine how the Museum could be helpful. Indeed, she suggested that, by presenting historically poor people's stories, the Tenement Museum could be aiding and abetting the enemy by placing issues such as housing and economic inequities in the past. If we are to be successful, we need to find convincing ways to respond to this scepticism about history's value. It is worth trying, for as long as history is viewed as an instrument of private value but not public value, it will not be afforded a role in public life. Commissions will be established to grapple with important social policies without regard to historical precedents involving those same policies. Decisions about our future will be made in the absence of understanding the past. This is why neither the Tenement Museum nor any historic site or museum can afford not to respond to those who see no practical use for their work.

As it turned out, just as the housing advocate was expressing her scepticism about the Museum's value for her work, the Museum's educational staff was developing *Tenement Inspectors*. The project emanated from staff's understanding that many children visiting the Tenement Museum live in circumstances that rival the difficult conditions portrayed in the Museum's historic apartments. Lack of plumbing, heat and ventilation and the battle against rats are not 'history' to these children and their families. Because the Tenement Museum views

history as a tool for the living, we asked: 'How can the history of our site be used as a vehicle for improving the housing conditions in which so many of our students live?' In *Tenement Inspectors*, children will be trained at the museum to identify violations of the 1901, 1910 and 1934 housing laws as well as those governing the present. Then, after returning home, they will inspect their own premises. With the support of the City's Housing and Preservation Department (the historic descendants of the Tenement Inspectors), the children will be helped to alert the appropriate authorities to the violations they uncover. Here, we are using the history of housing and housing reform, so integral to the Tenement Museum's site and story, not only to teach this history, but also to train a new generation of public advocates, and to communicate the rights and responsibilities of citizens in a democracy. But the museum's visitor from the housing advocacy group could not imagine a museum would undertake such a programme because it did not comport with her understanding of the role of a history museum, or historic site. That is because most of them continue to fail to help the public use their information to address personal and community problems. And worse, far too many don't even tell the truth.

Telling the truth

Concealment of the historical truth is a crime against the people.[2]

Just as the public yearns for history, it yearns for truth. In *Lying: Moral Choice in Public and Private Life*, Sissela Bok articulated a common wisdom: '[T]rust in some degree of veracity functions as a foundation of relations among human beings; when this trust shatters or wears away, institutions collapse' (Bok 1979: 33).

If you believe, as I do, that history holds a fundamental key to our present and future, and if you also believe that lying undermines the very fabric of a civil society, then you fully comprehend how very important it is to get that history right. One place we should certainly be getting it right is in our nation's schools. But in America and, as I understand from my colleagues, in other parts of the world too, we aren't. In *Lies My Teacher Told Me: Everything Your American History Textbook Got Wrong*, James W. Loewen documents a web of misinformation, omissions and lies in some of the nation's most popular and widely used history textbooks. No wonder, as the Rosenzweig and Thelen survey found, Americans have rejected history as it is taught in high school as 'dull' and 'irrelevant'. They felt this 'standard issue history' with its 'patriotic story of the American nation, denied them credit for their critical abilities and was insulting' to their sense of themselves as 'critical thinkers' (1998: 179).

But since the public regards history as critical to its well-being, it is determined to get it. Spurning school as an unreliable source, Americans turn elsewhere. More than one-third of the survey respondents had investigated the history of their family in the previous year; and two-fifths had worked on a hobby or collection related to the past. Furthermore, in large numbers, they turn to

historic sites and museums, which they regard as 'the most trustworthy sources of historical information'. More than half the survey respondents had visited a museum or historic site during the previous year. 'They trusted history museums as much as they trusted their grandmothers' (Rosenzweig and Thelen 1998: 12).

The American public trusts historic sites; and, time and again, historic sites have betrayed that trust. The terrible truth is that the history supplied in far too many historic sites is as lacking in depth, perspective and integrity, and is as dismissive of the public's intelligence as those textbooks the public has rejected. Criss-crossing the country, visiting historic sites big and small, James W. Loewen was forced to conclude:

> Guides almost always avoid negative or controversial facts, and most monuments, markers and historic sites omit any blemishes that might taint the heroes they commemorate, making them larger and less interesting than life . . . America has ended up with a landscape of denial.
>
> (1999: 19)

But the public remains faithful to the sites, impugning them with veracity withheld from other sources. Why? The difference is that in those sites and museums there are artefacts, and, according to the Rosenzweig and Thelen survey, the public regards those artefacts as the 'real' stuff of the past. But, as any museum professional knows, those artefacts can be used to support a lie. One example cited by Loewen involves the aircraft carrier, USS *Intrepid*. Displayed at dock by the Sea–Air–Space Museum, it is described as 'the battle-scarred veteran of World War II'. Visitors assume they are experiencing the environment known to thousands of WW II sailors, but, because the ship was completely overhauled for service in Vietnam, they are not. The ship's service in Vietnam, for which it won citations, is not mentioned because, according to Loewen, the Navy declared the information too political (1999: 404–405).

When historic sites get history wrong, they trivialise it, mislead the public and render history peripheral. According to the Rosenzweig and Thelen survey, Americans yearn for history that actively assists them in making connections between the past and the present, a history that 'can be used to answer pressing current-day questions about relationships, identity, immortality and agency' (Rosenzweig and Thelen 1998: 178). Yet, historic sites, which render this assistance, are rare. Worse, very few historic sites have even recognised that there is a problem, much less moved to address it.

The Lower East Side Tenement Museum

In founding the Tenement Museum, I decided to begin with what we have in common. Most Americans are descendants of people who came – willingly or no – from somewhere else. We share family histories containing the experience of dislocation, relocation and reinvention. I decided to introduce long rooted Americans to their family members before they became acceptable – at the point of their first arrival, when they knew not the language or the customs of their

adopted land. I hoped that, through this confrontation with revered ancestors, Americans could be moved to participate in a national conversation on similarly situated contemporary immigrants. I further hoped that Americans might realise that those strangers have more in common than not with the forebears they so admire. For those newly arrived, I hoped to offer the comfort that comes from the knowledge that, as immigrants, they are part of a vital American tradition.

The core visitor experience at the Tenement Museum is a guided tour of a nineteenth-century tenement building. Erected by a German-born tailor in 1863, this five-storey brick structure occupies a lot 25 feet wide × 87 feet deep. There are four 320-square-foot apartments per floor. Originally constructed without indoor plumbing, ventilation, or light, it was nevertheless sufficient for the owner and his family who moved right in. Before its condemnation as a residence in 1935, the building was home to an estimated 7,000 immigrants from over twenty nations; the museum has identified over 1,300. Although more citizens trace the beginning of their families' American experience to the urban rather than the rural environment, and most descend from working-class immigrants, 97 Orchard Street is the first homestead of urban working-class and poor immigrant people to be preserved and interpreted in the United States. This, in itself, serves as a corrective in the landscape of historic sites, which have heretofore failed to explore this, now majority, aspect of our national heritage.

Sensitive subject matter

Today, four carefully restored apartments set the stage on which guides introduce visitors to immigrant families who actually lived in 97 Orchard Street between 1863 and 1935. The stories were selected for their capacity to demonstrate the chronological span of 97 Orchard Street, and the tenants' national and religious diversity. Another consideration was the stories' emotional impact and their ability to raise contemporary issues. Thus, in meeting the German-born Natalie Gumpertz in the 1870s, visitors discover the first female-headed household ever presented in a National Historic Site. Encountering the Sicilian Baldizzi family in the 1930s (Figure 9.1), visitors confront the first family on welfare and the first illegal immigrants ever interpreted in an American historic house. Entering the Rogarshevsky home in 1918, visitors come face to face with death itself, and with the ever-present tendency to blame the victim of an epidemic for the epidemic. For at the time, tuberculosis, which claimed the life of the family's patriarch, was referred to as the 'Jewish Disease', though proportionately fewer Jews had it than did members of other groups.

To balance the presentations, Museum documents explain not only that Natalie Gumpertz's shoemaker husband disappeared, but also that she established a dressmaking business. Although the Baldizzi apartment is set on the day they were evicted, Morning Glories planted in a cheese box supplied by welfare spiral up the window, signalling the family's intent to claim its right to the 'pursuit of happiness'. By presenting three-dimensional stories of people who experience despair and delight, tragedy and triumph, we offer our

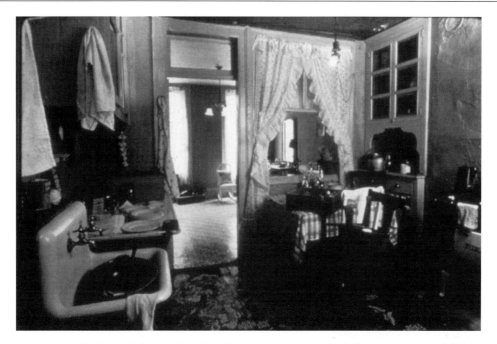

Figure 9.1 Kitchen of the Baldizzi Family, immigrants from Sicily, on the day of their eviction, 1935. By kind permission of the Lower East Side Tenement Museum.

tenement's characters as historical role models. Because our lives are also multi-dimensional and complex, we can relate to 97 Orchard Street's people, and learn from them.

Many museum professionals have asked 'How do you get away with it?', meaning: How has the Tenement Museum managed to take on so-called 'sensitive' subjects without bringing down the wrath of God – much less the public – upon its head? There is, in the museum profession, a certain fear of the public. At its base is the mistaken idea that the public cannot bear the truth, but the results of the Rosenzweig and Thelen survey and our own experience at the Tenement Museum say otherwise. The public is clamouring for the truth.

Battles over interpretation

There have been some skirmishes surrounding interpretation at the Tenement Museum. One involves whose history the Tenement Museum should tell. Most Americans familiar with the Lower East Side are under the misimpression that, until very recently, it had always been exclusively Jewish. For American Jews, the Lower East Side is something of a sacred site, and a place of pilgrimage. Members of bar and bat mitzvah classes and synagogues nationwide visit the Tenement Museum to 'see' their ancestors' first American homestead. Many have been surprised and some have been distressed to find the Museum's interpretation includes non-Jews.

The majority of the known residents of 97 Orchard Street appear to have been Jewish. At the same time, reflecting the patterns of immigration to the neighbourhood, inhabitants included substantial numbers of German, Irish and then Italian residents. The Museum has elected to tell the entire story. This decision prompted a leader of the local Jewish community council to write that he would be happy to assist the Tenement Museum 'if and when you make a decision to commit the necessary resources to chronicle the predominant "culture" of the Lower East Side – the Orthodox Jewish community and its myriad of synagogues, *shtiebels*, charitable and "self help" organizations'.[3]

Another dispute involved the depiction of the tenement's landlords. As everyone who has ever seen a Jacob Riis photograph 'knows', hard-working, decent tenement residents were exploited by greedy and uncaring landlords. But, as our research progressed, a more complex story emerged. The landlords, it turned out, were immigrants themselves. Our first landlord, Lucas Glockner, a German-born tailor, lived in the building as did his bookbinder son, daughter-in-law and grandchild. The court records, which first revealed Natalie Gumpertz's story, also recorded her landlord's testimony in support of her claim. When the death of her husband left Fannie Rogarshevsky, who spoke no English, high and dry, her landlord saved the day by hiring her as the building's janitor and furnishing her a rent-free apartment.

Many scholars and members of the public expected the Tenement Museum to corroborate their understanding of a tenement as a slum. But, as we peeled back the history and the wallpaper of our tenement, a more complex picture emerged. Although the building's early tenants, highly skilled crafts people, and the landlord himself, clearly had other choices, they chose to live at 97 Orchard Street. And indeed, some of the reasons for their decision are now clear. For example, although not required by law, 97's builder installed the most up-to-date outhouses – connected to a sewer system.

Associating tenements with poverty, many visitors expect to see dirty, unaesthetic apartments. Again, using memoirs of former residents as well as information scraped by conservators from walls and floors, we have had to conclude differently. Keeping persons and apartments clean was a battle, but it was one in which tenement dwellers were constantly engaged.

We have stood our ground against those who insisted that we tell the story as an exclusively Jewish one, featuring good, immigrant tenants and evil American-born landlords; and presenting lives of unrelieved drudgery in uniformly dreadful physical conditions exacerbated by tenants' inability or disinterest in aesthetics. We stood on the facts and could not be moved.

Of course, our knowledge of what happened in the building is constantly evolving. Sometimes, however, we have gotten the facts 'wrong' and we share that experience and the process of shifting knowledge with our visitors. For reasons I have never understood, many historic sites are reluctant to share their 'mistakes' with the public. Yet, if there is anything the public needs and deserves to know, it is that history is a continual process of discovery and correction.

The benefits of good history

What do we gain by insisting on calling and interpreting the facts as we see them? For a start, it helps us avoid becoming part of the problem of the erosion of trust that is so critical to the maintenance of a civil society. In *Lying: Moral Choice in Public and Private Life*, Sissela Bok pointed out:

> Those who learn they have been lied to in an important matter ... are resentful, disappointed and suspicious. They see that they were manipulated, that the deceit made them unable to make choices for themselves according to the most adequate information available, unable to act as they would have wanted to act had they known all along.
>
> (1979: 21)

In 1964, 78 per cent of the respondents to a Gallup poll said they could 'trust Washington to do what is right all or most of the time'. By 1994, the figure had plummeted to 19 per cent (Bok 1979: 21–22). Similar declines in the public's trust toward doctors, lawyers and major companies in the United States and elsewhere have also been documented. It is unconscionable for historic sites, perhaps the last of our public institutions to enjoy some modicum of confidence, to contribute to the decline in people's trust.

By insisting on 'truth', we help illuminate some important concepts, which, if taken to heart, could inform and improve lives. For instance, in offering a nuanced picture of the landlord, we offer an alternative model of behaviour for contemporary landlords – one in which they and their tenants are mutually dependent. It follows that a mutually supportive rather than antagonistic relationship makes the most sense. Also, our interpretation illuminates immigrant entrepreneurship. Then and now, tenement landlords were immigrants, seeking a foothold in the economic life of New York City. By admitting our mistakes, we invite the public to assist us. That suggests everyone is invited to regard history with scepticism because it is an ongoing process of discovery and (hopefully) correction. The bottom line message is that there is no shame in getting it wrong; but rather in refusing to correct what is known to be wrong. The Museum's decision to tell Jewish and non-Jewish stories may help people realise that sharing sacred space need not diminish its sacredness to any particular group. Rather, the shared experience – then and now – could be used as a point of commonality and a foundation for other joint ventures. In the urban environment, where all space must be shared, examples of earlier sharing can serve as a useful guide. Finally, by insisting that its interpretation rests solely on its research of the tenement's physical and social history, the Museum unexpectedly refuted several common fallacies about poor people as unsanitary and without aesthetic sensibilities.

Putting history to work

Historic sites compound the damage they are doing by concealment, obfuscation, simplification, and misrepresentation by ignoring the public's call for

135

usable past. With few exceptions, historic sites fail to provide the past in such a way that it can be used by the public to make informed choices for themselves. Yet, the process of becoming informed and making choices based on that information lies at the very heart of civil society. Of late, several American foundations have called for the revitalisation of our democratic processes, principles and institutions. These foundations are seeking to fund efforts to demonstrate the relevance of the arts and humanities to the task of fostering a more civil society. Were historic sites to respond to this challenge, they would stop disseminating skewed and dishonest portrayals of people and events; and they would provide good history in a form that allowed and encouraged its transformation into a tool for contemporary living. This is what we are attempting at the Tenement Museum.

Using history to teach English, welcome, acculturate and empower immigrants

Learning that area immigrants wait up to three years for places in free English classes, the Museum initiated its own. Our curriculum utilises the diaries, letters and memoirs of earlier immigrants. 'I not only learned English,' said a recent graduate, 'I learned I was not alone' (Figure 9.2). This year, we will explore the state of immigrant services in New York, using the information to design a more comprehensive approach. During a segment of the English classes, students learned that charity workers who provided employment or housing advice often met nineteenth-century immigrants at Ellis Island. 'No one was there for us at Kennedy Airport!' exclaimed a participant. With that, the idea for the *Immigrant Resource Guide* was conceived. To be published in several languages, the *Guide* will contain stories of immigrants, past and present, a list of immigrant assisting organisations, and answers to the most commonly asked questions. Thousands of copies will be distributed free to immigrants throughout New York City. As if responding to Rosenzweig and Thelen's conclusion that history can make people aware of possibilities for transforming the status quo, this history has furnished a new sense of possibility and entitlement.

Using history and historic preservation to establish common ground

To test whether the experience of immigration and migration was sufficiently powerful to serve as the basis for establishing a sense of 'common ground', the Museum launched *Kitchen Conversations*. Area residents from over twenty different nations and a wide array of ages, races and educational backgrounds listened intently as each told his/her individual story, which scholars placed in historical perspective. Having originally assumed they would have little in common, participants marvelled at discovering so many similarities with one another and with the stories of immigrants past. The success of the *Kitchen Conversations* led staff to wonder whether a diverse community could be united through the process of preserving and interpreting a historic site. At that moment, we were approached by the largely African-American congregation of

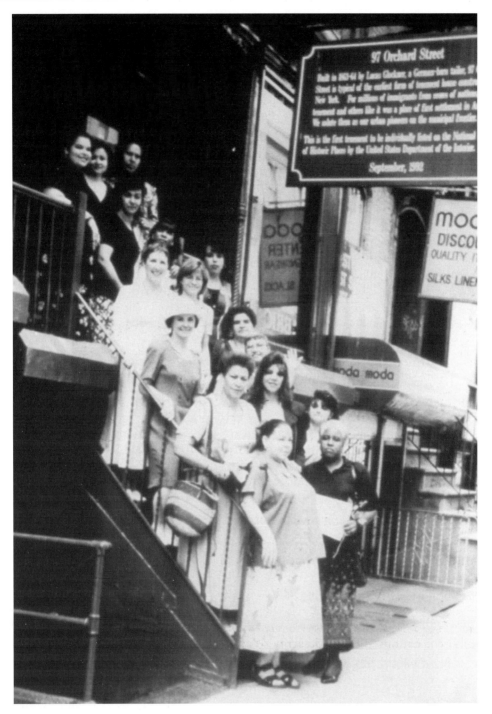

Figure 9.2 Graduation Day for students in the museum's English for Speakers of Other Languages Course on the steps of the Museum's 1863 tenement building. By kind permission of the Lower East Side Tenement Museum.

the 175-year-old St Augustine's Episcopal Church. Explaining that the Church contains the only slave gallery (holding pen) known to exist in a New York City church, they asked the Museum to assist in the gallery's preservation and interpretation. In February 2000, with over 100 community groups participating, the *Slave Gallery Project* was launched. The Episcopal Bishop sent an emissary with a formal apology for the Church's involvement in slavery. The healing had begun. As historians and preservationists report their findings, representatives of the participating community groups will involve their constituencies.

Using history to generate a dialogue on social problems

The Museum's *Sweatshop Project* builds on two years of scholarship on the garment industry, past and present. Plans are under way to re-create the Harris Levine sweatshop, cited by Factory Inspectors in the 1890s for working non-family members and children over 60 hours a week. Visitors will be helped to use the history of this subject as a basis for considering the present situation. What has changed? What has not? Assisted by UNITE!, the garment workers' union, and other labour and manufacturing groups, the Museum will reach out to invite factory workers, managers, buyers, advertisers and union organisers to participate in using this past to shape a future – together.

Using history to combat class bias and to stimulate empathy

Teaming up with private and public schools, and with Lyndhurst, a National Trust Site, the Museum is developing a programme with a simple message – a person's worth cannot be measured by calculating his/her material wealth. As a first step, nine-year-olds were invited to write down words they associated with the word 'poor' both before and after a visit to the Tenement Museum. The number of negative associations with the word 'poor' (including 'mean', 'dangerous', 'dishonest') plummeted from 90 before the visit to 20 after it.

Diversifying the museum profession

Responding to the American Association of Museums' challenge to diversify the Museum profession, the Tenement Museum joined the City College of the City University of New York to establish the nation's first 'Urban Museum Studies Program'. Offering a graduate degree to students largely drawn from minority, immigrant and working-class families, the course will train a new cadre of museum professionals, reflecting the nation's diversity.

Putting democratic and humanistic values to work institutionally

The Tenement Museum is committed to making all members of its full-time staff, regardless of education, prior training or position, part of the teaching and learning process. All conduct public tours of the Museum, all participate in a weekly programme which includes field trips to area organisations, historical or skills training, and all participate actively in planning the Museum's

goals and objectives. Last year, to provide further focus and to deepen the training experience, the staff focused on the neighbouring Chinatown and devoted three hours a month to studying Chinese and Chinese-American history and visiting Chinatown institutions, leaders and historic sites. This year, leading scholars will deliver a series of lectures on the history of immigration.

Far from satisfied

Despite its progress, the Tenement Museum is far from satisfied that it has achieved its own stated goals. While various specific programmes effectively make use of the past to understand and address related contemporary issues, our average visitor does not experience them. The majority of the Museum's visitors take one of the tours of historic immigrant apartments, and there, we have yet to make our intentions explicit. However, as I cautioned my colleagues in the Coalition, it is only by making *explicit* what has heretofore been *implicit* in the work of our sites that we can establish an objective whose outcome can be measured. If the Tenement Museum sets out, as it has, to use history to address prejudice against poor people, we can and should measure the outcome of that programme. It is not enough for us to ask simply whether participation in our programme made children think about the issue, for that was not our objective. Rather, we must ask whether children, who prior to their participation in the Tenement Museum programmes described a poor person with words such as 'mean', 'ugly', 'dishonest' and 'dangerous' actually changed their viewpoint after participating in our programme. If they did not, we must alter the programme so that the outcome meets our stated and explicit objective.

By making explicit what has been implicit, we will sharpen the focus and objectives of our programmes to meet these newly specified goals. Using the Tenement Museum as an example, if we really want to use the history of the American immigrant experience past to stimulate dialogue on contemporary immigration policies and related issues, it is not sufficient to simply present the story of immigrants past to visitors. A presentation is not a dialogue. Rather, to achieve our stated objective, we must find ways to engage our visitors with experts, and with one another, and we must furnish them with reliable, balanced and comparative information on immigration past and present. Further, we must establish a place and a format for dialogue, open and useful to all. Without the information, the place, and the format, we cannot expect our visitors to make full use of the power of history to inform their lives.

The Tenement Museum's challenge, I described at the Coalition's first meeting, is yet to be adequately addressed. Shortly, in an attempt to begin to rectify that, the museum will pilot a dialogue with its visitors. The topic upon which we will focus first is the one binding all our presentations – immigration. Our hope is to format an ongoing opportunity for visitors to discuss the contemporary implications of the history presented at our site. If we are successful, we will not only break new ground in the use of history, but also, because our visitors are diverse, pioneer in establishing a dialogue that crosses the usually divisive lines of class, race, religion, national origin and more.

Of course, the Tenement Museum is not the only historic site or museum where the staff has concerned itself with the accuracy and balance of the history it presents or the presentation of the past in such a way as to make it useful to the public. One can find excellent programmes in museums and historic sites, large and small, that achieve these objectives. Still, I am struck by the fact that while these projects clearly represented the longings and even actions of individuals within the museum community, they generally do not reflect a total and comprehensive institutional commitment. And until they do, rather than contribute to a civil society, historic sites and history museums will continue to undermine it.

Historic sites as places of engagement

A new role for historic sites and museums is emerging. Every site represented within the Coalition of Historic Site Museums of Conscience is important and their directors understand they are leading pioneering institutions. Every one of them embraces a mission that goes far beyond the simple chronicling of history. By coming together and further expanding our group, we hope to firmly and clearly articulate this larger mission and there is much we can do. First, we can establish an early warning system. One of the first signs of the rise of political repression is a move to destroy history. Should that transpire, we can work together to sound the alarm, to serve, if need be, as a temporary repository for whatever records and objects the new regime finds threatening. Second, we can lend our expertise and experience to newly emerging historic sites. Leaders of the international human rights organisations say that, when people arise from the shadows of an oppressive government, they frequently express the desire to preserve and interpret an historic site associated with that repression. But they are often prevented from realising this ambition simply because they have no contacts with the museum community and therefore have no ideas of how to proceed. Third, we can stimulate collaboration and exchange – not only among ourselves and other historic sites – but also with international human rights organisations, scholars, museum planners, artists and arts and media organisations internationally. Lastly, we can develop and apply evaluative tools with which to measure the impact of our work and thus demonstrate its relevance to contemporary society.

Members of the International Coalition of Historic Site Museums of Conscience are working toward the day when historic sites offer not only a deep sense of some aspect of history, but also assist the public in drawing connections between that history and its contemporary implications. We are conceiving of historic sites as places of engagement in which visitors, motivated to participate in finding solutions to enduring social, economic and political issues, will be directed to organisations working in the field. We hope to make explicit that which has heretofore been implicit. Our sites and history museums are important not because of the stories they tell but rather because implicit in these stories are lessons so powerful that they, if fully understood, could improve our

lives. Such is the power of history. Our challenge is to harness that potential to improve society.

Notes

1 Dobrzynski was quoting Marion A. Godfrey, Director of Culture Programs, Pew Foundation.
2 General Petro G. Grigorenk, in a Samizdat Letter to a history journal, 1975, cited in Loewen 1995: 11.
3 Letter to author from Joel Kaplan, Executive Director, United Jewish Council, Lower East Side, 29 November 1996.

References

Archbishop de Berranger, *New York Times*, October 1997.
Bestor, A. (1966) 'The humaneness of history' in A. S. Eisenstadt (ed.) *The Craft of American History*, Vol. 1, New York: Harper Torchbooks, Harper and Row.
Bloch, M. (1953) *The Historian's Craft*, New York: Vintage Books.
Bok, S. (1979) *Lying: Moral Choice in Public and Private Life*, New York: Random House.
Dobrzynski, J. H. (1999) 'Heavyweight foundation throws itself behind idea of a cultural policy', *The New York Times*, 2 August 1999: E-1.
Loewen, J. W. (1995) *Lies My Teacher Told Me: Everything Your American History Textbook Got Wrong*, New York: Simon and Schuster.
Loewen, J. W. (1999) *Lies Across America: What Our Historic Sites Got Wrong*, New York: The New Press.
Rosenzweig, R. and Thelen, D. (1998) *The Presence of the Past: Popular Uses of History in American Life*, New York: Columbia University Press.

10

Representing diversity and challenging racism: the Migration Museum

Viv Szekeres

The Migration Museum in Adelaide, South Australia opened in 1986 with the brief to document, collect, preserve and present the evidence of South Australia's immigration history. The museum also aims to create a greater awareness of the cultural traditions that survive and now contribute to the rich cultural diversity of the State.

These seemingly clear and simple aims do not perhaps immediately reveal the complexity that underlies them – unless of course questions are raised such as: Whose history? Told from which point(s) of view? Who is included and who left out? Whose voices are foregrounded and whose silenced – and is this typically the case? In fact, endless questions that are located in the arena of meaning-making and the construction and representation of reality.

It is these more difficult, though more interesting, questions that the twelve staff of the museum grapple with and debate. They do this not only from their own perspectives, but also from the perspective of operating within a State Government funded organisation, forming part of a larger South Australian History Trust that contains several divisions. The issues then, of voice, identity, and of who is speaking on whose behalf, surrounded the enterprise from the outset.

It is interesting that images and understandings about Australia from overseas often focus on the bizarre and exotic. There are the sharks, the cuddly koalas, the nasty snakes and spiders and some dubious cultural ambassadors, such as Dame Edna, Rolf Harris and Crocodile Dundee. Not to mention of course, the images and misinformation that surround Indigenous Australians. Given this picture alone it is difficult to contemplate what social inclusion might look like, so a brief demographic history providing some sense of a social and cultural framework is a useful backdrop.

Australian demography: an overview

Australia sits on the edge of the Pacific Rim. It is a somewhat ambivalent position because while this logically fits, at least in geographic and economic terms,

with Asia, Australia has in fact been aligned, since 1788, by strong cultural bonds to what is still referred to in some circles as 'The Mother Country'. Approximately 75 per cent of Australia's population claim Anglo-Celtic origin.

A map of Indigenous Australia before colonisation demonstrates the existence of hundreds of Aboriginal groups. This may help to explain the continuing indignation of Aboriginal peoples at the assumption that was made by the British Crown when, in 1788, they declared Australia to be *terra nullius*, the land of no one. This fiction was only recently and reluctantly acknowledged by the Australian government and is still by no means resolved. Invasion, as it was for the Aboriginal people, or colonisation as it is called in European history books, began with a penal colony in New South Wales and continued as a gradual process across the continent. It wasn't until 1836 that South Australia was proclaimed a colony, where the sale of land to wealthy businessmen raised sufficient funds to ship out free settlers, who it was hoped would work the land. To give some sense of attitudes about who belonged and who did not at this time, from the point of view of white settlers, one example (and there are hundreds) is some evidence presented to the House of Commons in 1837 by the Reverend E. Yates who reported:

> I have heard again and again people say that they [Aboriginal people] are nothing better than dogs, and that it was not more harm to shoot them, than it would be to shoot a dog when he barked to you.
>
> (cited in McConnochie et al. 1988: 59)

The Migration Museum

The Migration Museum itself houses its own history of several groups of outsiders who have been and continue to be treated as pariahs – Indigenous peoples, unemployed men, dispossessed women and the elderly poor. In the 1850s the first Aboriginal school was built on the museum's site. Aboriginal children were removed from their parents to be taught the ways of the whites. It took another 150 years before a Royal Commission was to investigate this practice and document the effects of the removal of Aboriginal children from their parents. The museum acknowledges this early Aboriginal history with a plaque in the courtyard, exhibitions and education programmes. Following the closure of the Aboriginal school, the site became a Destitute Asylum and was surrounded by a high wall, topped with tumble brick and broken glass, which effectively separated the poor inmates from the 'good citizens' of nineteenth-century Adelaide.

By the late 1850s the combination of economic recession and the discovery of gold in Victoria had created huge social problems for the early colony. There was a mass exodus of men seeking their fortunes in Victoria and leaving behind hundreds of destitute women, many pregnant. The residue of this history still clings to buildings known as the Lying-in Hospital and the Mothers' Wards. The stories of these women and their children are told in a display and publication called *Behind the Wall* (Geyer 1994).

The Migration Museum then, deals by definition with concepts of belonging, of inclusivity and with meanings surrounding the notion of 'home'. For the staff of the museum the task was understood to be that of representing the immigrant experience. Such stories would include those of early settlers, immigrants and refugees, not to mention the devastating impact that colonisation had on Indigenous peoples.

One of the first questions to be addressed was a basic one – which groups to represent? Some of the larger and more established community groups also began to lobby the museum, as they wished to be represented under their national banner. Had this model been adopted, the museum would have had for example a Polish section, Italian section, Greek section and so on. There are more than 150 groups who identify themselves by their ethnic origin, Australia being one of the most culturally diverse nations in the world. The model that was finally adopted followed a chronological story of immigration to, and settlement in, Australia, which enabled the museum to include different stories and different voices representing diverse moments in history. Another issue, which took longer to resolve, was how we should establish a collection. Within the first year it became clear that the museum was not going to acquire a collection through donated objects for many years. Analysis of why individuals and community groups were reluctant to donate objects revealed that many immigrant groups were cautious about dealing with government agencies. Furthermore, many had come to Australia as refugees with few possessions. Over the years these possessions had acquired great cultural significance to their owners and, understandably, they were not about to hand them over to anyone. The museum then introduced a policy of borrowing objects for display and it adopted a passive collecting policy. Currently the museum has a small collection of approximately 6,000 artefacts and 11,000 copy photographs. About 70 per cent of all objects on display at any time will be on loan from individuals and communities.

Planning of programmes emerged as a very sensitive area to navigate. On the one hand the museum was representing and even promoting cultural difference, but on the other hand it was desperately trying to avoid reinforcing stereotypical images and the potentially divisive aspects of difference. These tensions are, I believe, intrinsic for anyone involved in the work of representing diversity, and they are not easy to resolve.

A concrete example of such tension is provided in a description of early meetings held in my office. The curator and myself are negotiating between two groups from the same country with different religious beliefs. The several meetings with each group are held on separate occasions. The two groups do not wish to meet together. Each group has quite definite ideas of which bits of information are relevant and, even more clearly, which bits are to be left out. The discussion is confusing. It lacks logic until we intuit that we are negotiating around some very real but unspoken fears. Information that could be used in the programme in Australia has dangerous consequences for those who still live in the country of origin. Now this becomes not only a question of different

points of view but also an unspoken ethical dilemma. The challenge is to find a way to present the information in ways that have integrity and meaning and reflect their experiences, while at the same time protect their rights to privacy.

In representing people's real experiences, histories and identities the museum not only had problems between what is public and what is private, but also between competing versions of history amongst communities, particularly if they had been enemies for centuries. Of course, as in the previous example, there was and is, also, the problem of competing versions of the past from within the same community and across the generations.

What made it possible to proceed at all was that the nation was enjoying a period of buoyant optimism in the first flush of exploring the relatively new concept of multiculturalism. For the many who had lived through decades of a previous policy known as assimilation, there was a great sense of relief. The policy of assimilation is just as it sounds. Throughout the late 1940s, the 1950s and 1960s it had promoted the idea that to become a 'Good Australian' it would be wise to abandon all vestiges of personal cultural origin, customs and language and adopt cultural norms of Australian English, Australian dress and behaviour codes.

In contrast, multiculturalism appeared to accept ethnic, racial and cultural difference and promote ideas of self-esteem, respect and tolerance. This enthusiasm for the concept of multiculturalism enabled the museum to navigate around some of the internal politics within community groups and organisations. It enabled a critical analysis of previous policies that had impacted on immigrants and also, importantly, it allowed representation of a history of racism and intolerance.

Challenging racism

An example, which is featured in *The Immigration Story*, is a display about the Immigration Restriction Act. The legislation was more commonly known as the White Australia Policy and is central to the immigration story because it had a huge impact on the demography of Australia. Another probable legacy was that it encouraged a distrust and fear of immigrants, especially those from Asia. It was also the first piece of legislation to be enacted by the new Federal Government of Australia in 1901.

Although changes were made to the White Australia Policy during its seventy years of operation, it effectively prevented non-white immigrants from entering the country. For more than fifty years a dictation test was used as one of the mechanisms for judging eligibility. The dictation test was not always administered in English and one of the more notorious and absurd examples was the case of Egon Kirsch. He was a Jewish political activist from Czechoslovakia who spoke at least six languages fluently. When he tried to enter Australia in 1934 to warn people about what was happening in Nazi Germany he was given the test in Scottish Gaelic. Naturally he failed. The Act was designed to keep

out anyone who was judged by the immigration authorities to be an 'undesirable'. Egon Kirsch was considered to be from the dangerous political 'left'. One of the reasons we know of his case is that he actually jumped ship and his supporters took the government to court. Scottish Gaelic was found not to be a language but a dialect.

This is just one of the stories that is told in the museum, along with others that do not reflect well on either the nineteenth-century colonial government or on the twentieth-century federal government. Given that most of the Museum's funding comes from government sources, visitors from countries such as China, Indonesia and even America find it unusual that many of the displays are openly critical of government policies. It is interesting here to reflect about whether there is more freedom to be outspoken when funding comes from a democratic government than when it comes from business or industry sponsorship, particularly given the economic stringencies that most museums face.

When the museum was established, a deliberate decision was made to take an ideological position which would be clearly stated. Exhibitions were, and are, sympathetic to the experience of the immigrant. There is an acknowledgement that immigrants have been used as cheap labour; policies have discriminated against them for much of the century; and throughout this history there is the continuing presence of racism. For the individuals and communities whose stories were presented, and for many museum visitors, this position was welcomed. For others, fortunately only ever a small minority, the museum was viewed as a 'lefty' sort of place and as such, of course, could be relegated to the margins of what is taken seriously.

Under the banner of the newly-embraced multiculturalism, the museum embarked on the process of mapping how to represent all migrant groups. Though well intentioned, the production team would probably agree that we were fairly unsophisticated in our approach. The museum's first two changing exhibitions, one about costume from the Balkans and one about lace, did little to investigate cultural difference or to explore different histories. They simply displayed pretty things from different cultures. They were more ethnographic in content, rather thin on social history and certainly lacked any political analysis. Later a much more rigorous historical interpretation was introduced. Exhibitions were developed that focused on particular communities – for example, in 1988 a display about early German settlers called *Passenger from Hamburg*. Later one called *Il Cammino Continua* charted the continuing journey of South Australian Italians. The complexities involved in such stories opened possibilities to represent issues with more subtlety, to explore multiple meanings, and allow voices to speak about previously silent areas.

This style of working led also to an interest in highlighting specific themes in terms of their social and cultural impact. Exhibitions on themes such as sport or childhood were developed, for example. This enabled the inclusion of many groups and analysis of cross-cultural connections. Interestingly, these topic-based exhibitions had enormous popular appeal. For example, *Strictly Black*, which

explored the many different cultural reasons and meanings behind why people have worn and still wear black clothes; an exhibition about sport, called *Fair Game*, which took gender and discrimination as its main theme; and recently a travelling exhibition about food, called *Chops and Changes*, which showed that the ubiquitous lamb chop was now off the menu, displaced by foods from all over the world, brought in by immigrants after the Second World War.

Dozens of members from the communities whose stories we were representing were actively involved and participated in the process of developing programmes. But in the final analysis, or exhibition, it was essentially our version of their story that was displayed. Of course community members were interviewed, their stories recorded and their objects borrowed for display. But it was the museum staff who interpreted what was of significance within this range of material. Our brief, as we saw it, was to focus on ethnicity and difference – which would of course affect what we saw as important. Perhaps one of the key points here is that history museums cannot pretend to be objective. Historical interpretation and objectivity are contradictory ideas. Given that we cannot be objective, then at least let us honestly own our own bias and author displays. Let us also ask the public for their opinion and include these responses – as we frequently do with pin boards, which allow the visitor's interpretation as well as their opinion of displays.

Multiple voices

To balance the voice of the museum, a Community Access Gallery called *The Forum* was established. In *The Forum* for a period of three months, a community group presents their own display, telling their history from their own perspective. It is an ongoing programme with four *Forum* displays a year. In the mid-eighties this was a very novel concept. By now there are few history museums in Australia that do not have a community access space. From the perspective of community groups *The Forum* is a resounding success.

From the museum's perspective it enables us to meet and work with a range of people who become involved and interested in the museum's programmes and usually stay in contact. Each *Forum* launch brings notable community leaders, politicians and media to the museum, all of which helps build the profile. At another level the success and vibrancy of *Forum* activities depends significantly on the skills, cultural awareness and commitment of the curator who manages it.

The Forum raises the really big question of who exactly constitutes community. Who is it that the museum works with when we say we are working with the Slovenian, Indian or Cornish community? The answer is not straightforward. It would be possible to choose from dozens of different models to describe the protocols, procedures and levels of interaction that take place before even one of these displays can open.

For example, there was one community where power and control was administered entirely through the religious patriarchal leaders but where it was women who did all the work. Or the group where the organising committee was ruled with an iron rod by a quite formidable woman in her late seventies who made all the decisions and had the committee members running around in a frenzy trying to be helpful. Or the organising committee of twenty who were representing a relatively small community, but where every member of the committee had a different opinion about everything. Or a committee who represented just one of the regions of Italy and who managed to involve and represent a huge range of interests and who included the young and the very old, the religious and the secular.

To return briefly to the production process, which involves curators, designer, educator, and front of house staff, operations manager and myself as programme coordinator, decisions are made by consensus. As many of the staff have worked together for many years, their shared history is full of important moments of change and new directions based on emerging understandings. These have come sometimes as small incremental changes in approach, perception or presentation. At other times, a change of direction can represent a significant shift in thinking.

Exploring identities

One such moment was when a conclusion was reached that the way the museum was interpreting multiculturalism was much too narrow. It was decided to expand the definition to include not just ethnicity but other elements of identity such as class, race, gender, age and religion. It would have been good to say that our definition also included sexual preference, but it didn't. Perhaps at some stage the museum will include issues about sexual preference in its programmes. The reason this has not happened thus far indicates not only a lack of courage, but also the fact that most of the communities who work with us prefer not to think about, and certainly do not want to talk about, the gays and lesbians who are amongst them.

However, in spite of such limitations, our thinking represented a major shift, for it meant that ethnicity became only one of a number of aspects of identity. Visitors could now be introduced to some of the complexities that surround the concept of identity. Elsewhere I have described these as being like layers of an onion. A more poetic analogy is the petals of a tea rose. Under each layer of petals is another, which under the right circumstances of light and sun unfurls to reveal itself. So it is with identity – each of us has several identities, some of us have many, and different aspects of identity are relevant in different contexts.

An example, which might illustrate the point, happened a few years ago. The Hellenic Women's Cultural Group of the Pan Macedonian Society asked one of the museum's curators to attend a discussion that they were having about their

past and their lives. They showed her household items and personal treasures, which they had brought with them when they emigrated. Each item triggered a memory and a story. The result of this meeting was a display, which they called *Cycles of Life, Our Family, Our Home, Our Church*. Although this group identifies strongly as Macedonian Greek, the story they wished to tell, and which ended up being in the display, was not about themselves as Macedonian Greeks. It was about themselves as women, as daughters, grand-daughters, wives and mothers. It also highlighted another major feature of identity and of cultural difference, that of age. As they grew older they knew their story to be grounded in their times. With immense clarity they set out to communicate to later generations because they knew that their memories had begun to fade. They also realised that, as members of their group died, much of their history died with them.

The matter of who is included in museum displays starts with perceptions about identity – exactly which aspects of identity will be the subject matter represented in the display. The second issue is the question of why a particular subject matter has been chosen. Perhaps this is best understood in the context of another example from the museum's experience.

In the early 1990s Australia reluctantly began to prosecute some of those accused as war criminals from the Second World War. The first case in Adelaide involved a man accused of being a member of the Ukrainian Special Police. He was accused of commanding a troop who had massacred a large number of Jews. Public opinion was divided about whether this man was a monster or, as the right wing press described him, a gentle, 70-year-old grandfather. Never-theless, in spite of the ambivalence that surrounded his trial, South Australia's Ukrainian community became nervous and concerned that they could be labelled as war criminals. At about this time the President of the Ukrainian community contacted the museum, as the community wanted to mount an exhi-bition about their history, culture, religious practice and the traditions they brought with them to Australia. The museum agreed to assist them to mount their display, which opened with a lively festival over a weekend. Neither the President nor members of the Ukrainian organising committee talked to staff about their motives for wanting to mount this exhibition at that particular time – not, that is, until after the display was finished and the war criminal prose-cution had failed for lack of evidence.

How staff at the museum feel when we are clearly involved, wittingly or unwit-tingly, in matters of legitimising and promoting certain aspects of a past, whilst keeping silent about other aspects, is a matter of ongoing discomfort and debate amongst us. Every time a decision is taken about which exhibition is included in the programme, the museum faces the same kind of dilemmas. Every deci-sion will include some individuals and groups but will exclude others. Long-term strategic planning has become an absolute necessity for us.

A feeling of belonging

Another story from the Second World War illustrates a slightly different point, which is about the importance of belonging. The vast majority of the museum's constituents or stakeholders want to tell their stories and want recognition for their contributions to the development of Australia. Furthermore, they want to feel that they now belong somewhere. This need to belong is especially true for those who came as refugees.

This particular story began on the nights of the 13th and 14th of June 1941; the Soviet armies made hundreds of lightning strikes against the people, in particular against the intelligentsia of Estonia, Latvia and Lithuania. As a result thousands were arrested and deported to Siberia and were never seen again. Those who escaped this round-up fled west into Germany. After 1947 they were amongst 170,000 Displaced Persons who came to Australia as refugees. The Baltic Communities Council who represented some of these refugees wanted to find a way to tell Australians why they had come here and, for the first time in fifty years, to remember and commemorate those who had not made it. The museum's response was to establish a Remembrance Wall called *Reasons to Remember*, and currently we have eight plaques, which include one from the Vietnamese, Jewish, Serbian, Slovenian, Ukrainian, Polish, Tatar Bashkurt and Baltic communities. What has emerged quite spontaneously, and I doubt that the museum could have planned it even if it had tried, are the annual commemorative 'services' arranged by the communities represented on the wall. Several of these groups come each year and lay a wreath and enact a small ceremony of remembrance. The wall, and in this sense the museum, has become a sacred site as a symbolic resting place for the dead and a tangible example of belonging. In fact, at the launch for the Vietnamese Plaque last year, which was attended by several hundred members of the Vietnamese Community, they performed the Blessing of their Ancestors – a ceremony never performed in Adelaide before. One of the museum's curators was told that this event and the plaque had extraordinary significance for them and represented a feeling of belonging, of acceptance and of finally being at home, in ways that they had not felt before.

The idea of belonging raises another highly complex issue, which surrounds the concept of inclusion. It assumes, albeit loosely, a sense of ownership. Put bluntly, it implies that some have the defining power to include or not to include – to define as important or not so important in the broad picture.

This issue has come to the fore in the museum recently when immigrants who came from Britain have felt that they should feature more prominently in exhibitions. A visitor who went through a *Forum* display mounted by the Tatar Bashkurts, who are a refugee community oppressed for many years by the USSR, left a comment in the visitors' book. She said: 'As the English in Australia are now an abused and oppressed minority, should they be represented here?' Numerically, Anglo-Celts are by far the largest group in Australia and they are, of course, represented in museum displays. Reality is not the issue here but, rather, perceptions or misconceptions that the museum must deal with.

At the same time that the exhibition production team is finding ways to address such problems, Australia is also dealing with a change in Australian politics, which has impacted on concepts of multiculturalism. For the current federal government, multiculturalism is off the agenda, which has repercussions for museum programmes. The current Conservative Government is critical of former multicultural policies and in the political climate that they have created, parties such as Pauline Hanson's One Nation Party gained enormous public support. Her main message was that Australia was at risk of being overtaken by Asians – and that the real 'battlers' (working-class Anglo-Celts) were being overrun. Although the One Nation Party is thankfully disintegrating, there is no doubt, especially in economically difficult times, that the sentiments still exist. The facts are that the 1996 census estimated that 8 per cent of Australia's population are from Asia, the Middle East and North Africa.

A similar backlash against the stance taken by the museum is the notion that any analysis that is critical, or that raises problems from the past, is suspect. So when the museum recently mounted a very confronting exhibition about the plight of refugees, called *A Twist of Fate*, it was attacked from some quarters for being 'too politically correct', this phrase now being used as a term of abuse.

When the museum launched a plaque in the courtyard, which acknowledged the existence of the Aboriginal school on the museum's site, and we also made a public statement of 'Sorry' for previous wrongs done to Aboriginal people, some accused the curators and myself of peddling a 'black armband history'. This phrase has become that which is used to refer to any analysis of colonisation that is not celebratory and is a concept that is having a huge and detrimental impact on the process of Aboriginal Reconciliation.

A couple of years ago a Conservative federal politician, a member of the Prime Minister's Cabinet, from a family who were prominent in South Australia during the nineteenth century, told me that in his opinion the Migration Museum was nothing but a museum of misery. Why couldn't the museum proudly tell the 'Happy Migrant' story, the many stories of success? Given that there is no doubt that in more ways than not Australia's immigration history has been an extremely successful experiment, why does the museum not follow his advice? The answer is because the story he would like us to tell is less than half the story. It would only include a fraction of the people whose stories are currently included. Even if the museum restricted displays only to those of the majority who came from England, Ireland, Scotland and Wales, or the early pioneering settlers, the process of immigration, of leaving one place and settling in another, is never easy even if the story may have a happy ending.

One of the museum's curators has just completed a photographic history of 100 years of immigration to mark the Centenary of Federation. Amongst the 500 photographs that she chose are some smiling faces, but the stories behind even those photographs often contradict that happy image. Alienation, isolation, struggle and deprivation are much more common themes. And then there are the gaps in the photographic record, the people who were rarely included in the life of the Nation, out of sight and out of mind.

For the moment, with projects like this photographic one, *The Forum* and the changing exhibition programme, the Migration Museum is attempting to tell a larger story. It will never be the whole story, or the whole truth. It will always be our version or someone else's version of the truth. But perhaps over the years, the museum can create a mosaic of different interpretations, which will contribute to shaping the picture of our country. The picture needs to include Indigenous people, immigrants, settlers and refugees, and they need to be placed very firmly in the centre of the picture rather than in the margins or just outside the frame.

References

Geyer, M. (1994) *Behind The Wall: The Women of the Destitute Asylum, Adelaide, 1852–1918*, South Australia: Axiom.

McConnochie, K., Hollinsworth, D. and Pettman, J. (1988) *Race and Racism in Australia*, Australia: Social Science Press.

11

Developing a community of practice: museums and reconciliation in Australia

Lynda Kelly and Phil Gordon

Introduction

Museums in Australia have been actively involved in reconciliation since the late 1970s, long before its recognition as a formal political movement. In 1978 the UNESCO regional seminar, *Preserving Indigenous Cultures: A New Role for Museums*, was the first time museums and Indigenous people[1] sat down together as equals to talk about obligations and processes: the obligations of museums to respect Indigenous people's rights to their cultural heritage and addressing this within the practices of museums at the time.[2] Since then there have been immense changes in how museums have dealt with these issues, resulting in new relationships forged between Australian museums and Indigenous peoples in response to both internal and external political and cultural forces. This has produced a *community of practice* (Lave and Wenger 1991), where 'collective learning results in practices that reflect both the pursuit of enterprises and attendant social relations. These practices are thus the property of a kind of community created over time by the sustained pursuit of shared enterprise' (Wenger 1998: 45). Museums in Australia and the Indigenous communities that they work with have formed a community of practice: a learning community sharing common goals and developing sets of practices within a social relationship built over time, a community that continues to grow and shape its future.

This paper outlines issues for museums[3] in promoting reconciliation in Australia and the roles that they have played and continue to play, as agents for social change and inclusion through public learning and working with Indigenous communities. A number of audience research and evaluation projects will be discussed that show the difference museums can make in the reconciliation process and the consequences for future practice and social change, with a specific focus on the Australian Museum, Sydney.[4] We propose that the process by which Australian museums have built working relationships and shared understandings with Indigenous people, particularly at the practitioner level, could form a template for how museums deal with other issues and make themselves relevant to the broader community through active engagement with multiple communities of practice.[5]

Reconciliation in Australia: the 'people's movement'

The Australian Reconciliation Council has stated that: 'Reconciliation is about building new relationships between Aboriginal and Torres Strait Islander Australians and the wider community, one that heals the pains of the past and ensures we all share fairly and equally in our national citizenship' (Graham 1997: 8). The original inhabitants of Australia, the Indigenous people, have lived on this land for at least 60,000 years. After 1788 Australia began to be settled by Europeans, resulting in the removal of Indigenous peoples from their homelands and a cycle of dispossession, marginalisation and social disadvantage that has implications to this day.[6]

A number of key events in Australia's recent history have contributed to an increased awareness of the issues amongst Australians, resulting in political responses by Indigenous and non-Indigenous people. In 1965, the Freedom Ride through north-western New South Wales (styled after the United States Freedom Rides in the South) exposed racism issues to the broader community. With support from over 90 per cent of Australians, the 1967 referendum gave the Commonwealth Parliament the power to make laws for Aboriginal and Torres Strait Islander peoples, ensuring that they would be counted in the census, leading to uniform citizenship and voting rights. The Racial Discrimination Act in 1975 and the Land Rights (Northern Territory) Act in 1976 were also important contributions to a growing land rights, political rights and human rights movement. The 1992 High Court judgement in the Mabo case, where people from the Murray Islands asked for legal recognition of their native title rights, marked the beginning of a concentrated push for reconciliation in Australia. This landmark decision recognised prior Aboriginal ownership of Australia, overturning the concept that at contact Australia was *terra nullius*, that is, an 'unoccupied land' or 'land belonging to no one'. This led to the recognition of native title within Australian common law through the passage of the Native Title Act in 1993 (Council for Aboriginal Reconciliation 2000; Grattan 2000).

In 1991 a national enquiry into Aboriginal Deaths in Custody[7] recommended that reconciliation between Indigenous and non-Indigenous Australians must be achieved to progress social justice for Indigenous people. In response to this, the Council for Australian Reconciliation was established by a unanimous vote of the Federal Parliament with a ten-year brief to promote, 'a process of reconciliation between Aborigines and Torres Strait Islanders and the wider Australian community' (Council for Aboriginal Reconciliation 2000: 5). In 1997 the Human Rights Commission report, *Bringing Them Home*, highlighted the effect that the forced removal of Aboriginal children from their families had in fragmenting Aboriginal culture, contributing to social disadvantage. The report concluded that, in the period from 1910 to 1970, when the practice was at its peak, between 10 and 30 per cent of Indigenous children were forcibly removed from their families and communities, with no family unaffected. This report had strong resonance within the Australian community, and the issue of the 'Stolen Generations', as they became known, was a further trigger for reconciliation as well as generating much heated debate.

In 1992, Paul Keating, when he was Australian Prime Minister, addressed a gathering at Redfern Park, Sydney to launch the beginning of the International Year for the World's Indigenous People. This was the first time a Prime Minister acknowledged in a public forum the injustices suffered by Australia's Indigenous population and the urgent need for social change through reconciliation (Keating 2000). In 1996 a Conservative Federal government was elected that brought a different emphasis to social issues, with responses that were often out of step with community concerns. For example, despite the fact that '65 per cent of Australians supported a formal parliamentary apology being made to Aborigines' (Newspoll et al. 2000: 52), and the majority of State governments having done so, the current Federal government still refuses to apologise to Indigenous people for past injustices.

When asked about reconciliation, Australians recognise that: 'Official action can contribute to a climate, but in the end it will be what is done by ordinary people in their day-to-day lives which will be the measure of reconciliation' (Newspoll et al. 2000: 41). Reconciliation today is referred to as the 'people's movement' with many Australians signing sorry books, participating in marches and generally taking an active interest in the process and outcomes (Figure 11.1). The destination for reconciliation as expressed in the vision of the Council for Aboriginal Reconciliation is: 'A united Australia which respects this land of ours; values the Aboriginal and Torres Strait Islander heritage and provides justice and equity for all' (Council for Aboriginal Reconciliation 2000: 2).

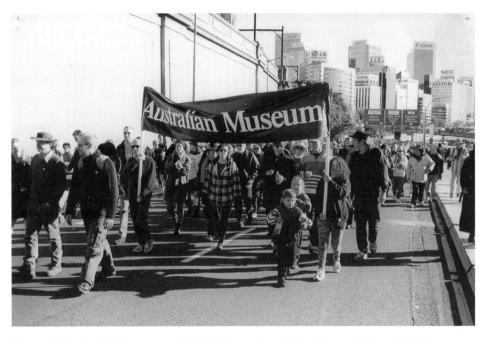

Figure 11.1 On 28 May over 250,000 Australians joined the People's Walk for Reconciliation across Sydney Harbour Bridge as part of Corroboree 2000. Photo Lynda Kelly.

The role of museums in contemporary Australian society

Museums have changed rapidly in the twentieth century from 'cabinets of curiosities' with thousands of objects displayed in didactic ways to institutions that are about ideas, actively encouraging debate, critical thought and action (Griffin 1998b; Kelly 2000a; Weil 1995, 1997). Museums are increasingly becoming involved in political issues, they are 'inherently political: they show some things and say some things, and not others' (Griffin and Sullivan 1997: 11). Many are more willing to engage in discourses that are confronting and controversial (Griffin 1998b; Macdonald 1998) and to work with their communities to provide rich learning experiences for a variety of users as 'safe places for unsafe ideas' (Gurian 1995). The recognition of the primary rights of Indigenous people to access their cultural material has set museums in Australia apart from other countries in the way they are responding to these issues.

Although the UNESCO conference in 1978 was a significant event in transforming the working relationships between museums and Indigenous people (Griffin 1996; Specht and MacLulich 1996), these changes have not been uniform in museums throughout Australia. Some, particularly those with significant collections of objects, secret-sacred material and human remains, were more willing than others to work with Indigenous communities in facilitating access to cultural material and involvement in public programmes. In 1993 the adoption of a national policy for Australian museums, *Previous Possessions, New Obligations: Policies for Museums in Australia and Aboriginal and Torres Strait Islander People*, was an important milestone that provided a framework for museums to engage in new ways with their Indigenous constituents, as well as placing an obligation on them to do so (Griffin 1996, 1998a). There has been a huge shift in expectations from both parties with an increased willingness to talk about ways Indigenous people can achieve their own cultural objectives in partnership with museums. This process has been one of open discussion and constant re-evaluation of internal processes aimed at changing the way both parties thought about the issues and subsequent practices (Gordon 1998a; Griffin 1996, 1998a; Kelly et al. 2000).

It has been recognised that museums need to act as facilitators and partners rather than as patriarchal institutions imposing their views and practices on the peoples whose cultural material they hold (Gordon 1998a; Griffin 1996, 1998a; Kelly et al. 2000; Vergo 1989). This has required a major rethink of many areas of museological practice in Australia, specifically in anthropological and archaeological research, collection management, conservation and public programmes. It was also widely accepted that the focus of museums needed to change from concentrating on objects to the meanings that they have within a cultural context, explained by Indigenous people in their own ways (Gordon 1998a; Griffin 1996, 1998a). The employment of Indigenous people within museums across a range of disciplines played a pivotal role in influencing attitudes and practice. There are also opportunities in many other areas where, in the past, dialogue with Indigenous people wouldn't have been considered, for example, scientific research in land management and biodiversity conservation;

the use of new technologies; reaching new audiences through different ways of accessing cultural material; and the management of intellectual property.

'[R]econciliation is about recognition, rights and reform' (Burney 2000: 68). For museums in Australia this has meant *recognising* the rights that Indigenous people have in their cultural heritage, their prior ownership and role as custodians of cultural material; giving them *rights* to access cultural material; and encouraging *reform* in practice. This has been evident in the ways that museums relate to and engage with Indigenous communities through a long process of working together and building relationships, resulting in collective learning through a community of practice. Museums in Australia are in a unique position to highlight Indigenous voices in public programmes and other activities, especially in this current political climate of confrontation, exclusiveness and reactionary movements. However, museums in Australia are in a state of flux, with new directors in seven major State museums and the National Museum in Canberra, Australia's capital, all within the past two to three years. In some States, significant capital funding has been made available for museum developments. For example a new museum opened in Melbourne, Victoria in 2000, the National Museum, Canberra opened in 2001 and there has been a significant injection of funds across the heritage sector in Queensland during the past two years.

There are many challenges facing museums in Australia. Data collected by the Australian Bureau of Statistics show that, in 1996, 28 per cent of Australians aged over 15 had visited a museum in the previous twelve months, yet in the most recent survey this figure had dropped to 20 per cent. Funding restrictions and increased competition from many sectors in the leisure, educational and tourism industries for a finite number of people means that museums in Australia must become more responsive to a range of audiences that use their services, both physically and via the Internet (Kelly 2000a, 2001b; Scott and Burton 2001). The demands of globalisation, access to new technologies and increasingly informed communities demanding rights to their cultural heritage are issues that museums must respond to. Responding to rural and regional constituents is a key policy area for governments who are more willing to fund museums outside capital cities to encourage cultural growth and economic sustainability.

These challenges can also be seen as opportunities for museums to make a difference. There are high levels of interest in topics such as sustainability, biodiversity, social justice and Indigenous rights by increasingly well-educated Australians (Kelly 2000b; Nelson 1999; Newspoll et al. 2000). For museums that are thinking strategically there is potential to receive funding that is being made available by governments for programmes that address these broad policy areas. The opportunities presented by new technologies, particularly in delivery of services to minority groups, are only just beginning to be explored. As well, there is potential for developing new audiences such as regional Australians, youth and Indigenous people who are wanting to engage with museums in different ways. Increased accountability means that new ways of working can

be developed and monitored through measurable and meaningful performance indicators that also assist in planning future directions.

Museums as agents for social change and inclusion

Reconciliation is not an end in itself but part of an iterative process of learning, change and growth. Museums presently have the opportunity to take a leadership role in promoting understanding of social change and being inclusive of diverse points of view, maintaining their relevance not only to Indigenous people but as active contributors to broader political debates. Museums do this in two key ways: as places for public learning and in the relationships they have established with Indigenous communities.

Museums and public learning

In thinking about their business there has been a shift in positioning for museums from places of education to places for learning. Museums are increasingly seen as key learning environments by those who work in them, write about them, and conduct research into them. At the same time, research has shown that people visit museums for enjoyable and meaningful learning experiences (Falk and Dierking 1995, 2000; Griffin 1998b; Hein 1998; Kelly 2000a; Weil 1997). An analysis of a series of exit surveys (n = 413) found that, when asked why they visited museums and galleries, the majority of visitors to the Australian Museum said *to experience something new*, followed by *entertainment*, *to learn* and because of *the interests of children/family* (Kelly 2001b). The primary way that museums facilitate public learning is through exhibitions.[8]

Exhibitions

Research has shown a lack of understanding by many non-Indigenous Australians about issues surrounding Aboriginal people, with strongly held perceptions that they get 'special treatment' (Kelly 2000b; Newspoll et al. 2000). However, it was acknowledged that in many instances this was because of an education system that, in the past, did not cover these aspects of Australia's history. Australians *are* willing to listen and understand (Kelly 2000b; Newspoll et al. 2000), which provides an opportunity for museums to assist in reconciliation in a practical way through exhibitions and other public programmes by providing access to information, objects, stories and Indigenous people themselves.

In 1995 the Australian Museum decided to redevelop the existing semi-permanent *Aboriginal Australia* exhibition[9] to present a contemporary view of Indigenous people and deal with key issues arising from the Royal Commission into Deaths in Custody and reconciliation. A deliberate decision was taken by the museum to reflect current concerns and foreground the voices of Australia's Indigenous people, specifically New South Wales communities. At that time this was quite groundbreaking, requiring a whole new way of approaching content

development, interpretation, audience research and consultation.[10] It meant a number of conceptual shifts for the museum: from museum interpretations to Indigenous peoples' stories based on their own experiences; from an object-focused exhibition to a thematic one based on current issues of importance to Indigenous people; and an emphasis on audience research, listening and responding to a variety of stakeholders throughout the development of the exhibition (Kelly 1997; Kelly and Sullivan 1997; Specht and MacLulich 1996).

A variety of strategies used in the front-end evaluation to meet the needs of identified audiences and stakeholders incorporated multiple ways of collecting data to ensure triangulation (Cohen and Manion 1994). These included a number of separate, yet interrelated, projects: quantitative and qualitative visitor interviews, surveys and workshops with Indigenous people, focus groups and prototype testing (Kelly 1997; Kelly and Sullivan 1997). Indigenous communities in Australia are widely distributed with many diverse people and viewpoints, therefore, usual evaluation methods, such as surveys, interviews and focus groups, need to be combined with more flexible ways of collecting information. An emphasis on extensive consultation[11] and liaison with Indigenous communities was important to ensure incorporation of new information and feedback for responsive and relevant content (Kelly 1997).

The evaluation showed that visitors and stakeholders wanted an exhibition that explored contemporary issues, with objects to touch and investigate, where they could meet an Indigenous person and hear their stories and points of view in ways that helped guide people through difficult issues, in ways that provided mediation of confronting content and in ways that left a positive message for the future (Griffin and Sullivan 1997; Kelly 1997; Kelly and Sullivan 1997). The political and social context in which the exhibition was developed also needed to be considered. Native Title, Deaths in Custody and Stolen Generations were prominent political issues at the time with extensive media coverage and debate. This made consultation more difficult due to the sensitive and confrontational nature of the subject matter, requiring more intensive discussion and negotiation to ensure that these were dealt with in a culturally sensitive way that also met audience needs.

The exhibition was developed from the outset to cover a wide range of topics important to Indigenous people, as well as showing their diversity in material culture, beliefs and geographic location, coupled with contemporary views and representations of Indigenous people. This made the requirements for consultation a challenging one given limitations of money and time. To this end, it was decided that the process would need to be managed in a way that allowed the greatest input by a large number of Indigenous people. First, the Indigenous staff at the Museum were brought together to help develop key issues and interpretive strategies in a framework that could be responded to by Indigenous communities. The Museum's Aboriginal Heritage Unit then undertook a series of community seminars throughout New South Wales and attended forums to discuss the framework, which ensured that specific issues such as Deaths in

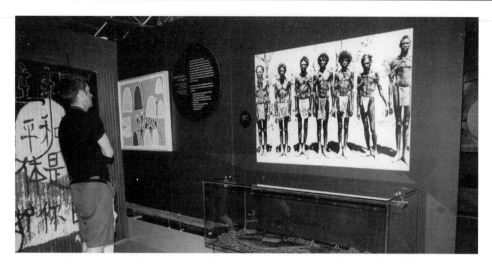

Figure 11.2 Australia's Secret Histories: the summative evaluation showed that this section of the exhibition had an incredible impact on visitors. Photo Lynda Kelly.

Custody, the Stolen Generations and Family, that had been identified as important, were included in the exhibition.

The front-end evaluation was a vital reference point, a touchstone for resolving difficult issues of interpretation as they arose (Kelly and Sullivan 1997). *Indigenous Australians: Australia's First Peoples* opened in March 1997 and is huge in scope, size, intellectual input, diversity and emotional impact, with an expected lifespan of around ten years. The exhibition explores themes of spirituality, cultural heritage, family, land and social justice using a variety of interpretive strategies whilst emphasising the Indigenous voice. One way this is achieved is through a series of oral history videos where Indigenous people tell their own stories in their own words. This moves visitors from the familiar – 'they are people just like me telling their life story in their own way' – to the unfamiliar, dealing with confronting issues of dispossession, social justice and the resulting fracturing of family and culture, through a constructivist approach to learning (Hein 1998).

One important lesson the museum learned from this is that wide consultation is critical in developing public programmes that are 'culturally appropriate, respect Indigenous cultural belief systems and knowledge, and contribute to understanding and appreciation of Indigenous cultural heritage' (Graham 1997: 8). In 1998 the exhibition won the New South Wales Premier's Award for Excellence in Public Sector Service Delivery on Social Justice Issues (Figure 11.2).

Visitor learning

Learning is a key issue for museums to address, particularly in the current environment of increased competition and accountability. How are we going to demonstrate to funding bodies and other stakeholders that our programmes are

making an impact? How do we know that learning happens? Learning is a dynamic process dependant on the individual and their environment within a social context that focuses on some change. Measuring learning in a museum context requires imagination, creativity and commitment using a variety of methodologies drawn from a range of disciplines (Falk and Dierking 1995, 2000; Hein 1998; Kelly 2000b, 2001a; Schauble et al. 1997; Schouten 1992). Ultimately, museum learning is about 'changing as a person': how well a visit inspires and stimulates people into wanting to know more, as well as changing how they see themselves and their world both as an individual and as part of a community (Kelly 2000a, 2001a; Lave and Wenger 1991; Marton et al. 1993). Through this process it is important to understand for visitors 'what difference did it make that your museum was there?' (Weil 1994: 43).

Has the exhibition made a difference to visitors? To test this, a number of methodologies were used in evaluating the impact of the exhibition: a survey of attitudes and concepts with similar questions administered to a sample of visitors before they entered the exhibition and after; a qualitative study of long-term change; a semiotic analysis;[12] and a tracking study. Media reviews and the museum's Public Comment Book were also monitored.

The visitor survey showed an increase in understanding as well as engendering a sense of empathy for the way Indigenous people had been treated in the past. Regarding questions about increased knowledge of stolen children and native title the rate of converting 'don't know' answers to correct answers was between 50 and 70 per cent. After visiting the exhibition 56 per cent of visitors felt that relationships between Indigenous and non-Indigenous Australians had improved, compared to 45 per cent of visitors before they had seen it. When surveyed on exit, 57 per cent of visitors stated that the exhibition made them more *interested*, 54 per cent more *understanding*, 50 per cent more *informed*, 43 per cent *sad* and 39 per cent *hopeful*. When asked what they would tell their friends, most talked about how it informed them of the issues and the importance for all Australians to learn about these: '[It's] very interesting, informative. Come and bloody see it!'

The fact that the Indigenous 'voice' was prominent in the exhibition was cited by many visitors: '[the exhibition was] enlightening – understanding of situation from an Indigenous point of view.' When asked who they thought was telling the stories in the exhibition, 75 per cent of visitors stated that it was Indigenous people themselves and not the museum. However, it was noted in the semiotic analysis that: 'The curatorial voice remains, and it has a role. If there is to be reconciliation it needs dialogue, and dialogue needs more than one speaker' (Hodge 1998: 22). This study also maintained that the consultation work the museum undertook was critical to the success of the exhibition and could be seen through unobtrusive but pervasive signs that went beyond written exhibition texts, with obvious care taken to be inclusive and not cause offence, and with a strong Indigenous voice coming through in the interpretation, especially the oral history videos (Hodge 1998).

Eighty-four exhibition visitors were tracked by museum staff, with notes made of stops, behaviour and time spent. This study showed that objects were of major interest, with high visitor attention to exhibits in the early parts of the exhibition, waning during the middle but increasing significantly at the end, where emotional issues of secret histories and social justice were dealt with. The oral history videos were well used, usually in the five exhibits most often looked at in each section. Visitors observed showed 'reflective' behaviour: they spoke very little to companions, tending to view exhibits on their own, echoing results reported in the Holocaust Memorial Museum evaluation (Gurian 1995). Most visitors surveyed pre-visit expected to stay in the exhibition for less than 30 minutes, yet on exit 72 per cent reported having spent more than 30 minutes. The tracking study showed that the average time spent in the exhibition was 23 minutes, with a range of 5 minutes to 2 hours.

Focus group interviews were held with adults and children six months after they had visited the exhibition to investigate long-term learning, impact and change. Participants in this study gave many examples of gaining greater understanding through relating what they had seen in the exhibition to their own experiences and knowledge:

> I came again actually to have another look at the exhibition. What really struck me, I think, is a feeling of dispossession . . . and in a way there were many similarities to the Welsh people. The English, of course, came into and invaded Wales and took over half of the village houses and tribes, and later on they actually banned the Welsh language from being spoken. So we have many similarities that I noticed going around.

Participants also talked about thinking differently after seeing the exhibition:

> I thought differently. I've met Aboriginal people . . . and it didn't click with the way that, as a child, when you grew up and everything you heard [was negative] and then you see an exhibition like this, well then you see a lot more of the story.

Another respondent said: 'Every time you hear about Aboriginals they're either going to jail or fighting. [Now I'd] think why do they always show this type of story? Why don't they show the nice story?'

When prompted by photographs of the exhibition, participants wrote vivid descriptions of how they remembered feeling at particular points. They reported doing the following after their visit: buying Aboriginal books; purchasing Aboriginal artworks; using the information in school projects; recommending the exhibition; returning to the exhibition with others, thinking differently and gaining more understanding of and respect for Indigenous people. In terms of learning, the exhibition is a fantastic example of how a visit can inspire and stimulate people into wanting to know more, changing how they see themselves and their world. As one visitor wrote in the museum's Public Comment Book shortly after the exhibition opened:

> Thank you for the marvellous and moving Indigenous Australians exhibi-
> tion. We need this now especially when racism is rearing its ugly head and

Native Title rights are in the process of being overturned. Everyone should see and listen to what people here have to tell us.

Working with communities

'Talking is the tool of reconciliation' (Grattan 2000: 8). Museums in Australia have a long history of talking to and working with a variety of communities (Gordon 1998a, 1998b; Griffin 1996; Kelly et al. 2000; Specht and MacLulich 1996), which is a key component in establishing a community of practice. A learning community is formed through the active participation of both parties in a process of change (Falk and Dierking 2000; Lave and Wenger 1991; Matusov and Rogoff 1995; Wenger 1998). There are three ways that these relationships have been, and continue to be, established, maintained and evaluated in Australia: through development of policy; Keeping Places in regional Australia; and repatriation programmes. Together, these form a package of responses developed by museums over the years to assist Indigenous people in the pursuit of their cultural objectives.

Policy

In the 1993 International Year for the World's Indigenous People, Museums Australia, the body representing museums and museum professionals in Australia, released a national policy following two years of development, including extensive consultations with museum staff, Indigenous communities and agencies and governments. *Previous Possessions, New Obligations: Policies for Museums in Australia and Aboriginal and Torres Strait Islander People* was designed to establish a national policy framework to provide consistency in guiding the development of partnerships between museums and Indigenous people and assist practice within museums (Gordon 1998a; Griffin 1996, 1998a; Kelly et al. 2000; Pearce 1997). The principles inherent in the policy promote the primary rights of Indigenous people in their cultural material held in museums, self-determination in cultural heritage matters and consultation in management of collections (Griffin 1996, 1998a; Kelly et al. 2000). Other countries responded to the challenges posed by these issues in two ways: through policy, for example Canada's 1992 policy, *Turning The Page: Forging New Relationships Between Museums and Indigenous People* (Ames 2000), and legislation, particularly the 1990 United States Native American Graves Protection and Repatriation Act (Sullivan et al. in press). In the United Kingdom guidelines for repatriation practices have also been developed by the Museums and Galleries Commission (Leggett 2000).

An evaluation of *Previous Possessions, New Obligations* was undertaken in 2000 to review the effectiveness of the implementation of the policy and how it has influenced or changed practice in museums.[13] The evaluation involved a quantitative survey of major museums[14] and workshops with staff from larger institutions across Australia. Overall, the study found that the policy had achieved its goals in relation to the major collecting and research museums and galleries in Australia by providing a framework in which to establish the

primary rights of Indigenous people in the management and interpretation of cultural material held in museum collections (Kelly et al. 2000).

Four major findings emerged from this study. First, although awareness of *Previous Possessions, New Obligations* as a policy was generally low across organisations, the principles inherent in it had been incorporated into everyday practice and institutional policies. Participants in the workshops spoke passionately about their commitment to involving Indigenous people in programmes and respecting their rights and points of view, a positive and strongly articulated reaction to the policy's principles. Second, a lack of resources meant a varied level of response to the policy across institutions, with museums acting in isolation from each other and often in competition for resources. The third finding showed a concentration of resources within organisations, rather than outreach[15] and regional funding. Finally, there was universal recognition that *Previous Possessions, New Obligations* needed to be more inclusive of a broad range of contemporary issues that will impact on the next generation of policy and funding programmes, including Native Title, intellectual property rights, digitisation, new technologies and managing Pacific Islander collections.[16]

Previous Possessions, New Obligations can be viewed as an instrument for organisational change and learning: museums in Australia have had to change in response to the demands and expectations placed on them by Indigenous people and governments within a broad social and political context. One major outcome found from discussions with museum staff in the workshops was that institutions that have worked closely with Indigenous communities in developing public programmes, conducting research programmes or in policy development reported positive changes in organisational practice and in understandings on both sides. This came primarily through recognising that the dialogue is about 'relationships, not just objects' (Kelly et al. 2000). The employment of Indigenous staff was a particularly strong factor in assisting this process, something that more museums would like to increase. Overall, there was acknowledgement that these issues present opportunities for an integrated national strategy and closer working relationships across institutions and within Indigenous communities: developing a genuine community of practice in Australia.

Community museums: Keeping Places and Cultural Centres
'[T]he Aboriginal idea of belonging to the land and being responsible for country is critical . . . This relates to the idea of belonging not just to the land in general, but to a particular place, or "country" as we call it' (Burney 2000: 73).

In Australia, Keeping Places or Cultural Centres are an important way in which museums and Indigenous people can proactively respond to reconciliation through repatriation and educating the broader community about Indigenous issues. These community museums are established by Indigenous people in their local areas to house repatriated artefacts, host exhibitions, conduct education and research programmes whilst providing employment and a meeting place.

Keeping Places are a practical way that Indigenous communities and museums can respond to a range of concerns including access to cultural material; development of museological practices through training programmes in display, conservation, etc.; and in repatriation, ultimately making a significant contribution to the reconciliation process. The important factor is that each museum is 'a unique response to *community* wishes and needs and, as such, [is] more likely to be useful to [each] community' (Gordon 1998b: 122, emphasis added).

In an initial evaluation of Keeping Places in New South Wales and Victoria a series of workshops were conducted with Indigenous community representatives to discuss the reasons they were established, the goals and objectives they are meeting, with an exploration of the lessons learned for the future.[17] An analysis of responses found that Keeping Places were created for two reasons: to meet the needs of their own immediate community and for broader community outcomes (Kelly 1999).

Maintenance and preservation of cultural heritage was the main reason behind establishing a Keeping Place within the local community: 'To keep our culture alive through community displays, documentation of objects and artefacts, through education . . . [and] information on a database' (Kelly 1999: 4). Other identified ways of meeting community needs were in promoting contemporary ways of living and working, educating Indigenous youth in their cultural heritage as well as in 'traditional' practices, providing a meeting place for the community, and a place for preserving and maintaining artefacts, and establishing a way for Indigenous people to tell their stories in their own ways. Associated with this was the strong feeling that Keeping Places supported community spirit and pride, encouraging self-sufficiency through providing employment and skills and showing the diversity of culture, languages, stories and histories.

It was felt that Keeping Places were an effective way to promote Indigenous culture to the broader Australian community and overseas visitors, through education and tourism programmes, as well as viable businesses that bring economic benefits to a region. The positive aspects of establishing a Keeping Place were summarised as: 'Increasing pride and self-esteem through keeping the culture alive, and achieving self-sufficiency by educating the wider community, promoting ways of working together and with Government in documenting histories' (Kelly 1999: 6). Responding to diversity in community needs and outcomes ensures that: 'Aboriginal people [become] partners in the management of their cultural material . . . [and they] understand how museums can assist them' (Gordon 1998b: 123).

Following from this, a pilot oral history study was undertaken with Keeping Places as part of a broader documentation of the history of these in New South Wales.[18] A series of in-depth interviews were held with staff from a sample of four diverse Keeping Places to discuss their cultural objectives – why they were set up, what they are aiming to achieve, and what impact they are having in the Indigenous and non-Indigenous community.

The main theme that emerged related to self-determination. Keeping Places contribute to the achievement of Indigenous peoples' cultural objectives in their

own ways that are managed by them: 'It's ours. We're able to provide something to the wider community' (Interview Transcript 2). Another theme identified was the education of Indigenous and non-Indigenous people, especially youth, about history, stories and culture:

> To me the museum is one of the best things that has happened to the area because we've had that many schools go through, we've had that many university people go through, we've had that many tourists go through, it's unbelievable . . . It's a really good feeling to be able to share that with other people besides your own community.
>
> (Interview Transcript 3)

Associated with this was the instilling of pride and respect within the community by educating visitors through public programmes: 'it's educating the local non-Indigenous community of our ways [and because of that] we are getting a lot more respect from them now' (Interview Transcript 2).

Preservation of and research into significant sites within the local area was another important role identified for Keeping Places: 'So it's time to say "we want to preserve that site" so you can say "there's the site" and tell them the Dreamtime story and tell them what it means' (Interview Transcript 3). Keeping Places are also established as a dedication: 'I think one of the main ideas of this was to dedicate to the memory [of] the Aboriginal people that had suffered injustices in the past . . . and the people who tried to stand up for our Aboriginal rights [in] times of struggle' (Interview Transcript 4).

In summary, it was felt that Keeping Places contributed to the maintenance of culture as a path to reconciliation and understanding:

> culture [is a] big strong word when you look at it. It comes from your heart, and if you share it around everybody gets to know a bit more about it and they won't keep putting everyone down all the time . . . Sharing culture is the biggest part, or it's one step anyway.
>
> (Interview Transcript 3)

Although the Keeping Place movement is in its early stages in Australia, increasing numbers of communities are thinking about establishing something in their local area with plans to initiate a national policy to guide systematic development. Those working in and with Keeping Places see the many benefits of these community museums as a way to 'promote reconciliation through understanding' (Kelly 1999: 2).

Repatriation

Repatriation of objects is fundamental to the development of the relationship between museums and Indigenous peoples. At its broadest level, repatriation means returning objects and human remains to the Indigenous communities from which they were originally acquired. This act of returning an object, photograph or other cultural property to representatives of the originating culture is an extreme example of how far museums have come from their nineteenth-century perspective of collecting and documenting material culture

of 'dying' cultures before they disappeared completely. At that time the predominant view was that collections were the sole preserve of the curator, with no thought given to Indigenous people having any say in the management or display of this material.

How did this attitude shift? In the late 1970s there was a generational change in employment at all levels of museums, from directors to curators and researchers. Many people came from outside the 'classic' museum fields, such as universities and Indigenous communities, carrying no preconceived views about how collections could be accessed and used. During this time there was also a fluid and rapidly changing political environment in Australia, primarily through the Land Rights movement, which had a dramatic impact upon the perceptions of Indigenous rights within a museum context. The initial contacts between museums and Indigenous peoples centred on the return of skeletal remains and material of a secret-sacred nature. During the late 1980s and 1990s one outcome was the development of institutional policies relating to a whole range of issues that Indigenous people found important, such as access to collections, display of objects, training and employment.

In Australia, repatriation programmes have been undertaken since the late 1970s, although the extent of them varied between institutions. Currently, there is a national initiative, the *Return of Indigenous Cultural Property Program*, dealing with the repatriation of human remains and other objects of significance,

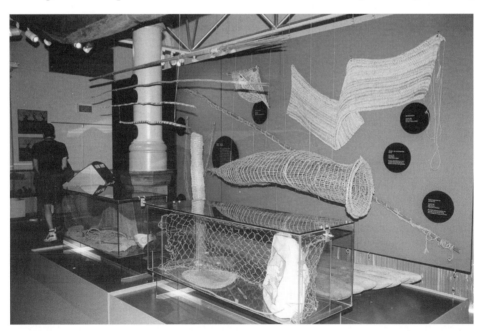

Figure 11.3 Many items that are repatriated to Indigenous communities cannot be shown due to their secret-sacred nature. Objects from the Museum's collections, such as fish traps, spears and clubs, are often sent on long-term loan to Keeping Places.
Photo Lynda Kelly.

jointly funded by the Commonwealth and State governments. The major aim is the return of cultural material and/or implementation of negotiations with appropriate Indigenous people about objects and remains held by large museums across Australia. Repatriation is a complex, time-consuming, yet rewarding process. Before it occurs a number of activities are undertaken: extensive collection research; visits by elders for identification purposes; field visits; update of database records; liaison with other institutions and communities; engagement of specific expert consultants; as well as budgeting for items such as transportation and packing costs. An associated *Community Support Program* covers travel and accommodation for community representatives for consultation, reburial expenses and ceremonies.

Repatriation, along with other activities that museums are pursuing to support Indigenous cultural objectives, is a positive response to reconciliation. The ways that museums have reacted to Indigenous political and cultural issues highlight how museums with flexible and supportive management structures can capitalise on the relationships that have been built up over time and take a leadership role in these areas. Through having to deal with highly emotive subjects such as repatriation of human remains and cultural material, not only have relationships been developed, but tested and strengthened, with opportunities in new and exciting areas being identified (Figure 11.3).

Communities of practice: museums, reconciliation, social change and inclusion

What Indigenous people and museums want is changing. It was reported recently in the United States that the NAGPRA legislation has had positive effects on the relationships between museums and Native Americans. Both sides learned more about each other and their needs, breaking down barriers through mutual understanding and working together (Kinzer 2000). This was also found in research undertaken into the effectiveness of the legislation in promoting organisational change with a sample of United States museums (Sullivan et al., in press). When thinking about the impact of museums in society we need to look at the difference they are making (Weil 1994). Museums in Australia have made a difference in promoting reconciliation principally through public learning and developing partnerships, working together to form a community of practice.

Bradburne envisions that the new museum will be 'a place where communities of learners can work together to generate new knowledge' (1998: 127). This is happening in the changing nature of relationships between museums and Indigenous communities, sharing understandings and dialogue about issues of common concern and exploring practical solutions resulting in a community of practice: museums and Indigenous people. Both of these groups share actively in structuring inquiry and learning as a community of learners, focusing on 'mutuality in joint activity and guidance rather than on control by one side or the other' (Matusov and Rogoff 1995: 98).

Future opportunities: 'practical' reconciliation

The current Australian Federal government is promoting a policy of 'practical reconciliation', specific strategies and programmes that focus on the future in areas such as education, health and employment (Howard 2000). Within a community of practice there are two ways that museums achieve social change: in accessing knowledge and through new ways of working together. Together these support the cultural objectives of Indigenous peoples, as well as taking advantage of government policy initiatives and funding.

Utilising new technology, which stores and retrieves information and stories, will be the primary way people will access knowledge in the future, particularly as 'Australians are fast adopters of new technology' (Nelson 1999: 38). Continuing to incorporate Indigenous views and practices into exhibitions and other public programmes is another way to include community voices. In being more accepting of their role in controversy museums can be conduits, acting as mediators through which these issues can be explored in more impartial ways. Different approaches to collection management and access can be achieved through: employment of Indigenous curators; responses to special needs such as secret-sacred material and repatriation; inviting community input to collection storage, information and stories; as well as providing virtual access.

Finding new ways of working together is another opportunity for museums, especially through outreach programmes and service delivery to regional Australia. This can result in government support and funding, as well as practical benefits to communities through economic development and tourism. Another novel way of working together is in bringing Indigenous perspectives to other aspects of museum work such as scientific research, both in anthropology and archaeology, as well as non-'traditional' areas like biodiversity, land management and evolutionary studies. Continuing an active policy of employing Indigenous staff across organisations and recognising the importance of having Indigenous people on Boards of Management and Trusts will further enhance this engagement and involvement, especially in areas such as Native Title, intellectual property and Indigenous knowledge.

Museums and reconciliation: can museums be agents for social change?

Australians recognise that there is a need for 'strong passionate leadership on the subject of reconciliation . . . [Australians are] moving towards the conviction that something more creative, more enlightened and more effective needs to be done' (Newspoll et al. 2000: 46, 51). Through their role in public learning and working with communities, museums have the opportunity to take on a leadership role and model sets of practices that can be followed and adapted by other organisations in their dealings with Indigenous people. Are museums able to meet this challenge? There is passion, commitment and creativity; is there leadership?

Museums will continually need to find new models to deal with the evolving requirements of contemporary society, responding to an ever-changing political climate and audience needs by recognising and reacting to opportunities as they present themselves. They will need flexible management structures that are able to change in response to the demands of the many communities they serve, whilst taking a strategic and long-term view. Museums in Australia have played an active role in reconciliation in a variety of ways: maintaining cultural heritage by providing access to information and increasing understanding; giving Indigenous people a voice in the ways that they are represented in exhibitions, especially in how their stories are told; assisting with self-sufficiency and employment in their support of community museums through outreach programmes; and in the repatriation of cultural material. Evaluation studies conducted by the Australian Museum have shown that visitors, staff *and* communities can positively benefit from programmes that address issues identified as important by Indigenous people in ways that meet their needs. Although responses have been patchy and there is still a long way to go, museums in Australia can be proud of what has been achieved over the past twenty years.

'[C]ommunities of practice are engaged in the generative process of producing their own future' (Lave and Wenger 1991: 57–58). The ways museums have responded to Indigenous issues through involvement, engagement and partnership form a template they could use in other areas: developing a broad range of overlapping and synergistic communities of practice that make a difference. The principles are the same, it is the practices, outcomes and associated learnings that will vary. This presents an exciting opportunity for museums to actively promote social change and inclusion through taking a leadership role in dealing with complex, controversial and difficult issues, producing their own future in equal and inclusive partnership with a diverse range of communities.

Acknowledgements

We would sincerely like to thank those who generously assisted us in the preparation of this paper, especially Dr Des Griffin, former Director of the Australian Museum, and Mr Tim Sullivan, formerly of the Australian Museum, currently Director of Historical Interpretation, Sovereign Hill, Ballarat, who were closely involved in many of the events described in this paper. Dr Val Attenbrow, Australian Museum, provided much needed editorial help. Conclusions reached and any subsequent shortcomings are ours alone.

Notes

1 We are using the term 'Indigenous people' to include the Aboriginal and Torres Strait Islander people of Australia.
2 For more details about the importance of this conference in setting the agenda for museums in Australia and their relationships with Indigenous people see Gordon 1998a; Griffin 1996; and Specht and MacLulich 1996.

3 We are using a modified version of the ICOM definition of a museum. For the purposes of this paper the term 'museum' covers cultural institutions including natural history, general/social history museums, science centres, historic houses, art galleries, archives and libraries, Aboriginal Keeping Places/Cultural Centres, as well as outdoor sites such as historic parks, botanical gardens and national parks that have exhibitions and displays visited by the public.

4 The Australian Museum was established in 1827 and is Australia's oldest natural history museum. The mission of the Museum is to '*Research, interpret, communicate and apply understanding of the environments and cultures of the Australian region to increase their long-term sustainability.*' The primary functions of the Museum are to undertake scientific research and manage the vast range of collections across zoology, mineralogy, palaeontology and anthropology. Public communication and learning through physical exhibitions, public programmes, publishing, regional outreach and on-line delivery of services are key ways the Museum makes information, collections and research available to a wide range of audiences. The Museum holds about 100,000 ethnographic items, mostly from Australia, the western Pacific Islands and Southeast Asia. The collections reflect an emphasis on Indigenous cultures, including contemporary art and craft items, with the archaeological collections primarily relating to the history of the Indigenous peoples of Australia (Gordon 1998a; Specht and MacLulich 1996; Strahan 1979).

5 In this paper our primary focus is the practitioner level. We acknowledge that leadership and strategic management are critical variables impacting on organisational learning and change. Through our review of the Museums Australia policy *Previous Possessions, New Obligations*, we have data that shows the importance of these factors in dealing with the issues. This will be the subject of a future paper (Sullivan, Kelly and Gordon, in preparation).

6 Issues surrounding the history of Indigenous people in Australia are long and complex and beyond the scope of this paper. For further information the following websites are recommended: Aboriginal and Torres Strait Islander Commission, Canberra <http://www.atsic.gov.au/>; Australian Institute for Aboriginal and Torres Strait Islander Studies, Canberra <http://www.aiatsis.gov.au/index.htm>; Australian Museum Aboriginal Heritage Unit, Sydney <http://www.austmus.gov.au/ahu/>; Australian Museums Online, Indigenous Resources, Canberra <http://amol.org.au/craft.indigenous/indig_index.asp>; Reconciliation Australia, Canberra <http://www.reconciliation.org.au/>

7 In October 1987 the Royal Commission into Aboriginal Deaths in Custody was established to find out why so many Aboriginal people were dying in prison. The Commission made 339 recommendations on how the past hurt and current disadvantage of the Aboriginal people can be redressed. The findings of the Royal Commission and its recommendations have been widely publicised since their release in May 1991. In July 1991, the Commonwealth, States and Territories agreed to develop a National Response to the recommendations, which was to include full consultation with Indigenous people, their community organisation and national peak bodies (for more information see the Aboriginal and Torres Strait Islander Commission website <http://www.atsic.gov.au/>).

8 We recognise that there are many other ways that museums facilitate public learning: access to collections through behind-the-scenes tours and open storage for example, outreach and other public programmes, as well as the Internet. Here we have chosen to focus on physical exhibitions as the primary way museums communicate with their public.

9 The development of the Museum's 1985 *Aboriginal Australia* exhibition included a consultative process, which was the first time this had been undertaken in a museum in Australia and led to subsequent rethinking of content and approaches in the final exhibition (see Specht and MacLulich 1996: 31–33).

10 In writing this paper it became clear that there are many interpretations of how this exhibition evolved, its messages and focus, as well as the various roles of Project Team members. We have concentrated on the exhibition development from our personal perspectives: Indigenous, as Gordon is an Indigenous person who undertook the bulk of the consultations; and Evaluation, primarily projects undertaken by the Head of the Museum's Audience Research Centre (Kelly).

11 In this context consultation means the process of involving people in decision making through face-to-face discussions, community meetings, workshops and forums. It requires extensive fieldwork, visiting Indigenous people in their own communities rather than having them come into the Museum.

12 Semiotics in its simplest form is about signs as carriers of meaning in society (Hodge 1998; Schouten 1992): 'semiotics attempts to find a bridge between the different kinds of indicators or sign-systems in order to locate the deeper levels of meaning where the primary encounter takes place between the museum and the public' (Hodge 1998: 2).

13 This evaluation was conducted in partnership with Museums Australia National Office, Canberra (Kelly et al. 2000).

14 This survey was based on a similar study undertaken of United States museums and their responses to NAGPRA. For an outline of that research see Sullivan et al. in press.

15 Outreach programmes are defined as providing services to rural and regional communities, for example through travelling exhibitions, training programmes, long-term loans and provision of resources including educational materials and catalogues.

16 Museums in Australia hold vast collections from the Pacific region, including material from Melanesia, Micronesia and Polynesia. The Australian Museum holds the largest collection of artefacts from the western Pacific Islands, which came about because, in the late nineteenth century, interest in Aboriginal culture remained low, and artefacts from Melanesia dominated the collection until the early twentieth century. For many years the Australian Museum also acted as a repository for the official collections of the colony of Papua (Specht and MacLulich 1996; Strahan 1979).

17 This project was undertaken with the assistance of the Aboriginal and Torres Strait Islander Commission, Canberra.

18 This project was undertaken in collaboration with the Australian Museum Aboriginal Heritage Unit, with partial funding from the Aboriginal and Torres Strait Islander Commission, Canberra. Further research and developmental work is being undertaken in this project to document the development of Keeping Places/Cultural Centres within New South Wales via a CD-ROM currently being produced by the Australian Museum Multi-Media Unit.

References

Ames, M. (2000) 'Are Changing Representations of First Peoples in Canadian Museums and Galleries Changing the Cultural Prerogative?' in A. Kawasaki (ed.) *The Changing Presentation of the American Indian: Museums and Native Cultures*. Washington, DC: Smithsonian Institution.

Bradburne, J. (1998) 'Dinosaurs and White Elephants: The Science Centre in the 21st Century', *Museum Management and Curatorship*, 17(2): 119–137.

Burney, L. (2000) 'Not Just a Challenge, an Opportunity' in M. Grattan (ed.) *Essays on Australian Reconciliation*. Melbourne: Black Inc., pp. 65–73.

Cohen, L. and Manion, L. (1994) *Research Methods in Education*. London; New York: Routledge.

Council for Aboriginal Reconciliation (2000) *Final Report*. December, Canberra: Commonwealth of Australia. Online. Available at <http://www.reconciliation.org.au> (accessed April 2001).

Council of Australian Museums Association Inc. (1993) *Previous Possessions, New Obligations: Policies for Museums in Australia and Aboriginal and Torres Strait Islander People*. http://www.museumsaustralia.org.au/hottopics.htm

Falk, J. and Dierking, L. (eds) (1995) *Public Institutions for Personal Learning: Establishing a Research Agenda*. Washington, DC: American Association of Museums.

Falk, J. and Dierking, L. (2000) *Learning from Museums: Visitor Experiences and the Making of Meaning*. Walnut Creek, CA: AltaMira Press.

Gordon, P. (1998a) 'Museums, Indigenous Peoples and the 21st Century: Or Is There a Place for Museums in This Brave New World?', in *Community Museums in Asia: Report on a Training Workshop*. Tokyo: The Japan Foundation Asia Centre, pp. 34–41.

Gordon, P. (1998b) 'Community Museums: The Australian Experience', in *Community Museums in Asia: Report on a Training Workshop*. Tokyo: The Japan Foundation Asia Centre, pp. 118–132.

Graham, N. (1997) 'The Aboriginal Centre at the New Museum of Victoria', *Insite*, September: 7–8.

Grattan, M. (ed.) (2000) *Essays on Australian Reconciliation*. Melbourne: Black Inc.

Griffin, D. (1996) 'Previous Possessions, New Obligations: A Commitment by Australian Museums', *Curator*, 39(1): 45–62.

Griffin, D. (1998a) 'The Return of Indigenous Cultural Property', *Museum National*, 7(1): 7–9.

Griffin, D. (1998b) 'Not the Last Hurrah!', *Muse*, Sept./Oct.: 2–3, 13–15.

Griffin, D. and Sullivan, T. (1997) 'Shared Histories', *Muse*, Mar./Apr.: 3, 11.

Gurian, E. (1995) 'A Blurring of the Boundaries', *Curator*, 38(1): 31–37.

Hein, G. (1998) *Learning in the Museum*. London: Routledge.

Hodge, R. (1998) 'A Semiotic Analysis of the Australian Museum's Indigenous Australians: Australia's First Peoples Exhibition'. Report prepared for the Australian Museum Audience Research Centre (unpublished).

Howard, J. (2000) 'Practical Reconciliation' in M. Grattan (ed.) *Essays on Australian Reconciliation*. Melbourne: Black Inc., pp. 88–96.

Interview Transcript 2. Coorambah Aboriginal Cultural Centre, Glen Innes. March 2000.

Interview Transcript 3. Mindaribba Keeping Place, Maitland. March 2000.

Interview Transcript 4. Brewarrina Aboriginal Cultural Museum, Brewarrina. March 2000.

Keating, P. (2000) 'The Redfern Park Speech' in M. Grattan (ed.) *Essays on Australian Reconciliation*. Melbourne: Black Inc., pp. 60–64.

Kelly, L. (1997) 'Indigenous Issues in Evaluation and Visitor Research', *Visitor Behaviour*, 10: 24–25.

Kelly, L. (1999) Creating Partnerships Conference: Report on Training Needs Assessment Workshop. Report prepared for the Australian Museum Aboriginal Heritage Unit, June (unpublished).

Kelly, L. (2000a) 'Understanding Conceptions of Learning' in *Change and Choice in the New Century: Is Education Y2K Compliant?* Change in Education Research Group Conference Proceedings, Sydney, pp. 115–121.

Kelly, L. (2000b) 'Finding Evidence of Visitor Learning', *Informal Learning Review*, May/June.

Kelly, L. (2001a) 'Researching Learning … and Learning About Research' in *Changing Identities, Changing Knowledges*. Change in Education Research Group Conference Proceedings, Sydney.

Kelly, L. (2001b) 'Developing a Model of Museum Visiting'. Paper presented at *National Collections, National Cultures*, 2001 Museums Australia Conference, Canberra.

Kelly, L. and Sullivan, T. (1997) 'Front-end Evaluation: Beyond the Field of Dreams', *Museum National*, 5(4): 7–8.

Kelly, L., Gordon, P. and Sullivan, T. (2000) 'Evaluation of Previous Possessions, New Obligations: Policies for Museums and Aboriginal and Torres Strait Islander People'. Green Paper prepared for Museums Australia National Office, November (unpublished).

Kinzer, S. (2000) 'Museums and Tribes: A Tricky Truce', *New York Times*, 24 December.

Lave, J. and Wenger, E. (1991) *Situated Learning: Legitimate Peripheral Participation*. Cambridge: Cambridge University Press.

Leggett, J. (2000) *Restitution and Repatriation: Guidelines for Good Practice*. London: Museums and Galleries Commission.

Macdonald, S. (ed.) (1998) *The Politics of Display: Museums, Science, Culture*. London: Routledge.

173

Marton, F., Dall'Alba, G. and Beaty, E. (1993) 'Conceptions of Learning', *International Journal of Educational Research*, 19(3): 277–300.

Matusov, E. and Rogoff, B. (1995) 'Evidence of Development from People's Participation in Communities of Learners' in J. Falk and L. Dierking (eds) *Public Institutions for Personal Learning: Establishing a Research Agenda*. Washington, DC: American Association of Museums, pp. 97–104.

Nelson, C. (1999) 'The Future Has Already Happened', *Business Review Weekly*, 17 December: 36–38.

Newspoll, Saulwick and Muller, and Mackay (2000) 'Public Opinion on Reconciliation: Snap Shot, Close Focus, Long Lens' in M. Grattan (ed.) *Essays on Australian Reconciliation*. Melbourne: Black Inc., 33–52.

Pearce, T. (1997) 'Reconciliation: A Peoples Movement', *Museum National*, 6(1): 16–18.

Schauble, L., Leinhardt, G. and Martin, L. (1997) 'A Framework for Organising a Cumulative Research Agenda in Informal Learning Contexts' in S. Paris (ed.) 'Understanding the Visitor Experience: Theory and Practice, Part 1', *Journal of Museum Education*, 22(2/3): 3–8.

Schouten, F. (1992) 'The Paradox of the Map: Semiotics and Museum Education', *Museum Management and Curatorship*, 11: 285–289.

Scott, C. and Burton, C. (2001) 'Museums: Challenges for the 21st Century'. Paper presented at *National Collections, National Cultures*, 2001 Museums Australia Conference, Canberra.

Specht, J. and MacLulich, C. (1996) 'Changes and Challenges: The Australian Museum and Indigenous Communities' in P. McManus (ed.) *Archaeological Displays and the Public: Museology and Interpretation*. London: Institute of Archaeology, pp. 27–49.

Strahan, R. (ed.) (1979) *Rare and Curious Specimens: An Illustrated History of the Australian Museum 1827–1979*. Sydney: The Australian Museum.

Sullivan, T., Abraham, M. and Griffin, D. (in press) 'NAGPRA, Effective Repatriation Programs and Cultural Change in Museums'.

Vergo, P. (ed.) (1989) *The New Museology*. London: Reaktion Books.

Weil, S. (1994) 'Creampuffs and Hardball: Are You Really Worth What You Cost?' *Museum News*, Sept./Oct., 73(5): 42–44, 62.

Weil, S. (1995) *A Cabinet of Curiosities: Inquiries Into Museums and Their Prospects*. Washington: Smithsonian Institution Press.

Weil, S. (1997) 'The Museum and The Public', *Museum Management and Curatorship*, 16(3): 257–271.

Wenger, E. (1998) *Communities of Practice: Learning, Meaning and Identity*. Cambridge: Cambridge University Press.

12

The National Museums of Kenya and social responsibility: working with street children

Fredrick Karanja Mirara

Museums as cultural institutions have a social responsibility to the communities within which they are located. This requires us to understand community needs and be responsive to social issues; indeed, the survival of the National Museums of Kenya rests on its ability to demonstrate its social utility.

Alongside admission charges, the National Museums of Kenya relies heavily on the support of government whose priorities range from the eradication of poverty to the provision of food, clothing, education, shelter and clothing for its citizens. Alongside the organisation's belief in its social role and value, it is also imperative, for pragmatic reasons, that museum functions and activities are seen to address these priorities.

The National Museums of Kenya

The first museum initially started as a private venture in 1910, established by amateur naturalists and anthropologists who formed the East Africa and Uganda Natural History Society, later known as the East African Wildlife Society. Today, the National Museums of Kenya is a government institution and one of the leading research and education organisations in eastern Africa. Its mission is 'to collect, document and preserve, to study and present our past and present cultural and natural heritage and to enhance knowledge, appreciation, respect, management and use of these resources for the benefit of Kenya and the world' (Bennun 1997: 4).

An acknowledgement of the organisation's social responsibility affects all aspects of its work: collection, research, exhibition and education. For example, the museums aim to represent the widest possible social and ethnic groupings within the diverse collections of children's toys, clothing, ornaments, musical instruments, charms, and agricultural and pastoral items.

Similarly, research priorities must also take account of community and wider social needs. Research into the collections as well as field research is therefore

influenced by social need. For example, the Indigenous Food Programme, a research project within the museums, was established in response to the issue of food shortage. It is hoped that the study of traditional farming techniques may play a part in contributing to the alleviation of poverty and food shortage. The farming of many traditional foods has been abandoned in Kenya and yet many indigenous species have advantages over their exotic replacements as they are suited to local environmental conditions. It is hoped that the museums' work in this area can help to educate people about the value of indigenous species and begin to alter attitudes towards traditional foods.

A further example of a research project that has addressed broader socio-political concerns is the Peace, Conflict and Reconciliation Project. The project surveyed the peace traditions of some pastoral groups in Kenya, including *Pokot, Turkana, Samburu, Rendille, Maasai, Gabra Somali* and *Boran*. The research generated information about ways in which these groups maintain peace and foster harmony and respect within the community and was used as the basis for subsequent collection, publication and exhibition programmes. It is hoped that this work may, in future, form the foundation for a peace museum in Kenya.

The Asian African Heritage Project was an attempt to acknowledge the important contributions that Asian Africans in Kenya have played in the country's development. The research project and resulting exhibition encouraged the participation of individuals and groups from this minority community in the collection and display of material that highlighted their role in the areas of politics, agriculture, business, and transport.

The social responsibility ethic needs to permeate all museum activities so that collection, research, exhibition and education programmes collectively seek to address contemporary social and environmental issues.

The Education Department of the National Museums of Kenya, part of the Division of Public Programmes, seeks to 'promote people's understanding and sustainable use of natural and cultural heritage by enhancing access to the [museums'] collections, research and exhibitions' (Ndung'u 1998: 2), and handles over 130,000 people per year. To achieve its mission, the Department develops both general programmes for museum visitors and also special programmes aimed at specific groups. The project working with street children falls into this latter category of programmes.

Street children: situation and causes

The street children problem in Kenya is a relatively new phenomenon. The issue first received attention in 1975 when 115 cases of street children were recorded. Since then the increase has been very sharp and as of now there are 190,000 street children in the country. There are about 70,000 street children in Nairobi alone. The term 'street child' includes both homeless children (those who actually sleep on or near the streets) and those who spend their days working on

the streets but who go home to sleep. Approximately half of Nairobi's street children actually sleep on the streets. Studies carried out indicate that some of the children are orphans and, in recent years, HIV/AIDS has led to an increase in the number of children without parents (Abungu and Maikweki 1999).

The average Nairobi street child is likely to have had only a few years' schooling, although around 15 per cent will have never been to school at all. Recent studies have shown that, with the current economic situation of the country, around half of those who enrol in primary schools will not complete their primary education. Parents contribute 31 per cent of primary school expenses and 60 per cent of secondary school expenses (Croll 1998).

Street children are also likely to come from single parent families, most likely headed by a mother with several children and with little education, income or social support. Poverty is closely linked with the issue of street children. Other factors include appalling living conditions in the city, rural to urban migration and increased levels of unemployment. The process of urbanisation was accelerated by colonialism when industries were established in major towns in the country. This in turn led to the breakdown of traditional societies (Croll 1998).

These factors have also contributed to the disintegration of traditional family structures, a further significant cause of the street children problem. Traditional family structures provided additional security to all members of the family including orphans. The extended family included grandparents, step parents, cousins and nephews. Within this structure, orphans were part and parcel of the extended family and enjoyed full rights that included inheritance. These traditional structures, which assumed collective responsibility for children, have steadily been eroded.

High proportions of street children are boys, the majority of them between the ages of 12 and 15. Many have been arrested at least once and are likely to have used drugs such as glue. Most street children have grown up in Nairobi slums and other urban centres and many live together in groups. They are a form of child labour; many collect papers and material from refuse collection sites as they hunt for food there. Sexual exploitation is commonplace (Abungu and Maikweki 1999).

Increasing poverty, rural to urban migration, unemployment, and the breakdown of traditional society have all contributed to the growing numbers of street children. Many concerned individuals, organisations and agencies have sought to help to address the problem. The government has a Children's Department that is responsible for a street children programme and, in addition, in Nairobi alone, there are more than 240 street children organisations (Croll 1998).

What part can museums play in contributing towards collaborative efforts to tackle social issues of this kind?

The street children programme

The National Museums of Kenya has sought to address the street children problem in two main ways. First, the programme was established to work directly with street children not only to create access to the museum facilities for this group but also to help to create new opportunities and possibilities for the participants, beyond the museums. For example, the programme aims to inspire children and broaden their horizons through involvement in creative activities. Activities were programmed that would introduce new skills to participants, encourage them to discover their talents and stimulate their creativity. It is hoped that a long-term outreach programme can be established to facilitate follow-up work with individual children and groups.

Second, the programme was established to use the museums as a forum in which diverse perspectives on the issue of street children can be brought together to generate new ideas and solutions. The programmes were designed to raise public awareness of the issue and to stimulate and support further action. It was also hoped that this would develop public understanding of the museums' social roles and responsibilities.

The first street children programme was introduced on 25 October 1995, a national public holiday in memory of the day when the late Jomo Kenyatta, first President of Kenya, and other leading freedom fighters were arrested and detained. Children were initially wary of the approach by the museum organisation; however, sixty children were eventually brought to the main site, participated in music and drama activities and were given a guided tour of the exhibitions. This first programme was offered like any other special programme and was financed by the museum.

The programme was repeated again in 1997, this time jointly initiated by the National Museums of Kenya, the German Ambassador and the Kuona Trust. The Kuona Trust was set up in 1995 with a mission to develop opportunities for East African people to have meaningful contact with art, and works to integrate art into the local community through a combination of hands-on support to artists, public exhibitions and innovative public outreach programmes. The Trust manages the Museum Art Studio.

Planning for the programme proved challenging. Unlike activities for those in formal education, there was no curriculum to guide the process, and consultation with and involvement of agencies that worked with street children were essential to our understanding of the children's needs, interests, likely background and behaviour. The first step was to set up a Steering Committee composed of representatives from the Museums of Kenya Education Department, the Kuona Trust, and a teacher from a rehabilitation centre. The Committee started by developing a proposal, which was then used as the basis for fundraising; the programme budget included funds for transport, art materials, food, stationery and facilitators. The Embassy of Germany in Kenya agreed to fund the project and we developed our plans further. A study carried out by one of the partners was especially helpful in the planning of activities for our

programme and the teacher from one of the rehabilitation centres advised us on ways to engage and interest the children.

The Committee allocated a day each month, starting from December 1997, for the main museum to work with street children. On each of these days, sixty children were collected from rehabilitation centres and brought to the museum to participate in activities. During the mornings, children were given a guided tour of the museum, which included a snake-handling activity in the museum's snake park. They later participated in activities in the Museum Art Studio with artists who participated on a voluntary basis (Figure 12.1). Caterers were appointed to provide food for all participants. During the afternoon, drama and song activities were programmed to sustain the children's attention and explored themes that would resonate with their lives. In addition, some children learned photographic skills and were provided with disposable cameras, which they took away with them to record aspects of their lives on the streets. These they returned to the museum the following week and an exhibition of the photographs was organised for a special open day.

The exhibition of photographs depicting the street children's daily lives was opened on the museum's first special open day on 20 March 1998 by the Head of State, whose presence served to bring widespread public attention to the street children issue and acted as a catalyst for attracting increased public support for the museum's initiatives. Alongside the exhibition itself, children performed plays, songs and poems (Figure 12.2).

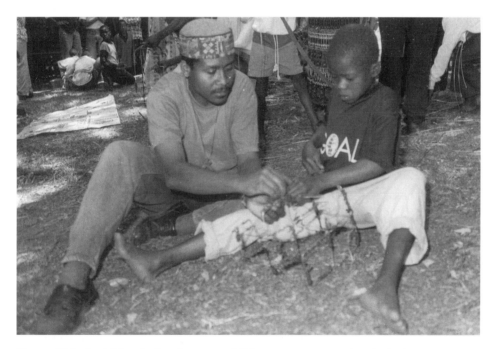

Figure 12.1 Activities during the street children programme. Photo by kind permission of the National Museums of Kenya.

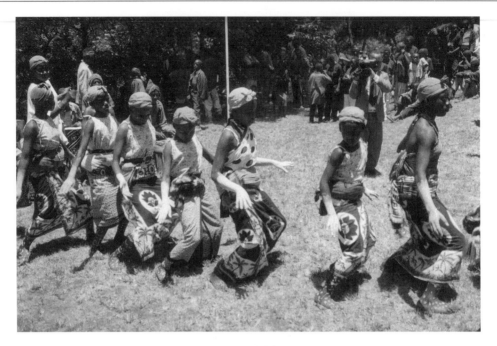

Figure 12.2 Performances during the street children programme. Photo by kind permission of the National Museums of Kenya.

The open day also served to bring together different interested parties to discuss the issues and action plans were drawn up as a result. The government's responsibility to ensure that the legal framework provides adequate protection for all children was underscored. On the same day, fundraising activities were organised and the funds raised were distributed to various street children projects in Nairobi. In addition, funds were secured for the museum to continue its programmes for the following two years.

In the subsequent programmes, a new component was introduced in the form of follow-up visits by artists to the rehabilitation centres, thereby extending the provision to those who were not able to visit the museum.

Evaluation

During the first two years, over 2,400 children participated in the museum's programmes. Of course the programmes do not provide a solution to the street children issue, but nonetheless they demonstrated that it is possible for museums, alongside government and community organisations, to work collaboratively towards positive political change and greater social equity.

Additionally, on a small scale, some individuals have gained enormously. A number of children have utilised the skills they have learned to start making models and to sell them on the streets. One has retained links with the Museum

Art Studio for over a year and it is our hope that he will continue to benefit from this. Undoubtedly, further evaluation is required to assess the impact of these programmes both within the museum and in the community.

The programmes demonstrated that museums have the potential to engage with and contribute towards finding solutions for social problems but we continue to debate the question: 'What are we doing at the National Museums of Kenya to perform our functions in ways that benefit the whole community, including disadvantaged individuals?'

Museums face tremendous challenges in trying to meet their social and moral obligations; obligations that will vary from context to context and institution to institution. It is hoped that this case study, whilst presenting our response to one of the issues facing Kenyan society, serves to highlight the importance for all museums of being rooted in their communities and driven by their needs.

References

Abungu, A. O. H. and Maikweki, J. (1999) 'Street children problem, the dark side of modern society. The role of museums in building a peaceful society'. Paper presented at the Commonwealth Association of Museums Seminar, Barbados Museum and Historical Society, 5–12 May.

Bennun, L. (1997) *The National Museums of Kenya: An Overview in NMK Horizons*, Nairobi: National Museums of Kenya.

Croll, P. (1998) 'The situation in brief: street children in Nairobi'. Presentation at the launch of the street children programme at Nairobi Museum.

Ndung'u, M. (1988) *The Museum Education Three Year Strategic Plan 1998–2001*, Nairobi: National Museums of Kenya.

13

Museums and the health of the community

Jocelyn Dodd

In memory of my precious mother, Mary Dodd 1926–99.

Factors which make for health are concerned with a sense of personal and social identity, human worth, communication, participation in the making of political decisions, celebration and responsibility, so the language of science alone is insufficient to describe health: the languages of story, myth and poetry also disclose its truth.

(Wilson 1975: 59)

Do museums and galleries really have a part to play in the health of the community? What impact might they have and by what means can this be achieved?

Our Bodies Ourselves, a temporary exhibition at Nottingham Castle Museum and Art Gallery in September 1994, featured bold, explicit, uncompromising black and white photographs presenting stark images of the reality of radical breast surgery. The photographs were self-images by the artist Jo Spence, exploring her personal journey as breast cancer shaped her life. The photographs present the effects of lumpectomies and full mastectomy whilst the artist's everyday face stares out at the viewer. The photographs pull no punches – not clinical, not abstract – as they present a sense of the physical reality of this disease; a reality which statistically one in three women will in some way experience as they are diagnosed with cancer. At the time of the exhibition I found the images haunting. They appeared to hold such power to present an insight into something so widely experienced, but the reality of which was so often hidden, understated, superficially made good by prosthesis and reconstructive surgery.

An art gallery seems an unlikely place to embark on a journey of understanding of a medical condition, but it was to the images of Jo Spence that I returned, years later, when my mother was diagnosed with breast cancer. My experience of her illness was not of some abstract disease, though much of her time was spent in hospital having surgery, radiotherapy treatment, hopeful check-ups and debilitating chemotherapy. Her ill health was not simply a medical condition,

it became inextricably part of her, a complex mixture of emotions and experiences; a part of her life and her death. But it was in an art gallery that I experienced the courageous, educative, thought-provoking, public images displaying the savagery of breast cancer surgery. It was here that I saw the bold role that art can play in helping people to see the universality of disease and ill health, to open dialogues, fears, embarrassments; all realities in facing the dreads and fears of breast cancer.

Drawing on largely British museum examples, this chapter seeks to explore the different roles that museums and galleries can have in contributing to the health and well-being of the community. The multidimensional context of health, which places it not just within a narrowly conceived medical model but which also acknowledges social and economic influences, will be explored. The discussion seeks to position museums as part of multi-agency approaches to health issues. These discussions draw on an understanding of health defined by the World Health Organisation as 'a state of complete physical, mental and social well being and not merely the absence of disease or infirmity' (Nottingham Health Authority 1999a: 1).

The social context of health

Despite the economic growth of developed countries the remarkable two, three or even fourfold differences in death rates between different social classes or income groups illustrate the power of social and economic determinants of health (Wilkinson 1996: 13).

In the UK, the government's Social Exclusion Unit defines social exclusion as 'a shorthand term for what can happen when people or areas suffer from a combination of linked problems such as unemployment, poor skills, low incomes, poor housing, high crime environments, bad health, poverty and family breakdown (DCMS 2000: 7). In this definition, health is identified as one of the indicators of social exclusion. However a characteristic of the concept of social exclusion is the interdependency between different aspects or indicators of disadvantage. So, for example, health can be linked to place: where there is poor housing, high unemployment, crime and poor educational achievement, such factors can manifest themselves in health inequalities.

Despite increasing recognition of the social, economic and environmental factors that can impinge on health, attitudes in most western societies are characterised by a reliance on the doctor's prescription pad; a narrowly conceived medical model of health that places responsibility squarely with the medical profession alone and that relies on their diagnosis and treatment of physical symptoms. However, with a growing awareness of the health consequences of complex economic and social factors, the doctor's prescription can be likened to placing a sticking plaster over a gaping wound: medical expertise can diagnose disease, treat individuals' *symptoms* but do little or nothing to prevent the *causes* of depression, stress and chronic diseases resulting from unemployment, the disintegration of stable relationships, poor housing and poverty.

183

Medical advances of the past have involved identifying single risk factors for single diseases but, in so far as health is a social product we need to better understand how social and economic structures influence health and find ways of reducing inequalities and strengthening the fabric of society. In the developed world it is not the richest countries that have the best health, but the most egalitarian (Wilkinson 1996: 3). Epidemiological evidence from studies of the effects of social networks on health clearly point to the health benefits of social cohesion (ibid.). People with more social contact and more involvement in local activities seem to have better health.

Campbell (1999) explores the relationship between health and social capital. Health is not simply defined by disease within a medical model of clinical diagnosis and treatment, but is part of the wider concept of a healthy community and society. The healthy community will have good education, stable tenancies, safe and secure environments, active participation and development of citizenship, thereby creating a situation where people have self-worth, respect diversity, where creativity is harnessed and where people are engaged in their culture. A healthy community is one where the burden of ill health is reduced both by social cohesion and social capital (1999: 21).

This holistic view of health issues can be seen emerging in recent policy developments in the UK. When Health Action Zones were established by the government in England in 1998, targeting the geographical areas of poorest health, the notion of integrating health with other issues such as unemployment, education, housing, leisure, social care and the environment was central to their vision and development (Nottingham Health Authority 1999b: 4). Within this holistic perspective, a number of organisations, not only those principally concerned with health, share some responsibility for health issues. This begins to suggest a role for museums as one of partnership with many agencies collectively beginning to look at the bigger health picture. In this model, professional responsibilities begin to merge and the health of the community is no longer the sole responsibility of the medical profession. Matarasso describes this as 'the right moment to start talking about what the arts can do for society, rather than what society can do for the arts' (1997: iv). Culture, arts and heritage move from being viewed as intrinsically valuable to a position where their value exists in relation to people – individuals, communities and wider society.

Potential roles for the museum

What role then can museums play in contributing to the healthy community? How can they address the interrelated processes of social exclusion that lead to health inequalities? How can they help to create the social capital to reverse these? Whilst there are relatively few examples on which to draw, the following, from Britain, suggest that museums can play a part in impacting on individuals' health, responding to local health concerns and acting as a forum in which health issues can be publicly explored.

Impacting on individuals' health

Amongst some of the most socially excluded members of society are users of mental health services. Historically, the psychiatric health system has reinforced exclusion with nineteenth-century mental hospitals and asylums effectively isolating and removing people from society (Bates 2001). Over the past two decades changes in UK government policy have resulted in the closure of many mental hospitals to be replaced by health care within the community. In response Nottingham Castle Museum and Art Gallery began to work in partnership with mental health professionals. Whilst there are long-established links between the use of arts and creativity within health care settings, the initial aims of this partnership were to create access to the museum. Early links were tentative. The process was one of exploring possibilities for both health workers and museum staff – new territory that set out to involve and engage people, many of whom had been institutionalised for decades.

Through an evolutionary process, programmes developed drawing widely on museum collections. Training and mentoring for museum staff was essential to enable them to begin to understand the complex barriers to community integration that individuals faced. These included a lack of self-esteem, lack of motivation and limited support networks and structures such as those usually provided by family, friends, home, work and social life. Facilitated sessions used objects to stimulate and engage interest and, for some, this was the starting point for the development of their own creativity. The resulting exhibition of one group's work, *Art and Empowerment*, gave an enormous boost to confidence and self-esteem. The programmes were reviewed to establish new pathways to independence where it was possible for some participants to move into accessing the mainstream programmes of the museum. The facilitated sessions were still maintained for those who were less confident, sometimes using museum programmes to bridge the gap between the experiences in mental health day care centres and life in the community.

What was the significance of this partnership between the museum and mental health services? There was undoubtedly a positive impact on individual participants, many of whom became more confident and outgoing. For some it created pathways to more fulfilling and integrated lives:

> When I was very poorly I felt ashamed, withdrawn and I didn't like mixing with people. When you have been ill for a long period of time it is hard for people to relate to your experiences, you don't relate to them well either. I felt more relaxed with other users of mental health services; there is a sense of community, of some social interaction.

> One project we did culminated in a Victorian Garden Party at one of the museums, it was a four week programme, we had to sign up for it all. We found out about life at the time and saw Victorian paintings and costumes. There was a great atmosphere at the garden party; it was funny, entertaining and you could relax and forget your problems. It wasn't just about having some good food and entertainment, it was about responsibility and

commitment – you could only go to the garden party if you had attended the other sessions first, so it was about taking decisions and the consequences of those decisions.

One thing led to another, it is easy to get negative if you are not stimulated, so I got involved with a disability organisation called East Midlands Shape. This led to several gallery activities. I had more control over these, I moved out of being cared for, I felt more empowered, more in control.

(Guy 2001: 40–41)

Though significant and life-changing for some, the experience was by no means universal. One participant explained that attending the sessions had not helped him, a salutary indication of how long a journey some people are making. 'I've got no faith in myself. You know that frightening thing that you feel? I've got that bugger' (Matarasso 1997: 69).

The partnership demonstrated that museums could play a part in developing innovative approaches to meeting health care objectives, that they could stimulate, engage and create pathways to independence. For the museum, it served to demonstrate the complexity of barriers that exist to creating cultural inclusion and the breadth and depth of skills that are needed to facilitate this.

Equally museums have the potential to raise some of the wider societal issues around mental health, to inform, to challenge taboos and to raise knowledge. *Out of Sight, Out of Mind*, an exhibition at Kelvingrove Museum and Art Gallery in 1995 importantly reflected on how our attitudes to mental health have been shaped by history.

Responding to local health concerns

When a Health Action Zone was established in Nottingham, one of its challenges was to reduce the number of unwanted pregnancies, especially amongst young people under the age of 16. Traditional health education had failed to impact on soaring numbers, amongst the highest in Europe. Alongside this were extremely high rates of sexually transmitted diseases including gonorrhoea and chlamydia. The Health Action Zone was committed to exploring innovative ways of tackling the problem, providing an opportunity for the museum to become involved. An exhibition, *Sexwise*, and a linked education programme developed. *Sexwise* focused on issues of teenage pregnancy, contraception and sexual choice. The exhibition featured collaborative work by artist Susie Freeman and Dr Liz Lee, including a beautiful ball gown with fitted bodice and a glittering, flowing multi-layered skirt (Figure 13.1).

The gown was glittering, not from sequins but from thousands of contraceptive pills illustrating the quantity of drugs needed to provide protection for a fertile lifetime. Associated interpretation and health-related resources within the gallery set out to raise issues around parenting and sexual choice within the public arena. For general practitioner, Dr Michael Varnam, the exhibition served to 'expose the rest of the population to this important issue and the fact that

14

Children's museums in hospitals

Despina Kalessopoulou

Hospitalisation can have a highly significant impact on children's lives: often unsettling, isolating and traumatic. What place do children's museums have in the hospital environment, what impact might they have and how might this be achieved? Drawing on the experiences of recent programmes developed by the Hellenic Children's Museum, this chapter considers these questions, and in doing so, raises issues about the wider social role and responsibility of all museums.

The social role of children's museums

Originating in the US over a hundred years ago, children's museums have now spread all around the world and have developed their own niche in the traditional museum scene. Collections are not the primary focus for this genre of museums. Rather, objects, exhibitions and programmes are viewed as instruments for stimulating curiosity, enabling interaction, and motivating learning (Maher 1997: 2). Children, parents, educators, and their needs and interests are central to their role and function.

This focus on people and their needs informs every aspect of the museum's work and community involvement is fundamental to the establishment and operation of a children's museum. Children's museums are set up by people, usually educators or parents, who want to create an environment that encourages exploration and helps children better understand the world in which they live. They are responsive to local circumstances and frequently function as social venues where adults and children can cooperate, play, learn and have fun. They are widely perceived as an educational resource for the local community with an important role to play in meeting social needs.

Children's museums have assumed the role of social support centres in many different ways: they offer parenting services, they conduct after-school and evening programmes, and they act as community centres inviting all types of audiences to participate and share experiences in a safe, supportive and enabling environment. Lastly, children's museums often seek to become fully integrated into the life of the community in which they are located by developing programmes

The [final] option at last begins to affect the social role and relationships of people with psychiatric difficulties, as well as transforming the museum or gallery itself. Full inclusion demands that the museum employ people with experiences of mental ill health alongside their other workers and harness their skills and expertise amongst the volunteer workforce. Users of mental health services will receive their share of the invitations to the grand exhibition opening and will occupy seats at the museum's advisory group. Information about how members of the public can contribute to the museum's decision-making will be readily available and presented in an accessible format. In addition to its traditional role as an archive of historic artefacts, the museum will have a clear role as a sponsor of contemporary culture, and people who have previously been marginalised will find their contributions valued and celebrated. Clear pathways will be forged into the local history group that delves into the archives held in the basement and, indeed, people with mental health experiences are supported to become full members of every social group and network that together form the informal culture of the museum community. They will find that this museum community has become a place rich in opportunities for identity, positive social roles and friendship with others who share their values.

(Bates 2001: 109)

References

Bates, P. (2001) 'Museums and mental health services' in J. Dodd and R. Sandell (eds) *Including Museums: Perspectives on Museums, Galleries and Social Inclusion*, Leicester: Research Centre for Museums and Galleries, Department of Museum Studies, University of Leicester.

Campbell, K. (1999) *Social Capital and Health*, London: Health Education Authority.

Department for Culture, Media and Sport (1999) *Policy Action Team 10: A Report to the Social Exclusion Unit: Arts and Sport*, London: Department for Culture, Media and Sport.

Department for Culture, Media and Sport (2000) *Centres for Social Change: Museums, Galleries and Archives for All*, London: Department for Culture, Media and Sport.

Guy, J. (2001) 'A personal perspective' in J. Dodd and R. Sandell (eds) *Including Museums: Perspectives on Museums, Galleries and Social Inclusion*, Leicester: Research Centre for Museums and Galleries, Department of Museum Studies, University of Leicester.

Matarasso, F. (1997) *Use or Ornament? The Social Impact of Participation in the Arts*, Stroud: Comedia.

Nottingham Health Authority (1999a) *Health Promotion Bulletin*, Nottingham: Nottingham Health Action Zone.

Nottingham Health Authority (1999b) *Nottingham Health Action Zone – Work Programme: Mainstreaming Innovation, Spotlight on Families*, Nottingham: Nottingham Health Authority.

Robinson, D. (1996) Personal communication, November.

Silverman, L. (1998) *The Therapeutic Potential of Museums: A Guide to Social Service/Museum Collaboration*, Indiana: Institute of Museum and Library Services.

Varnam, M. (2001) 'Museums and the health of a community' in J. Dodd and R. Sandell (eds) *Including Museums: Perspectives on Museums, Galleries and Social Inclusion*, Leicester: Research Centre for Museums and Galleries, Department of Museum Studies, University of Leicester.

Wilkinson, R. (1996) *Unhealthy Societies*, London: Routledge.

Wilson, M. (1975) *Health Is For People*, London: Darton, Longman and Todd.

A forum for awareness raising and debate

An illustration of the role that museums can play in raising awareness of health issues can be found in Walsall Art Gallery's exhibition, *Brenda and Other Stories*, which used contemporary art to explore issues around HIV and AIDS. The exhibition served as a powerful vehicle for public debate and for the dissemination of health promotion messages. The gallery worked with the health authority to train all staff around HIV awareness, and health promotion literature was featured alongside paintings, sculpture and installations from internationally renowned and emerging artists. The exhibition addressed misconceptions around the means of HIV transmission and underlined the impact that the virus can have on all communities. In spite of vicious attacks from national tabloid and local media, the exhibition was warmly received by visitors. Interestingly, evaluation during and following the exhibition in Walsall demonstrated a significant increase in the number people who sought HIV tests at the local clinic (Robinson 1996).

It is a challenge to get people to own their health and to take responsibility for it, but a tiny volunteer-run museum in the George Eliot Hospital, Nuneaton uses its historical medical collection as the basis for innovative programmes and displays in hospital corridors to illustrate important health messages. Recent exhibitions have, for example, used historical photographs to raise awareness of the potentially life-threatening nature of diabetes and the role that medicine has played in managing it. Other displays have illustrated the benefits of breast-feeding. 'Heartbeat' and 'Lungs are us' similarly draw on historic collections, including an iron lung, to demonstrate health issues in carefully constructed, entertaining hands-on sessions.

Conclusion

Though there is increasing interest in the role that museums and other cultural organisations can have in relation to health, their actual impact and the means by which outcomes can be achieved are only just emerging. Whilst discussion to date has focused largely on the benefits to individuals (e.g. Matarasso 1997; Department for Culture, Media and Sport 1999; Silverman 1998) evidence of the impact that museums can have through exhibitions and the public debate of health issues is largely anecdotal.

Museums have the potential to engage with social and health issues, not just through outreach programmes, though those undoubtedly play a key role, but through utilising their potential as a public forum for debate and the exploration of issues that, for many, remain taboo. To fulfil their potential in this way museums face the challenge of change. Some measure of the scale of this challenge can be found in Peter Bates' discussion of museums' relationships with one particular community and his vision of the road along which museums must travel in order to become truly inclusive organisations:

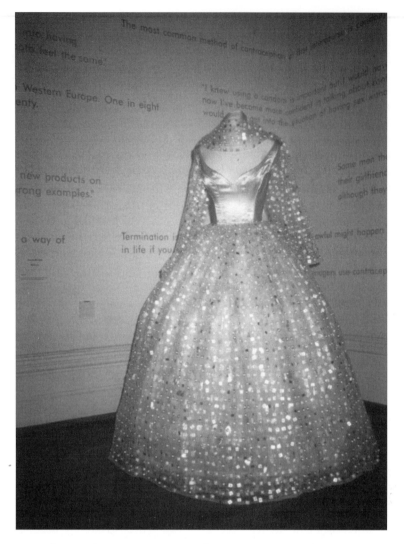

Figure 13.1 Ball gown by Susie Freeman and Dr Liz Lee, part of *Sexwise*, at Nottingham Castle Museum and Art Gallery. Photo by kind permission of Nottingham Castle Museum and Art Gallery: Nottingham City Museums and Galleries.

levels of teenage pregnancy in Nottingham are so high. It raises awareness in parents and gives them access to the knowledge they need to have' (Varnam 2001: 78).

Alongside the art works, a video created by a group of 14- and 15-year-olds presented 'A teenage guide to being sexwise', the product of collaboration between a local school, the museum, artists and health workers. Later evaluations showed a subtle but significant shift in the group's attitudes towards being pregnant, from a fear of telling their parents to the fear of becoming a (young) parent.

beyond their walls. Disadvantaged groups are often the focus of outreach services and, in order to most effectively meet their needs, children's museums often work in partnership with diverse community organisations to enrich or complement their work. Programmes in hospitals, prisons, and under-served areas are among the range of activities they foster.

In recent years, there has been increasing interest in the role that museums of all kinds can play in the direct provision of social services (Gurian 1992; Thomas 1998: 5). However, children's museums, as institutions that are firmly rooted in their local communities, can experience a greater sense of commitment to making their services accessible to all people, rendering the museum more inclusive and contributing to social change. As Mindy Duitz of the Brooklyn Children's Museum comments, 'developing a social conscience has become an integral part of our mission (Duitz 1992: 261). Children's museums see themselves as advocates for improving the overall quality of life in their communities (Biderman 1997: 157).

The Hellenic Children's Museum

The Hellenic Children's Museum (HCM) is a not-for-profit, educational and cultural organisation established in 1987 and, since 1994, has been operated in collaboration with the municipality of Athens. The motto of the HCM is 'Learning how to learn', indicating that the focus of all our projects is on enabling participants to develop their greatest potential through self-motivated inquiry into a subject, rather than the transmission of knowledge. Activities and exhibits are structured in a manner that invites active participation, discovery through the use of all senses, hands-on experiences and 'minds-on' discussions.

The general aims of the HCM's educational programmes are: to familiarise children and their families with museums and the natural and cultural heritage of Greece; to make the visit to the museum a happy experience, adapted to individuals; to develop the personal and social skills of children; and to equip them for independent learning and observation in analogous settings.

Each educational programme is designed to take account of three main variables: the needs and interest of the audience; the qualities of the space in which the programme will take place (its potentials and limitations); and the theme for the programme (its potential relevance and appropriateness).

The following case study concerning museum education in the hospital setting will examine each of these variables and their impact on the resulting programme.

Meeting the needs of different groups: a strategic approach

The HCM's educational programmes in hospitals stem from a wider strategy of provision for children with different needs. Central to the museum's mission

Table 14.1 Objectives and outcomes for educational activities at the Hellenic Children's Museum

Focus	Objectives/outcomes
The individual	Self-awareness, self-esteem, development of personal skills, confidence building, self-expression, self-fulfilment, self-identity.
Interpersonal relationships	Communication, acknowledging and understanding of other's viewpoints, cooperation, negotiation, sharing feelings and emotions, social bonds, affirmation of self-image.
The community	Active participation, acceptance and celebration of difference, inclusion, equality of opportunity, networking, positive group identification.

is the belief that every child, independent of any differences in opportunity and ability, should be enabled to explore, understand, enjoy, and shape the world in which they live, with a respect for individuality and an emphasis on team-work. Many factors – cultural, social, environmental – can contribute to an individual's disadvantage in both the short and longer term. Since its inception, the museum has developed educational programmes that cater for a wide range of groups including children with special needs, gypsies, immigrant children, hospitalised children with cancer and, recently, earthquake victims who have lost their homes and relatives.

Although the needs of these groups vary considerably, we have developed a set of general goals that apply to our work with all groups. Our educational activities are built around generic objectives and outcomes in relation to the individual, interpersonal relationships and the wider community (Table 14.1).

On the principle of equality of opportunity for all regardless of circumstance, the museum provides services in the form of separate provision for some groups, either in the museum premises or in a community venue, as well as in the form of integrated activities open and accessible to all children. The museum's involvement in the field of education provision in hospitals started in 1997. Before presenting the project, the variables that influence and shape the hospital experience will firstly be considered.

The hospital environment

Hospitalisation is likely to be experienced, at least temporarily, by everyone during their lives. Hospitalisation can be a traumatic experience as patients and their families confront an uncertain present and a precarious future. For children, hospitalisation may result in significant changes in behaviour and personality, depending on the seriousness of their illness, their age and their developmental stage.

What are the potential consequences of hospitalisation for children? First, it can deprive them of a sense of normality through the disruption of daily routine.

Children find themselves in an unfamiliar environment where they may feel totally dependent on others, even for things over which they have previously had control. They frequently lack the day-to-day interaction with their friends and family with which they are accustomed, resulting in social and emotional isolation.

In addition, the hospital environment or space can result in negative psychological impacts and produce a unique pattern of social organisation which is unfamiliar and unsettling for many patients. The hospital space can be considered through three different dimensions: material space (the physical design of the building), social space (the rules that organise the function of the space), and psychological space (the way people feel in this environment).

With regards to material space, the hospital environment can impose isolation and impede social interactions. The uniformity of colours and furniture do not encourage a sense of personal space and parents may feel uncomfortable, as there is no room planned for them in the ward. Where, for medical reasons, patients must be placed in a sterile environment, children can be confined to their room for several days, exacerbating feelings of loneliness and isolation.

The treatment schedule, often inflexible visiting hours, a restriction of movement, absence of favourite games and activities can all contribute to a social space in which children experience loss of control over their lives. Parents' associations and psychologists have argued that absence from home, familiar activities and routines, friends and school, can be more distressing than the symptoms and treatment of the illness itself (Capello 1994: 44). It is this unfamiliar, clinical environment, where time seems endless and unstructured, where people are unfamiliar and privacy is invaded, that can engender in children strong feelings of fear and anxiety. As a result, they may develop a tendency to adopt a passive role rather than be active participants in most aspects of their lives (Leukemia and Lymphoma Society 2000).

The psychological implications of the hospital environment, over and above those that stem from illness itself, are clear. Fear and anxiety prevail. Changes in lifestyle, stressful medical procedures, side effects of treatment and poor communication may cause feelings that range from anger to apathy and depression. When the reason for hospitalisation is a cancer diagnosis, all these symptoms may be accentuated and the psychological and social issues involved become more complicated.

Children with cancer: psychological and social issues

Childhood cancer is not a single disease. There are many different types; the most common of them are leukemia, brain tumours and lymphomas. Childhood cancer is rare. Only 100 in 1,000,000 children per year develop it before the age of 15 (Malpas 1994: 21). Yet every year 7,500 children are affected in the European Union and it is still the second highest cause of childhood mortality (ibid.). The high percentages of full recovery or long-term survival

(around 60–70 per cent) are a result of medical advances of the last twenty years in both the diagnosis and treatment of sick children (Pession 1994: 26). The fact that the treatment process can last up to three years has made concerns for quality of life and the psychological health of the child an imperative. Psychological support plays a lead role in therapy and a critical role in the holistic cure of the child (ibid.).

Children in hospital with cancer face many challenges. First, there is physical pain and fatigue. Children suffer from the symptoms of their illness, the treatment and its side effects. Pain is combined with fear; fear of bodily harm and intrusion, of being left alone or depending on others, and fear of the future. The child's psychological responses and the coping strategies they employ are directly related to their age and developmental stage. For example, separation issues have different impacts on toddlers in comparison with teenagers. Young children are acutely affected by the repeated, however brief, separations from their parents. They can become uncooperative and react negatively to all interventions, even those that are not painful. Older children suffer more from the lack of independence and autonomy. They can become rebellious and build defences to protect themselves from those they feel exert control over their lives such as doctors, psychologists, even parents.

Given the lengthy periods of treatment, school absenteeism and the interruption of usual activities have serious implications for the child's social and cognitive development. Children have limited opportunities to maintain close ties with friends. In addition, the fear and stigma surrounding cancer means that children may fear rejection as they are usually perceived and treated differently by other children and their family (Children's Cancer Foundation 1999). This is potentially traumatic for teenagers, for whom the need to be accepted by peers is heightened (Health Canada 2000).

Family dynamics also change. Parents may become overprotective as the child's condition poses restrictions on a wide range of activities. Often children regress in their development while hospitalised, as the wealth of their experiences and their sense of autonomy shrink. Children need to find out about their illness but they are often discouraged from asking questions or receive only partial answers. This lack of meaningful communication combined with a lack of confidence in their own academic ability, due to frequent disruption in studies, can compromise the child's disposition for learning.

All of these issues, combined with changes in levels of activity and physical appearance resulting from treatments, undermine the child's self-esteem and heighten their need for recognition and affiliation with others (Health Canada 2000).

The education programme

In January 1997 the HCM received a letter from PISTI (which means 'faith' in Greek), an association of parents with ill children, inviting the museum to

provide a series of educational activities within the children's hospital, Agia Sofia.

The Haematology/Oncology Department of Agia Sofia accommodates fifteen to twenty children as in-patients and around fifteen children on daily nursing. The hospital also has a Centre of Special Treatment, run by the University Clinic, which is host to fifteen more children. Children range from infants to young adolescents, up to 16 years of age. A number of them come from provincial towns of Greece, as well as from Albania, Yugoslavia and the Middle East.

The children in Agia Sofia are hospitalised for one month on average. The length of stay depends on the type of cancer they have and on the stage of their illness. A newly diagnosed child will generally spend six weeks inside the hospital. Children with brain tumours may need to remain in hospital for two to three months. Repeated hospitalisations may also be required as a result of infection, treatment complications or relapse. During their hospitalisation, children are basically limited to their ward. During their stay, boredom and isolation increase as they are not offered any entertaining activities apart from during the holiday periods.

The HCM's response to PISTI's request was immediate. As the museum's director stated:

> We didn't give much consideration as to whether or not we should get involved in this venture. Of course we lacked any previous knowledge and experience in the field but the social value of this project was so great that we didn't hesitate to try. It was an experiment we accepted to undertake in order to identify the needs of the children, their families and even the hospital staff, and be consistent with our mission statement to serve every child. And from this experiment, we learned a lot.
>
> (Muradyan 2000)

As in the case of every collaborative outreach programme, the agencies involved have their own expectations but also a set of common goals. The common goal in the collaboration of the museum and PISTI Association was to programme an event in the lives of the children inside the hospital that they would anticipate with eagerness and pleasure. For that reason the programmes were scheduled on a fixed day and were developed around the theme of 'bubbles'. Our internal expectations were to develop a new type of educational programme that would promote the affiliation of the museum with the community it serves. A part of the children's museum could be transferred to the hospital and become available to an audience never addressed before. The selection of the theme of bubbles, one commonly utilised with children's museum exhibits and programmes, was seen to be appropriate.

The general aims of the project were twofold: to help children's coping strategies and enable them to adapt to the hospital environment by conveying the message that the hospital can act as a space for play, pleasure and creativity and not only as a context connected with pain and discomfort; and to give children the opportunity to feel a sense of normality and do what other children are

doing, while attempting to cope with the difficulties they face as a result of their illness.

The specific objectives for the ten pilot programmes that were scheduled were:

• to give children an incentive to develop an energetic stance and a participatory mood;
• to enable communication, interaction and cooperation (a) with other children, (b) with their own family inside the hospital, (c) between parents of other hospitalised children, and (d) between children and parents and the medical staff;
• to familiarise children with medical equipment (e.g. syringes) and seek to counteract the negative feelings and fears with which they are associated;
• to help children regain confidence in their abilities and boost their self-esteem;
• to offer a positive experience that contributes to feelings of satisfaction during a day in hospital.

When we accepted the challenge of implementing these programmes in the ward, we had limited understanding of the needs of our audience. Although doctors informed the museum's staff and volunteers about the physical and psychological needs of the children and about the hospital routine, no other systematic investigation was carried out. So we started with no fixed ideas about what could be achieved and with openness to discovering what approaches would be most effective. The programme took place in the foyer of the ward for two hours. At least four representatives of the museum were present each time. Pictures of bubbles as found in nature, colourful bowls, and strange objects, including syringes and medical tubes, with which one could create bubbles, were placed on tables in the middle of the room. All objects were sterilised beforehand.

Activities during the first session were stilted. Children and parents gathered in a circle but hesitated to move from their chairs to participate. With subsequent sessions and the presence of regular members of staff from the museum, communication was improved and children became more open and ready to abandon their usual passive role. During the second programme, we realised that not all children of the ward were able to attend. Some of them could not leave their room for fear of infection. From that point on, interpreters, dressed with the necessary equipment (uniforms and masks), would visit each room for 15 to 20 minutes and play individually with children that were in confinement. In fact, the realisation of the importance of personal, individualised interpretation and interaction changed the way in which we perceived and developed the programme. It was evident that children in this situation have significantly increased personal needs and find it difficult to form a team and participate within it.

The need for an individualised approach became steadily clearer. First, children's ages and developmental needs ranged widely and, in addition, a few children did not speak Greek. The very young children were thrilled by the

opportunity they had to play with water and colours, but they needed extra assistance with using some of the equipment. Older children were happy to experiment with water and soap, but there were also a number of them that considered the theme childish. Teenagers may have felt uncomfortable participating in an activity that was so popular with younger children. Our interpreters had to show great flexibility and be ready to improvise so as to involve older children in activities where they could express themselves, for example by providing opportunities for creative writing and drawing. Finally, many of the children had intravenous tubes in their hands and masks on their face, which restricted their movement. Here, the involvement of parents and siblings was very helpful once they felt confident that the activity would not endanger their child's medical condition.

The programmes were implemented every Saturday and, whilst some of the children each week were new, others had participated in previous sessions. This required us to develop a variety of activities that could engage both groups. There were also frequent interruptions due to children's fatigue or need to take medicine. The restructured programme, based on short, interconnected, individualised activities, gave them the opportunity to participate or withdraw according to their needs.

Evaluation

Although we were unable to conduct in-depth evaluation of the programme, after each session internal discussions took place among the museum's staff and decisions were made about any required changes. Following the first series of pilot programmes, discussions with museum and hospital staff, as well as parents, took place to help to inform the planning of future programmes. Based on this evaluation, it is possible to reflect on each of the elements on which the design of programmes is based: space, thematic approach and audience.

Regarding the hospital space, it was inevitably difficult to transform the appearance of the foyer to conform with that of the exhibitions at the museum. However, we managed to change both the physical appearance and feeling of the venue through the introduction of the activities. As the medical staff observed, smiling children, liveliness, and carefree play are rarely encountered in the ward. We also feel we managed to change the dynamics of the environment from a space of simple coexistence to one of interaction and engagement.

In relation to the thematic approach, we felt confident to experiment with one single theme as it was the first time we had tried activities in a hospital setting. The selection of the theme itself was considered successful for several reasons. The use and integration of hospital equipment within the activities was particularly effective. Children creatively utilised objects that ordinarily inspire fear or are associated with negative emotions and found new ways of confronting them in a positive manner. Many children were actively engaged in the process of requesting syringes and tubes from nurses and collecting them throughout the week in order to use them as bubble blowers when the museum arrived, or

independently. Furthermore the theme offered opportunities to connect with life outside the hospital. The introductory question of the programme – 'In which other settings have you seen bubbles?' – acquires a new meaning in the hospital, as it prompts children to travel through their imagination to other settings, and connects with their past as well as with their future ('When I am out of here, where else can I see bubbles?').

The activities were designed to appeal to several senses. Children experienced the pleasure of watching, hearing, touching and smelling, which can be both relaxing and stimulating.

One of the major difficulties we encountered was the heterogeneity of the audience. The lack of systematic research on the needs of our audience before the beginning of the project made us believe that, despite the differences in age, the children had a set of common needs deriving from their medical condition. Whilst this was partly true, we were required to revise the design of the programme to meet the needs of individual participants.

Our audience was not only ill children, but their families as well. Cancer affects the whole family and parents and siblings also needed to find ways to relax. Parents were close to their children and helped them with the activities, but future programmes will need to identify ways to encourage them to participate more fully. However, being able to watch their children play and have fun helped them to interact with each other and with other families with similar experiences.

Although children share health problems, they are also very isolated and preoccupied with their own situation. The programme provided a good opportunity to develop cooperation between them, but it did not seem to work as we had planned. Children needed activities together on a more frequent basis because they are much more reserved in the hospital environment. In addition, as new children appeared every Saturday, the need to build in time to become acquainted was considerable for each session.

We succeeded in creating valuable social bonds between children and the most regular interpreters from the museum. Children were anticipating their arrival, and participation was steadily increasing from programme to programme. The activity of socialising with people from outside the hospital context was, in itself, valuable in contributing to a sense of normality. The older children especially appreciated opportunities to talk with the interpreters rather than participating in the activities themselves.

The last issue to assess is how our interpreters felt and responded during this project. The motives for everyone involved were different, but they all stemmed from a desire to enhance the quality of life for children who are experiencing great anguish. We all needed extra time to familiarise ourselves with the hospital environment and adapt our interpretation skills, but we all learned a tremendous amount from the project. However, better training and closer collaboration with the hospital staff, and the parents, would have helped us be more knowledgeable of the children's states of mind under the circumstances

and feel less awkward when children refused to participate or were expressing their thoughts and anxiety about their lives and the quality of their lives.

Conclusion

At the Hellenic Children's Museum, we learned a tremendous amount through this pilot project, but we are only beginning. What are we ready to offer these children? Whatever their situation they require stimulating, fulfilling and enjoyable experiences and we believe it is crucial that we sustain our involvement with the hospital.

The project has provoked broader questions for the museum around its wider role and purpose. We continue not only to explore the means by which we can broaden our audiences to reach children with limited opportunities, but also to consider the impact of the museum on the lives of individuals and the communities of which we are part.

References

Biderman, E. (1997) 'Reaching beyond the walls: outreach programming at the Santa Fe Children's Museum' in M. Maher (ed.) *Collective Vision: Starting and Sustaining a Children's Museum*, Washington DC: Association of Youth Museums, pp. 157–158.

Capello, S. (1994) 'Support to the sick child: the family's view' in *Europe with a Human Face: Help to the Sick Child*, Proceedings of the 1st European Conference, Athens: Elpida: Association of Friends of Children with Cancer, pp. 43–45.

Children's Cancer Foundation (1999) Singapore: Children's Cancer Foundation. Online. Available at <http://www.ccf.org> (accessed 27 November 1999).

Duitz, M. (1992) 'The soul of the museum: commitment to community at the Brooklyn Children's Museum' in I. Karp, C. Kreamer and S. Levine (eds) *Museums and Communities: The Politics of Public Culture*, Washington and London: Smithsonian Institution Press.

Gurian, E. H. (1992) 'The opportunity for social service' in A. Zemer and V. Eden (eds) *The Museum and the Needs of People: Proceedings of ICOM/CECA Annual Conference 1991*, Hafia: ICOM, pp. 82–85.

Health Canada (2000) 'This battle which I must fight: cancer in Canada's children and teenagers', Canada: Health Canada. Online. Available at: <http://www.hc-sc.gc.ca/hpb/lcdc/bc/children/feel1_e.html> (accessed 14 January 2000).

Leukemia and Lymphoma Society (2000) 'Emotional aspects of childhood leukemia', New York: Leukemia and Lymphoma Society. Online. Available at <http://www.leukemia.org> (accessed 13 January 2000).

Maher, M. (1997) *Collective Vision: Starting and Sustaining a Children's Museum*, Washington DC: Association of Youth Museums.

Malpas, J. (1994) 'The timely diagnosis of childhood cancer as guide for family and the general practitioner' in *Europe with a Human Face: Help to the Sick Child*, Proceedings of the 1st European Conference, Athens: Elpida: Association of Friends of Children with Cancer, pp. 21–24.

Muradyan, Z. (2000) Personal comment to author, 10 March 2000.

Pession, A. (1994) 'Epidemiology data of childhood cancer in Europe' in *Europe with a Human Face: Help to the Sick Child*, Proceedings of the 1st European Conference, Athens: Elpida: Association of Friends of Children with Cancer, pp. 25–28.

Thomas, R. (1998) 'Chancellor's millennial mantra for museums', *Museums Journal*, 8(5).

Part 3

Towards the inclusive museum

15

Rethinking heritage: cultural policy and inclusion

Lola Young

This chapter will raise a number of issues related to policy and the heritage sector[1] in what has come to be termed 'culturally diverse' Britain.[2] In many respects we have only just begun to think and speak about the meanings attached to Britain's sense of national and cultural identity in the twenty-first century, but although what Stuart Hall has termed 'the multicultural question' is the underpinning of these early thoughts on policy-making within the heritage sector, my discussion has wider parameters than that might suggest.[3] I want to indicate – in a necessarily schematic manner – the potential of making critical interventions in the sector through the deployment of theories and practices, and policy initiatives, in combination and separately. I am acutely aware that policy can never achieve all the objectives that we might desire, but I believe that it is essential for academics who have contributed to debates on culture, identity and representation in the sphere of the arts – especially black intellectuals and critics – to engage more deeply with cultural policy, interrogating, analysing, dismantling and reconstructing the policies, and the processes and practices of policy-making. There are a number of grounds for arguing that it is important to engage with policy in relation to the significant, rapidly developing sector both within and on the margins of the mainstream/ conventional heritage domain, and I will refer to these reasons in a later section.

I will be discussing policy in general terms whilst acknowledging the problems in doing so. The difficulty is due, at least in part, to the fact that levels of policy-making are abundant, and definitions are slippery: how is it possible to get to grips with and differentiate between all the guidelines, strategy papers, planning papers, policy statements, directives, implicit unwritten policies, explicit but coded policies, as well as the 'gaps between the lines' of policy statements? Then there are the effects of the combination of and tensions between policies such as those developed by local authorities, regional regeneration schemes, and heritage funders. Small wonder that many people – clients and staff alike – in the cultural and arts sector find it difficult to think about what making and implementing policy actually means.

Implicit in this essay is the argument that the major institutions and strategic bodies of the heritage sector have reached a point where changes are necessary,

and that policy is a valuable tool for encouraging such changes. Although a museum, an archive, or a funding body cannot by itself transform society for the better, such organisations can contribute to feelings of enrichment or feelings of alienation amongst the communities that comprise contemporary Britain.

Notes on inclusion/exclusion

Having worked through an era during which it was declared that there was 'no such thing as society', it is important to note the significance of the notion of social inclusion[4] since it is predicated on the assumption that there is such a thing, and that we are all better off being embraced within it. Although the issues that now cluster together under the heading of social inclusion are not new in one sense, they have proved to be deeply unsettling for a number of organisations as the ideas behind the rhetoric move to a central position in policy-making terms. What used to be safely contained under the rubric of 'outreach and education', handed to staff with little power within the cultural institutions, and ticked off in a box, is now having to be considered more carefully.

However, there is a dissenting view worth noting: there is an argument that says that there are many who wish to remain 'excluded' because they do not wish to be a part of a system that promotes inequality and injustice throughout its structures. Any publicly funded organisation may stand accused of reproducing the problems that it is supposedly attempting to resolve since it is, necessarily, part of the system and thus part of the problem. It is necessary at least to acknowledge that position because, if there really is a desire to change, rather than paying lip-service to a policy initiative in order to gain funding, we need to be clear about the implications of the work we are setting out to do.

It is worth, for a moment, stopping to consider some of the complexities involved in cultural organisations trying to deliver on 'inclusion'. The heritage sector, like most others, is dependent on exploited labour, hiring people for low-paid, low-status jobs, such as cleaners, caterers and security personnel. In the great cultural institutions in which these staff work, these employees are likely to be considered as 'the socially included' because they are in paid employment and represent an essential part of the labour infrastructure of the organisation and this society. Those staff with higher-status, better-paid jobs could not live and work in the way that they do without that workforce. However, low-paid staff are 'excluded' because they are often unable – due to economic considerations – to indulge in the high levels of consumption that many take for granted; they will have few opportunities for educational and career advancement; and are on the lower rungs of a hierarchical staffing structure that denies them full participation in decision-making processes.

Another, related, set of problems is highlighted by *The Parekh Report* of the Commission on the Future of Multi-Ethnic Britain (2000: 78–82). In summary,

the Report argues that there are four disadvantages in using the social inclusion/exclusion model as deployed in Britain. First is the concentration on marginality that leaves those at the centre unexamined and unchanged. Second, the term misrepresents the nature of the problem, failing to locate it as being one of inequality. Third, the concept does not acknowledge that the right to participate fully in society must be coupled with a right to cultural respect and recognition. Finally, there appears to be an underlying assumption that 'in so far as black, Asian and Irish people suffer from poverty, they will automatically, and indeed by definition, benefit from anti-poverty measures' (ibid.: 82).[5]

I raise these points not to get locked into an ideological skirmish but to signal some of the terminological difficulties that, if not addressed, serve to undermine what some of us would like to achieve. Social inclusion *is* a useful political term because it suggests a kind of benevolent social management, and the possibility of empowerment: it is hard for critics to argue against the idea of inclusiveness even if they do not want to promote it themselves in their workplace. But 'offering' inclusivity is still problematic for the reasons suggested above: why would anyone want to be part of that which they despise? And as for empowerment – the whole idea is radical and for that reason unlikely to occur. Can those who run or work in national institutions relinquish some of their power in order that others may exercise some? Is it possible that a large museum or archive can resist seeing itself as a 'centre for social change',[6] instead becoming part of a matrix of groups that combine as partners? Can established, high-status institutions readily adapt to the interests and needs of a local community-based project that wishes to approach them to take on the role of delivery partner, rather than lead body?

In an essay exploring precisely these kind of predicaments, James Clifford notes how 'Centers become borders crossed by objects and makers. Such crossings are never 'free' and indeed are routinely blocked by budgets and curatorial control, by restrictive definitions of art and culture, by community hostility and miscomprehension' (1999: 446). Curatorial decisions made by experts behind closed doors can lead to insurmountable difficulties when 'the community' is consulted once plans are already in place or have been executed. In those circumstances, who can be innocently surprised if the socially excluded turn and say, 'well we would rather be out here than in there'?

Professionals in the heritage sector – including public and civil servants, and board members/trustees – need to familiarise themselves with a range of tools and skills, which facilitate active engagement with the historical contexts and diverse heritages of a variety of cultures and diasporic narratives. Through this process the influences, exchanges and appropriations will become apparent and will have to be critically evaluated. A reconceptualisation of historical narratives is required, represented in terms of inter-cultural histories, exhibition and display practices, theory-making, and analyses that develop a keener sense of the various roles played at different times by various national, cultural, and ethnic groupings within a version of internationalism that goes beyond the conventional Euro-North American axis.

Challenging times

Few would dispute that the heritage sector has experienced a period of rapid transformations – from changing policy directives from governments, local and national, substantial funds for capital and little increase in revenue streams, as well as growth *and* decline over the last twenty years or so. In addition – and this is especially pertinent in the context of Britain's changing demographics – pressures from outside the heritage sector have impinged on professional sensibilities. The comments that follow do not by any means constitute an exhaustive account of the major features that have erupted on Britain's racial landscape within the last five years or so: rather, they serve to signal some of the upheavals and their possible impact on how we think about the place of the 'socially excluded' in this society.

When the Macpherson Report (1999)[7] on the murder of black teenager Stephen Lawrence and the subsequent mishandling of the police investigation was published, all British institutions were urged to examine their structures and policies to see how they dealt with the many varieties of racism in their organisations. Although, in retrospect, some of the confessions of previous racist sentiments by senior police officers seem now rather naïve, at least some made public their intention to take seriously the recommendations made by Sir William Macpherson regarding institutionalised racism.[8] Clearly, the main thrust of the report was directed at the police but, in his summary, Macpherson made it clear that all institutions were invited and expected to participate in a thoroughgoing review of their practices and policies in this respect. Responses from organisations within the heritage and cultural sector have been varied and, although several arts and heritage funding bodies have referred to Macpherson in their policy papers on social inclusion/exclusion and/or cultural diversity, few have seen fit to undertake a radical overhaul of their role and services.[9]

The period during which the Macpherson Report on the Stephen Lawrence Inquiry was being completed and discussed was crucial as it roughly coincided with other developments relating to 'race' and the national psyche. During 1998, the commemorative events surrounding the 50th anniversary of the arrival of the troopship *Empire Windrush* raised a number of questions about the presence and experiences of black people from the Caribbean, Asia and Africa after the Second World War. Although the focus of the exhibitions, plays, poems and essays generated by the anniversary was clearly on the arrival in 1948 at Tilbury Docks of 492 Jamaicans, it was a moment for black people to think about events further back in the past – in particular the history of slavery, indentured labour, colonialism and imperialism that led to the *Windrush* – and the future. The memories of past injustices at the hands of the police evoked during the Stephen Lawrence Inquiry were a significant part of that thinking.

The momentum was maintained by the establishment of the Commission on the Future of Multi-Ethnic Britain whose report was published in 2000. The Commission, chaired by Professor Bhikhu Parekh, produced a wide-ranging analysis of the current state of play of issues relating to racial equity that dealt

with all aspects of British life, attracting a frenzy of media attention based on the 'misreading' of a key word in the text of the report.[10]

In addition to the debates that were taking place during the gestation of both these reports, policy papers from the Department for Culture, Media and Sport (DCMS) made it clear that museums, archives, libraries and arts organisations were expected to contribute more fully to the developing political agenda of social inclusion.[11] In some respects, these documents were not fully attuned to the questions and predicaments exposed by the Macpherson and Parekh reports, the emphasis being on social factors rather than racial ones. There are a number of references to 'cultural diversity' in these papers, but often such references are embedded in a discourse of social exclusion seen in terms of economic and educational deprivation. Similarly, the question of widening access is often addressed in terms of intellectual, physical and, occasionally, cultural barriers preventing the great mass of people from taking advantage of the resources offered by national and local cultural institutions. However, the specificities of racist behaviour need to be comprehensively addressed at policy level: a black person who is singled out as an object for the contempt of the white receptionist in a museum, and decides not to return, may not have just encountered a 'cultural or intellectual barrier' but is likely to have experienced racism.

Rethinking heritage

Two major conferences took place in 1999 and, each in their own way, elaborated on the issues being outlined in some of the policy documents circulating.[12] In January, the Black and Asian Studies Association (BASA) organised a conference that set out to address a number of issues relating to black peoples' participation in the archives domain, from which emerged the Black and Asian Archives Working Party (BAAWP); and in November 1999, the *Whose Heritage?* event organised and funded jointly by the Arts Council of England (ACE), the Heritage Lottery Fund (HLF), the Museums Association, and North West Arts Board (NWAB) attempted to place 'race' and cultural diversity at the heart of debates on British heritage. Organisations such as BASA, the George Padmore Institute, the African and Asian Visual Arts Archive, Panchayat, the Black Cultural Archives, and the Black Environment Network were brought together along with major funders such as the HLF, the ACE, and various regional arts boards, and directors of national and regional institutions such as the Victoria and Albert Museum, and Nottingham City Museums and Galleries.[13] All the indications were that a number of black-led organisations were ready to demand a better service from the funders and strategic bodies in a more coordinated manner than previously, in order that this under-resourced but developing field could begin to redress past imbalances in the construction of historical narratives. Another key factor at this time was the establishment of the Archives and Museum of Black Heritage (AMBH).[14] Awarded £344,000 in 1999 by HLF, the main aims of AMBH are to raise awareness of the long history of the black African presence in Britain; disseminate information through

exhibitions, resource packs, on-line services and scholarly research; carry out a nationwide programme of education and outreach; and collate information about other organisations' resources and collections.

The sense that black British heritage was ready to move from the periphery was confirmed by the number of initiatives emerging across Britain, and the revitalisation of long-established organisations. Oral history and other community-based projects concerned with the past have, of course, been in existence for many years. Mostly funded on a piecemeal basis with explicit social policy agendas – relating, for example, to the well-being of the elderly, or to mental health – these projects may have wished for more funds to support their work but without a realistic chance of finding substantial, long-term finance from state or local agencies. However, with the prospect of being left out of the funding opportunities offered by lottery monies, veterans and newcomers entered the funding and policy arena with renewed vigour. Combined with the social and political climate change after the 1980s, and the aftermath of Macpherson and Parekh, there was talk of 'windows of opportunity' for those with a stake in black British heritage. In a general survey of the situation, several key points become apparent.

First, there is a lack of trained, qualified black professionals in the sector, and minimal knowledge of basic conservation and preservation requirements, and archiving skills in black communities, which means that documents, objects, artworks and so on are being inadvertently destroyed. Second, there is a lack of depth of understanding and awareness in most of the mainstream heritage sector regarding the needs and aspirations of black communities in respect of our histories. Finally, in order for organisations like AMBH to thrive, there needs to be a significant cultural shift within the heritage sector at all levels, including government policy-making. The scale and depth of the change required is not yet fully understood, but it needs to be fought for not only for black people but also for all communities and constituencies in the country.

To expect the transformation in required thinking to occur spontaneously, without the aid of external critical interventions, is naïve in the extreme, especially in the context of government departments' demands for 'quick wins' over long-term strategic planning and implementation, and reports couched in terms of 'action points' rather than allocating space to reflect, and explore in depth. Due to time constraints and political demands, it is a real challenge for most policy-makers and bureaucrats to find the space to rethink and to interrogate their processes and practices, and to see the value of engaging with theory and abstraction. However, not to do so, and for those of us with a stake in the outcomes of the policy-making process not to intervene, would be a mistake, for there is much to be gained in developing more widespread forms of critical theory and practice in the heritage sector.

The national heritage under interrogation

Heritage as a discursive activity inevitably reflects the governing assumptions of its time and context. It is always inflected by the power and

authority of those whose versions of history matter. These assumptions and co-ordinates of power are inhabited as natural – given, timeless, true and inevitable. But it only takes the passage of time, the shift of circumstances, the reversals of history, to reveal those assumptions as time – and context – bound, historically specific, and thus open to contestation, and revision.

(Hall 1999: 15)

There has been a long struggle for equity for black artists, which is by no means over, but the disparity in thinking, action, and progress towards that goal between the heritage and arts domains is, at all levels, very marked. Additionally, academics concerned with issues of 'race' and culture have yet to engage with the labour of translating certain kinds of theory into the practice of policy-making: cultural theory and discourse analysis – for all their flaws – have enabled studies of the complex interactions of various manifestations of power, privilege, racism, and discrimination in the arts.

Hall has pointed out that there have been a number of critiques of

the Enlightenment ideal of dispassionate universal knowledge, which drove and inspired so much of heritage activity in the past coupled with a rising cultural relativism which is part of the growing de-centring of the West and western-orientated or Eurocentric grand narratives.

(1999: 17)

There have been sustained attempts to democratise history and heritage in ways that signal the partial nature of recorded accounts of the past, and the particular interpretation of documents, texts and images. In addition, the tools, domestic objects, memorabilia, oral testimonies – the material culture of everyday life – are beginning to be recognised as important aspects of the nation's past. The increasing popularity of family history, and efforts to encourage a broader spectrum of visitors to national monuments, heritage sites, museums and archives have also contributed to a wider conceptualisation of what constitutes the national heritage, and what is worth preserving and conserving. However, with a few exceptions, the extent of the history of inter-cultural exchange, which underpins a substantial proportion of Britain's social, cultural and political development, has yet to be fully realised in museum and other presentations.

This reappraisal of the conventions of heritage practices raises a number of questions: Who has the power/right to represent narratives of the past? Who has the right/authority to represent 'other' cultures? Once raised, these questions will not simply disappear if they are ignored, or treated as if they are questions to be addressed only by the 'others' themselves. Failure to act upon the issues raised by these critiques leads to a loss of credibility and of the authority that organisations and individuals seek to retain. Another consequence is that alienated, disenfranchised people turn to other fantastical accounts of the past lacking in rigour and accuracy, in order to satisfy the demand for more historical knowledge.

Bill Schwarz argues that

> In order to achieve a position in the popular mind the public stories of the nation need, at least to a degree, to work from the experiences of individual histories . . . Critical to this process are museums, for they function as the key repositories and interpreters of the history of the people.
>
> (1996: 9)

This is important as a riposte to those within the sector who fear being accused of presenting tokenistic images by highlighting one or two black people in their exhibitions and resources.

Whilst I was working on representations of black people in post-war British cinema I came across the story of Sarah Baartman, a South African woman who was abducted from her home in 1810, brought to London – subsequently to Manchester, and Paris – where she was put on display in a semi-naked state and extensively examined by the scientists of the day. She died in Paris aged about 25 in 1815. After her death, she was dissected and her genitalia – which so fascinated the men and women who paid to see her in 'exhibitions' when she was alive – were put on display in the Musée de l'Homme in Paris. North American academic, Sander L. Gilman's powerful essay on Sarah Baartman (also known as the Hottentot Venus) analyses the processes by which she gained iconic status during the nineteenth century as representative of all that was different, anomalous and deviant from the norm, sexually and racially (1985). I was intrigued not only by the way in which her image and subjectivity were appropriated by those nineteenth-century scientists as emblematic of the intellectual, moral and cultural inferiority of the African 'race', but also by her absence/presence, her simultaneous visibility – which she certainly maintained during the five years when she was displayed around Europe, written about, drawn in cartoons, referred to in court and the House of Commons – *and* her invisibility, since many people grow up believing that black people first arrived in Britain in the 1950s. What might this story tell us about the kinds of narratives that are constructed out of the materials from the past? What does it tell us about the gaps in our knowledge of history?

'Everything is still at stake'

Promoting inclusion in the sense that I am most comfortable with means that national institutions have to find ways of abandoning linear notions of control, thinking instead in terms of a network with no centre: the cultural objectives and outputs driven by negotiated policies and strategies worked on in partnership with the strands of the web. If institutions continue to see themselves as the only bodies able to hold the centre, this implies that 'others' have to come to them and the balance of power is not shifted.

We need to beware that we do not simply reach for off-the-peg terms like social inclusion, access and diversity, whenever we write policy statements, fill in funding application forms or write annual reports: I have seen some fanciful

abuses of the terms in a number of documents. The abuse may not be of malign intention: it may be that the language used is, as one person put it to me, 'a vocabulary to assuage the conscience and gloss over our ineffectualness'. The challenge is there: to connect with the disconnected and the alienated, but not in ways that say 'come and be like us'. Let us encourage people to ask the awkward questions, and to make self-determined critical interventions that enrich our understanding of the ways in which history is made and represented.

Potentially radical plans for overhaul of the sector may be undermined by the failure to think less conventionally about who should be involved in decision-making processes, and the kind of subject matter deemed appropriate for exhibition, research, resources and so on. Those who have previously regarded it as their right to hold the authority, at the centre, will need urgently to reassess their positions in the context of developing challenges to the status quo, in order to allow others previously excluded to participate on an equal footing. People in power, who have nurtured and developed the heritage to its current position will find it difficult to change their perspectives, and review their mode of operation without assistance. The experience of those of us who are working to make progress in this area suggests that such changes only occur because we keep pushing for it to happen, and when we can participate in active, meaningful ways that recognise our skills and areas of expertise.

Notes

1 I am using this term to refer to the museum, gallery and archive domains, and cognate areas such as certain kinds of arts activities concerned with interpreting and re-presenting the past.

2 As always, 'Britain' is problematical, since some government documents relate specifically to England, and the Arts Council of England has, of course, a remit in England only. Additionally, the issue of black peoples' identification with the 'national' is complex, and shifting.

3 I believe that many of the issues I raise also have relevance outside Britain.

4 In recent years, the concept of social inclusion has become embedded in many areas of British government policy-making.

5 The Report does go on to cite some important exceptions in policy documents that do acknowledge the specificity of racial disadvantage (82).

6 This term is taken from the title of the Department for Culture, Media and Sport's (2000) policy document, *Centres for Social Change: Museums, Galleries and Archives for All*.

7 For a full version of the report and recommendations see Macpherson of Cluny (1999) *The Stephen Lawrence Inquiry: Report of an Inquiry*, London: Stationery Office.

8 There is an argument that says that 'institutionalised racism' is not a very helpful term, as it does not differentiate between different manifestations of workplace/institutional racisms, and flattens out the wide range and scale of manifestations of its presence. For now, I use this as a shorthand to describe the myriad ways in which organisations and institutions place obstacles in the way of achieving equity and justice for all cultural, faith, and 'racial' communities.

9 In 2000, the Arts Council of England (ACE) committed itself to a 'root and branch' review of all services, funding practices, recruitment and employment strategies and hopefully the fruits of this internal, high-level action plan will be seen over the coming years.

10 In the Commission's report, the text referred to the racist connotations of 'British' as an identity. This was reported by the press as a statement that the term 'British' was 'racist'.
11 For example, Department for Culture, Media and Sport (1999) *Policy Action Team 10: A Report to the Social Exclusion Unit: Arts and Sport*.
12 For example, Department for Culture, Media and Sport (1999) *Policy Action Team 10: A Report to the Social Exclusion Unit: Arts and Sport*.
13 See Arts Council of England (2000) *Whose Heritage? The Impact of Cultural Diversity on Britain's Living Heritage: Report of National Conference*.
14 AMBH was originally known as the National Museum and Archives of Black History and Culture (NMABHC). The organisation was not able to retain the 'National' since the organisation could not fulfil the criteria relating to collections management.

References

Arts Council of England (2000) *Whose Heritage? The Impact of Cultural Diversity on Britain's Living Heritage: Report of National Conference*, London: Arts Council of England.

Clifford, J. (1999) 'Museums as contact zones' in D. Boswell and J. Evans (eds) *Representing the Nation: Histories, Heritage, and Museums*, London: Routledge, pp. 435–457.

The Commission on the Future of Multi-Ethnic Britain (2000) *The Future of Multi-Ethnic Britain: The Parekh Report*, London: The Runnymede Trust and Profile Books.

Department for Culture, Media and Sport (1999) *Policy Action Team 10: A Report to the Social Exclusion Unit: Arts and Sport*, London: Department for Culture, Media and Sport.

Department for Culture, Media and Sport (2000) *Centres for Social Change: Museums, Galleries and Archives for All*, London: Department for Culture, Media and Sport.

Gilman, S. L. (1985) *Difference and Pathology: Stereotypes of Sexuality, Race and Madness*, Ithaca: Cornell University Press.

Hall, S. (1999) 'Unsettling "The heritage": re-imagining the post-nation' in *Whose Heritage? The Impact of Cultural Diversity on Britain's Living Heritage*, London: Arts Council of England, pp. 13–22.

Schwarz, B. (1996) 'Powers of the past' in S. Selwood, B. Schwarz and N. Merriman (eds) *The Peopling of London: Fifteen Thousand Years of Settlement from Overseas, An Evaluation of the Exhibition*, London: Museum of London.

Positioning the museum for social inclusion

David Fleming

Traditionally, museums have not been positioned to contribute to social inclusion[1] for four reasons: who has run them; what they contain; the way they have been run; and what they have been perceived to be for – to put this last reason another way, for whom they have been run.

Because of these factors, museums have restricted themselves to serving the interests of an educated and prosperous minority, which has jealously guarded its privileged access. Museums became publicly funded, yet private and exclusive clubs, annexed by self-seeking interests because of the museum's cultural authority and power. Contrary to at least some of the principles according to which most museums were created, museums have not been democratic, inclusive organisations, but agents of social exclusion, and not by accident but by design.

Writing from a British perspective, this chapter analyses these factors (which, together, I would describe as the Great Museum Conspiracy) and the structures and practices that predominate in museums, to consider how as organisations they might become better positioned to contribute towards social inclusion.

The Great Museum Conspiracy

Who has run them

Coming from a prosperous, middle-class background with the benefit of a good education is not a criminal offence, so one wonders why many of those who do are so reluctant to discuss it. The museum profession is one wherein the positions of power – curatorships and directorships – have traditionally been occupied by people with a good education, usually involving attendance at university, and an academic degree as a qualification. By definition, this has meant that such people have come from an environment wherein they have enjoyed parental encouragement to study at school, and to remain there until they are 17 or 18. There was not pressure upon them to get out of school as quickly as possible, find a job, and earn a living.

Since the 1960s, and at an accelerating rate, more people from poorer backgrounds have benefited from a higher education and, therefore, the museum intake has become more diverse, more representative of society at large. Nonetheless, no one could argue convincingly that museums in the last quarter of the twentieth century were anything other than dominated by middle-class people from comfortable backgrounds. And herein lies one clue as to why museums have been *exclusive* rather than *inclusive* organisations.

Even with the best will in the world, it is hard for people from a privileged background to understand the pressures, anxieties and aspirations of those less fortunate: for homeowners to truly understand what it means to have to live in rented accommodation, or to have no home at all; for salaried staff to understand what it is like to live on state benefits; for people with lots of qualifications to know what it feels like to have none. It is hard for *anyone* to understand the experience of another. It is no surprise, then, that a sector that recruits staff from a particular stratum of society has managed to create a product that appeals most to others from the same stratum. This point was made succinctly by Bryan Magee:

> To people who know different classes from the inside, the lesson that keeps being driven home most powerfully is how ignorant they are about each other; or rather, worse than ignorant, wrong. Each class is internally variegated in elaborate ways, but each is seen from outside by the others in terms of one or two stereotypes which dominate their thinking about it. This is because the majority of people go through life without sharing any really significant part of it on equal terms with individuals from other classes, and therefore never really know people from other classes.
>
> (1990: 21)

But there is more to the museum experience than this. The curatorial part of our world is, by definition, one built on the pursuit of academic excellence. It has tended to attract scholarly types, and scholarly types are often quite introverted, because the pursuit of scholarship is a solitary one. Moreover, as universities have always found, the desire to study often leaves little room or inclination for the dissemination of learning. In terms of creating museums that are successful in attracting ordinary non-specialists, we have an inbuilt obstacle, which is the need to staff the museums with specialists who are knowledgeable about collections. It is not inevitable that specialists will struggle to communicate with lay audiences, but because they often lack the necessary skills, it has been common.

> To the professional educator, the most conspicuous feature of conventional museum exhibitions is their communicative incompetence. The emphasis is plainly on the displaying of objects, rather than on the transmitting of ideas. When attempts *are* made to transmit ideas, amateurism manifests itself at almost every point.
>
> (Lewis 1980: 151)

If we look deeper into the impact on museum communication that many specialists have had, we may begin to glimpse a more sinister aspect of the issue

which is the degree to which some specialists simply do not bother, or even unconsciously refuse to disseminate messages that are comprehensive to lay audiences. I shall return to this point below.

What they contain

The concept of collecting material culture and natural specimens, assembling the items in a formal institution which could not be more different from where the items originate, then displaying them in the hope of communicating to visitors what they mean and represent, is complex in the extreme.

We all know it is not possible to assemble items that are fully representative of the people, place and/or time they come from, and the best we can hope is that we evoke something of the era and place. The exception to this is the display of modern and contemporary art, much of which has been created specifically for display in an art gallery rather than, as with older artworks, in a domestic, or specific religious, or public, setting.

The core issue is, what is it that museums have collected, and why? Almost without exception, museum collections have been put together by different individuals, using different mechanisms, over different periods. While in recent years the degree of formalisation has grown, so that there is a more generally acknowledged rationale for collecting, this has made little impact on the bulk of museum collections. They remain haphazard assemblages, which curators mine in order to create means of communicating messages to visitors. Haphazard they may be, but someone has selected and collected according to some criteria, however obscure.

What we collected cannot be dissociated from *who* did the collecting. And this is where it starts becoming difficult, because our history collections, for example, reflect not the make-up of society at large, but the make-up of the collectors. They also reflect, of course, the survival chances of items. It is far more likely that an oil painting, or a nice oak refectory table, will have survived to represent seventeenth-century life, than the everyday bits and pieces that were familiar to most people living at the time.

In short, nobody in their right mind believes that museum collections contain everything they should in order to enable curators to create the Holy Grail of the fully representative exhibition. Because of their partial nature, museum collections have an inbuilt set of biases, and even when curators are keen to give pictures of life in the round, say of seventeenth-century Newcastle, they are handicapped by the range of material they have to hand. And, of course, not all curators have been so motivated. Only in recent years, on any scale, have history curators begun seriously to tackle the problem that has resulted in the creation of displays that suggest that our towns and countryside have been wholly populated by prosperous, well-fed, literate, burghers and bucolic yeomen, with their large families and houses stocked with valuables. Indeed, the pendulum has swung in a number of institutions away from collecting middle-class paraphernalia to collecting material that is likely to be owned by

215

people from poorer backgrounds: a form of positive discrimination, but so long overdue that one can have little hope that there will be an impact on the nature of collections generally.

All of this is significant in the present context because museum collections, in representing the lives of the richer minority, have helped alienate the very people whom contemporary social inclusion policies are trying to address.

The way they have been run

Much of what I have to say here derives from what I had to say about who runs museums. I have observed that the real power-brokers in museums, the curator-directors, have tended to have three features in common: they came from middle-class backgrounds; they were, or aspired to be, scholars; and they worked according to an amateur ethic rather than a professional code. It is also worth pointing out a glaringly obvious fourth feature – they were nearly all men.

The way in which museums have managed to exclude many people can be exemplified simply by looking at them from the outside. Many museums were designed to overwhelm visitors. The classical columns and pediments, the banks of steps, the ornate iron gates – these are devices that convey numerous messages, all quite conscious, about what an entry to this grand edifice will lead to. I don't believe that these architectural messages were created to actually dissuade people from visiting, but this is the effect they can have. Any student of marketing could tell you that intimidating façades are bad.

Then the insides – often cavernous, like great cathedrals, and certainly rarely comfortable. Museum architecture has always been, and still is, an area where pomposity and vainglory can run riot. Museum architects do seem to think that the building is more important that what's in it, and we have a number of recent examples of how wrong this can be. It is the cavernous interior that often reduces people to hushed whispers and an impression that, somehow, they oughtn't to be there. The quasi-religious museum setting is no accident. It derives from a period when the Victorian Establishment believed that this setting was the most appropriate for absorbing knowledge: that humility was the springboard to learning.

Curators are not usually in a position to do much about the architecture, so they need not shoulder all the blame. No one else, however, is responsible for the displays that museums contain. It is here that the betrayal of the socially excluded really begins to take shape. I have made several references to the nature of the curator-directors who have moulded our museums and made them the exclusive institutions most of them are. I have considered the nature of the collections that museums hold. It is time to look, in more detail, at what this combination has led to.

One could be kind and suggest that most of the problem has been caused by simple incompetence. On the other hand, one has to wonder how so many

curators, supposedly intelligent people, could unknowingly produce displays, the communicative value of which was so low. Over twenty years ago, Raymond Singleton wrote that, 'just as the public in the past accepted the notion that museums were static, unchanging places, many museum curators were simply content to have it so; anything for a quiet life' (1979: 11).

It is not, then, as though it is anything new to observe the tendency for museum displays to do a poor job for general audiences. Doubtless such views have been expressed for many decades. But what has resulted? Overall, not much. Curators have not been listening on a wide scale. Why? To a degree, their own limitations and the nature of collections have restricted the ability of curators to produce displays with broad appeal. I have to say, though, that I have more understanding of the difficulties confronting art curators than those in other disciplines,

> because art . . . has been socially constructed in such a way that while purporting to represent moral and spiritual values for every man – beyond class, beyond politics and beyond price – it is in fact used as aggressive propaganda for a particular notion of civilisation and to reinforce social division and actively uphold the status quo.
>
> (Gilmour 1979: 121)

This is certainly less true of much contemporary than historic art, but the display of contemporary art brings its own range of issues, notably the role of artists – not always a breed with an overwhelming urge to find popularity among mass audiences!

But I do not wish to find too many excuses for curators. In the end, they themselves are knowingly responsible for their failure to find wider appeal with the general public. Our profession has been complacent about its role, largely satisfied with its narrow appeal. And, until recently, we have got away with it. When 'value for money' reared its head in the 1970s and 1980s, new pressures began to be exerted, and things began to improve, though slowly. The main reason for the slow rate of change is the nature of the power system, which has had such a strong influence on museums. This power system is at the heart of the Great Museum Conspiracy.

For whom they have been run

One might think that because traditional museums are publicly funded cultural institutions, they would, by definition, have been institutions run in the interests of the public at large. Nothing could be further from the truth. All kinds of interest groups and individuals have exerted such pressure that they have subverted the museum's democratic role. These interests include donors, private collectors, corporate interests, funding bodies, trustees, scholars, academics, intellectuals, artists, architects, journalists, critics, volunteers and politicians.

Museums have often been founded in a spirit of public good, but the temptation to influence and control the way they operate can be powerful. In any

event, it would be naïve to suggest that the 'public good' was really any more than 'what's good for the public'. Museums have long been mechanisms for reinforcing the status quo through the familiar device of providing sufficient knowledge and awareness to satisfy curiosity, but in a way that means social control is not threatened. However, it is one thing to offer up a range of ideas for consideration. It is quite another to impose a doctrinal view, especially when motivated by a contempt for the masses. Elites always manipulate culture, and museums are convenient (and all the more attractive through being publicly funded) vehicles for the promotion and glorification of minority tastes, which are perceived by their adherents to be superior and inviolable. I first encountered this contemptuous elitism in 1991, when Tyne and Wear Museums opened a new art display in Newcastle's Laing Art Gallery:

> [I]t was clear from comments in the visitors' book that, with some sectors of the public, *Art on Tyneside* has been popular. I suppose one must accept this. If some visitors are so unimaginative that they need half-baked gimmicks to make history come alive, then by all means let them have them. But not in an art museum . . .
>
> 'It is the policy of the Laing to make Art more Accessible to the People' reads a large notice at the entrance to the museum, signed by a Mr Barney Rice. Yes, but accessible to which people? Not, certainly, to those who are interested in fine art.
>
> (Dorment 1992: 14)

Another critic wrote:

> Most imaginative art galleries allow their collections the quiet dignity of the sort of space in which the work can perform its true function of being intellectually challenging, contemplative, and uplifting. If this sounds elitist, then the fault could possibly lie with the shortcomings of those gallery-goers whose discrimination is as suspect as their art education is limited.
>
> (Evening Chronicle 1992)

The ways are many and various in which control of museums has been exerted, with trends set by the national museums having their inevitable influence on smaller institutions.

> I do not think the national museums should be allowed to go on functioning in the way that they do, behaving as laws unto themselves with bodies of trustees actually responsible to no-one (the fag-end of aristocratic consensus) and a tendency to regard as their personal property the loot, which they are often too mean or too lazy to lend.
>
> (Gilmour 1979: 122)

It is ironic that, in the area where we might have expected more respect for popularising culture, the local authority museum, we have seen the opposite, and on a widespread scale. The explanation for this is that, by and large, local authority councillors have been less interested in the goings-on in their museums than

in their council estates or schools. So, museums have been left to their own devices, and subject to a combination of curatorial shortcomings, with pressure from others.

This has included pressure from funding bodies of one type or another, exerted quite clinically through their failure to fund what they do not like, and their funding of what they do. What kind of a system is it that will go into funding overdrive to save a multi-million pound foreign painting from being exported, but which fails conspicuously and consistently to provide cash, for example, to prevent the sale into private hands of local literary treasures out of our public libraries? The answer is, the same system that wishes museums to perpetuate their narrow appeal, that rejects notions of populism as vulgar: the essence of elitism.

We in museums should not feel especially paranoid about the Great Museum Conspiracy. The same conspiracy can be found at work in all areas of cultural life, for exactly the same reasons. The crude ideology underpinning this is that there is, and needs to be, an absolute division between inferior majorities and refined minorities. The origins of this lie in classical times, its clearest articulation probably in the nineteenth century, varied by conservatives such as Friedrich Nietzsche, but also by liberals like Matthew Arnold and John Stuart Mill. One fear is that, if cultural institutions fall into the hands of populists, then standards will be lowered. Some on the left have argued that 'mass culture' suppresses critical reason and therefore threatens the possibility of social and political change. So, in fact, the desire to eliminate cultural elitism can energise opposition at both ends of the political spectrum.

The backlash

Optimistically, I would say that there are at work a number of factors that have begun to counter the influence of the Great Museum Conspiracy. First, the agents of the conspiracy, the 'enemy within', have begun to lose power. Gone, largely, are the days of the over-mighty curator-director, who willingly ensured that museums remained stubbornly exclusive. The past decade in the UK saw retirements and severances in great numbers as, in many cases, new scrutiny and new demands being made of museums saw off those unable or unwilling to change their ways. The trouble is, that the reputation of museums in the local government sector had suffered from twenty years or more of the apparent inability of curator-directors to modernise their organisations, and from their tendency to behave as though they were running miniature national museums. So, we saw the gradual loss of seniority within local authority structures, and the loss of senior posts.

Museums have, almost without exception, been downgraded in the new structures of the twentieth century. This means that museum professionals now have far less authority and independence of action than formerly, which, given our track record, is difficult to lament. However, at least where we once had

dinosaur leadership, we now have lots of fresh blood, fresh ideas and new ways. In a few years' time the prejudices held against museums in local authorities will be a memory, one hopes.

As to the situation in the national museums, two recent significant acts in the UK were the appointment of a merchant banker at the British Museum as Managing Director, and of a naval officer as Director of the National Maritime Museum. Not quite the same, perhaps, as bringing in a new, inclusive approach, but a sign of government's uneasiness with what we might call traditional museum values.

Second, we are becoming a democratised profession, rather than an elitist one. Increased educational opportunity has, for three decades or more, been producing a much healthier cross-section of society among museum recruits than ever before. Curators remain largely middle class, but at least many more people are able to haul themselves up the socio-economic hierarchy than was the case when there were far fewer higher educational opportunities. Just as big a change has been the gender swing. We were once dominated by middle-class men. Now there's a much improved gender balance to set alongside the broader socio-economic background. These changes are enabling our profession to be far more community orientated than ever before, because we are, as individuals, more rooted in ordinary community life than ever before. This is a key issue in museums' ability to turn themselves into inclusive organisations. While there are other balances to strike, and positive action is still needed, and there is a long way to go, we are nonetheless heading in the right direction.

Third, the days of amateurism are definitely numbered. It is now rare to find curator-directors unwilling to admit that they don't know everything. On the contrary, we are becoming a far better trained profession than ever before. The problem here is that training and development budgets are slimmer than ever, and we still have problems providing good-quality in-service training. However, there is a new willingness to train, which, as long as we have a supportive government, augurs well for the future. Training and development have brought a new awareness of the importance of sound management, which has led to all sorts of changes in how museums are run. For example, there is a growing recognition of the importance of effective teamwork, and of the debilitating effects of departmentalism. We are becoming less rigidly hierarchical, and more consensual in terms of policy-making. These are important requisites for an inclusive organisation.

Fourth, there are, of course, the new political demands being made of museums, and even the national museums, bastions of independence, are feeling the pressure. Apart from the value for money issues, which have been around for some time, we are now moving into performance measurement very seriously, both at local and at national levels. Like all publicly funded bodies we are being urged to be more consultative, to find out what users think, to address issues of representation, identity and access. Over and above all, we are being urged to be socially inclusive. We have a government that is adamant that organisations such as ours will cease trading as private clubs and go all out for total

inclusion. The importance of this for tackling the Great Museum Conspiracy cannot be overestimated, any more than we should underestimate the capacity of the Conspiracy to resist, or to neutralise by incorporation, change to the status quo. Nor should we take for granted that social inclusion policies will survive changes of government: we need to act now while the imperatives are strong, and while there is government support in taking on the forces of reaction.

The inclusive museum

I hope that, if nothing else, I have illustrated that creating the socially inclusive museum is not an overnight job. There is an awful lot to do to the traditional, exclusive museum, and there is powerful opposition out there, making the task even more difficult. I should acknowledge, of course, that there are museums and museum projects that have demonstrated that museums can be of relevance to a wider community, though not many museums, perhaps, have overtly attempted to counter social exclusion. Where should we look to find a more concerted inclusion movement?

The independent museum movement was founded on that great obstacle to inclusion, the admission charge. The university museum sector has not been noted for its commitment to broadening access. The national museums, of course, began the process of reintroducing admission charges in the mid-1980s, thus turning away from an inclusive approach. Those that did not introduce admission charges are, arguably, among those where the display ethic is to be seen at its most intimidating. Government pressure to remove admission charges has not met with universal acclaim among the trustees of national museums.

It is in the free access local authority museums that we have seen most of the inclusive initiatives, for example the wave of social history museums and displays created during the 1980s and early 1990s, in cities such as Edinburgh, Hull and Liverpool (the latter nationalised in 1986). These museums were created quite deliberately to appeal to ordinary local people, to fill a yawning gap in museum provision with something that said 'we place a value on your story, and we want you to come to the museum'. There were other examples where a similar ethic could be found, such as in Glasgow, but they were rare.

Tyne and Wear Museums

At Tyne and Wear we have been striving to create a fully inclusive museum service for ten years. Prior to 1990 there had been occasional initiatives, but there was no corporate commitment of the kind we made in the 1990s. We were a traditional, regional museum service, which had poor penetration in terms of attracting people from the lower socio-economic groups. We were also a service coming under increasing scrutiny from our funding authorities in terms of our lack of relevance to local people. Financial cuts bit hard over several years,

and the service was demoralised and in trouble. Changes in management proved to be the catalyst for changes in outlook and aspiration. From 1991, with the opening of *Art on Tyneside*, a radical new approach by the service was signalled, and the display's immediate success in winning new audiences for the Laing Art Gallery was the encouragement we needed to transform the service wholesale.

There are a number of major factors underlying the way in which this transformation came about, some of which I have referred to generally already. First, we built a new sense of teamwork. We broke down artificial structural barriers among our staff, and shifted away from a divisive approach that implied that managing collections and managing the whole museum are somehow separate tasks. We have never had generous funding, and we made hard choices about what skills we needed in our reinvented service, losing curatorial and conservation posts in order to gain education and marketing posts. We created multi-disciplinary project teams, ending the perceived supremacy of the curator, replacing it with a more consultative methodology that placed great emphasis on mutual respect among staff with different skills and knowledge.

Second, we placed a new emphasis on understanding the policies and strategies of our five local authority funding bodies. Previously, the museums had struggled to make sense of what potential there was for our keying into local social and economic imperatives. In gaining an understanding of political priorities, inevitably we repositioned the service both in the eyes of others and in the eyes of our own staff. Our new structure acknowledged the need for improved communication with colleagues in the local authorities, and the requirement to communicate thus was spread more widely among museum staff than just the Director. This is especially important both in exposing museum staff to the wider political and therefore socio-economic context, but also in evangelising the role museums could play.

Third, we became much more resourceful in obtaining funding to enable us to run revenue and capital projects. For example, securing funds available for urban regeneration enabled major improvements to the Museum of Science and Engineering, a process that meant difficult negotiations, encountering first scepticism, then hostility, from a number of quarters. Taking risks – another characteristic without which no museum service can reinvent itself – won political support, which eventually won a share of the funding. Had we not fought we could have been sidelined, and the museum, now the Discovery Museum, one of our flagship successes in terms of social inclusion, would have been hamstrung for years. Nor would we have had the crucially important *People's Gallery*, nor its dedicated outreach post, which has been responsible for so much of our success in winning the confidence and support of socially excluded communities in Newcastle.

Fourth, we ceased creating exhibitions and displays that appealed to no one, and became far more aware of the need to win new audiences. We started producing social history exhibitions – the quickest way through to the hearts and minds of local people. We varied the mix in our art galleries, with a new

emphasis on building younger audiences. Such programmes will win no new audiences, though, without effective marketing and publicity, and at this we got better and better. The museum service started to gain widespread publicity and, crucially, media support, so important to winning political support and protected funding.

Between 1991 and 1993 visitor numbers in Newcastle rose from 153,000 to 344,000 per year, an increase of 125 per cent. Visitors overall rose to over one million for the first time, an increase of 52 per cent over the two years. The number of schoolchildren and students visiting rose to 81,000, an increase of 130 per cent. These were results that won us financial stability, and that opened lots of new doors for us. They made it easier to forge the partnerships that are so essential to pursuing a socially inclusive agenda. Museums will never have the resources to go it alone, nor should they want to do so. They will be far more effective keying into support networks, working in collaboration with other arts organisations, seeking the backing of public agencies and commercial enterprises. In 2000/1, the Newcastle visitor numbers had risen to 574,000, so the process continues.

Our exhibitions and displays are winning awards, exciting critical debate, attracting grants and sponsorship. More important, though, is that they are broadening our audiences.

> Does the term 'broadening audiences', threatening to some, mean that we are adopting a role of cultural Robin Hoods – taking culture from the educated and well-off, and giving it, in a debased form, to those less fortunate? We wouldn't agree: widening access does not inevitably mean debasing the message. We are committed to the idea of museums as agents of social change, and if, in increasing access to museums, we cause offence to an elitist few, who believe that museums have no role in enriching society at large, then perhaps we are getting things just about right.
>
> (Tyne and Wear Museums 1993: 3)

This quotation, from Tyne and Wear Museums' Annual report for 1992/3, indicates the key to our 'positioning for social inclusion'. The real positioning comes about not from changing structure, or from studying political agendas, or from finding resources, or from programming and publicity. It comes about because the museum decides that this is what it wants to do. By museum, I mean the whole thing: the governing body, the staff, the supporters. Nothing less will do than a wholesale corporate commitment, with all the perils and pitfalls this brings. This commitment drives the recruitment policy of the museum – recruit for attitude, not for skills – and the training and development policy. It provides the reference point for everything you do. Social inclusion is a worthy thing to aspire to, but for a museum to really make progress, inclusion must become the driving force that overcomes all others, whatever they may be. It will win you friends, it will make you enemies, it will cause you problems, it will get you into arguments. At times you will have doubts, sometimes severe. But personally I cannot imagine what else it is museums are supposed to do, what they are for.

223

Moreover, inclusion is only a means to an end. Simply attracting visitors or users is not the aim. The aim of inclusion is to help the process of social change and regeneration, nothing less. In creating a museum that inspires and uplifts people, that confronts them with ideas, that helps them understand a little more about themselves and their surroundings, you are doing the best a museum can do. It is having this aim that refutes the accusation that, in order to have widespread mass appeal the museum must 'dumb down'. Not so, not if you want to make a difference to people's lives.

Note

1 I use a definition of social inclusion that relates to the social role and purpose of museums and their ability to contribute to social change and regeneration. Recent government policies have served to increase attention to these issues in the UK. See, for example, Department for Culture, Media and Sport 2000.

References

Department for Culture, Media and Sport (2000) *Centres for Social Change: Museums, Galleries and Archives for All*, London: Department for Culture, Media and Sport.

Dorment, R. (1992) 'Are galleries losing art?', *Daily Telegraph*, 9 September: 14.

Evening Chronicle (1992) 26 September, Newcastle, letters page.

Gilmour, P. (1979) 'How can museums be more effective in society?', *Museums Journal* 79(3), December: 120–122.

Lewis, B. N. (1980) 'The museum as an educational facility', *Museums Journal* 80(3), December: 151–155.

Magee, B. (1990) 'Bound by the chains of class', *Guardian*, 30 May: 21.

Singleton, R. (1979) 'Museums in a changing world', *Museums Journal* 19(1), December: 11–12.

Tyne and Wear Museums (1993) *Tyne and Wear Museums, Annual Report 1992/93*, Newcastle: Tyne and Wear Museums.

17

Māori and museums: the politics of indigenous recognition

David Butts

Introduction

This chapter explores the evolving relationships between museums and Māori in Aotearoa, New Zealand, with particular emphasis on the period 1980–2001. The *Te Māori* exhibition (1984–7) is identified as a turning point in Māori relationships with museums. Since that time most museums have worked constructively to build better relationships with Māori people, not only because elements of Māori heritage form a large part of museum collections, but also because museum credibility depends to a large extent on those collections. These evolving relationships are documented with reference to recent developments in three institutions, Museum of New Zealand Te Papa Tongarewa, Tairawhiti Museum, and Whanganui Regional Museum, especially as they affect museum governance. The paper considers the significance of these evolving models of museum governance, organisational structures and professional practice for the museum sector and the extent to which they may contribute to issues of social change and social equity in the wider society.

From the 1860s until the early 1980s, New Zealand museums collected and interpreted Māori cultural treasures without forming close relationships with the *iwi* (tribes) who had originally owned the collections. While some museum directors and staff, particularly museum anthropologists, had begun to initiate changes from the 1960s, it was not until after the *Te Māori* exhibition travelled to the United States and toured New Zealand that the initiatives gained momentum.

During the 1980s the concept of biculturalism entered the discourse of museum politics in New Zealand:

> By focusing on power, biculturalism is concerned with creating a partnered society in which two founding peoples can coexist legitimately without undermining the interconnectedness that binds the system. Biculturalism envisions Aotearoa [New Zealand] society as a partnership between two founding peoples, neither of whom are superior, but are autonomous over

their respective spheres, thus sharing the sovereignty of Aotearoa New Zealand as a whole.

(Fleras 1999: 207)

Following the work of Professor Mason Durie (1993), Fleras describes a bicultural continuum from the 'inclusion of Māori values and perspectives within existing institutional structures to the creation of specific parallel institutions that exhibit some degree of control over Māori outcomes' (ibid.). When the Museum of New Zealand Te Papa Tongarewa (known as Te Papa) opened in 1998 it declared that it would be a bicultural institution. Exactly where Te Papa sits in the bicultural continuum is a matter for debate but there is no doubt that it has taken a leading and constructive role in exploring the notion of a bicultural museum (Butts 1994b).

Gerard O'Regan's report on bicultural developments in New Zealand museums documents the progress achieved and challenges still facing the museum sector ten years after *Te Māori* (O'Regan 1997). Since 1997 there has been an increasing level of commitment by individual museums, and the sector collectively, to the development of partnerships with Māori to the extent that a fundamental rethinking of museum governance models, policy, staffing, and professional practice has occurred. Underpinning the concept of partnership and the notion of biculturalism is the Treaty of Waitangi (signed 1840) that guaranteed Māori leaders and their people 'full, exclusive and undisturbed possession of their lands and Estates, Forests and Fisheries and other properties which they may collectively or individually possess so long as it is their wish and desire to retain the same in their possession' (quoted from Durie 1998: 249). Following the Treaty of Waitangi Act 1975 there has been a renewed commitment to the Treaty by the Crown and in the new climate Māori have worked progressively to achieve greater levels of autonomy (Durie 1998). It is within this wider context of the settlement of Treaty grievances that Māori and museums have begun to explore new relationships. Many Māori communities are also actively pursuing their own heritage maintenance initiatives, leading to the establishment of their own heritage facilities and programmes and greater pressure for the repatriation of significant cultural treasures from public museums both in New Zealand and overseas (see, for example, Tapsell 1997 and 2000).

Historical context 1769–1980

Since Captain James Cook's expeditions visited New Zealand in the late eighteenth century, a succession of explorers, missionaries, soldiers, traders, travellers, and settlers purchased, traded, were gifted or appropriated Māori cultural treasures that were returned to family, gifted or sold to private collectors and public museums in Europe and North America. (See, for example, Kaeppler 1978; King 1981; Lindsay 1992.) By 1901 the New Zealand government was sufficiently concerned to pass the Māori Antiquities Act restricting the export of Māori cultural treasures, thus reflecting a concern on the part of

scholars and politicians that the heritage of the 'nation' was being appropriated (Pishief 1996). New Zealand public museums were creating their own collections of Māori cultural treasures and using them as the basis for interpretations of Māori culture and history in public displays.

Although these activities ensured the preservation of many Māori cultural treasures in New Zealand that may otherwise have been destroyed or exported to Europe and North America, their presence in museum collections was, and remains, symbolic of the colonial enthusiasm for both appropriating Māori heritage and reinterpreting it according to Eurocentric perspectives.

The four metropolitan museums in Auckland, Wellington, Christchurch and Dunedin hold the largest Māori collections in New Zealand, although a number of smaller regional museums also hold significant Māori collections.[1] These metropolitan institutions were established in the 1860s and have progressively built their Māori collections since that time (Thomson 1981). Augustus Hamilton, for example, who became Director of the Colonial Museum (now the Museum of New Zealand) from 1903–12, negotiated the addition of a number of major private collections of *taonga Māori* (Māori treasures) and created the foundation of the Māori collections in the national museum (Pishief 1996). In more recent times the New Zealand government has funded the return to New Zealand from Britain of several major collections including the Oldman and Webster collections (Thomson 1978). The Oldman collection was distributed to a number of museums throughout the country.

Exhibitions of *taonga Māori* before the 1980s were predominantly systematic arrangements of artefact types. Each of the metropolitan institutions has a long tradition of exhibiting a *wharenui* (tribal meeting house) as the centrepiece of their exhibitions. Other major treasures used as focal points include *pātaka* (storehouses) and *waka* (canoes). Individual *wharenui*, *pātaka* and *waka* carvings, weapons, cloaks, and amulets formed the next level of the exhibitionary hierarchy. Adze heads, fish-hooks and other artefact types were exhibited in much the same way as natural history specimens. The primary concern was with materials, technology and use. Tribal treasures often became disassociated from their origins. There was little attempt to create a sense of continuity between the 'authentic' pre-European Māori and the Māori communities of the time, or to collect contemporary Māori art.

While there are many instances of museum staff, particularly ethnologists and anthropologists, working closely with Māori individuals and communities during the period 1900–80, it is not until the 1980s that most museums began to recognise, in both policy and practice, the right of Māori to determine the way in which their *taonga tuku iho* (treasures handed down through generations) are managed and interpreted. Prior to the 1980s a number of institutions had one or perhaps even two Māori trustees, who represented the interests of their people. Throughout this period there were no Māori curators responsible for Māori collections. The appointment of the first Māori director of a museum in New Zealand, Mina McKenzie of *Ngāti* Hauiti, at the Manawatu Museum in 1978 was an exception (McKenzie 1991).

Te Māori 1981–7

Te Māori was the first international exhibition of *taonga Māori* from New Zealand museum collections (Mead 1986). Opening at the Metropolitan Museum of Art in New York in 1984, the exhibition then travelled to the St Louis Art Museum, the M. H. de Young Memorial Museum, San Francisco, and the Field Museum, Chicago, before returning to New Zealand in 1986 where it was shown at the National Museum and Art Gallery, Wellington; Otago Museum, Dunedin; Robert McDougal Art Gallery, Christchurch; and Auckland City Art Gallery. The *taonga* were returned to the twelve New Zealand museums from which they had been borrowed towards the end of 1987. The total attendance at the four venues in New Zealand was circa 920,000, nearly 300,000 more visitors than had seen the exhibition in the four venues in the United States.

Why is this exhibition seen as a turning point in the relationship between Māori and museums? Was it merely fortuitous that Māori were able to use the *Te Māori* experience not only to raise the international profile of Māori art, but also to initiate a dialogue with New Zealand museums from a position of strength that had somehow eluded them prior to that time?

Although discussions involving the American Federation of Arts, the Metropolitan Museum of Art, the New Zealand government and New Zealand museums about sending an exhibition of Māori art to the United States began in 1973, it was not until 1981 that the New Zealand government formally approved the proposal and created the New Zealand Management Committee chaired by the Secretary of the Department of Māori Affairs. A Māori Subcommittee was formed 'to ensure that Māoridom had a voice in all operations of the exhibition from the time of approval and agreement of the exhibition to the time of the return' (*Te Māori* Management Committee 1988: 16). It was this subcommittee, consisting of senior public servants, scholars, and arts and museum administrators, which ensured that the traditional owners of the treasures that had been selected for the exhibition would be asked to approve their inclusion. The round of consultations seeking permission to include *taonga* in the exhibition raised the awareness of many Māori to the presence of these treasures in museum collections. The Māori Subcommittee also ensured that the tribes represented in the exhibition had representatives at each opening ceremony for the exhibition in the United States. For the first time Māori were in control of a major museum exhibition of treasures that had been beyond their reach for so long in museum collections. When the exhibition returned to New Zealand, Māori managed the opening ceremonies at each venue and the day-to-day management of the exhibition, including welcoming visitors in customary Māori form and training Māori students to interpret the exhibition to visitors.

Ironically, when the exhibition opened in New York, the television coverage of the dawn opening ceremony with elders chanting *karakia* (incantations) as they ascended the front steps of the Metropolitan Museum of Art heralded in a new

period of museum practice in New Zealand. For the first time New Zealanders saw *taonga Māori* exhibited as art works of international standing rather than ethnological specimens and, moreover, were able to glimpse something of the relationship between *taonga* and tribal people. This revelation reinforced the already growing recognition in many New Zealand museums of the need to redevelop the exhibitions of *taonga Māori* that had remained essentially unchanged for decades. The Māori protocol used by the elders to ceremonially open *Te Māori* quickly became the accepted form for opening most exhibitions of *taonga Māori* in New Zealand museums. The level of consultation between Māori and museums about issues of Māori collection care and interpretation increased significantly in the wake of *Te Māori*. In fact, the planning process followed for *Te Māori* had an immediate effect on museum practice in many institutions. Hawkes Bay Museum and Art Gallery, Napier, for example, opened an exhibition of *Ngāti Kahungunu*[2] *taonga* in 1986. The planning process for this exhibition had been significantly influenced by the *Te Māori* exhibition and the people involved in its planning. There was extensive consultation and a *Ngāti Kahungunu* artist, Sandy Adsett, designed the exhibition at the request of his elders (Butts 1990).

Te Māori continues to be a focus for scholars interested in the evolving relationship between Māori and museums (McManus 1992; Butler 1996). It is now clear that *Te Māori* happened at a time when new and more vigorous Māori voices were joining those of the elders, who had been advising museums for generations, in a call for greater Māori participation in museum governance and management. Throughout the 1980s the number of Māori staff in New Zealand museums was slowly increasing. The early 1980s was also a time when indigenous peoples in Australia, Canada and the United States were challenging museums to recognise their rights in relation to the care and interpretation of their cultural treasures. The repatriation of human remains and sacred objects was also a prominent issue. *Te Māori* provided a focus for those Māori and *Pākehā* (New Zealanders, of European descent) in metropolitan and regional communities, who recognised the need for change in the way museums cared for and interpreted *taonga Māori*, enabling them to bring these issues to the attention of museum practitioners in a way that had never happened before (Hakiwai 1995; Mead 1985; Neich 1985; O'Regan 1990; Te Awekotuku 1988). Tribal *kaitiakitanga* (customary practices relating to guardianship of and authority over *taonga*) were recognised by museums during *Te Māori*, and consequently this recognition has been taken into individual institutional negotiations with tribes at the local level. Nowhere was this more evident than in the planning for the Museum of New Zealand Te Papa Tongarewa, in Wellington.

Te Papa Tongarewa Museum of New Zealand

In May 1985, while *Te Māori* was on its successful tour in the Unites States, the New Zealand government affirmed in principle a commitment to construct a new national art gallery as part of a major Pacific Cultural Centre. A Project

Development Team, consisting of three Māori (all members of the Māori Subcommittee of the *Te Māori* Management Committee), one Pacific Islander and three *Pākehā*, one of whom had had a close association with *Te Māori* since 1979, was asked to define the parameters of the Pacific Cultural Centre and its relationship to the existing cultural institutions, namely the National Art Gallery and National Museum. In August 1985 the Project Development Team completed its report *Ngā Taonga o Te Motu: the Treasures of the Nation* in which it recommended a concept to government that it hoped would provide 'an appropriate expression of national unity and identity to commemorate 1990 and for the twenty-first century'.[3] The team's investigation had been 'conducted on the basis of a full and equal partnership between the two main cultures in New Zealand', Māori and Pākehā (Project Development Team 1985). It recommended that the term 'Pacific Cultural Centre' be replaced with National Museum of New Zealand/Te Marae Taonga o Aotearoa. This new museum would 'allow New Zealand's different cultural traditions their own special mana and recognition, while allowing each to contribute with equal importance to shaping the nation's identity' (ibid.: 2). The combined collections of the National Art Gallery and the National Museum were described as 'a powerful, irreplaceable and unique expression of this nation's culture'. Around this centralised resource the Team recommended a family of three largely independent museums: the National Art Museum, Te Whare Taonga Tangata Whenua/National Museum of Māori and Pacific Art, and the National Museum of Human Society and the Natural Environment Te Whare o Papatūānuku. Government, however, was slow to respond to the recommendations.

In 1989 a newly established Project Development Board confirmed a museum concept. The family of museums had been replaced by one institution combining the National Art Gallery and National Museum organised around three foci: *Papatūānuku* – the earth on which we live; *Tangata Whenua* – those who belong to the land by right of first discovery; and *Tangata Tiriti* – those who belong to the land by right of the Treaty of Waitangi. The bicultural principle articulated by the Project Development Team remained central to the concept. In 1992 the Museum of New Zealand Te Papa Tongarewa Act ensured that the new institution would become a reality. Te Papa opened to the public in 1998.

Five Corporate Principles underpin the operation and outputs of Te Papa: biculturalism, scholarship/*mātauranga Māori* (Māori knowledge and learning), customer focus, being commercially positive and being a *waharoa* – an entry way to New Zealand and a catalyst for New Zealanders to explore and reflect on their cultural identity and natural heritage. It is the explicit nature of Te Papa's aim to be a bicultural institution that is most important in the context of this paper. However, the governance provisions of the Museum of New Zealand Te Papa Tongarewa Act 1992 do not provide explicitly for Māori representation. Appointments to the board are made on the basis of individual merit and the skills individuals contribute. The notion of partnership would suggest that Māori should have the right to appoint their own members to the board, or at least make provision for Māori to recommend individuals for appointment. At the present time, although there are two Māori members of

the board appointed by the Governor General on the recommendation of the Minister for Cultural Affairs, neither of them would claim to represent Māori.[4]

The establishment of the *Kaihautū* (Māori Director) position at the same level as the CEO is, however, a significant step by the board towards ensuring that the organisational structure within the museum reflects the institution's commitment to biculturalism. This is also reflected in the commitment to employ Māori staff in all divisions of the organisation and at all levels. A major commitment has been made by the museum to host a series of tribal exhibitions. Such exhibitions ensure that Te Papa continues to build and strengthen its relationships with *iwi* throughout the country. The creation of *Te Marae ō Te Papa Tongarewa*, a space for ceremonies of encounter, adds a further dimension to the way in which a museum can sustain relationships with and between the peoples of the nation.

Te Papa National Services, the programme providing support for regional museums, offers partnership programmes to New Zealand museums in the areas of biculturalism, museum assessment, marketing and promotion, training and revenue generation. National Services has supported bicultural initiatives at the national and local level. Some national initiatives are discussed in the next section of the paper. Local initiatives have been of four types: governance projects, Māori staff development, Māori collection research, and Māori exhibition development.[5]

The history of the development of the museum concept for the new national museum encapsulates the challenge for those responsible for giving substance to notions such as biculturalism. While the Project Development Team proposed a model that would have given a degree of autonomy to the Māori component and thus acknowledged the principle of 'two peoples development', the Project Development Board followed the politically more acceptable line of weaving the cultural strands together in one structure to give the appearance of unity. To date it is only vociferous elements of the art community that have sought to have the art gallery component separated from this arrangement. Whether Māori eventually seek the establishment of a national Māori museum will depend on the extent to which Te Papa is robust enough to allow *iwi Māori* to pursue their own agenda within the existing structure.

The O'Regan report

In 1994 *kaitiaki Māori* (Māori heritage workers) and the Museums Association of Aotearoa New Zealand[6] established a partnership with National Services, Te Papa, to commission a report on bicultural developments in New Zealand museums. Gerard O'Regan was commissioned in 1995 to undertake the research. His report was published by the partnership in 1997 (O'Regan 1997).

O'Regan reviewed heritage legislation, museum governance and Māori staffing levels and interviewed Māori working in the museum and heritage sector.

Although in the review he acknowledged the importance of the wider international context of the growing recognition of the rights of indigenous peoples, he emphasised the centrality of the Treaty of Waitangi as the source of a set of principles that should guide the relationships between public institutions and Māori. These principles include the government's right to govern, tribal self-regulation of their own resources, that the Treaty partners will act reasonably and in good faith, active participation of both partners in decision making, the active protection of Māori interests in the use and management of their resources, and redress for past grievances.[7] While O'Regan acknowledged that progress had been made in relation to some aspects of the partnership between Māori and museums, he also identified areas such as governance, management structures and procedures that require further change.

Government is responsible for creating a legislative environment within which the provisions of the Treaty of Waitangi are recognised. O'Regan identifies changes required in the Antiquities Act 1975, the Resource Management Act 1991 and the New Zealand Historic Places Act 1993. While there has been a comprehensive review of historic heritage legislation, it now seems unlikely an independent Māori Heritage Council, advocated by many, will be established. A Heritage Review being undertaken by Te Puni Kokiri, the Ministry of Māori Development, seems to have stalled. The Antiquities Act review, stretching back more than a decade, has been activated again by the Ministry of Culture and Heritage. However, there is no clear timetable for the introduction of the proposed Protection of Moveable Cultural Heritage Bill that will replace the Antiquities Act. The basic problem with the Antiquities Act is the assumption of prima facie Crown ownership of recently found Māori artefacts (including artefacts recovered from archaeological sites), in contradiction to the rights guaranteed in the Treaty of Waitangi (Butts 1994a). It is now widely accepted that the new law should vest this ownership in the traditional Māori owners.

O'Regan's interviews with Māori museum staff provide a sobering insight into their view of museums. Māori staff indicated that relationships between museums and *iwi* have not progressed as much as some museum practitioners would like to think they have. Māori staff were of the view that Māori still view museums as essentially Pākehā-centric institutions. Museums are seen by some Māori staff as culturally insensitive, to varying degrees, towards *taonga Māori*, Māori issues in general and to Māori staff. Some provided evidence of institutional racism and it was suggested that some managers lack understanding of Māori culture. Some institutions, both metropolitan and regional, with significant Māori collections do not have Māori curators. Māori staff acknowledged the progress made in this area in some institutions but noted the need for significant change in others where the Māori advisory committee structure still remained. This inside view provides a balance to the notion that, since the *Te Māori* exhibition, museums have made the type of fundamental changes that are required to create bicultural institutions. However, O'Regan acknowledges that some progress has been made and argues that the sector must continue to invest in the development of bicultural relationships:

It would appear that there is a growing force for change within Ngā iwi Māori regarding the management of their cultural heritage. There is also a widespread concern that museums should be adequately prepared to meet these changes constructively.

(1997: 125)

O'Regan recommended cultural awareness training, *iwi* values training for managers, training for *kaitiaki Māori*, the appointment of Māori to positions across all divisions of museums and continuing dialogue between museums and *iwi*. It was clear from his investigation that museums had to engage Māori in substantive discussions if bicultural developments were to advance. Finally he recommended a series of *hui* (meetings) at a regional level to facilitate such substantive discussion between museums and *iwi*.

Te Papa National Services adopted this final recommendation and funded eight regional *hui* in 1998–9 (Murphy 1999). These *hui* focused on three issues: the nature of *taonga Māori* (Māori heritage), the nature of biculturalism and the implications of biculturalism for museum organisations. Reviewing the findings from this series of *hui*, Murphy identified a significant difference in the understanding of biculturalism:

To museums, biculturalism often is about bringing Māori and Non-Māori together as one. For Māori the concept means something completely different . . .

For Māori there is a link between colonialism and current moves towards bicultural development. The discussions at some regional *hui* illustrate that Māori associate one event of the colonial process with another. Grievances relating to the loss of guardianship of *taonga* (artefacts) are not seen in isolation from other grievances, such as those concerning land, language, and cultural property.

(1999: 10)

Murphy also noted the pivotal role of museum directors in communicating their vision of biculturalism and their responsibility to actively nurture bicultural relationships. The *hui* identified four areas that are currently the focus of bicultural activity: governance, training, resourcing, and communicating and networking. She recommended that Te Papa National Services Advisory Committee support bicultural partnership projects that 'seek to strategically develop relationships with Māori and fit into an overall plan for developing a bicultural organisation' (1999: 14), and develop a bicultural training plan.

In order to sustain bicultural developments at a national level, Te Papa National Services organised *wānanga* (conferences) on bicultural development in New Zealand museums in 1999[8] and 2000.[9] These *wānanga* provided an opportunity for directors and trustees from museums throughout New Zealand to share their experiences and identify important issues requiring further exploration. The *wānanga* concluded that bicultural partnerships should be based on a clear understanding of separate and common interests, supportive governance structures, committed leadership and formal agreements.[10]

233

The second *wānanga*, Bicultural Governance and Leadership in Museums, featured presentations from two regional museums, Tairawhiti Museum and Whanganui Regional Museum, which have developed innovative bicultural governance models. Other topics discussed at this *wānanga* included heritage legislation, local government, repatriation, *kaitiakitanga* and *taonga*. There are continuing themes running through these discussions that echo the issues identified by O'Regan and Murphy. After five years of intensive exploration of these issues it is increasingly apparent that partnerships evolve over time as relationships grow and trust is earned. An imposed structure that has not been negotiated by the parties concerned will have little meaning beyond the boardroom. It is at the institutional level that some of the most innovative developments have occurred, particularly in the development of new governance models that attempt to apply the notion of biculturalism. The next section of this paper outlines two such models.

Tairawhiti Museum

The Tairawhiti Museum, established in 1954, services the city of Gisborne and the surrounding region of Tairawhiti on the East Coast of the North Island (Thomson 1981). Total population of the area is about 40,000, 45 per cent of which is Māori. The first museum director was appointed in 1970 and a modern museum facility, located on the banks of the Taruheru river, opened in 1977. Following further extensions to the original building, the museum now consists of six galleries, an education centre, maritime museum, colonial cottage, artists' studios, archive centre, collections stores, work spaces, café and retail outlet. The collecting policy focuses on the Tairawhiti region and the museum holds significant regional collections of *taonga Māori*, archives and history objects, natural history specimens and fine art.

Since 1954 the museum had been governed by a twenty-six-member council with representation from the incorporated society, affiliated groups (e.g. artists, camera club, potters), local authority representatives, Māori advisory representatives and institutional representatives (e.g. Historic Places Trust, East Coast Museum of Technology). From the time of its founding the museum has fostered a relationship with the Māori community through certain families who have maintained their interest and support for the museum through to the present time.

In the mid-1990s the Gisborne District Council indicated it wanted the museum to move to a governance model that drew representation from across the whole community. The museum director, in consultation with members of the museum's Māori Advisory Committee and other local *kaumātua* (Māori elders), and members of the museum society, developed a new governance model. This model proposed representation for each of the five *iwi* in the Tairawhiti region. In an attempt to create a bicultural partnership a board of eleven members was proposed: five *iwi* representatives, four representatives of the Friends of the Museum and two local authority representatives. Although

some members of the museum society were concerned about the proposal, the existing museum board endorsed the proposal to replace the incorporated society with a new trust incorporating the proposed governance model. When formally consulted about the model, four *iwi* endorsed the model immediately and the fifth agreed to participate once the new trust was operational. The new trust was formally constituted in late 1999.

The introduction of the new governance model at Tairawhiti Museum was assisted by the fact that nearly half of the population of the Tairawhiti region is Māori. This process was also assisted by the close relationship between the museum and Ngā Taonga ā Ngā Tama Toa Trust, representing the men and their families of C Company of the 28th Māori Battalion, which fought in the Second World War (Soutar and Spedding 2000). C Company included men from the five *iwi* of the Tairawhiti region. The relationship developed because the museum had signed a formal agreement with the Trust to care for the C Company collection and to create an exhibition about C Company. There can be little doubt that the relationship has been fundamental to the evolving relationship with the *iwi* of Tairawhiti and the implementation of the new governance structure.

The director has been proactive in building a close relationship between the museum and C Company and he has also been successful in increasing the number of Māori staff at the museum. Of the fourteen staff currently working at the museum, half are Māori, including the assistant director/curator. This was an indication to *iwi* that the museum is committed to developing a bicultural organisation to serve the communities throughout the Tairawhiti region. Members of the new trust board, Māori and *Pākehā*, are unanimous in their view that the commitment of the museum director has been essential to the process of implementing the bicultural governance structure.[11]

Whanganui Regional Museum

Established in 1892, the Whanganui Regional Museum (Figure 17.1) holds significant collections of *taonga Māori*, natural and human history and local history archives. The present museum building, now owned by the Wanganui[12] District Council, was opened in 1928 and extended in 1968. The museum was operated by an incorporated society until July 2001 when governance transferred to a new Museum Trust. Until recently the museum board had been elected from the members of the society at the Annual General Meeting. In practice this had meant that there was little change in the composition of the board and individuals served for many years. As the museum made the transition to a fully professional museum in the 1980s it became apparent that it required a board with a wider range of skills and the membership began to change. The board had included Māori representatives from very early on, principally drawn from prominent local Māori families. In 1993 the museum board recognised the need to develop a more formal relationship with *iwi* in the region with particular reference to the *kaitiakitanga* of the *taonga*. At the same time

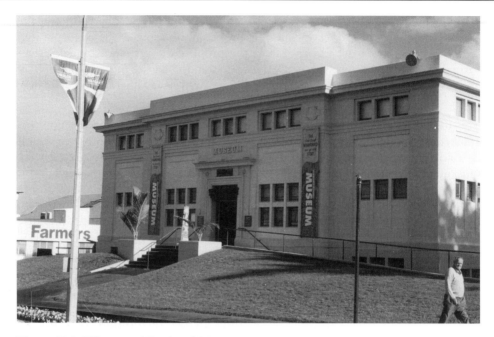

Figure 17.1 Whanganui Regional Museum. Photo by kind permission of Whanganui Regional Museum.

museum staff were increasingly involving Māori connected to *taonga* within the collection in all decisions relating to their care, protection and use. In one example, proposals to undertake conservation work on a *waka* (canoe) were referred to descendants of the owners who also participated in the cleaning, measuring and stabilising work. In another, descendants of the people portrayed in an oil painting were intimately involved in all decisions relating to the loan of the painting for a touring exhibition.

By 1995 the museum had developed to the stage where it required a substantial increase in the level of its annual grant from the Wanganui District Council. In agreeing to the increase, the council required the museum to improve its management systems and to explore ways of ensuring wider community representation on the board. In particular there was an awareness of Māori interest in establishing their own museums in the region and removing their *taonga* from the museum. Whanganui *iwi* had been particularly active at that time in protesting the lack of progress with the settlement of their Treaty grievances. These protests polarised the local population and continued to influence *Pākehā* attitudes towards Māori involvement in civic affairs.

In 1997 a project facilitator was contracted to manage the consultation process that would lead to a proposal for a new governance structure. A series of meetings were held that canvassed a wide range of issues relating to governance, but it proved difficult to engage *iwi* representatives in this process. In order to overcome this impasse a Māori consultant was contracted and a *hui-ā-iwi* (meeting of all the tribes of the region) was held in 1998 at which a group of

iwi representatives, to be known as *Te Rōpū Mahi mō Ngā Taonga*, the Tangata Whenua Working Party, was mandated to work with the museum to develop a new governance model.

The *hui-ā-iwi* adopted a bicultural bicameral governance model, known as the Mihinare model, because it has been adopted by the Anglican Church in New Zealand, as the preferred model for the museum. The Mihinare model is based on the principles of partnership and *tikanga-ā-rua* or 'two peoples development'. The principle of 'two peoples development' provides for each of the partners to be able to operate and develop according to their own *tikanga* (customary practice and authority). These principles are derived from the Treaty of Waitangi and are referred to in the constitutional principles of the newly formed Whanganui Museum Trust.

The Mihinare model is based on the establishment of two houses, the Tikanga Māori House and the Tikanga *Pākehā* House (renamed the Tikanga Civic House for the purposes of the Whanganui Regional Museum model). The Tikanga Māori House consists of representatives of the *iwi* in the Whanganui Region. The Tikanga Civic House consists of representatives of the museum's key stakeholders. Each house elects members to the Joint Council that is responsible for governing the organisation. If proposals cannot be agreed by consensus in the Joint Council, for any formal motion to pass, a majority of members from each house must agree. Thus, the model requires a partnership of peoples and not the traditional majority-driven democratic process.

In late 1998 the Museum Board and Museum Society endorsed the proposal but the Wanganui District Council asked the museum to undertake further consultation with the community. At the 1999 AGM the Society again approved the proposal despite vigorous opposition to it. When the proposal was later discussed at a Wanganui District Council meeting a majority disapproved of the proposal. However, the museum board decided to continue with the implementation of the new governance model.

Reflecting on the process Grant Huwyler, *Ngāti Apa* representative on the Whanganui Regional Museum Joint Council, observed:

> Looking back, one particular highlight of the process was the debate that the governance proposal stimulated in the local *Pākehā* community. The issue of the bicultural model had created quite a stir and this had been picked up in the local media. The issue of the model had been compounded by the fact that the Museum has a significant contract with the Wanganui District Council, the Museum's largest source of funding. Debate centred on the issue of democracy and the sharing of power with Māori who are considered by many as merely a minority in society, despite the fact that Māori are the indigenous people of Aotearoa, and are signatories with the Crown to Te Tiriti o Waitangi.

> This issue came to a head at the AGM for the Museum Society in November 1999 when people from the local *Pākehā* community joined the Museum Society specially to vote on the governance structure. Some

237

joined to vote for the model, others joined to vote against it. At the end of the night once the votes were counted there was a clear majority in favour of the model. This provided an interesting indication on where the community sits on race related issues affecting this type of organization.

Another aspect of the process has been the positive response of key individuals within the local Māori community to the opportunity that the new governance model presents. These individuals are typically *hapū* (sub-tribe) and *Iwi* people who have a strong interest in heritage preservation and the survival and cultural wellbeing of their respective *hapū* and *Iwi*. They bring a range of knowledge, skills, networks and experiences from a *tikanga* Māori context, the extent of which has never before been seen within the Whanganui Regional Museum.

The entire process and its various aspects has been a learning experience for all those involved as the two different *tikanga* worked together toward the common goal of implementing the new governance model . . . The process has been very empowering.

(2001)

Comparisons

Tairawhiti Museum, Gisborne, and Whanganui Regional Museum Trust present two significant examples of the way regional museums are working with their stakeholder communities. It is interesting to reflect on the different responses of the local bodies and the communities in Gisborne and Whanganui to the respective governance proposals. In the Tairawhiti Museum governance model each member of the board has one vote and a simple majority is required to pass a motion. Fifty per cent of the board consists of *iwi* representatives and this is seen to be consistent with nearly 50 per cent of the population of the region being Māori. Hence, the Tairawhiti Museum model is seen to conform to traditional democratic notions of representation. As a result there was very little public opposition to the implementation of the new governance model. However, the proposed new governance model for Whanganui Regional Museum requires a majority of the representatives from both houses to agree to any motion and hence the notion of a simple majority does not apply. A number of *Pākehā* commentators found the 'right of veto' given to Māori unacceptable. It is clear that these people do not understand the difference between a model in which citizens participate as individuals and one in which peoples are represented collectively. It was also observed by those who objected to the model that it was undemocratic because Māori in the Whanganui region comprise only 18 per cent of the population and yet they would have half the membership of the Joint Council. These objectors did not acknowledge that, in supporting this model, Māori had accepted that the Civic House representatives have the same 'right of veto' over proposals *iwi* may bring to the table. Those who object to this feature of the model also ignore the requirement placed on both Houses to consult and resolve differences, in so far as this is possible, before issues are raised at the Joint Council.

One commentator has warned that biculturalism is subject to popular resistance:

> It would be overly dramatic to announce the end of biculturalism while so much earnest effort to realise its promise continues. In schools, universities and government departments, among cultural mandarins and Anglican vicars, the work of making a bicultural society continues. Within the government, senior ministers continue to favour writing Treaty clauses into new legislation. The word 'partnership' still has the urgency and slipperiness of a political password. Yet it is difficult to mistake the hesitation of New Zealand's most authoritative and able political leader in recent memory in the face of popular resistance to her Government's perceived favouritism of Māori.
>
> (Williams 2001: 12)

The Whanganui Regional Museum experience suggests that, in so far as museums are seen to be committed to developing bicultural organisations, they will find themselves subject to the same popular resistance, especially when proposed changes in governance arrangements challenge traditional power structures. The response of some influential people in the Whanganui community, including district councillors, to the new governance model at the museum suggests there may be a fear that these ideas might permeate into local and even national government.

In Whanganui, as in Gisborne, the museum director played a central role in managing and supporting the proposal development process. The director's commitment to developing a meaningful partnership between the museum and the *iwi* of Whanganui is acknowledged by all those who have been involved in the *Tangata Whenua* and Governance working parties.[13] The evidence from these two institutions confirms the observations made at national conferences that the commitment of directors is crucial in the development of bicultural institutions.

It is also significant that, in the period prior to the review of the governance structures, both institutions had been engaging individuals and families in decisions relating to the care and use of particular *taonga* in the collections. This created a more receptive environment for them to become involved in governance issues.

Both institutions have also shown that *iwi* representation can become an effective mechanism broadening the focus of the museum beyond the city in which it is located to the whole region it must serve. Equally important has been the focus these new governance models have brought to our consideration of the increasingly multicultural nature of the non-Māori population in these regions. There is a very real responsibility to include representation of the diverse cultural communities within each region and to recognise the particular needs of these communities within the programmes of the museum. Whanganui Regional Museum, for example, has been proactive in building relationships with a number of Pacific Island communities and this has resulted in a range of public programmes such as the exhibition *Tapa: Heartbeat of the Pacific*.

Return of human remains

When questions of repatriation arise, priority is always given to the return of *kōiwi tangata* (human remains). In the past museums in New Zealand and overseas have accepted into their collections Māori skeletal remains that have been fossicked or excavated from archaeological sites, including burial grounds,[14] and *toi moko* (tattooed preserved heads) have been stolen or traded. Since the 1970s most New Zealand museums have ceased to collect such material without close consultation with the *iwi* concerned. In some instances museums have been proactive in returning Māori skeletal remains, long held in collection storage, to the appropriate *iwi* where the provenance of the remains is known. The natural response of most Māori is to rebury such remains when they are returned. No museum in New Zealand publicly exhibits *kōiwi tangata Māori* and those that still hold such remains do so under strict protocols in a secure and consecrated facility.

There is also the challenge facing Māori to secure the return of ancestral remains from museums and private collections overseas. New Zealand museums, and Te Papa in particular, are working closely with *iwi* to facilitate the resolution of these issues. However, there has been much debate in recent times about what should be done with the *toi moko* now being returned to New Zealand from Australia, Europe and North America and the significant collection held at Te Papa.[15] Decisions relating to those with known provenance will be made by their descendants, while those with no known provenance will remain in a consecrated facility at Te Papa, and managed according to strict protocol.

Ngāi Tahu, whose tribal territory covers most of the South Island, have been the most proactive *iwi* in resolving the disposition of their ancestors held by museums in their tribal territory. Rather than begin by negotiating agreements with museums, *Ngāi Tahu* first consulted with their own people and wrote their own *Kōiwi Tangata* policy.[16] This policy asserts the tribal authority (*kaitiaki-tanga*) granted in the Treaty of Waitangi to *Ngāi Tahu* to manage the human remains of their ancestors. *Ngāi Tahu* consider the collecting of such remains 'abhorrent and culturally insensitive in the extreme'. Following the development of the policy, *Ngāi Tahu* have negotiated agreements with each of the museums in their tribal territory to continue to care for the remains they hold, in special storage facilities, until further decisions are made about the long-term disposition of the remains. Applications for access to the remains for research or other purposes will be considered by *Te Runanganui o Tahu* (Ngāi Tahu Tribal Council). This is an example of negotiated repatriation where an *iwi* asserts its *kaitiakitanga* over cultural property and the parameters of that assertion are acknowledged by the museums currently holding the property.

Conclusion

Within New Zealand there have been fundamental attitudinal shifts in the relationships of museums with Māori people. This paper has highlighted four significant changes. First, Māori collections have been reconceptualised and revalued, not as ethnological curiosities, but as *taonga tuku iho* and as art. Second, the link between those works, and the people for whom they have particular significance (no matter how many generations ago) has been acknowledged. Third, the manner in which Māori collections are exhibited has shifted from an emphasis on typological and static displays to a stronger focus on the collections as part of a wider, ongoing context. Fourth, Māori participation in museums has moved from a donor/subject focus to one of participation in all aspects of the museum, including the museum workforce and museum governance. There is not a single formula for these new governance structures. *Iwi Māori* and museums will negotiate governance structures that emerge from and respond to their local circumstances. While these changes are not occurring uniformly throughout the museum sector it is evident that there have been and continue to be significant initiatives occurring at both the national and regional levels. It is also widely acknowledged that there is still much to be done and the commitment and investment in new initiatives must be sustained.

Acknowledgements

Thanks are due to the following people for commenting on a draft of this paper: Professor Mason Durie, and Dr Monty Soutar, Te Pūtahi ā Toi, School of Māori Studies, Massey University; Sharon Dell, Director, Whanganui Regional Museum; Michael Spedding, Director, Tairawhiti Museum. Particular thanks are due to Grant Huwyler, *Ngāti Apa* member of the Whanganui Regional Museum Joint Council, for permission to quote from his seminar paper. During February and March 2001, I undertook a Fellowship in Museum Practice at the Center for Museum Studies, Smithsonian Institution. I wish to acknowledge the opportunity this provided for me to consider the development of museums in Aotearoa, New Zealand from afar.

Notes

1 For a brief introduction to New Zealand museums see Butts 2000. For a more detailed account see Thomson (1981).
2 Ngāti Kahungunu is the tribe located in Hawkes Bay in the North Island.
3 Project Development Team 1985: Front Page (letter from Project Development Team to Hon. Dr Peter Tapsell, Minister of the Arts).
4 Personal communication, Professor Mason Durie.
5 Museum of New Zealand Te Papa Tongarewa 1999: 30–31 (see <http://www.tepapa. govt.nz/briefing_paper/briefingpaper.html> (accessed March 2000)).

6 The Museums Association of Aotearoa New Zealand (MAANZ) board consisted of 50 per cent *kaitiaki Māori* and 50 per cent *Pākehā* representatives. When Museums Aotearoa replaced MAANZ the new constitution made no provision for *kaitiaki Māori* membership on the board.
7 These principles provide the framework for the Auckland Museum *Taumata-ā-iwi Kaupapa*. The *Taumata-ā-iwi* is a Māori advisory body to the Auckland Museum Trust Board. The *Taumata-ā-iwi Kaupapa* is a policy document outlining the principles to which the *Taumata-ā-iwi* will adhere in discharging its responsibilities. See Whaanga 1999.
8 Te Papa National Services 1999.
9 Te Papa National Services 2000.
10 Te Papa National Services 2000: 3.
11 Personal communications to the author in a series of interviews undertaken in 1999.
12 Correct Māori spelling is Whanganui, with the 'h' included. Wanganui District Council has refused to change from the long-used Pākehā spelling of Wanganui, with the 'h' excluded.
13 Personal communications to the author who is a member of the Whanganui Regional Museum Joint Council.
14 For example see King 1981: 91–106.
15 Museum of New Zealand Te Papa Tongarewa 1998.
16 Te Runanganui o Tahu 1993.

References

Butler, P. (1996) 'Te Māori Past and Present: Stories of Te Māori', unpublished MA Thesis, Massey University.
Butts, D. (1990) 'Ngā Tukemata: Ngā Taonga o Ngāti Kahungunu (The Awakening: The Treasures of Ngāti Kahungunu)' in P. Gathercole and D. Lowenthal (eds) *The Politics of the Past*, London: Unwin Hyman, pp. 107–117.
Butts, D. (1994a) 'The Antiquities Act Review 1986–1994: Time to Mobilise', *New Zealand Museums Journal* 24(1): 48–49.
Butts, D. (1994b) 'The Orthodoxy of Biculturalism', *New Zealand Museums Journal* 24(2): 32–34.
Butts, D. (2000) 'Museums' in R. McCahon and G. Olliver (eds) *Informing New Zealand: Libraries, Archives and Museums*, Wellington: Open Mind Publishing, pp. 150–160.
Durie, M. (1993) 'Māori and the State: Professional and Ethical Implications for the Public Service' in *Proceedings of the Public Service Senior Management Conference*, State Services Commission, Wellington.
Durie, M. (1998) *Te Mana Te Kāwanatanga: The Politics of Māori Self-Determination*, Auckland: Oxford University Press.
Fleras, A. (1999) 'Politicising Identity: Ethno-Politics in White Settler Dominions' in P. Havemann (ed.), *Indigenous Peoples' Rights in Australia, Canada and New Zealand*, Auckland: Oxford University Press, pp. 187–234.
Hakiwai, A. (1995) 'The Search for Legitimacy: Museums in Aotearoa, New Zealand – A Māori Viewpoint' in Tsong-yuan, L. (ed.) *Proceedings of the International Conference on Anthropology and the Museum*, Taipei, Taiwan: Taiwan Museum.
Huwyler, G. (2001) Typescript of presentation to Curators' *Hui* at Whanganui Regional Museum, 24 April 2001.
Kaeppler, A. (1978) *'Artificial Curiosities': An Exposition of Native Manufactures Collected on the Three Pacific Voyages of Captain James Cook, R.N.*, Honolulu: Bishop Museum Press.
King, M. (1981) *The Collector: Andreas Reischek – A Biography*, Auckland: Hodder and Stoughton.
Lindsay, M. (ed.) (1992) *Taonga Māori Conference, New Zealand: 18–27 November 1990*, Wellington: Department of Internal Affairs.

McKenzie, M. (1991) *Manawatu Museum Society Incorporated 1970–1991: An Historical Survey*, Wellington: Manawatu Museum Society.

McManus, G. (1992) 'The "Te Māori" Exhibition and the Future of Museology in New Zealand' in S. Pearce (ed.) *Museums and Europe*, London: Athlone Press, pp. 192–199.

Mead, H. (1986) *Magnificent Te Māori: Te Māori Whakahirahira*, Auckland: Heinemann.

Mead, S. (1985) 'Concepts and Models for Māori Museums and Cultural Centres', *Art Galleries and Museums Association of New Zealand Journal* 16(3): 3–5.

Murphy, H. (1999) *Bicultural Developments in Museums of Aotearoa: A Way Forward*, Wellington: Te Papa National Services.

Museum of New Zealand Te Papa Tongarewa (1998) *Management of Human Remains Hui: Report on a Hui Held at Te Papa*, Wellington: Museum of New Zealand.

Museum of New Zealand Te Papa Tongarewa (1999) 'Briefing on the Museum of New Zealand Te Papa Tongarewa for the Right Honourable Helen Clark Prime Minister', Wellington: Museum of New Zealand.

Neich, R. (1985) 'Interpretation and Presentation of Māori Culture', *Art Galleries and Museums Association of New Zealand Journal* 16(4): 5–7.

O'Regan, G. (1997) *Bicultural Developments in Museums of Aotearoa: What is the Current Status?*, Wellington: Museum of New Zealand and Museums Association of Aotearoa New Zealand.

O'Regan, S. (1990) 'Māori Control of the Māori Heritage' in P. Gathercole and D. Lowenthal (eds) *The Politics of the Past*, London: Unwin Hyman, pp. 95–106.

Pishief, E. (1996) 'Augustus Hamilton: Appropriation, Ownership and Authority', unpublished MA Thesis (Museum Studies), Massey University.

Project Development Team (1985) *Ngā Taonga o Te Motu: The Treasures of the Nation: National Museum of New Zealand – A Development Plan*, Wellington: Department of Internal Affairs.

Soutar, M. and Spedding, M. (2000) *Improving Bicultural Relations – A Case Study: The C Company 28 Māori Battalion Collection and Exhibition at Gisborne Museum and Arts Centre*, Wellington: Te Papa National Services, Museum of New Zealand.

Tapsell, P. (1997) 'The Flight of Pareraututu: An Investigation of Taonga from a Tribal Perspective', *Journal of the Polynesian Society*, 106(4): 323–374.

Tapsell, P. (2000) *Pūkaki: A Comet Returns*, Auckland: Reed.

Te Awekotuku, N. (1988) 'The Role of Museums in Interpreting Culture', *Art Galleries and Museums Association of New Zealand Journal* 19(2): 36–37.

Te Māori Management Committee (1988) *Te Māori: He Tukunga Kōrero: A Report*, Wellington: Department of Māori Affairs.

Te Papa National Services (1999) *Wānanga on Bicultural Development in Museums*, Wellington: Museum of New Zealand Te Papa Tongarewa.

Te Papa National Services (2000) *Wānanga on Bicultural Governance and Leadership in Museums*, Wellington: Museum of New Zealand Te Papa Tongarewa.

Te Runanganui o Tahu (1993) *Kōiwi Tangata: Te Wawata o Ngāi Tahu e pā ana Ki Ngā Taoka Kōiwi o Ngā Tūpuna*, Christchurch: Te Runanganui o Tahu.

Thomson, K. (1978) 'The Role of the New Zealand Government in Retrieving Cultural Property', *Art Galleries and Museums Association of New Zealand Journal* 9(4): 12–14.

Thomson, K. (1981) *Art Galleries and Museums in New Zealand*, Wellington: Reed.

Whaanga, M. (1999) Development of Bicultural Policy for the Auckland Museum, unpublished M.Phil. Thesis (Māori Studies), Massey University.

Williams, M. (2001) 'Asking the Hard Questions', *New Zealand Books* 11(1): 12–13.

18

Inclusion and the power of representation: South African museums and the cultural politics of social transformation

Khwezi ka Mpumlwana, Gerard Corsane, Juanita Pastor-Makhurane and Ciraj Rassool

Introduction

In Britain, over recent years, the discussions about making museums more responsive to societal concerns and accessible to wider layers of society have taken place around the question of 'inclusion'. This approach is connected to wider concerns in Britain and Europe about forms of social disenfranchisement, marginalisation and cultural deprivation that are referred to as 'social exclusion'.[1] Indeed, museums in Britain have been seen to hold potential as 'agents of social regeneration' and 'vehicles of broad social change'.[2] Some museums in Britain have approached this question as nothing more than an access dilemma, while others have embarked on a more controversial approach, which 'requires museums setting aside existing agendas and rethinking their role and purpose'.[3] In essence, this latter approach means that museums need to go further than simply looking at the public services provided. Instead, they need to go right back to their foundations and consider transforming and reconfiguring themselves from deep within.

This paper seeks to contribute to debates around the social role and purpose of museums by referring to the challenges, achievements and tensions of the processes of museum and heritage transformation that have been started in South Africa. It is hoped that this discussion of the South African experience will help stimulate thought in other countries, especially those with colonial legacies. The aim of the chapter is to introduce what must be the critical, long-term success factor of museums and heritage transformation – the democratisation of the profession and its thinking.[4] Alongside this theme, the chapter will also consider certain initiatives that have already started to reshape the values, purposes, roles, services, functions and activities of museums and heritage management, thereby making them more inclusive.

Nelson Mandela reflected upon the challenges of the processes of transforming the South African museums and heritage sector at the official opening of the Robben Island Museum, on Heritage Day in September 1997, when he stated that:

> With democracy, we have the opportunity to ensure that our institutions reflect history in a way that respects the heritage of all our citizens. Government has taken up the challenge. Our museums and the heritage sector as a whole are being restructured. Community consultation, effective use of limited resources and accessibility are our guiding principles as we seek to redress the imbalances . . . When our museums and monuments preserve the whole of our diverse heritage, when they are inviting to the public and interact with the changes all around them, then they will strengthen our attachment to human rights, mutual respect and democracy, and help prevent these ever again being violated.[5]

In the South African museums and heritage context, one issue of concern has been that attempts to be more inclusive at the level of access to public programmes, and drives to entice new audiences, will not be enough. Without a total transformation of the sector itself, these attempts are little more than 'quick-fix', bolt-on solutions to a system that will remain largely unchanged. With regard to South African museums, such an add-on approach would do very little to benefit the individual institutions, or South Africans in general. Instead, the questions of museum transformation needing to be addressed are far more deep-rooted and arise from characteristics that are at the core of the museum project. They concern the very notion of the museum as a western construct imposed on South Africa during the processes of colonisation, as well as the classification systems that characterised museums. Therefore, if South African museums are to truly become more inclusive, the whole notion of the museum has to be interrogated and new ways of thinking about museums and their place within the heritage sector, and society as a whole, stimulated. Surely, the processes of transformation have to start with this type of critical reflection, which can only really happen if 'new' voices are allowed to be heard, both from within and outside the museum profession.

Democratising the museum profession

The collaborative discussion found in this chapter is one outcome of an unusual partnership in higher education in South Africa: that between institutions of public culture and the academy. All of the authors are, or have been,[6] connected to the Postgraduate Diploma in Museum and Heritage Studies (the Diploma) and its component section, the Robben Island Training Programme (RITP).[7] This Diploma, which had its first intake of participants in March 1998, is offered through a partnership between the Robben Island Museum, the University of the Western Cape and the University of Cape Town,[8] and is jointly certified by the two universities. The partnership is historically significant because of its strong affirmative-action basis, as is the fact that the two universities have

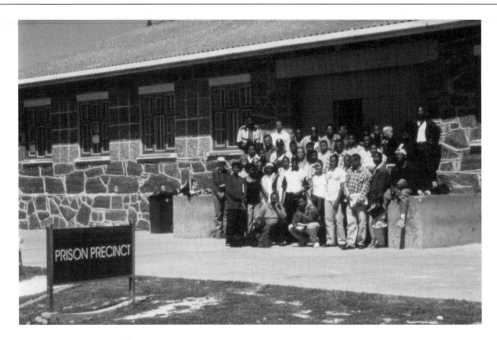

Figure 18.1 A cohort of the Postgraduate Diploma students outside the Maximum Security Prison on Robben Island. Photo: Gerard Corsane.

agreed on joint certification – something unusual in a higher education system that has a strong market orientation, where higher education institutions are expected to compete for student numbers (Figure 18.1).

The reason for the willingness of the Diploma partners to work together, and the success of the Diploma to date, has been the belief among all those involved – along with many others in the South African museums and heritage sector[9] – that within the new democracy the sector must transform and become more inclusive of, and relevant to, *all* South Africans. Central to this belief was a consensus among the partners that, before proposed transformation processes could work, and for the sector to become more inclusive, any action had to be cognisant of the need to redistribute power and to enable previously disadvantaged people to enter and make contributions in the cultural politics of social transformation. Changing the profile of the profession, therefore, was a priority. Transformation is not only about changing *what* is represented in old and new museums, but crucially concerns *who* is empowered to make the representations. Therefore, it is argued that these transformation processes cannot be initiated, sustained, or succeed, unless serious attention is given to the democratisation of the museum profession in demographic terms, particularly in the middle- and top-management decision-making levels.

Historically, the decision-making levels of the South African museum profession in the government-supported museums have been almost exclusively the domains of whites, with blacks being employed only in the lower ranks. Still today, there is no black director of a national state-supported museum. This

being said, it should be noted that there was some repositioning that took place during the 1980s and 1990s, with certain black museum workers being raised to the positions of education officer or outreach officer. This move was primarily done for the sake of the institutions, as museums, fighting for survival, attempted to attract new users from the groups who had for so long seen museums as alien western constructs. However, for many people in these groups, this repositioning was seen as being very superficial. They perceived museums as colonial power bases for the production and entrenchment of Eurocentric heritages and knowledge systems, including classification and signifying schemes, used to 'order' the world and understand it within a particular world-view. For the majority of South Africans then, museums, at best, had little or no value for them. At worst, these institutions were seen as agents that helped to reproduce and maintain the status quo of inequalities controlled by, and in the service of, the dominant cultures. Thus, more was needed than the simple creation of 'Outreach Officer'[10] posts for black staff members. Indeed, for this legacy of alienation to be changed, the profession *as a whole* needs to be changed. This will allow for opportunities to draw on the knowledge systems of different cultures in ways that will challenge the traditional notion of the museum and museum practices.

The Diploma programme is intended to provide opportunities for fast-track affirmative action education and training to empower black South Africans both already working in, and wanting to enter, the sector. A desired outcome of this empowerment is to prepare and enable participants to rise to positions where they could influence decisions made in both individual institutions and in the sector as a whole.

Museums in South Africa have been characterised by the contestation of culture, as reflected both in the reconstruction of old museums and in the emergence of new museums and heritage sites. Through the Diploma, it is anticipated that black South Africans will be able to positively engage in this contestation. They will become equipped to participate on an equal footing in the cultural politics of social transformation through the development and sharing of new ideas, while at the same time working towards a recognised and competitive qualification that will open opportunities for them to move into decision-making positions at all levels in the sector. These positions include key posts in national and provincial government departments responsible for arts, culture, heritage and museums, as well as top- and middle-management posts in individual institutions, organisations and agencies. In addition, it is hoped that, as the Diploma develops, it will also encourage some black South Africans to work towards forming consultancies that will further impact on the sector, bringing fresh insights and input.

The Diploma is considered to be a starting point for the partner institutions, and in time it is hoped that it will feed into masters programmes, higher degrees and research opportunities to be fostered by the partnership. Cumulatively, these developments will help to stimulate and give voice to new ways of thinking about, and working in, museums that will ultimately lead to shifts in

the power dynamics of representation, which will result in these institutions becoming more inclusive.[11] In all of this, it is hoped that the old museum mould that has confined museum thinking and practice will be broken.

However, although the democratisation of the profession and museum thinking is viewed as being something that needs to take place, there are other ongoing initiatives that have fed into the transformation processes from other angles. These include the government plans to restructure the established 'national' museums and to facilitate the creation of new museums and heritage projects, as well as a number of community-driven museums and heritage initiatives.

The restructuring of the established museums

By the beginning of the 1990s, at the end of apartheid's life, established museums in South Africa were characterised by a number of features. In the first place, all major museums were located in the larger cities and only certain of these were designated and funded as 'Declared Cultural Institutions' (DCIs). The value of these institutions was seen to be that they:

> have the potential to play a vital role in the development of arts, culture, heritage and science in South Africa. They provide opportunities for life-long learning, which are not found at other types of public institution. Not only are their scientific resources and expertise a major national and regional asset, but they also promote tourism and other entrepreneurial activities.[12]

The DCIs were 'national' in that they were budgeted for by the state 'because of *ad hoc* decisions made in the past'.[13] Many museums that were designated as 'national museums' were located in the three largest cities. Among the DCIs in Pretoria and Johannesburg were the Transvaal Museum, the National Cultural History Museum and the South African Military History Museum, while in Cape Town, the South African Museum (SAM), the South African Cultural History Museum (SACHM), and the South African National Gallery (SANG) were some of the DCIs.

The 'national' status granted to such museums gave the impression that their collections were of importance to the nation. However, not all of these museums were of 'national' status, when considered in relation to their collections or services. Indeed, it was argued, several other museums were perhaps more 'national' in this respect than some of the institutions that were nationally funded.[14] Moreover, the national status of certain collections entrenched the bias in favour of colonial cultural forms, which depicted the 'civilisation' of whites and connected them to a European heritage. In this vein, collections bequeathed to the nation, such as the William Fehr and the Michaelis Collections in Cape Town, had been designated as DCIs. Consider, for example, a description of the Michaelis Collection:

> In this museum, one of the most exquisite little art museums in the country, both the collection and the building in which it is housed are of great

aesthetic and historical importance. The early Cape Dutch building, one of the architectural gems of the Mother City, houses a precious and internationally renowned collection of the artworks by 16th to 18th century Dutch and Flemish masters. Situated on Greenmarket Square in the heart of old Cape Town, the Old Town House was one of the first double-storey buildings when it was erected in 1755–1761 under the governorship of the popular Rijk Tulbagh. The Cape-silver trowel with which its first stone was laid by Baerendt Artois, member of the Court of Justice, is still on view in the Museum. With its proud three-arched portico, its gay green shutters against the white and yellow plasterwork, its exuberant moundings and fanlights and its quaint belfry the Old Town House, for all its modesty, is as endearing a little Rococo building as any found in Europe.[15]

The policy analysis of the state of museums in South Africa as represented in the 1996 *White Paper on Arts, Culture, and Heritage*[16] was clear: the provision of museum services 'lacked co-ordination'; there was no coherent national museum policy; planning was 'fragmented'; 'many communities did not have access to museums'; and 'cultural collections are often biased'.[17] There was a 'lack of transparency and accountability'. Importantly, the DCIs needed re-evaluation according to agreed criteria of what 'national' meant.[18] 'Heritage', it was felt 'could not continue to be managed in an elitist manner'.[19] The report of the Arts and Culture Task Group (ACTAG),[20] which had been set up in 1994 to advise on cultural transformation and policy formulation, had noted that 'the heritage of the majority of our people has not only been neglected, but also (deliberately) suppressed'.[21]

Some of the institutional histories of the larger DCIs are worth reflecting on because they reveal deeper issues of cultural politics and classification, which continue to bedevil South African institutions. These museums were administered within the apartheid framework for culture and education. The SACHM, for example, was administered within the tricameral parliamentary system as a white 'own-affairs' institution. This museum had its origins in the gradual separation of the 'historical collections' from the SAM building during the 1960s to a newly formed Cultural History division of the SAM, housed at what was then called the 'Old Supreme Court'. In 1969, the SACHM became a separate museum.

The SAM, on the other hand, from which 'historical collections' were taken away, was left with its 'vast collections of natural history and anthropological objects' that documented 'all forms of life, living and extinct, from southern Africa, and the material cultural heritage of our indigenous populations back to their earliest origins'.[22] It might be that the SAM is now able, by sleight of hand, to recast its collections and displays as 'indigenous heritage', and even worse, reconfigure its work as taking place within the framework of the 'African renaissance'. But this move belies a key characteristic that emerged from the late nineteenth century, and that was completed in 1969; that is, the fundamental separation between cultural history and ethnography, and the grouping of ethnographic collections with the natural history specimens.[23]

With a transformative agenda, the democratic government has attempted to intervene by 'co-ordinating policy, rationalising institutions and establishing new institutions and programmes that would primarily reflect the realities of where we are in South Africa'.[24] The 'core objectives' of this intervention in transforming existing museums and establishing new ones has been 'redress and broadening of the scope of our collective understanding of what heritage is'.[25]

To this end, two national 'flagship institutions', the Northern and Southern Flagships, were established, based on the model of the Smithsonian Institution. The idea was to group what were previously DCIs, in the Gauteng and Western Cape provinces respectively, into a restructured core of a national museums service.[26] The goal in this was to review and upgrade management systems, rationalise and co-ordinate these remodelled institutions, and ensure that they were made less dependent on government.

Museum restructuring has not only taken place at a national level. Within provincial structures in the nine provinces of South Africa, transformation processes have been undertaken following initiatives stimulated by provincial departments and by the individual institutions themselves. In one such initiative, the McGregor Museum in Kimberley repositioned itself as the 'flagship museum' in the Northern Cape and embarked on a process of change by adding new displays to its old exhibitions. By the end of the 1990s, two new displays, *Frontiers* and *Ancestors* had been added on to old exhibitions of Kimberley personalities, Kimberley 'firsts', the siege of Kimberley and the Kimberley military regiment. In addition, token black personalities and achievements have been added to the old displays. Here, the add-on method was the primary mechanism of including black history.[27]

New museums, heritage sites and heritage projects

In addition to attending to the institutional reshaping of the old 'national' museums, the management of their collections and their democratisation, the new democratic state has also instituted new national museums and heritage projects within the framework of the Department of Arts and Culture's 'Portfolio of Heritage Projects'. The important tasks of building new museums and heritage initiatives for the new nation are being carried out through the Legacy Project, constituted in 1996, and co-ordinated by a Legacy Committee. This project seeks 'to approve and facilitate the setting up of new monuments, museums ... plaques, outdoor artworks, history trails and other symbolic representations'. These would ensure that 'visible reminders' of the 'many aspects of our formerly neglected heritage' would be created. The Legacy Committee has sought to present 'a coherent set of principles' that would enable different initiatives to be 'harmonised' and ensure 'integrity, inclusiveness, balance and broad participation'. With wide distribution throughout South Africa, and with the focus on national symbols with 'provincial and local participation' encouraged, the proposed legacy initiatives will 'communicate a stimulating message of rich cultural diversity'.[28] In essence then, the Legacy

Project was established to think about and plan the overall introduction of new cultural interventions, with social inclusion as one of the many ideas captured within its structure. The project has already seen a fairly co-ordinated introduction of new cultural interventions, of which at least three are museums. These are the Robben Island Museum, the Ncome Museum and the Nelson Mandela Museum.

The first major intervention of the Legacy Project was the establishment of the Robben Island Museum, with its international significance and global symbolism. Officially opened as a museum by Nelson Mandela on Heritage Day, 24 September 1997, Robben Island was also listed as a World Heritage Site in December 1999. Based on transforming a story of imprisonment and isolation into one of survival and 'the triumph of the human spirit'[29] in spite of apartheid's repressive system, Robben Island is a place where a new public memory of South Africa is being constructed. When the Robben Island Museum was established there was no collection in the traditional museological sense of the word, except perhaps for objects and furniture left behind by the prison authorities. This gap was considered an advantage because it provided an opportunity to explore a new collecting strategy that would attempt to raise awareness among the public and specific target audiences of the value of their own possessions and their own stories. The new strategy also helps to challenge the notion that a museum must have a permanent collection based primarily around tangible and movable material. It recognises the equal importance in the documentation of intangible heritage sources like individual testimonies and public memories, as well as the value of borrowing 'collectables' from individuals and communities.

In an early phase of the museum's development, a media campaign was set up and aimed at ex-political prisoners who had spent time in Robben Island Maximum Security Prison. They were asked to share their 'memories' and/or loan valuable souvenirs of their time in prison to the museum. This 'collecting' programme was initiated alongside an oral history programme that collected the life stories of ex-prisoners on audiotape. In this way, a loan collection was set up of objects that reflected the memories of an important period in South Africa's history. This collections strategy, in tandem with the oral history programme, formed the basis of an exhibition, *Cell Stories*, recently installed in one section of the Maximum Security Prison. In essence, the exhibition constitutes a dialogue with ex-political prisoners and the resulting recorded interaction. The installation consists of an edited paragraph from the oral history interview, the object that has been on loan and a photograph of the person whose story is represented to the visitor.

Integral to the broader presentation of the prison is an interpretation of the space by guides or hosts who are former political prisoners and by the visitors. The hosts use the opportunity to tell their personal story of imprisonment and to develop a dialogue between themselves and the visitors. The host is the co-interpreter of an important aspect of the struggle towards a democratic South Africa, by sharing his experience and by allowing the visitors to respond and

engage. This is a break from the traditional didactic authoritative monologues that tend to be the dominant discourse in South African museums.

The Robben Island Museum has also established educational programmes that, at present, cater primarily for schools and young people but which draw on both the history of the museum and on experiences of the communities from which the learners and young people come from. In one of the museum's Spring Schools (a week-long educational session in the South African Spring Holidays) a travelling exhibition entitled *From Incarceration to Liberation* was developed using apple boxes as display units – the boxes being symbolic, as it was this type of box that the last political prisoners used to move their property on release. The exhibition travels to community libraries and multi-purpose centres to be experienced by people who would otherwise not have access to Robben Island. The host communities are free to integrate their own experiences to its interpretation and organisation.

In line with being a forum for critical debate, the museum has also invited back former political prisoners to lecture in seminars, hosted on the mainland in different venues, on issues that link Robben Island to the contemporary experiences of human rights, education, culture and leadership. Diverse audiences were attracted to these seminars and this was a step towards expressing historically silenced voices and knowledge. A number of conferences that reflect on the wider meaning of the Robben Island experience have also been organised in partnership with non-governmental organisations, academic institutions and ordinary people of different kinds.

Although the Robben Island Museum has a high profile because it has captured the world's attention, the two other museum Legacy Project initiatives are of value with regard to the transformation of museums in South Africa. These are the Ncome Museum, located at the site of the 1838 Zulu–Boer War in KwaZulu Natal, and the Nelson Mandela Museum in Umtata in the Eastern Cape.

The first of these new museum initiatives is expected to function as a multi-purpose cultural community resource and interpretation centre. Emphasis will be placed on 'bringing vibrancy, creativity and community participation'. It was intended that 'ordinary members of the community, the local schools and other local organisations'[30] would take ownership of the site. The second of these museum initiatives, the Nelson Mandela Museum, 'named and themed after one of the greatest statesmen of our time', began its operations on 11 February 2000, the tenth anniversary of Nelson Mandela's release from imprisonment. It is multi-sited, at Umtata in the renovated Bhunga (meaning 'place of discussion') Building, Mvezo village (Mandela's birthplace) and Qunu village (his childhood home). As it develops, it is the intention that the project will consist of a 'conventional museum, a cultural village and a community centre'. This museum is projected 'to mark a complete departure' from a static view of museums, to one that prioritises 'accessibility, broad participation, tourism promotion, and community ownership'.[31] Although it is national in status and ideas represented, the majority of its leadership and targeted beneficiaries are from local communities. One of the immediate benefits of its construction was

the improvement of an access road and other infrastructure developments. In the build-up to the museum's opening, the idea of a museum shop was recast in ways appropriate to the needs of the local communities. As a result, the concept of a museum market place emerged. In time, a shuttle service, owned by a community co-operative, will also be developed to transport visitors between the three sites at Umtata, Mvezo and Qunu, which are at least 20 kilometres apart from each other.

The core exhibition, based on Mandela's autobiography *Long Walk to Freedom* and on gifts given to Mandela, seeks to: 'articulate and promote nation building and reconciliation; document the struggle for democracy in context; to affirm and explain the international contribution to the antiapartheid struggle'. The entire project is a cultural element to a Spatial Development Initiative calculated at alleviating rural poverty and 'stimulating development, [aimed at] uplifting affected communities by creating sustainable employment opportunities'. The project will contribute to youth development, leadership training and the development of cultural tourism.

Other plans within the original twenty proposed Legacy Project initiatives deal with: developing recognition of pre-colonial sites; commemorating the 1899–1902 'Anglo–Boer war'; memorials to forced removals; a monument to the San; the creation of tourism trails that focus on the activities and settlements of Christian missionaries; and commemorations of events, such as the Congress of the People (1955), the Sharpeville massacre (1960) and the Soweto student action (1976), that are deemed to be 'historical turning points'. Such diverse projects of monumentalisation, it was felt, would 'acknowledge and celebrate South Africa's multi-cultural heritage'.[32]

A central feature of the programme of monumentalisation is the 'contribution' of leaders to 'our legacy of democracy' and, in a broad-ranging proposal, a Freedom Park has been proposed, which suggests the development of a 'dynamic multi-dimensional commemoration' aimed at telling the history of South Africa from pre-colonial times up to the present. This project will 'commemorate all those who fell in the struggle for liberation' and, at the same time, mark the 'celebration of the attainment of freedom and democracy'. It is envisaged that the project will be a symbolic expression of the themes of 'Struggle, Democracy and Nation-Building', which will 'represent our past, present and future'.[33]

Community-driven museums and heritage projects

While interventions by the state through policy formation, the restructuring of established institutions, museum-building and the framing of heritage have been important in driving museum transformation, access to heritage and cultural resources has also been broadened through the emergence of new community-driven museums and heritage sites. These projects range from the Clanwilliam Living Landscapes initiative and the Lwandle Migrant Labour Museum & Arts

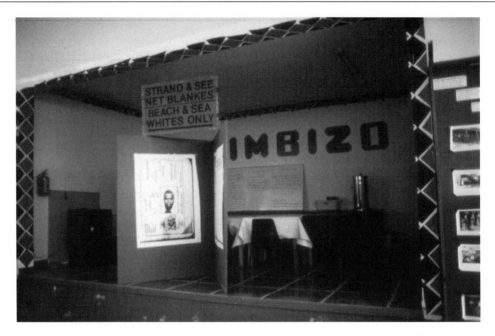

Figure 18.2 Lwandle Migrant Labour Museum & Arts and Crafts Centre displays in the community hall. Photo Elizabeth Crooke.

and Crafts Centre in the Western Cape (Figure 18.2) to the Makuleke Interpretation Centre in the Northern Province. Many of these fledgling projects are fragile and tentative, and have emerged on the fringes of the centrally driven transformation process. Some of them are connected to the research presence of universities in particular localities, while others have been facilitated by the work of non-government organisations that have supported successful land claims through an emphasis on heritage. Nevertheless, many of these projects are expressions of some of the central themes of museum and heritage transformation: the recovery of heritage previously suppressed; the validation of ordinary experience; an emphasis on living heritage and orality; and the engagement with systems of tourism to ensure that 'the other side' is reflected.

District Six Museum

Perhaps the most significant example of such a community initiative has been the District Six Museum (Figure 18.3), built to commemorate a community in central Cape Town that had experienced forced removals.[34] At one level, the museum is a project about the histories of District Six, the forced removals and the retrieval of memory as a resource of solidarity and reclamation. The museum speaks of itself as a 'community museum', whose work is addressed to a community who had been removed under apartheid's Group Areas Act. But in the face of a historiography that has tended to privilege 'District Six' in the story of 'forced removals', the museum has also had to go further and address

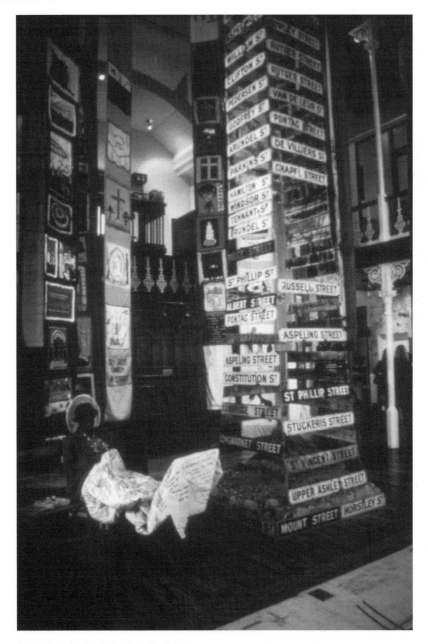

Figure 18.3 Inside the District Six Museum. Photo Elizabeth Crooke.

255

a general history of forced removals, narrated on a national scale. So, it is the widespread experience of removals and dislocation that is seen as the source of a national history of South Africa. In its collections and curatorial work, the museum seeks to produce and generate such national histories. At times this identification intersects with the interests of the tourism industry, who require a 'space of apartheid' for tourists to witness.

And yet, at another level, the District Six Museum as a space is a project about different genres of knowledge production. It is concerned to examine the different modalities, methods and discursive strategies employed by different knowledge genres. Here, the museum seeks to open up questions of *relations of knowledge* contained in and generated by the museum, and of the processes of meaning-making in all facets of the museum's work, including collections formulation and management, curatorship and exhibitions. On one hand, this is an attempt at a self-critical and reflexive pedagogy on the part of an institution that, in its founding structures, had brought together community-connected academics, some of whom see themselves as 'activist intellectuals', but who often bear the restrictive marks of the academy, and former residents, many of whom have been activist intellectuals for decades with their roots in District Six-based political organisations that had set out, from the 1930s and 1940s, to construct independent spaces of political engagement and knowledge production and an alternative, modernist public sphere.[35] In order to transcend uncritical frameworks of triumphalism and celebration, the museum sees it as necessary to examine the meanings that staff and trustees bring to the institution, as well as the claims made about the museum. It also wishes to analyse the ways in which the museum and its work are reflected upon by outsiders, both South African and international, as well as by academics and members of the public.

As a site of knowledge of society, the museum, by its very nature, confronts the issue of ethnography in all of its work, and resists its construction as a convenient field site for the study of culture and the politics of transition. The increasing scale of visiting academics and graduate students, bent on finding spaces of engagement in South Africa, can be seen as an emerging, highly specialised site of tourism. South African academics, students and public scholars increasingly find themselves in the position of 'native' informants, facilitating a double relationship of ethnography, as a research encounter, as well as a cultural encounter in a post-colony in transition.[36] In addition, the museum is also mindful of the need to challenge meanings that are attributed to it within relations of tourism more generally, which might also derive from a quest for an encounter with 'the other'. Implicitly, the museum is concerned to develop a productive ambivalence about academic forms of knowledge appropriation as well as the power of tourist discourses of diversity.[37]

The newly installed South African Heritage Resources Agency (SAHRA), created in terms of the National Heritage Resources Act (No. 25 of 1999), has also placed emphasis on community-based heritage projects. SAHRA has inaugurated a National Heritage Resources Fund to stimulate local, community-

based projects that would draw on oral history and intangible heritage resources, also sometimes referred to as 'living heritage' or *amasiko* in Nguni languages and *Ditso* in seSotho. It is intended that such projects should address the needs of marginalised communities by providing training, so that they are empowered to contribute to the 'maintenance, management and promotion of the national estate'.[38]

Towards improved representation in South African museums

Although the work to restructure the DCIs and provincial flagships has progressed some way, these 'old' museums still seem suspended in time, weighed down by their collections, limited resources and old staffing hierarchies. The conservation of old museum collections, in large measure, seems to perpetuate outdated colonial values, in spite of the new institutional structure. By early 2000, there was no systematic re-examination of the classificatory divisions, nor of collection and disposal policies. In addition, by 2000, revision of the permanent exhibitions in these museums had taken one of three lines: to remain the same and hope that other museums will tackle the 'gaps' in representation; to establish parallel representations; or to attempt to integrate new 'bits' into older exhibitions using a kind of tack-on approach. In 2001, in a controversial step, the Bushman Diorama in the SAM was closed down. First created in 1959 using life-casts of prisoners, shepherds, and rural workers that had been made at the beginning of the twentieth century, this exhibition had long been a source of public debate. However, there was no indication that this step was taken as part of a more thoroughgoing commitment to re-examine the SAM's deep legacy of ethnography and racial science. Little has been done to address the static ethnographic representations of African people at the SAM and in other museums, or to challenge the old notion of the museum. The tack-on exhibitions have just contributed to the emergence of a conservative pluralism where it is implied that we must 'hear the other side', which was overlooked during apartheid.

The Nelson Mandela Museum and the Robben Island Museum, on the other hand, have emerged in relation to approaches that interrogate the notion of the museum, seeking to move away from older approaches based on old collections in old buildings. These museums have drawn on ideas like the eco-museum model, 'museums without walls', and living museums as sites of heritage interpretation, and in some ways reflect these features. The Nelson Mandela Museum seeks to draw on and reflect the needs of local communities, for example the need of road building. At the Robben Island Museum, there has been a holistic approach to heritage, with the management strategies and plans for the cultural landscapes encompassing everything that humans have modified, and the use of the natural resources by those on the island, thereby simultaneously encompassing the environment, culture and history. While the main focus of work has been the larger South African story of resistance, triumph and reconciliation, with Robben Island as the birthplace of democracy, increasingly the focus has fallen on collecting, documenting and exhibiting ordinary experience

257

of imprisonment, exclusion and banishment. Furthermore, this effort to study personal experience and memory has begun to rely on oral methods of collection and research. At the District Six Museum, a sound archive has been created and curatorial methods have been explored that draw on the creative energies and memories of a wider layer of ex-District Six residents.

Overall, certain key principles from these efforts at transforming museums and the new initiatives have begun to emerge. These include moving away from an 'object-centred' approach, to one which is described as 'people-centred'. Museums should thus not only be 'preoccupied with the collection and display of physical objects' but should 'collect, preserve and access memories, stories, ideas, concepts, music, oral testimonies'. This will ensure that museums will cease to be seen as alien spaces, places where 'dead things' are stored.[39]

'The Museum': towards a new definition in South Africa

Museum transformation in South Africa has had a number of characteristics. On the one hand, the democratic state has had to find a museum structure through which the collections and institutional legacies of old museums can be re-articulated. While the most challenging work in this setting has occurred through temporary exhibitions, held sometimes in partnership with outside projects or through the work of outside curators, the central feature of attempts to alter displays and collections has been through the 'tack-on' method. Old museums have hardly begun to confront their legacies of classification, ordering and appropriation. New national museums and legacy projects, on the other hand, have been charged with the task of altering the face of museums and heritage in South Africa. This has entailed the consideration of new national narratives, as the basis of displays and heritage work, as well as a reconsideration of the institution of the museum itself. The focus on collecting and reflecting intangible heritage and on engaging with the possibilities of inclusion through community management, guiding, and even performance has raised questions about the museum as a repository of collections in a fortress-like building. These questions have also been raised in the setting of community-based museums. Important tensions and contradictions have begun to emerge, about the management of transformation, and about the importance of reconciling different demands. The creation and re-creation of displays have occurred largely through the efforts of an already skilled, professional layer, artists and curators intent on creative expression on the cutting edge, and working largely with conventional and established processes of knowledge production. However, the real work of transformation will only come into its own once the achievements of new education and training projects in Museum and Heritage Studies begin to be expressed in the everyday work and management systems of museums in South Africa. Without this, transformation will be hollow.

Notes

1 See Sandell, R. (2000) 'Museums as agents of social inclusion', *Museum Management and Curatorship* 17(4): 401–418.
2 See ibid.: 413–417. See also Sandell, R. (1999) 'The regeneration game', *Museums Journal* 7, July: 30–31.
3 See the discussion by Carrington, L. (1999) 'An open door policy', *Museums Journal* 7, July: 26–29.
4 For a discussion of the strategic significance of a more representative profession, see Sandell, R. (2000) 'The strategic significance of workforce diversity in museums', *International Journal of Heritage Studies* 6(3): 213–230.
5 A copy of the speech is recorded in the Robben Island Museum newsletter: *Ilifa Labantu – Heritage of the People*, October 1997, 1(9): 3.
6 Although Gerard Corsane is now based at the Department of Museum Studies at the University of Leicester, he was the first Robben Island Training Programme Co-ordinator and played an important role in the establishment of the Postgraduate Diploma in Museum and Heritage Studies.
7 In many ways the RITP acted as a catalyst that helped to bring initiatives in the three institutions together.
8 The University of the Western Cape was a 'historically black university' and the University of Cape Town a 'historically white' institution in the old apartheid system.
9 Two of the heritage institutions that have representation on the co-ordinating committee of the Postgraduate Diploma in Museum and Heritage Studies are the District Six Museum and the South African Heritage Resources Agency.
10 The whole notion of 'museum outreach' can be problematised, especially in the South African context, as it still communicates that the museum (possibly in its traditional format) has to reach out to stakeholders, rather than allowing these stakeholders to 'reach in' to the museum and affect change and transformation.
11 The Diploma, and what may grow out of it, along with similar academic programmes in other institutions, constitute one way of transforming the museum profession. There are a number of experienced South Africans, both black and white, who are already working in either the old institutions or the new initiatives and who have had significant influences on the processes of transformation.
12 Department of Arts, Culture, Science and Technology (1996) *White Paper on Arts, Culture and Heritage: All our legacies, our common future*, Department of Arts, Culture, Science and Technology, Pretoria. Ch. 5, paragraph 5. Online. Available at <http://www.dacst.gov.za/arts_culture/artculwp.htm> (accessed May 2001).
13 Ibid., Ch. 5, paragraph 6.
14 Ibid.
15 Iziko – Museums of Cape Town (2001) *Michaelis Collection in the Old Town House*, Museums Online: South Africa, Cape Town. Available at <http://www.museums.org.za/michaelis/townhouse.htm> (accessed May 2001).
16 Department of Arts, Culture, Science and Technology (1996) *White Paper on Arts, Culture and Heritage: All Our Legacies, Our Common Future*, Department of Arts, Culture, Science and Technology, Pretoria.
17 Ibid., Ch. 5, paragraph 9.
18 Ibid., Ch. 5, paragraph 6.
19 Speech by the Minister of Arts, Culture, Science and Technology, Dr B. S. Ngubane, to the Southern Flagship Institutions on 27 January 2000. *Visit to Flagship Institutions*, Department of Arts, Culture, Science and Technology, Pretoria. Online. Available at <http://www.dacst.gov/za/speeches/minister/jan2000/flagship.htm> (accessed June 2001).
20 Arts and Culture Task Group (1995) *Report of the Arts and Culture Task Group, presented to the Minister of Arts, Culture, Science and Technology*, ACTAG, Pretoria.
21 See note 19 above.
22 Iziko – Museums of Cape Town (2001) *History of the South African Museum*, Museums Online: South Africa, Cape Town. Available at <http://www.museums.org.za/sam/hist/history.htm> (accessed May 2001).

23 See Davison, P. (1990) 'Rethinking the practice of ethnography and cultural history in South African museums', *African Studies* 49(1).

24 Speech by the Minister of Arts, Culture, Science and Technology, Dr B. S. Ngubane, to the Southern Flagship Institutions on 27 January 2000. *Visit to Flagship Institutions*, Department of Arts, Culture, Science and Technology, Pretoria. Online. Available at <http://www.dacst.gov.za/speeches/minister/jan2000/flagship.htm> (accessed June 2001).

25 Ibid.

26 Department of Arts, Culture, Science and Technology, Sub-directorate: Heritage (2000) *Declared Cultural Institutions*, Department of Arts, Culture, Science and Technology, Pretoria. Online. Available at <http://www.dacst.gov.za/arts_culture/culture/heritage/index.htm> (accessed May 2001).

27 See Witz, L., Rassool, C. and Minkley, G. (2000) 'Sydafrika och historien: Om gestaltning av det förflutna under 1900-talet', *Kulturella Perspektiv* 4, for a discussion of the 'add-on' method of transformation in old museums in South Africa. See also Witz, L., Rassool, C. and Minkley, G. (2000) 'The Boer War, museums and Ratanga Junction, the wildest place in Africa: public history in South Africa in the 1990s', Basler Afrika Bibliographien Seminar, Basel, Switzerland, 10 February.

28 'The Portfolio of Legacy Projects: a portfolio of commemorations acknowledging neglected or marginalised heritage' (unpublished Discussion Document, January 1998). See also: Department of Arts, Culture, Science and Technology (2000) *Draft Document of the National Legacy Project*, Department of Arts, Culture, Science and Technology, Pretoria. Online. Available at <http://www.dacst.gov.za/arts_culture/culture/development/index.htm> (accessed May 2001).

29 This phrase was used by former Robben Island political prisoner and Chairperson of the Robben Island Museum Council, Ahmed Kathrada, and has since become a key framing theme for heritage interpretation at the Robben Island Museum.

30 Speech by the Minister of Arts, Culture, Science and Technology, Dr B. S. Ngubane, to the Southern Flagship Institutions on 27 January 2000. *Visit to Flagship Institutions*. Department of Arts, Culture, Science and Technology, Pretoria. Online. Available at <http://www.dacst.gov.za/speeches/minister/jan2000/flagship.htm> (accessed June 2001).

31 These quotes were recorded during the processes leading up to the development of the unpublished exhibition brief and planning document for the Nelson Mandela Museum. See also: Press release issued by the Minister of Arts, Culture, Science and Technology, Dr Ben Ngubane on 22 December 1999. *The Nelson Mandela Museum Project*, Department of Arts, Culture, Science and Technology, Pretoria. Online. Available at <http://www.dacst.gov.za/speeches/press/dec1999/mandela_museum.htm> (accessed May 2001). Opening remarks by the Minister of Arts, Culture, Science and Technology, Dr Ben Ngubane, at the media briefing in Pretoria on 1 February 2000. *Opening of the Nelson Mandela Museum*, Department of Arts, Culture, Science and Technology, Pretoria. Online. Available at <http://www.dacst.gov.za/speeches/minister/feb2000/nmuseum.htm> (accessed May 2001).
Speech by the Minister of Arts, Culture, Science and Technology, Dr B. S. Ngubane, in Qunu on Friday 11 February 2000. *The Opening of the Nelson Mandela Museum*, Department of Arts, Culture, Science and Technology, Pretoria. Online. Available at <http://www.dacst.gov.za/speeches/minister/feb2000/nmusqunu.htm> (accessed May 2001).

32 'The Portfolio of Legacy Projects: a portfolio of commemorations acknowledging neglected or marginalised heritage' (unpublished Discussion Document, January 1998).

33 Ibid.

34 For an extensive examination of the District Six Museum see Rassool, C. and Prosalendis, S. (eds) (2001) *Recalling Community in Cape Town: Creating and Curating the District Six Museum*, District Six Museum Foundation, Cape Town.

35 For some discussion of the political and intellectual formations of District Six see chapters by Soudien, C., Lewis, A., Omar, D. and Dudley, R. O. in S. Jeppie, and C. Soudien, (eds) (1990) *The Struggle for District Six: Past and Present*, Buchu Books, Cape Town.

36 Two recent publications on the District Six Museum reflect such problems of research and appropriation. See Bohlin, A. (1998) 'The politics of locality: memories of District Six in Cape Town' in N. Lovell (ed.) *Locality and Belonging*, Routledge, London; and, McEachern, C. (1998) 'Working with memory: The District Six Museum in the new South Africa', *Social Analysis*: 42(2): 48–72.

37 Unpublished memorandum prepared by Delport, P., Rassool, C. and Soudien, C. (1999) 'District Six and its pasts: identity, memory and transgression in public culture'. A District Six Museum, University of Cape Town and University of the Western Cape collaborative project funded by the National Research Foundation, Cape Town.

38 South African Heritage Resources Agency. (2001) 'National Heritage Resources Fund (NRF) for the conservation of our cultural heritage'. Draft Publicity Brochure, South African Heritage Resources Agency, Cape Town.

39 Speech by the Minister of Arts, Culture, Science and Technology, Dr B. S. Ngubane, to the Southern Flagship Institutions on 27 January 2000. *Visit to Flagship Institutions*, Department of Arts, Culture, Science and Technology, Pretoria. Online. Available at <http://www.dacst.gov.za/speeches/minister/jan2000/flagship.htm> (accessed June 2001).

Index

Italic page numbers refer to illustrations